*f*P

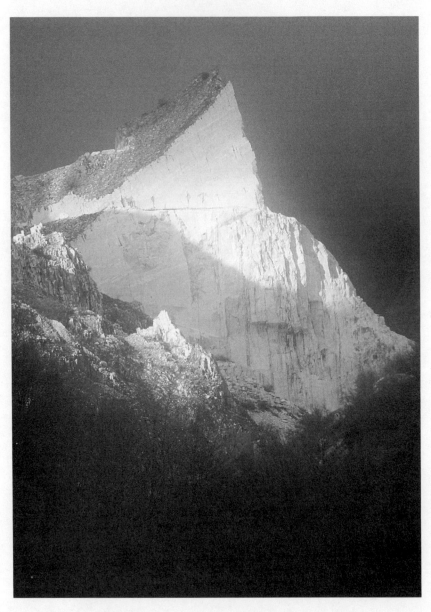

The greatest trompe l'oeil ever shaped by human hands:
a quarry in Carrara's Colonnata basin.

MICHELANGELO'S MOUNTAIN

The Quest for Perfection in the Marble Quarries of Carrara

ERIC SCIGLIANO

FREE PRESS

New York London Toronto Sydney

FREE PRESS
A Division of Simon & Schuster, Inc.
1230 Avenue of the Americas
New York, NY 10020

For information about special discounts for bulk purchases,
please contact Simon & Schuster Special Sales at 1-800-456-6798
or business@simonandschuster.com.

Map © 2005 by Karen Steichen

Book design by Ellen R. Sasahara

Manufactured in the United States of America

1 3 5 7 9 10 8 6 4 2

Library of Congress Cataloging-in-Publication Data
Scigliano, Eric, 1953–
Michelangelo's Mountain : the quest for perfection in the marble quarries
of Carrara / Eric Scigliano.
p. cm.
Includes bibliographical references and index.
1. Michelangelo Buonarroti, 1475–1564. 2. Sculptors—Italy—Biography.
3. Marble industry and trade—Italy—Carrara—History. I. Title.

NB623.B9S39 2005
709.2—dc22
[B]
2005040150

ISBN-13: 978-0-7432-5477-9
ISBN-10: 0-7432-5477-5

Permission to reproduce illustrations on the pages listed
is gratefully acknowledged to the following sources:

Author: iv, 17, 21, 75, 85, 107, 115, 121, 130, 139, 144, 147, 195, 201, 227, 245, 265, 273.
The Trustees of The British Museum: 59. Casa Buonarroti Foundation: 42. Fabbioni-
Morescalchi Collection: 2, 161, 212, 236. Civic Collections of Ancient and Modern Art,
Milan: 301. Italian Ministry of Cultural Resources and Activities, Special Superintendency
for the Museum Consortium of Florence: 55, 92, and 289 (author photos); 112, 276, and 279
(photos by Andrea Jemolo and Eliana Pallisco, Studio Jemolo). State Archive of Massa:
82 and 135. Superintendency for the Architectural Resources and Historic and Artistic
Patrimony of Rome: 190. Opera di Santa Maria del Fiore, Florence: 297.
Prefecture of Massa-Carrara, Massa: 176. Vatican Museums: 9.

To Luigi Brotini,
poet, guide, and *testimone*

CONTENTS

LIST OF ILLUSTRATIONS

OH CURSED A THOUSAND TIMES ARE THE DAY AND HOUR
WHEN I LEFT CARRARA! IT IS THE CAUSE OF MY UNDOING,
BUT I WILL RETURN THERE SOON.

MICHELANGELO BUONARROTI,
to his brother Buonarroto, from Pietrasanta, April 18, 1518

INTRODUCTION

ARISTIDE'S TRAIL

"I N ITALY," MY GRANDMOTHER USED to say, "our people wore *hats.*" Not the shapeless caps of ordinary laborers: the men of the Mazzei family wore the crowned fedoras appropriate to landowners and lawyers, government officials and . . . stone carvers. They worked with their hands, but in a trade that, in their home town, was as proud as a medieval guild: they worked the marble. Her grandfather Vincenzo had been a *cavatore* in the marble mecca of Carrara, one of the quarrymen who hacked and pried the great blocks of stone loose from the mountain and eased them down the slopes. Perhaps they had arrived in the marble belt just a few decades or generations back; Mazzei is typically a *toscano,* not *carrarino,* name, and my grandmother claimed (without any particular evidence) that we were related to one eminent Tuscan, Philip Mazzei. This peripatetic physician, merchant, and adventurer became a friend and neighbor of Thomas Jefferson, served as revolutionary Virginia's roving ambassa-

dor to Europe, and joined in both the French Revolution and the Polish government. His boosters call him, with unintended irony, "the godfather of the Declaration of Independence" because of his writings, which Jefferson translated and purportedly borrowed from. He did help draft a Polish constitution.

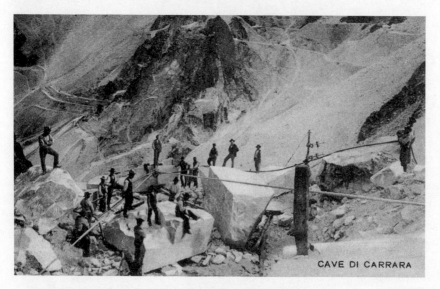

CAVE DI CARRARA

The hard work of the *cave* at the turn of the century, which Vincenzo
Mazzei's sons left behind.

Alleged ancestors aside, the familiar Tuscany of Chianti wine, rolling hills, and pricey, picturesque villas is a far cry from the rough peaks and rough-hewn ways of Carrara. Though the town and surrounding territory were nominally annexed to Tuscany when Italy was unified in the 1860s, they remain a world apart—as Michelangelo Buonarroti discovered more than five hundred years ago, when he came seeking marble for Rome's and Florence's grandest monuments.

The pay was meager in the mid-1800s and the quarry work was punishing. It began soon after midnight, when the *cavatori* started the long hike up the slopes to launch that morning's assault upon the stone before the heat of day set in. Death came suddenly and frequently, when shaky outcrops collapsed or ropes broke and twenty-ton blocks went careering off their skids. Nevertheless, Vincenzo Mazzei survived. He became *capocava*—foreman—of one of the

largest quarries, and his son Adolfo could have followed in his booted tracks. But Adolfo had other ideas. Though they did not study at Carrara's Accademia di Belle Arti, he and his brothers graduated to another stage in the gritty alchemy that turns rough rock into polished sculpture. Adolfo went to work at Laboratorio Lazzerini, Carrara's largest sculpture studio, rising to foreman when he was just twenty-three. Then he and his brothers set up their own *laboratorio,* where they chipped and scribed and shaped and buffed the stone, producing busts of Italy's aristocrats, nymphs, and fauns for its fountains, saints and Madonnas for its churches.

Adolfo became one of Carrara's most distinguished sculptors. In 1909 he won a first-place gold medal at Rome's Grand Exposition of Art, Industry, and Commerce for his bust of the locally born, nationally revered poet Giosuè Carducci; the photograph of the bust accompanying an article in *L'Illustrazione di Roma* reveals both hyperrealistic detail and the intense Romantic expression expected in portraits of poets. At that point Adolfo had already completed his most lucrative commission, four statues for Saint Patrick's Cathedral in New York, and used his earnings to buy and refurbish a spacious, stately house just up from Carrara's center, on a road to the marble quarries. To express his gratitude to America and his delight at what he saw in New York, he vowed to name his next son after its president, Theodore Roosevelt. When his wife, who was already pregnant, bore a daughter, he named her Roosevelt. But such a name was unseemly after the Fascists came to power, so "Roosevelt" was Italianized to "Rosvelda." She married a Tuscan immigrant from San Miniato, who founded a business inventing and manufacturing glues, blades, and abrasives for those who worked the stone. Their son Luigi Brotini took it over, and invented more. More than half a century later, Luigi introduced me to the lore of Carrara and the majesty of the marble mountain.

Working for Adolfo did not sit well with his younger brother Aristide, also an able stone carver, who did not want to work for his brother. Or so my father tells me; his sister Claire, who is older and so in a better position to know, remembers a more romantic explanation for her grandfather Aristide's embarkation. She says he fell in love with an unlettered village beauty who was beneath the station of a respected stone clan. Marry her, he was told, and lose your place in the business. He married her anyway.

Eleven decades later, under the impression that Ermelinda Masetti had been the belle of the quarrymen's village of Bedizzano, halfway up one of the three roads that run from Carrara to the quarries, I rode there in an afternoon bus filled with rambunctious middle-school kids. The *comune* (city) offices in Carrara, under whose jurisdiction Bedizzano falls, had no records of any births matching hers. But not all births were necessarily recorded, and so I determined to check the baptism records at Bedizzano's parish church.

I waited at the bottom of the narrow stairs behind the little church while the afternoon catechism class finished up. The kids streamed out, and Father Guido Sanguinetti followed. If central casting were to supply a kindly village priest for one of those heartwarming coming-of-age-in-the-old-country movies that used to flood out of Italy, it would send in Father Guido—who, I later learned, had shepherded the parish since 1947. He looked like a subcompact version of the singer Charles Aznavour—a tiny, cheerful octogenarian in a black robe, dark beret, and enormous black-rimmed glasses, with a merry smile, an air of eager distraction, and the stride of a race walker. I trotted to keep up, though I was at least a foot taller, as he beelined across Bedizzano's stately little piazza. Without slowing, he greeted the *cavatori* and pensioners hanging about the piazza bars as though they were still his pupils, and chided one who had resumed smoking. Reaching his office, Father Guido pulled out one enormous leather-bound record book after another, poring over the names marked in browned ink in the fine, florid hands of a bygone penmanship. Nope, no matches there either.

As it turned out, the chase was a wild and goosy one. I was mistaken; she came not from Bedizzano but from another hillside hamlet, La Foce, on the high road to Massa, Carrara's decidedly nonidentical twin city. There, her relatives would later start the first gas station in the area and become prominent Fascists—reputed participants in one of the most ghastly of many massacres the Germans and Italian Black Brigades perpetrated after making the Apuans their last-ditch defense against the approaching Allies. But it was not an entirely fruitless chase. Father Guido apologized profusely for coming up short, but then brightened. My great-grandmother's husband was a sculptor named Mazzei? Then he did have something to show me! He led me on another beeline to a storage shed—the treasury, they would call it

in a grander church—whose rough wood shelves were lined with goblets, candles, and simple, folksy sculptures. The prize was a plaster bust of some long-ago duchess or *marchesa*, the model for a final marble, Father Guido proudly announced, by the distinguished sculptor Adolfo Mazzei. He led me back out to the piazza, where, midway between the two bars, stood this marble village's most prominent work in marble, the sort of monument that stands in piazzas all across Italy: a monument to the local boys who fell in the First World War. It was signed, in large chiseled letters, A-MAZZEI / CARRARA.

No wonder Aristide left. He had to go all the way to America to get out from under his brother's shadow.

He arrived in Boston around 1890 and went to work in a marble shed in Lee, Massachusetts, due south of the Vermont quarries where Carrarese *cavatori* (quarrymen) and stonecutters (*scarpellini* or, in the modern spelling, *scarpellini*, literally "little chisels") would establish a "Little Carrara" at Barre. Today, just one master carver from Carrara, Giuliano Cecchinelli, is still active in Barre, though he works valiantly to keep the tradition alive.[1] But in Carrara's hole-in-the-wall cantinas, when the old *cavatori* and *scarpellini* learn you're from America, many will break into stories of their years in Barre. Damn cold winters, they'll say; sometimes their hands froze to the stone as they handled it. But damn good money.

Aristide, now called "Harry," soon moved back east, to the town of Everett, just north of Boston. He brought his young family over from Carrara and kept working the stone. He was not particularly religious himself, but he carved saints and Madonnas to inspire those who were. He carved gravestones and funeral monuments, now as then the bread and butter of the stone business. He won a part in two prestigious commissions: he carved stonework, including ornate inscriptions and bas-reliefs, for the Boston Public Library, America's premier Italian Renaissance palace, and he sculpted figures in the city's ornate Metropolitan Theatre (now the Wang Theatre), though its marble is mostly faux. When his daughter Alma, my grandmother, fell deathly ill with childhood pneumonia, the doctor drained her flooded lung cavity and treated her for months, then declined to take cash payment; he asked only for an exquisite small sculpture, a pair of clasped hands—*her* hands—that her father had carved. She cried when the doctor took it.

However uncongenial Aristide may have found the strict social code in the old country, he brought the same strictness to the new. He believed girls should stay home as their mothers had in Italy, and forbade my grandmother and her sister the movies, dances, and other diversions of the New World (which they snuck off to enjoy anyway). In photos he stands rigid as the stone itself, staring firm and unsmiling into the camera. His mustache is clipped and his hair close-cropped in the proto-crewcut called a "wiffle"; the effect is inescapably Teutonic. His wife, whom he doted on, called him "the German." He taught his children and grandchildren to sing, then tapped time with his cane as they did. The tunes he taught them were not Italian; years later, his granddaughter, my Aunt Claire, did a double take when she heard the same tunes sung at a German nightclub.

He inveighed often against "the Italians": "Italians are just no good," Aunt Claire recalls him saying. "Don't you marry one!"

"But Grampa," she replied, *"we're* Italian."

"No, we're not," he intoned. "We're Tuscan!"

My grandmother recalled how her father would come home after a day in the workshop, go to the bathroom, and cough up blood. But marble may not have been the culprit. In Carrara they say that marble dust does not hurt the lungs, at least not white *statuario* marble, which is very nearly pure calcium carbonate. But granite, which is full of abrasive silica, causes wasting, killing silicosis. And Aristide surely had to work granite in Massachusetts; it abounds in stony New England, and is much harder and tougher than marble. Before the advent of respirator masks and airflow systems to suck up the dust, generations of stone carvers and quarry workers died young providing enduring monuments to those who'd lived to ripe old age.

WHEN I START to explain why I set out to write a book on Michelangelo Buonarroti and the marble quarries of Carrara, my friends say what the reader may well be thinking: "Ah, you're writing a book about going back to your roots"—as if the world needed any more such books. But roots go only so far for most of us. I confess that I took some pleasure when people around Carrara—after asking about my ancestry (Scigliano, from my paternal grandfather's side, is a Calabrese name, as strange there as it is here) and learning of my

scarpellino great-grandfather—would say, *"O, sei proprio carrarino!"* You're one of us! And I had no qualms about exploiting the access that this connection thrice-removed sometimes afforded. But I had no intention of writing about "my roots," or any illusion that they were the stuff of epic.

But earlier, in a college preceptorial on Michelangelo Buonarroti, I encountered something that was. Call it genius, or *terribilità*, as Michelangelo's contemporaries did, it smacked me in the face like a gale wind. I felt that wind again a decade later when I arrived in Rome for the first time since childhood and beheld firsthand the Vatican *Pietà*, then *Moses* at the truncated tomb of Julius II, and then, in Florence, *David* and the Medici tombs. As I marveled at what genius had wrought from the same stone that the Mazzei once worked, I longed to see the marble mountain. But circumstances did not cooperate, and I never connected with the cousins who dwelt there still.

I finally arrived on a long-delayed train from Rome, late at night in early January 1985, during the coldest winter in Italy in a hundred years. The snow that slowed the train now filled the night sky, and the mountain of white marble was invisible and unapproachable, lost in a different whiteness. And so I pushed on to Milan.

Years later I returned to Italy, crossed the Apennines in blinding sleet, and arrived to a fair morning in Carrara. I located my father's cousin Luigi Brotini, who lived in a marble-lined house with his Sardinian wife, Cecilia. Luigi was a better host and guide than anyone curious about the *cave* (quarries) could hope for. The family firm, which his sons now managed, made the bits and blades and grinding pads that thousands of local *lavoratori, artigiani,* and *scultori* used to cut and shape the stone. He seemed to know everyone on the mountain and in the valleys below, and still had boundless energy and enthusiasm for the subject of marble at the age of seventy-three. A madcap week in the *cave* and workshops, stumbling after the tireless Luigi through the white dust and debris, only piqued my hunger to know this hard, pale land and to understand these men of stone and this stone of men.

I did not intend to write anything about them, yet their stories begged to be told. But where to begin? The vertical moonscape of peaks and quarries and the twenty-six-hundred-year history of their conquest and exploitation—a history drenched in blood and occasionally limned by genius, peopled with slaves and centurions, emperors

and brigands, butchers and poets, anarchist saints and Fascist demons—and throughout, the stoic stonecutters and quarrymen, moving mountains with their bare hands: it all seemed a spectacle too ample for any chronicle to comprehend. Even the ordinarily sardonic, saturnine Michelangelo Buonarroti was swept away by this spectacle.

And there the streams converged. Michelangelo's exploits loom over Carrara and its quarries just as his art does over the history of Western sculpture and painting. Tramping around the *calco*-strewn slopes, or watching the master carvers at work in their powder-covered workshops, I was everywhere reminded of the restless feet that trod here and the powerful hands that took the marble's measure more than five hundred years ago, when Buonarroti came, as he put it, to "tame these mountains" and steal their stone. It seems especially apt to speak of the man and mountain together, almost as characters in a dual drama—at once a love story and a contest of wills. "A force of nature," we would call Michelangelo today, and the term fits. In appearance he was very unlike the ex-model, Charlton Heston, who played him—a man of modest height, slump shouldered and spindly legged, with an oversized forehead, a squashed nose, and a scraggly forked beard, given at times to sloppy dress, poor hygiene, paralyzing depressions and panic attacks, and flights of suspicion verging on paranoia. But there is an elemental, overpowering quality to his work and, beneath his quirks, to the man who made it. It is magnificent and monstrous at once. *Terribilità,* his contemporaries called this quality, invoking the dread as well as exhilaration that his art evoked even in their worldly hearts.

Perhaps no artist save Shakespeare (who was born two months after Michelangelo died) has cast so outsized a shadow, a shadow that falls especially long across this place. It is common to speak of his life as pulled between two poles—Florence with its artistic and political ferment, its Medici tyrants, and republican revolutions, and Rome with its imperious popes, scheming cardinals, and lavish projects. But his orbit had a third pole: Carrara, where he found his ideal medium and restorative solace and inspiration—as well as danger, frustration, wearying intrigue, and bitter disappointment. We cannot fully understand Michelangelo, or the importance of Carrara and its marble, without understanding his relationship to them.

Michelangelo was a sculptor by vocation, but he also stands among

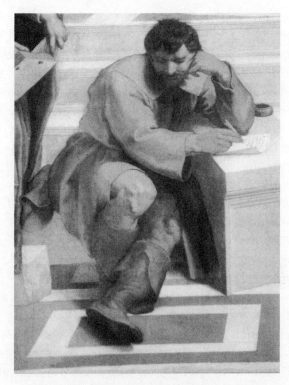

Michelangelo, the first Romantic artist, as painted
by Raphael in *The School of Athens*.

the great masters in architecture and painting and the near-great in po-
etry; he was a transformative influence in all these arts. His formal
schooling, like Shakespeare's, was slight, and he too had but little Latin
and no Greek. But he was recognized even in his lifetime as a supreme
example of the universal Renaissance genius, surpassing in some ways
even his rival Leonardo da Vinci. "The divine Michelangelo," Giorgio
Vasari called him, structuring his series of artistic biographies to build
to the apotheosis of Michelangelo's achievements. Just as, in the Old
Testament and in the Sistine Chapel ceiling scheme, the prophets
Daniel, Ezekiel, Isaiah, and Jonah were supposed to presage Christ's ar-
rival, so Giotto, Donatello, Masaccio, and the rest were cast as warm-
up acts for the artistic messiah, Michelangelo Buonarroti. Leonardo
played the part of John the Baptist.

At the same time, Michelangelo was the harbinger of chaos who
wrote *finito* to the rationalist Renaissance. He precipitated the era of

lurid color, flamboyant gesture, dramatic exaggeration, and highly personalized style called Mannerism, sometimes (implausibly) defined as "in the manner of Michelangelo." He was in many ways the first modern artist: the first Romantic, the first Expressionist, the proto-founder of a score of different schools. He was the first artistic super-star, in an age when artists were just beginning to discover the fruits and burdens of celebrity. He remains the only one whose merest jot-tings—his letters are concerned largely with money and petty family disputes—are subjected to repeated translation and the elaborate exe-gesis of both scholars and popular novelists. Even a pair of simple menus he jotted down one day are more often reproduced, and more familiar to the general public, than masterpieces by nearly every other Rennaissance artist. We can surmise his tastes were simple; we know that one day's fare consisted of "one salad, four loaves of bread, two fennel soups, one herring, and one round pitcher," presumably of wine. The accompanying sketches show he would have made a great menu artist.

His rare pronouncements on art were treated as oracular in his time, and still are in ours. When the genre of biography was just be-ing revived, he was honored with three biographies in his lifetime. Other authors, most notably the irrepressible Portuguese painter and poseur Francisco de Holanda, recorded (or perhaps concocted) lengthy dialogues with Michelangelo in which the master casts wise pearls to his apostles.

The Francisco de Holandas of our time write press releases and sit-uation comedies rather than pseudo-Platonic dialogues, but they still haven't let off exploiting Michelangelo. If anything, they drop his name even more often, and just as self-servingly. "Michelangelo" has become a metabrand, a universal code for artistic achievement just as "Kleenex" is for paper tissue and "Xerox" for photocopies—with the added advantage that using "Michelangelo" indiscriminately won't draw letters from his lawyers. He is the default example of excellence and the much-abused term "genius," and not just in discussions of art.

His name serves as handy shorthand for writers celebrating virtu-osity in any field, however mundane. Newspapers have lauded Olympic swimmers and runners, molecule-bending drug designers, a celebrated butcher, and an Indiana pumpkin carver as the Michelan-gelos of their professions.[2] To call a certain $37,500 bicycle just a bicy-

cle "would be like calling Michelangelo's *David* just another sculpture."[3] The marketing chief for the 76ers basketball team "works in the medium of bobbleheads and Beanie Babies the way Michelangelo worked in marble."[4] Still, the trope has a distinguished literary lineage: Marcel Proust described the family cook going "to the central market to get the best cuts of rump steak, beef shin, calves' feet, like Michelangelo spending eight months in the mountains of Carrara choosing the most perfect blocks of marble for his monument to Julius II."[5]

"CARRARA," or (as it's almost inevitably paired) "Carrara marble," has become just as ubiquitous a metabrand, the emblem of luxury with a dash of Old World dignity and élan. In the electronic marketplace of ideas, stature is measured in online hits, and the Google search engine, when I last checked, turned up 47,400 references to "Carrara marble," plus another 18,400 to its Italian equivalent—more than twice the total of the references to the three major American marbles (Georgia, Colorado, and Vermont). As press releases and newspaper puff pieces tell it, the counters in swank new Manhattan restaurants, the bathrooms aboard cruise ships, and the lobbies of new five-star hotels and class A office towers are never clad in mere marble; they're done up in *Carrara marble.* Since marble comes from scores of places around the world, it's a fair bet that much of this "Carrara marble" is about as Carrarese as a Starbucks triple-tall skinny vanilla latte is Italian—or at best it was cut and polished in Carrara after being quarried somewhere else.

This glamour is incongruous, because most of those who gush over luxurious Carrara marble would probably run for the nearest Hilton (or at least the nearest cute Tuscan expat haven) if they actually saw the town of Carrara. If you find anyone who appreciates the town itself, cleave to him or her, because you have found a friend with discernment, imagination, and adventurous spirit. The real Carrara is raw, rough-edged, and quirky. It is that anathema of guidebooks, an "industrial" community whose residents do something other than cater to tourists. *Lock the doors, Myrtle, we're heading for San Gimignano.*

Likewise, many of those who blithely invoke Michelangelo's name might be dismayed by a closer look, or an honest look, at him. The

fascination with Michelangelo shows plaintively in the contortions that his scholarly disciples turn to deny or excuse aspects of his character that they find unseemly. For example, on four occasions, as a youth and young man and in middle and old age, he took flight when political turmoil, invading armies, or supposed Vatican rivals loomed in view. Once, in 1529, he even abandoned a position of high trust as chief of fortifications for his besieged city (though he later returned and resumed his post). These bouts of panic hardly jibe with the steadfast heroes he sculpted—*David, Moses, The Defiant Captive, Brutus*—or with the nonchalance he showed in the face of natural dangers, such as tumbling blocks of marble on the steep Apuan slopes. Nevertheless, Charles De Tolnay, the dean of Michelangelo's many twentieth-century biographers and an indefatigable apologist for him, found an ennobling logic in these episodes: "These escapes are actually symptoms of a sense of responsibility for his genius which seems to be constantly present in Michelangelo. At the first indication of approaching danger, he takes to flight."[6]

And then there is the thornier matter of Michelangelo's sexuality, which one biographer after another has tried to present as sublimated and unconsummated (possible), nonexistent (implausible), or heterosexual (preposterous). Irving Stone's novel *The Agony and the Ecstasy,* which has likely done more than all other books together to shape popular impressions of Michelangelo, gives him *three* female love interests, none well grounded in historical evidence: Lorenzo de' Medici's consumptive youngest daughter, with whom he mutually pines from puberty on; a Bolognese grandee's ravishing mistress, who falls for him—squashed nose, bodily stench, and all; and a lady of the Roman night who gives him "the French sickness," syphilis.[7] Perhaps he got a discount as an employee of the Vatican, whose priests and visitors supported a booming fleshpot sector.

Luckily for Stone, novelists needn't defend their presumptions. Biographers must, but the best argument the neo-Victorian advocates of a "manly" Michelangelo can muster is that he couldn't possibly be an "invert" because no one who is could render such sensuous female figures as Eve in the Sistine ceiling's *Temptation* panel, *Dawn* in the Medici Chapel, and the painted *Leda*.[8] Michelangelo may indeed have used a female model for Eve (though she is incongruously brawny for a girl who was supposed to have been born yesterday). He certainly

seems to have used one for *Dawn,* though her expression is anxious rather than beckoning; she is a conspicuously soft contrast to the wiry masculine figure, with saclike breasts hanging from taut pectorals, of her sister *Night.* But the *Leda,* known only through copies, is a twin to *Night.* And even if these few exceptions were alluring nymphs, they would still be far outnumbered by the innumerable beautiful male nudes Michelangelo carved, painted, and drew throughout his career, from the decidedly unbiblical youths lolling behind the Holy Family in his *Doni Tondo* tempera panel to the army of cavorting, contorted *ignudi* on the Sistine ceiling and the swooning, langorous figures of the marble *Dying Captive* and the charcoal *Ganymede.*

It is true that the unclothed body, even when enticingly formed, can be used to convey many ideas other than enticement: innocence, perfection, wisdom, freedom, pagan antiquity, even divinity. (Titian's *Sacred Love* is nude, while his *Profane Love* is clothed.) But when Titian and Botticelli sought to convey such ideas, they painted *female* nudes. Michelangelo almost invariably, and obsessively, depicted idealized male figures. Two voluptuous female nudes do not a skirt chaser make.

Still, hard evidence is lacking. Unlike the roguish Benvenuto Cellini, Michelangelo was never prosecuted for sodomy, which was a crime in their day though common among the artistic and intellectual elite. Whatever we might surmise from the preoccupations of his art, the whisperings of his contemporaries, and his passionate correspondence with the dashing young courtier Tommaso de' Cavalieri, we cannot *know* that he had homosexual relationships. We can know only to what objects his imagination ran, and not even all these, since he destroyed most of his private drawings. But the fact that we still speculate on his erotic affinities, and that there are those who concoct absurd "defenses" four centuries after his death, is one more proof of the power of the fruits of that imagination.

EVERY SCULPTOR AND PAINTER who has since tried to capture the human figure or soul has followed in Michelangelo's wake—or fought to escape it. I've heard both an Iraqi-born sculptor in Seattle and a painter–turned–television documentary producer in Boston say it was Michelangelo who inspired them most of all, whose example gave them the courage to strike out as artists. His own strength never

flagged—though he grumbled for five decades about the miseries of growing old—nor did his passion for working stone. Six days before he died, just shy of eighty-nine, he was chipping away at his last marble *Pietà*.

This passion extended to three other arts: *disegno* (*deseigno* in his day, a word that meant both drawing and design), which he saw as sculpture's foundation; architecture, which he saw as its extension; and poetry. The last he pursued both avidly—leaving behind more than three hundred madrigals, sonnets, epitaphs, and unfinished fragments—and sculpturally, hammering out blunt, plaintive verses like figures in stone. But his passion did not extend to other arts, not even to other sculptural media. In nearly eight decades of work, he produced at least three hundred marble sculptures (many unfinished) and conceived or roughed out scores of others that he never managed to execute. At the same time, he is known to have executed just two bronze statues, one wooden crucifix, two finished easel paintings (one of which survives) and two unfinished ones, one snow statue (at the insistence of his rapscallion patron Piero de' Medici), and four monumental frescoes. Two of those, the Sistine Chapel ceiling and *The Last Judgment*, are the most celebrated frescoes and arguably the greatest painting cycle ever undertaken. But he complained bitterly about having to paint them, insisting that painting "is not my profession." He would say the same of architectural projects.

Such demurrals may have been self-serving—a stratagem to lower expectations and make his eventual achievements seem all the more miraculous—but the fact that he made the claim most plaintively to his father, to whom he had nothing to prove, suggests that it was on at least some occasions heartfelt.[9] Coerced, cajoled, and lured by his own ambition into unfamiliar media that he mastered in spite of himself, he lamented in the chords of exile his banishment from his true medium, and from the marble mountain that supplied that medium in such abundance.

Perhaps he could not return there, but I could, and I decided to retrace his steps, and trace the part that mountain's celebrated stone played in the creation not just of some of the greatest works of art ever shaped by human hands, but of our essential models of beauty, order, and civilization.

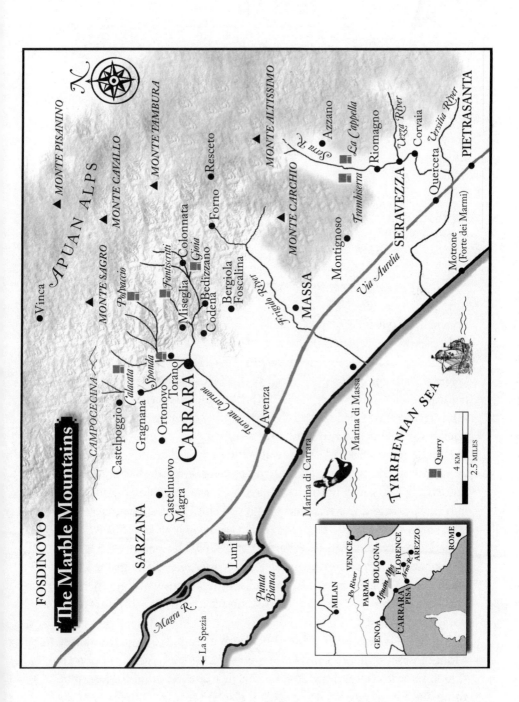

CHAPTER 1

PIETRA VIVA

LIFE HAS GROWN FROM THE ROCK AND STILL
RESTS UPON IT; BECAUSE MEN HAVE LEFT IT FAR BEHIND,
THEY ARE ABLE CONSCIOUSLY TO TURN BACK TO IT. WE DO
TURN BACK, FOR IT HAS KEPT SOME HOLD OVER US.

JACQUETTA HAWKES, *A Land*

THE MOUNTAINS THAT HANG like a theatrical backdrop behind the town of Carrara form what is surely the largest trompe l'oeil effect ever shaped by human hands. You may come upon them from the south, from Pisa and Livorno and the earnest flatlands of the Arno delta, riding the train or driving the ancient Via Aurelia or the new autostrada. Or you'll follow the narrow coastal corridor from Genoa and La Spezia and the terraced villages of the Cinque Terre. You may stray onto a side road lined, like backroads everywhere in Italy, with household gardens and little farms, and view the peaks through an improbable scrim of semitropical palms, limes, and pomegranates. At Carrara you'll see a break in the hills and a narrow valley, speckled with the red roofs of the town, pushing up into the mountains like a wedge. Or a chisel.

As the numbers tell it, these Alpi Apuane are modest: the tallest, Monte Pisanino, stands only 1,946 meters (6,385 feet) high. But perception lies in the context; the Apuan Alps jut rudely toward the sea, jamming like a boot into the long coastal plane that rolls all the way south to Naples, and shoot up impossibly straight and sheer from near sea

level. Nature made these peaks steep, and human labors have made them steeper still. And they gleam, white like Rainier or the Matterhorn, even in summer, when snow is no more thinkable here than it would be in Bangkok. Down their slopes, as though about to engulf the city at their feet, stream glaciers of an even brighter white.

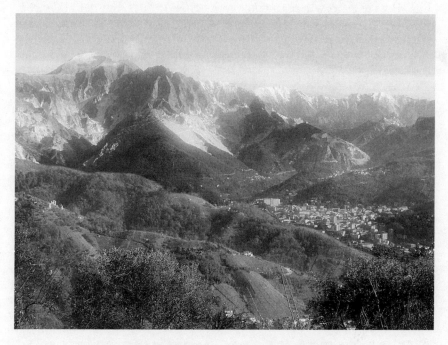

Carrara, with the marble glaciers and Apuan Alps behind and the Castello di Moneta to the left.

This "snow" follows the eighteen-mile ridge of the Apuan Alps, essentially an enormous fissured block of marble. The valleys and foothills and most of the lower slopes are skinned over with dirt, brambles, chestnut trees, and the occasional picturesque village, but the higher, steeper reaches stand as stark and white as the walls of an ancient temple, or a statue in a piazza. They form a sort of negative image: if these were your usual snow-covered granite mountains, their steepest faces would be bare rock. It is a spectacle that does not cease to amaze, even when you see it every day, on your way to buy bread and drink coffee: exhilarating, baffling, alarming by turns. This is not the cozy Tuscany so beloved of writers, tourism promoters, and wealthy retirees. It is its own land, brooding and hard but intoxicated

with art, steeped in tradition and yet as unstable as a landslide. "It's never the same," a shop owner named Oreste Morescalchi muses one day as he lolls outside his little gallery, appropriately named Pietra Viva (Living Stone), in Carrara's *centro storico,* gazing at the slice of Apuan silhouette that appears between a break in the medieval buildings. People everywhere say that about their locales, but here they can prove it empirically; Morescalchi is charting the progress of the quarrymen, the *cavatori,* who are cutting and reshaping the mountains even as we speak. The spectacle is at once ghastly and beautiful. "It's horrible what we're doing to the mountains," says Mario Venutelli, who heads the Carrara chapter of the history and conservation society Italia Nostra. "There are twenty unique varieties of orchid growing up there, and look what we're doing!"

These little big mountains loom behind every vista in Carrara, framed by the now decaying palaces of the quarry owners who grew rich off them, by the incongruous palms, by the many marble monuments and heroic statues—chips off the old block—that speckle the city. They play tricks with your senses of scale and perspective. The spectacle overwhelmed Michelangelo Buonarroti, a man not ordinarily taken with the marvels of nonhuman nature, and inspired a vision that dwarfed even his usual ambitions. Breathing the high air as he tramped up and down seeking the right stone for his art, he dreamed of carving the marble mountaintop itself into a personal Mount Rushmore, four centuries before power tools made such projects feasible. He never attempted such a grandiose project. But after his first visit to the marble mountains, this artist who had before produced only ordinary-sized works began undertaking enormous projects—the *David,* the tomb of Pope Julius II, the Sistine Chapel ceiling, the Church of San Lorenzo façade—such as had never been seen before. In the marble mountains above Carrara, he learned to think big.

The Carrarese tell various tales to explain how all this marble came to be here. I heard one from Don Raffaello Monsantini, monsignore of Carrara's Duomo di Sant'Andrea. It seems God had almost finished making the world when he grew tired. He called two angels, one smart and one not, and directed them to finish the last remaining chore: to take sacks of ore, granite, marble, and other mountain-building materials and spread them evenly over the Italian peninsula. "I'll start at Venice and make the Alps," the clever angel told the

dunce. "You start at Genoa and make the Apennines." But the dumb angel dozed off at the first beach he found, below what's now Carrara. Waking in a panic, he dropped all his marble in a heap and slunk back to Heaven. "What have you done with all that precious marble?" God thundered, but then He smiled. "This may not be so bad after all. Now artists will come from all over the world and make sculptures for me."

AS MINERALS GO, marble is nothing special. It occurs in scores of places around the world—most commonly along the Mediterranean rim, but also in France, Belgium, Brazil, China, and India, and in the American states of Georgia, Colorado, and Vermont. But nowhere is it so concentrated as in the Apuan Alps—an eighty-square-mile oval bed of unusually pure calcium carbonate a quarter-mile or more thick, a quarter of it thrusting right through to the surface. Ordinarily, quarrying is a superficial business: the beds lie beneath the hills or plains, and the quarriers dig them up, in a sort of strip or pit mining. The Apuan Alps present more varied and dramatic challenges: the same continental collisions that provided the gigantic hot press needed to form this stone also tossed it up in a precipitous, jagged jumble of peaks and valleys; blink and you can think you're in the North Cascades, the youngest, steepest peaks in forty-eight U.S. states. To get the good stone from such forbidding terrain, the quarriers have tunneled beneath the mountains and dug out underground *gallerie* the size of stadiums; peeled them away from bottom to top; holed them like Swiss cheese; scraped and penetrated them from every side. In the old days, before heavy trucks and steam shovels and front loaders, this work precipitated the evolution of a whole set of daredevil specialists: *minatori*, experts at setting explosive mines to tear away what they did not pulverize of the mountain's marble skin; *tecchiaioli*, human flies who, with simple ropes wrapped around their waists, would descend the sheer quarry faces with heavy steel bars to knock away the outcrops and residual clutter that might otherwise fall and brain their comrades; *lizzatori*, sled men who could ease nearly thirty tons of marble strapped on rough wooden runners down rubbled sixty-degree chutes; and *mollatori*, masters at playing out the ropes and cables on which their comrades' lives depended. The danger and the

proud specialization of these jobs shaped a culture that still sets Carrara apart from the rest of the world—and, it often seems, from ordinary reality.

Even some of its streets, and many more downtown sidewalks, are paved with smooth *bianco di Carrara* marble, a welcome respite for the feet after the rough cobblestones of Florence. Surplus blocks, each hand-squared in a honeycomb pattern of chisel marks, fill extra spaces in Carrara's rough stone walls. The Torrente Carrione, which runs—sometimes a trickle and sometimes a fearsome flood—from the *cave* through the city's heart, is a watery museum of quarry waste. Incongruous white chips and pebbles and, after a surge, small boulders cover its bed and sometimes yield treasures. Robert Gove, an American sculptor who has lived monkishly in Carrara for more than thirty years, laboriously shaping and polishing exquisitely refined abstract forms, hardly needs to buy his stone (a good thing, since he has a hard time finishing sculptures to his satisfaction and putting them up for sale). He finds it in the streambed. He also finds half-worked pieces, cutout negative forms, and stones of indecipherable provenance but of such wise balance you'd think some neo-Constructivist mountain troll had taken a chisel to them. His rough but spacious studio and the yard outside it had become a shrine to the stone and a museum of found marble art, whose gritty surfaces set off the polished arcs and ripples of his own work.

Gove is not the only one. Everybody who works with marble seems to have the soul of a rock hound, to be a scrounger and a collector; the entry to the bustling stone yard of Barattini Marmi, also known as Cave Michelangelo, one of Carrara's larger marble companies, is lined with Roman trophies. But it's from Gove that I catch the vice. After I leave his studio, I find my eyes straying over the stones in the ditches along the road; I cannot cross any of the endless bridges over the Carrione and the tributaries that wind like noodles through the town without peering over, hoping for some lapidary masterpiece in the rough. Occasionally I give in, at one of the rare unfenced accesses to the streams, and scrounge the banks and channels. The closest thing to a treasure I can find is a river-worn chunk of *bianco,* thickly grown with algae and inscribed with two cryptic symbols, like a beehive or an arched window with double mullions, which I found on my first try. Since then, I've accumulated curiosities, mill ends

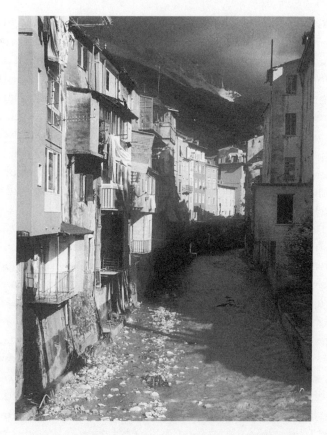

Sawmills once lined the marble-littered Carrione
on its course through Carrara.

gashed by saw blades and drilled half through. They fill the win-
dowsill and spill onto the desk and floor. I pretend they are here to
serve as bookends and candleholders, and idle away my time tracing
their grain and wear and crystal structures.

NOT ALL MARBLE is created equal. Tinted with iron, manganese, and
other impurities, it takes on nearly every color of the spectrum, from
earthy tan and buff to smoky gray, extravagant green, gold, maroon,
black, and even purple, flecked and mottled and striated in patterns
human minds could not conceive and human hands strive forever to
imitate. Untainted, however, marble is white—sometimes surpass-
ingly so. There, the purest marble of all, unblemished *statuario,* often

extracted by tunneling along elusive underground veins, stands at the top of a castelike international classification system. Such classifications are a matter not just of mineralogical convenience but of national pride. Some Georgia and Colorado marbles are at least as white as Carrara stone, and those from the Greek islands of Naxos and Paros are even whiter—a deathly, unmodulated (and, in the case of Naxos, lightly bluish gray) white, like skim milk. But whiteness is not all; pure-looking stone may be too soft and friable, or shot through with hard quartz crystals that make it brittle and obdurate. And even fine Parian stone lacks the translucence that makes Carrara's seem alive.

Again and again, other countries and regions have tried to shake the Carrara habit and develop their own marble quarries, for reasons both patriotic and practical. But the results have often been disappointing. Florence resolved in the fourteenth century to exploit the quarries at Campiglia in southwest Tuscany, but soon dropped the idea. Later, it ordered the reluctant Michelangelo Buonarroti to build roads and open new quarries near Seravezza, but these eventually languished while Carrara continued to prosper. When the American sculptor Daniel Chester French designed the Lincoln Memorial in Washington, D.C., he and his Italian carvers were obliged to use coarse-grained marble from Pickens County, Georgia, for Honest Abe, under a memorial dome of Colorado Yule stone. But given a choice, French and other American sculptors preferred Carrara *bianco*.[1] Yule and one other American quarry, Danby in Vermont, can produce statuary marble as good as Carrara's best. But the supply and size of Imperial Danby blocks is severely limited, and inexperienced operators have hurt the Yule Quarry's reputation by selling carelessly cut and graded blocks. The most notorious example is the Tomb of the Unknown Soldier, the United States' most hallowed monument, carved in Yule marble in 1931. It cracked in 1940, and the crack has since spread all the way through it. The next year the quarry shut down.[2]

Amid such debacles, Carrara's stone remains the world standard for workability and durability, and the Apuan Alps the motherlode—the site of what are still the largest and finest marble quarries in the world. The people of Carrara—the *carraresi*, in Italian, or *carrarini*, in local dialect—have told many stories about how the stone came to be

and how it has shaped their lives. One is a fable remembered by old-timers still alive today and recorded by an indefatigable local historian and folklorist named Beniamino Gemignani, a *cavatore*'s son who told me he "did not want to be the last one to hear these stories" and so began taking them down.[3]

"Our mountains were not always as we see them today," the fable begins. Once they were covered with great forests and pastures, an Edenic garden blissfully placed midway between the icy clouds of the great heights and the fog of the plain. Below the mountains lay another, underground world of caverns and tunnels, and below that dwelt the "monster of monsters," a creature so dreadful it scared even itself. And so it dwelt always in darkness, emerging only to seize fresh prey.

Atop the mountains, in the scenic glen of Campocecina, lived a young shepherd and shepherdess, giddily in love. She was pregnant with their first child, and he insisted she stay in the cottage and rest. One day he returned to find her gone, then spotted the cave monster's enormous footprints and knew she'd been abducted. He roused his fellow shepherds, and they traced the path to the grotto that led to the monster's lair. The others feared to proceed, knowing the search was hopeless, but the grieving swain could not give up. He gathered rope, ax, and torches and plunged into the cavern. The tunnel went on, until his rope ran out, his torches burned out, and he was lost in the darkness. He called to his wife and heard her call back faintly, but could not see her. The monster, however, found him, and was poised to strike when "a great light grew and spread throughout the belly of the mountain, white, clean, beautiful, and good for good eyes but unbearable for the monster." Blinded, the beast stumbled and fell into the Stygian depths, and the mysterious light lit the lovers' way back to safety—"a petrified light that men would call marble." The moral of the tale, as I heard it told by someone else in Carrara: "Marble lights the way of love."

Man had discovered marble—or rather, the marble had found him. Cold stone had become a living presence, a subterranean angel leading humankind out of darkness.

* * *

MICHELANGELO also touched on the notion of illumination hidden within the stone, in the best known of the more than eighty sonnets (and three hundred poems in various forms) that he left behind:

> *The finest artist can't conceive a thought*
> *that the marble itself does not bind*
> *within its shell, waiting to be brought*
> *out by the hand that serves the artist's mind.*[4]

This verse immensely impressed and intrigued Michelangelo's peers, as it has later generations; soon after it was disseminated the humanist scholar Benedetto Varchi devoted two lectures to its interpretation. It propounds an appealing image, at once grandiose, nonchalant, self-deprecating, and, for those who take it as a literal description of Michelangelo's technique, terribly misleading: the artist as revealer rather than maker, midwife rather than creator, the modest servant of a nature ensconced in stone. Rather than imposing his will upon the marble, he draws out the life incubated in it. This suggests a paradoxical balance between willful design and spontaneous discovery: the *concetto* (concept) is bound within the stone, but the *intelletto* (intellect) guides the hand in drawing it out. It is the same paradox that underlies the conception of knowledge outlined in Plato's dialogue *Meno*: all learning is actually remembering, and all knowledge resides in a potential state within each soul.

Neoplatonism, a philosophical school that arose in Alexandria in the second and third centuries C.E., took Plato's doctrines to a new, mystical level, holding that individual souls are emanations of a universal World Soul and ultimately of the indescribable, all-embracing One. Neoplatonist teachings were rife in Michelangelo's Florence, especially in the home-cum-academy of Lorenzo de' Medici, where he spent several formative years; they inform his art and permeate his thinking, in particular his ideas about the meaning and mystery hidden within the stone. They were not the only intellectual influence he encountered there; a stew of philosophies bubbled in the Medicean cauldron, from Aristotelian logic to the esoteric Jewish Kaballah. But none held more sway than the third-century Neoplatonist mystic Plotinus, whom Florence's humanists saw as a bridge between classical philosophy and biblical revelation. For Michelangelo, Ploti-

nus was an especially apt inspiration, a philosopher who upheld the
sculptor's art—"taking away"—as a model of spiritual self-perfection.
To the question "How can one see the beauty of a good soul?" Ploti-
nus replied,

> Withdraw into yourself and look. If you do not as yet see beauty
> within you, do as does the sculptor of a statue that is to be beauti-
> fied: he cuts away here, he smooths it there, he makes this line
> lighter, this other one purer, until he disengages beautiful linea-
> ments in the marble. Do you this, too. Cut away all that is exces-
> sive, straighten all that is crooked, bring light to all that is overcast,
> labor to make all one radiance of beauty. Never cease "working at
> the statue."[5]

Thus we become our own statues, and our life's work is to pare away
the dross and reach the virtuous form within. These were heady no-
tions for an impressionable adolescent to imbibe—ideas he might
scarcely understand at the time, but that would root in his mind, set
out buds in his art, and blossom in his poetry.

The ideas Michelangelo expressed also strangely match those of
the stone-quarrying *cavatori* and stone-carving *scarpellini* of Carrara.
Though they lack even his smattering of classical education, they have
derived their own notions of *pietra viva*, "living stone," from the stone
itself. They speak both of finding life in it and putting life into it: "*È
una bella cosa*, to make a beautiful piece of marble live," says Eugenio
Dell'Amico, an ebullient fellow with an Errol Flynn mustache who
operates a vast underground quarry, a thousand feet deep inside Car-
rara's Monte Torrione. Officially it's named Galleria Ravaccione, but
everyone calls it "*la galleria di Carlòn*," (Big Carl's cavern) after Euge-
nio's father, who gambled everything he had to excavate it. Now Big
Carl's son spends his days amidst roaring machines and dripping
springs in sawn-out subterranean chambers the size of stadiums, and
never loses his delight in the stone. "It's a beautiful work."

Marble is not a uniform mass, the same in all directions. As
Dell'Amico says, "It's like the trunk of a tree": it has three *venature*, or
grains, which everyone who works it seriously comes to know like
"up" and "down." The straightest, smoothest, and easiest to cut is the
verso, which corresponds to the radiating grain of a tree trunk along

which wood splits. The *contro* is wavier and tougher, corresponding to a tree's concentric rings. And the *secondo* runs perpendicular to the others, like a crosscut. "Each piece has its *venatura,* its structure, its character," explains master carver Vittorio Bizzarri. "You have to know which is the good grain, and follow it." High-power tools can hack through marble as through wood, regardless of grain, but this sacrifices beauty, durability, and something else. "You can't just hit it," says Susanne Paucker, a young German sculptor in Carrara. "The marble has a spirit, and you have to respect that. It's your enemy, and your friend."

IN 1820 A Carrarese pharmacist-turned-geologist, Emanuele Repetti, published the first full-scale study of the Apuan mountains; even to-day, he is regarded as a cultural patriarch, along with Dante Alighieri and Gabriele d'Annunzio, both of whom spent brief but significant periods here, and of course Michelangelo. Repetti describes the local landforms and minerals according to the best earth science of the day, but he also recounts some extraordinary beliefs among the *cavatori.* One, which he quotes from an earlier observer, is prescient of the modern geologic understanding of how mountains form and erode: "Only the ignorant believe, because they do not see them move, that the mountains are constantly and entirely inert. The rest are certain that motion resides within these mountains [and] that they produce secretions and excretions and are, like organic bodies, involved in per-petual destruction and reproduction."[6]

The *cavatori,* however, believed this stony cycle of birth and decay was much faster than geologists now know it to be. They saw the mountains as living bodies, whose elements circulated in a network of veins (the same word is used, in Italian as in English, to describe blood and stone). The master veins were the *madrimacchie,* "mother marks," (*madre macchie* in modern orthography), which frame what we would call the motherlode. Over long periods, the *madrimacchie* could "atten-uate, absorb, and extinguish" the lesser, metallic veins "by the force of their greater molecular attraction." The *cavatori* knew to trace the progress of these master veins, because the marble found between them would be well drained and "of the highest grade of neatness

and purity." But if the *madrimacchie* were not good—if the distance to them was too great or the circulation too weak—then the marble would be polluted, or as the *cavatori* would say, "not yet purged." Give it time, and it would be.[7]

Repetti cites a wealthy quarry owner who told him that one mass of marble, "ashen and dirty and stained, almost greasy-looking," had been partially excavated, then abandoned for forty years at the Poggio Silvestro quarry. When it was finally extracted, it had lost all its defects and become "a fresh block, purged and clear like the most beautiful *statuario.*" Repetti withholds endorsing or dismissing such claims. He merely notes that "marble quarriers, like miners, have a language of their own, which naturalists should study and ponder. . . . Chemistry and metallurgy have not yet devised equivalent expressions to explain nature's hidden mysteries."[8]

As late as the 1980s, a researcher reported hearing *cavatori* talk about this "regeneration" of marble, which they viewed as a "renewable resource."[9] Perhaps views have changed—the nature of quarry work and the number of people doing it certainly have, and the old guys who shaped and hauled the stone with their hands, and knew it as only those who do so can know it, are mostly dead or *pensionati.* Some of those I put the questions to—"Does the marble grow back? Does it purge its impurities?"—just laughed or looked at me like I was nuts. But when I put the question around a table in a little bar in the ancient quarry village of Bedizzano, it started a debate.

"Yes, the marble regenerates," said one retired *cavatore.* "But it takes thousands of years."

"Not thousands," snorted one of his mates, who had a better sense of geological time if not of mineralogical processes. "*Millions* of years."

These ideas still seem to underlie their views of the marble lode. They scoff at suggestions that the resource, or at least the stone that can be extracted without undue human risk or environmental damage, might be finite: how could *Carrara,* the marble heartland, ever run out of marble? To some extent this is the instinctive, self-protective view of all workers in extractive economies, especially those whose fathers and grandfathers and their grandfathers worked in the same economy; loggers in the ancient forests of the Pacific Northwest and fishermen on the North Atlantic cod banks likewise

could not imagine that their mainstays could ever run out. But this view also reflects the particular passion that marble excites in those who work it—and not just the *cavatori* who undertake the first stage in its extraction and transformation. It is the sense of life, or something like it, within the stone.

PIETRA VIVA, living stone, is a concept that resonates deeply and widely in Italian culture. At its most mundane, it means the rough, uncut stone used to build castles and farmhouses—a selling point, redolent of tradition and permanence, in real estate ads. For the *cavatori, scarpellini,* and *scultori* it meant fresh, vivacious stone newly cut from the mountain, still dense and resilient, with its crystals still twinkling and translucent, before the marble "sap" drains from it and it becomes *cotto,* "cooked," brittle and breakable; in old Florence, sculptors were called "masters of *la pietra viva.*"[10] And at its most exalted, *pietra viva* is the invocation sounded by Saint Peter, the rock on which Jesus built his church: "So come to him, our living Stone—the stone rejected by men but choice and precious in the sight of God. Come, and let yourselves be built, as living stones, into a spiritual temple."[11]

Somewhere between lies the mystery that Michelangelo evokes in another verse, dedicated to the friend and muse of his later years, Vittoria Colonna:

> *Only through a living stone*
> *Does art allow this countenance*
> *To live on despite the years.*[12]

The conceit seems odd, since Michelangelo famously scorned making likenesses of particular persons, save when he savagely caricatured a prudish papal aide who had assailed him for painting nudes in *The Last Judgment* and consigned the hapless bluenose to hell. When other kibbitzers complained that two funereal statues did not resemble their subjects, he replied, So what? It would not matter in a thousand years—which gives an idea of the posterity he looked forward to. When Michelangelo spoke of capturing the *volto,* a less common and more nuanced word for "face" than the straightforward *faccia,* he meant it in the sense of the expression *rivelare suo vero volto,* "to reveal

one's true nature." And that is just what he set out to do: to reveal in stone the inner self that is masked by flesh and dissemblance.

It is a sort of transubstantiation mystery, this paradox of life captured in stone. At one end it recalls the cautionary tales of Medusa's victims and Lot's wife, and various macabre modern films and stories—of living persons turned to stone through their own vanity and folly. At the other it is the Pygmalion myth, cold stone brought to warm life through the sculptor's surpassing skill and love. These twin mythic tropes run like a vein of marble through the landscape of ancient stories.

In another verse, Michelangelo imagines himself as a Pygmalion:

> *I believe, if you were made of rocks,*
> *I would love you with such faith that I*
> *Could make you run to me.*[13]

With this conceit he plays with the notion of becoming like God himself (or like Plotinus's World Soul emanating from the universal Intelligence), infusing life into stony inert matter, which then turns back to contemplate the divine source.

This myth had a raunchy parallel; the sculptor's gift that inspired purifying contemplation could also arouse desperate passion. The Roman encyclopedist Pliny, never one to let an eyebrow-raising tale go untold, recounts that the *Venus* carved at Cnidus by the great Greek sculptor Praxiteles seemed so lifelike "that a man once fell in love with it and hiding by night embraced it, and that a stain betrays this lustful act." The *Cupid* that Praxiteles carved at Parium suffered likewise when "Alcetas, a man from Rhodes, fell in love with it and left upon it a similar mark of his passion."[14]

Anyone so susceptible to marble's allures should stay away from Carrara. The town is drunk on stone, decked with monuments, statues, and carved plaques executed at every level of accomplishment and dedicated to every conceivable ideology, from Fascism to anarchism to colonialism to workers' rights to kitsch eroticism. A life-size *Venus* by Aldo Buttini greets every motorist approaching Carrara's downtown. At a dramatic fork in the road, she stands—or rather strips—in coy *contrapposto* atop a fountain whose spigots are wolves' heads, while a ring of putti gambol around her. With no pretensions

to moral uplift, patriotic import, or allegoric significance, she is as cheerfully uninhibited a nude as ever graced a public site. A few blocks away, behind City Hall, a 1930s-vintage sculptural assemblage blends Fascism, colonialism, and cheesecake in an unsettling package: a young, nude African woman, carved from dark gray *bardiglio*, stands atop a fountain, framed by reliefs in *bianco venato* depicting various industrial and agricultural activities—all to celebrate Italy's conquest of

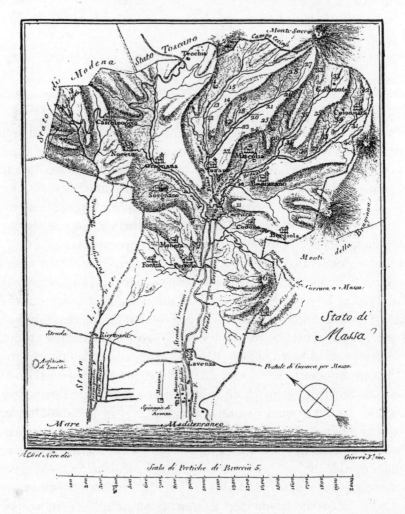

Carrara's marble basins circa 1820.

Ethiopia, the last free nation in black Africa, and the civilized blessings that would bring. That motive is now forgotten, and locals call the statue simply *"la nera."*

Divine effigies, civic cheesecake, and inspirational monuments are only three of marble's essential applications. Gravestones and funerary monuments are the most widespread use of carved marble, and the mainstay of many of Carrara's workshops; Eros and Thanatos meet in the stone. In this country, we prefer to honor the dead with granite, which is much harder and usually more durable.[15] Granite is also darker—even shiny jet black, a favored memorial stone—and lends a grim, imposing, and, well, funereal cast. But there is a reassuring, hopeful look to the endless rows and walls of warm white marble memorials in an Italian *camposanto*—an intimation of eternal light rather than everlasting darkness. The difference in stone goes far to explain the relative cheeriness of an Italian churchyard, or *cimetero*, compared to an English or American. The effect is augmented by the portrait cameos of the deceased commonly affixed to their stones, and the personal touches carved on some. A bas-relief tank for a soldier killed at Tobruk, a foundering ship for a capsized serviceman—these oddly delicate flourishes on tombstones in Carrara's sprawling Marcognano cemetery serve to neutralize the wartime tragedies they commemorate. All these seem more celebrations of the once-living than reminders of mortality. Death and life also meet in *la pietra viva*.

IT IS NOT SURPRISING that marble should seem alive; once upon a time, it was. All the world's marble formed on the backs of trillions of marine invertebrates that plied the seas and sediments over the course of a billion years or so. Their shells piled up and packed together, forming the sedimentary rocks limestone and dolomite—calcium carbonate and calcium magnesium carbonate, respectively. Over the geologic ages, cycles of pressure and heat packed these chalks into a crystalline form that polishes rather than powders when it is rubbed. Dowdy limestone and dolomite were transformed into elegant marble.

Two hundred million years ago, at the eastern edge of the great mother continent, called Pangaea, the warm, shallow Tethys Sea covered what would become the Mediterranean region, nurturing an

enormous mass of living creatures and an enormous accumulation of calcium carbonate shells. As continents drifted, split, merged, and grew, the Tethys Sea was squeezed into ever-smaller peripheral pockets, where sea life lingered and seashells piled up deeper and deeper. One such pocket was the Ligurian Basin, which endured until a scant 12 million years ago, when the island of Corsica came sailing (at geologic speed) into it. Plates crashed and seized and ground together. The deep Ligurian limestone beds were squeezed and baked into an enormous loaf of marble. Further tectonic thrusts shoved this loaf up above the endemic sandstone of the Tuscan Nappe, forming the Apuan Alps—and the marble mountain was born.

Reborn as stone, once-living shells again become vessels of life—life simulated and transmuted through the artist's hand.

THE SCULPTOR IN
THE GARDEN

From the high mountains and from a vast ravine,
enclosed and hidden within a great rock,
I came down to suffer in this low place
against my will, in such a tiny stone.

MICHELANGELO, VERSE FRAGMENT, CA. 1547–1550

STONE WAS MICHELANGELO'S first and most enduring attachment, the one that he jokingly—but not facetiously—claimed to have imbibed not merely like mother's milk but with it, and that he returned to again and again until the end of his long life. When human relationships left him feeling burdened, vexed, or abandoned, he turned to cold, obdurate marble, seeking a hopeless union.

The other members of his family, a Florentine merchant clan that claimed noble descent but had fallen into genteel poverty, showed no particular interest in sculpture or any other art—nor much aptitude for any other sort of work. Shortly before Michelangelo was born, however, his father, Lodovico di Buonarrota Simoni, received a six-month appointment (the Florentines, ever fearful of dynasties, applied narrow term limits) as podestà, magistrate-cum-mayor, of the township of Chiusi and Caprese. Today it's called Caprese Michelangelo; it lies southeast of Florence in the province of Arezzo. This is

rugged, hilly country, remote even today, and the ride there must have been grueling for a mother nearing her term. Perhaps it was that journey and the return to Florence soon after, or bearing three more sons in quick succession, that wore out Lodovico's wife, Francesca. She was unable to nurse Michelangelo, and he was sent out to a wet nurse—the wife of a stonecutter and the daughter of another—in the quarrying village of Settignano, a few miles northeast of Florence, where his family owned a small farm. His mother died when he was six years old, and his stepmother (his father soon remarried) six years later. He scarcely knew them, and never mentioned them in his correspondence or verse, nor in the authorized biography written by his acolyte and amanuensis Ascanio Condivi.

He did, however, recall his wet nurse, in a yarn he told both Condivi and his other worshipful contemporary biographer, the painter, courtier, and seminal art historian Giorgio Vasari. The latter's version includes a touch of flattery for its Arezzo-born author, who recounts how Michelangelo told him, "Giorgio, if there is any talent in me, it comes from being born in the pure air of your Arezzo countryside, and also because I took in with my nursemaid's milk the chisels and hammer with which I make my figures."

With clues like that, it's not surprising that psychoanalysts from Freud on have found Michelangelo an irresistible subject—nor that they tend to make more of his familial influences than do art historians, who look for influence in artistic lineages. Dr. Robert S. Liebert, in a "psychoanalytic study" of Michelangelo's life and art, argues that the "cold and stonelike" Mother Mary in his earliest surviving sculpture, the *Madonna of the Stairs,* "represents the fused image of Michelangelo's wet-nurse and natural mother, both of whom were forever lost to him. The yearning to recapture the lost sense of well-being in a symbiotic union with the breast remained an intense moving force within Michelangelo, as is indicated by the wet-nurse anecdotes in Condivi and Vasari."[1] That may sound like psychoanalytic self-parody, but the doctor is onto something. Not only the *Madonna of the Stairs* but nearly all Michelangelo's sculpted Madonnas-with-child sculptures seem curiously remote, ambivalent, and disengaged. These are not the doting young mothers of Raphael's and Filippo Lippi's Madonna-and-child tableaux, nor the sorrowing Marys of Michelangelo's own *Pietàs,* who gaze adoringly at their dead adult

son. His Madonnas look away from or past their living infants. Even the vivacious, animated Mary in Michelangelo's only surviving finished easel painting, the *Doni Tondo*, reaches toward her son with a distracted gaze and an ambiguous, contorted gesture: is she receiving him, or handing him off to Joseph?

THE WET-NURSE ANECDOTE is an origin myth propounded by Michelangelo himself—"a casual joke, but also said in earnest," as Condivi puts it. It shows how central sculpture, specifically sculpture in stone, was to Michelangelo's sense of who he was and what his purpose in life was.

Certainly Settignano did much to shape him, and to prepare him for his labors at Carrara. Today the town is a refuge for Florentine commuters, affording an appealing balance of suburban accessibility and rural tranquillity. Like them, the young Michelangelo would have beheld the cityscape stretched out below. He would have admired the two celebrated domes by Brunelleschi that cap it—the enormous one atop the Cathedral of Santa Maria del Fiore, which would inspire Michelangelo when he designed what he himself called a "bigger, but no more beautiful," dome for Saint Peter's Basilica, and the smaller one over the Church of San Lorenzo, where he would create his most haunting and elusive masterpiece. Brunelleschi's example would loom always in his eyes, but the noise and bustle of the city—clattering carts and horses in his day, sputtering Vespas in ours—seem a thousand miles away from Settignano.

The quarries of Maiano, Monte Ceceri, and Trassinaia that were Settignano's reason to be are closed now. But their legacy still hangs over the cornfields and pastures at Maiano, an easy hike on the westward path to Fiesole: artificial cliffs cut into the steep hills, still showing the outlines of the extracted blocks. This is not marble but humbler *macigno,* the greenish gray sandstone that was a main building block of Florence; Brunelleschi favored the elegant bluish variety called *pietra serena* in his church and portico designs. Virtually every Settignano family depended on the stone for sustenance and produced *cavatori* to extract it or *scarpellini* to shape it—as late as 1874, 181 of its 1,400-odd inhabitants were stone workers.[2] Even before Michelangelo arrived, this little district was a seedbed of Italian sculpture. The greatest sculp-

tors of the mid-to-late fifteenth century—until Michelangelo arrived—were sons of the *macigno* belt, named after their stony villages: Desiderio da Settignano and Benedetto da Maiano.

BY THE TIME he was ready to start school, Michelangelo had been brought from Settignano to live in his father's house in the bustling lower-middle-class district of Santa Croce, just east of the Piazza della Signoria, where Florence's civic and official life centered. But his ties to Settignano—or at least to its brotherhood of stone workers and quarrymen—lasted through his life. Three decades later, when he was forced to leave Carrara and urgently needed skilled hands to open new quarries and organize marble-working projects on an unprecedented scale, he turned to Settignano, and to families such as the Fancelli, Bertini, and Lucchesini, whom he had known since childhood, to fill out his work crews.[3]

Given these enduring connections, and considering all that Settignano offered a nascent sculptor, it seems scarcely an exaggeration for Michelangelo to boast that he was suckled on stone carving. But who nurtured his talent after that? As Vasari tells it, no one, not even some kindly old Settignano carver who might have shown him how to swing a hammer: until he made his first teenage stab at stone carving and amazed no less a connoisseur than Lorenzo de' Medici himself, "he had never before touched marble or chisels." Actually, Vasari, ever the ingenious mythmaker and servant of Michelangelo's self-mythologizing, tries to have it three different ways: He roots Michelangelo in the picturesque stone-carving culture of Settignano. He suggests that his genius was something innate, springing forth fully formed like Athena out of Zeus's head. And with his usual eye on the main chance, he credits his own patron's family, the Medici, with incubating this genius in an idyllic sculpture-garden art academy.

All these explanations are partly true, but all must be weighed with a skepticism often lacking in popular biographies, which tend to take Vasari's and Condivi's accounts at face value. The known facts about Michelangelo's childhood are painfully thin, and suffused with the spin that he and Vasari put on them. But it seems probable that, growing up in a *scarpellino's* household surrounded by stone workers, he got an early introduction to their tools and methods. He had certainly

contracted an obsession all too familiar to some parents in every era: all he wanted to do was draw. He neglected his studies and attached himself to anyone who could help him learn more about the mysteries of line, shadow, and perspective. His father and uncles tried to beat the urge out of him, fearful that he'd shame their family by becoming an artist rather than entering a respectable trade (like selling wool, as his younger brothers would—though they would forever depend on his income from art). Had Lodovico di Buonarrota guessed that his second son would gravitate not just to art but to *sculpture*—a dusty, plebeian trade scarcely elevated above masonry—he might not have left him all those years with the Settignano stonecutters.

Lodovico finally gave up and apprenticed his incorrigibly artistic son to Domenico Ghirlandaio, one of the last and greatest of Florence's quattrocento masters—and a leading exponent of a style and worldview that Michelangelo would blow away when he unveiled his Sistine Chapel ceiling twenty-four years later. Thirteen-year-old Michelangelo evidently showed unusual promise; rather than charging the usual fee for his training, Ghirlandaio contracted to *pay* him an escalating stipend, totaling twenty-four gold florins (about $3,600 today),[4] for three years' apprenticeship. What Michelangelo learned assisting in Ghirlandaio's studio and on his large frescoes at the Church of Santa Maria Novella surely served him well when he took on the Sistine ceiling, despite all his demurrals then about being a novice at painting. But the relationship was a fraught one, at least in Michelangelo's mind. He later put it out, through Condivi, that Ghirlandaio so "envied" his precocious gifts that he tried to appropriate his apprentice's sketchbook, presumably to crib from it. Condivi (or Michelangelo via Condivi) adds that, contrary to claims by Ghirlandaio's son that Michelangelo owed everything to Dad's training, Ghirlandaio "actually gave him no assistance at all."

This snub may seem ungracious, but it shows how wide the gulf was between Michelangelo's art and his master's. Ghirlandaio was the perfect artist for hire, "so loving his work," writes Vasari, that he made his assistants take every commission that came in, "even if it were only painting hoops for women's baskets," rather than sending any customer away unsatisfied.[5] His work was the epitome of late quattrocento bourgeois religious painting: at once refined and ingenuous, exquisitely composed and colored, with every cow in its proper

manger, every detail of dress and landscape sharply rendered, saints and Madonnas showing the same delicate features and honey-colored hair as Botticelli's pagan Venuses, and patrons cannily portrayed as pilgrims in the crowds. Disowning Ghirlandaio's influence also represented a rejection of painting itself in favor of sculpture, and of the workshop system that Ghirlandaio exemplified. Michelangelo was never quite the Romantic lone wolf—a *spartano,* as the Carrarese call solitary freelance toilers in stone—that popular imagination casts him as. But throughout his life, even when he commanded a large workforce preparing huge, complex stone projects, he was proud to proclaim that he had never operated a *bottega,* a commercial workshop. He had protégés and servants, colleagues and workmen, but not apprentices. And he left many patrons dissatisfied—not with what he produced but at what he failed to complete.

HALF A MILE NORTHWEST of Santa Maria Novella, the Florentine church where young Michelangelo labored for Ghirlandaio, sits a large building finished in rusticated brown *pietra forte:* the Medici or (as it's now called) Medici Riccardi Palace. It is imposing but, in the usual quattrocento fashion, rather plain and unassuming; those who had wealth in republican Florence knew better than to taunt their neighbors with it. And the Medici certainly had it; in the late fourteenth and early fifteenth centuries, Giovanni di Bicci de' Medici built up the most powerful bank in the world, thanks in large part to its management of the Catholic Church's finances. His son Cosimo "the Elder" de' Medici, Florence's designated *Pater Patriae,* multiplied the family fortune and through a combination of patronage and steadiness became the effective, though self-effacing, ruler of Florence.

Cosimo established another Medici tradition that would figure greatly in Michelangelo's life: the patronage of art and literature, including the founding of Italy's first extensive public library and a latter-day Platonic Academy with resident scholars supported by Cosimo. Cosimo's grandson Lorenzo de' Medici, who became head of the family and boss of the city in 1469, was better at spending than making money—a consummate politician, diplomat, art patron, and poet, even more ardent in his cultural pursuits than Cosimo had been. Lorenzo—"the Magnificent"—directed his energies, and much of the

fortune his ancestors had built, to shoring up the city's security and his family's status within it, and to the pursuit of learning and beautiful objects. He collected books, miniatures, jewelry, and—in a garden beside the palace and opposite the Piazza San Marco—ancient sculpture.

As a decorative feature, this was nothing unusual; with the reborn enthusiasm for classical art and philosophy and for excavating antiquities, sculpture gardens were fashionable fixtures among Florence's cultivated rich. But Lorenzo's is the only one renowned in history and legend—thanks to a fourteen-year-old truant who now played hooky from Ghirlandaio's workshop as well as from his grammar lessons, sneaking over to draw Lorenzo's old sculptures whenever he could. "Michelangelo, the sculptor from the garden," the priest Ser Amadeo di Giovanni, a member of Lorenzo's circle, called the lad,[6] and he became as much a fixture as the statues he sketched.

Vasari claims that this was not just a garden but a school of sculpture, which the beneficent Lorenzo established because it "pained him that there were not celebrated and noble sculptors to match the many illustrious painters of that time." The school may have been Vasari's concoction, but the garden did have a resident mentor and caretaker, Bertoldo di Giovanni, an old student of Donatello, Florence's greatest sculptor before Michelangelo.[7] And the circumstances Vasari credits Lorenzo with trying to correct were very real. Sculpture had dominated the proto-Renaissance cultural boom that began in Pisa in the mid–thirteenth century; it was the medium best suited to expressing the swelling civic pride of central Italy's fast-growing city-states and decorating their imposing new cathedrals and public buildings. But painting took the lead in the fourteenth century, spurred by development of the fresco technique for walls and of painted polyptychs on multiple wood panels. Also, an explosion of mendicant churches with privately funded chapels provided a nearly endless market for inspirational murals.[8] Painting flowered as never before in late-quattrocento Florence, even as sculpture declined with the passing of Donatello.

Bucking the trend, the adolescent Michelangelo spurned painting and studied the sculptures in the compound. His recollections of this time, transmitted through Vasari and Condivi, have the warming glow of fables—as well as a glint of Genesis, with Lorenzo the father walking about his Eden observing the progress of his foster son. Instead of a fruit from the forbidden tree, it is a scrap of stone that unleashes a

perilous knowledge, sending the young man out into the world to earn his way by a lifetime of toil. As Condivi tells it, Michelangelo determined to copy the carved head of a faun that sat, well worn, in the garden, using a chunk of marble and tools begged from the workmen dressing stone to build Lorenzo's library (a project that he himself would complete six decades later). When Lorenzo, passing by, notices Michelangelo polishing this debut effort, he marvels that so young a novice could execute such fine work, but chides him for giving the aged faun all his teeth, when "creatures of that age are always missing some." Michelangelo, ever the steadfast servant of truth, not only knocks out a tooth but bores a hole in the gum where it would have rooted. Lorenzo, charmed even more, rewards the young prodigy by inviting him to live in his house and sit next to him at his table, there to imbibe the wit and wisdom of the gathered artists, poets, and philosophers.[9]

Among the sages whose disquisitions would have thrilled young Michelangelo was the brilliant Neoplatonist philosopher Giovanni Pico della Mirandola. Pico stood out from the scholarly crowd for his youth, good looks, and courtly grace, his prodigious memory and linguistic abilities (he supposedly mastered twenty-two languages), and his zeal for melding classical thought, Christian faith, and Eastern mysticism, in particular the Kabbalah, in a grand theory of human destiny. A few years earlier, he had written his famous celebration of free will and the liberated mind, the *Oration on the Dignity of Man,* an essential Renaissance testament that also anticipates twentieth-century existentialism. In it, God speaks to man: "Neither heavenly nor earthly, neither mortal nor immortal have we made thee. Thou, like a judge appointed for being honorable, art the molder and maker of thyself; thou mayest sculpt thyself in whatever shape thou dost prefer."[10] Such declamations would be deeply stirring to a sculptor just awakening to his art.

One other encounter helped shape Michelangelo's outlook, and his face. Every primeval setting must have its ogre, and in Lorenzo's garden that role was filled by Pietro Torrigiano, a brawny, hot-tempered, but talented young sculptor who went with Michelangelo to sketch Masaccio's great frescoes in the Church of the Carmine. As Vasari tells it, Torrigiano, burning with jealousy at Michelangelo's gifts and application, taunted him "until they finally came to blows" and then

smashed his nose. Torrigiano himself gave the sculptor Benvenuto Cellini a different account: "It was Buonarroti's habit to banter all who drew there, and one day, when he was annoying me, I grew more angry than usual and, clenching my fist, gave him such a blow on the nose that I felt bone and cartilage go down like biscuit beneath my knuckles, and this mark of mine he will carry to the grave."[11] Cellini, who revered Michelangelo, recounts that he was so shocked to hear of his idol being thus abused that he refused Torrigiano's otherwise alluring invitation to join him in executing magnificent projects for Henry VIII in England. Lorenzo de' Medici also did not take well to his protégés' being treated thus, and Torrigiano fled Florence. He took to soldiering for a while, then returned to sculpture, but never got his temper under control; he died in a Spanish jail, imprisoned by the Inquisition for the blasphemous act of smashing his own statue of the Virgin Mary when a client tried to cheat him.

Michelangelo, now permanently disfigured, joined the roster of famously ill-favored Renaissance figures—from Cimabue and Giotto to Lorenzo de' Medici himself—whose work redefined and reinvigorated the world's sense of beauty. In the best likeness we have of him, a bronze bust based on his death mask by his follower Daniele da Volterra, the flattened nose, together with his high, broad cheekbones, furrowed brow, sad eyes, and thin-lipped, downcast mouth, evoke an old Chinese sage.

If Michelangelo did indeed carve the faun's head, it was lost long ago; no record of it survives save the yarns he told his biographers six decades later, though that has not stopped would-be cultural detectives from trying to reconstruct and recover it. Probably lost as well is a *Christ Crucified*, the only wooden sculpture he is known to have carved, made for the high altar of the Church of Santo Spirito out of gratitude to its abbot for allowing him to dissect and draw cadavers in the church morgue (an interesting exchange). Many authorities attribute a poplar crucifix discovered in the church in 1963 to Michelangelo, but it seems a dicey choice; its smooth, sinuous lines, Gothic symmetry, delicate sweetness, and naïve proportions bear no resemblance to the robust, anatomically informed figures of even his earliest works in stone. Still, it's been judged fit to hang in the Casa Buonarroti, the museum that occupies the house Michelangelo bought for his nephew and sole heir, Lionardo.

* * *

TWO SMALL MARBLE WORKS of surer authenticity survive from the teenage idyll in Lorenzo's garden, carved from blocks provided by Lorenzo: the low-relief *Madonna of the Stairs*—a cryptic, precocious, youthful performance—and a high-relief *Battle of the Centaurs* that would be remarkable even if it weren't a youthful work. It's often said that in the *Madonna*, Michelangelo digested and recast the lessons of his greatest predecessor, Donatello, who brought sculpture into the Renaissance a century earlier, and that he transmuted the legacy of the Greeks and Romans into the *Battle of the Centaurs*.

The poet Angelo Poliziano, a resident scholar in the Medici household and tutor to Lorenzo's sons, suggested the latter tableau's subject, a tale from Ovid's *Metamorphoses,* and coached Michelangelo on its execution. The Lapiths, who dwelt in the rocky mountains of Thessaly, often clashed with the centaurs living in the woods and

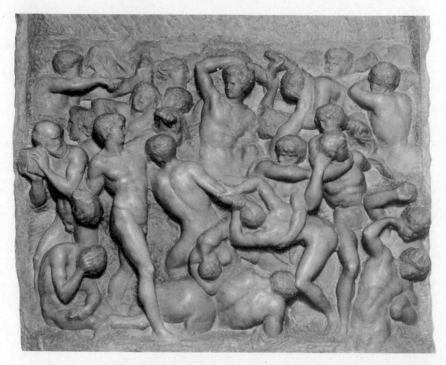

The Battle of the Centaurs, the adolescent work Michelangelo cherished through his life (marble, 1491–92).

meadows below. The Lapith king Perithous tried to patch things up by inviting the centaurs to celebrate his marriage to Hippodamia—"horse woman" in Greek, hinting that she herself may have been a centaur, which would further seal the peace. But one centaur, Eurytion, got drunk and randy and tried to carry off the bride. A bloody brawl ensued; the Lapiths won and banished the centaurs.

It was a tale that would appeal for different reasons to Lorenzo de' Medici's Neoplatonist circle, to a scholar with an eye for boys, and to a young sculptor just discovering the wonder of stone. It recalls *Pallas and the Centaur,* a much kinder and gentler image of civilization triumphing over centaurian barbarism, painted a few years earlier by Sandro Botticelli to commemorate Lorenzo's bold diplomatic mission to head off war with Naples. It also evokes the *Phaedrus,* Plato's dialogue on love, in which the "dark horse" of lust and irrationality must be restrained from pulling the soul's chariot off its track. The *Phaedrus* celebrates love as a "divine madness"; not surprisingly, it was a favorite book of the Florentine Neoplatonists, who, like their Greek predecessors, savored infatuations with beautiful youths and maidens and at the same time aspired to channel such passions to spiritual ends.

Marsilio Ficino, who established Cosimo's Platonic Academy, wrote commentaries on the *Phaedrus.* He and Poliziano and their circle reenacted another classic tradition: the cultivation, erotic as well as didactic, of promising youths by wise older men. In the *Phaedrus,* Plato's protagonist Socrates even evokes sculpture as a metaphor for this cultivation: "Each selects his love according to his character; and as though the youth were the very god whom he once followed, the lover fashions and adorns him like an image to be the object of his worship and veneration."[12]

Poliziano "loved Michelangelo greatly," Condivi recounts, "knowing him for the exalted spirit he was. And, though not always needing to, he constantly spurred him on to study." But Poliziano—or Politianus as he was called in Latin, a language he spoke (along with Greek) as fluently as Italian and wrote as well as the ancients—enjoyed a less exalted reputation outside the Medici gates. By one account, "scurrilous lampoons" circulated after his death in 1494, one of which alleged that Poliziano "died in a paroxysm while composing a pederastic ode."[13] He was "covered with as much infamy and public

disgrace as any man could suffer," one Florentine diarist noted, though it "arose not so much from his vices as from the ill-will borne in our city against [his pupil and Lorenzo's son] Piero de' Medici." Blink, and *The Battle of the Centaurs* can look much like an orgy; might Poliziano have seen something more than combat in the twining, straining mass of athletic bodies that he encouraged his young protégé to carve?

At the same time, the *Battle* is a bone-crunchingly realistic depiction of combat. It crackles with tension, not just between its battling figures but in their individual *contrapposto* torsion. In this it anticipates Michelangelo's work to come—full of conflict and struggle, occasionally external, always internal.

The eager young sculptor may have found this subject especially congenial for another reason: as he depicts it, it is not only a story set in stone but a story *about* stone. His Lapiths lift large rocks, rather than the swords of the original Greek tale or the mugs and wine jugs of Ovid's version, to swing at the centaurs. Their very name, by a coincidence that Poliziano and Michelangelo could hardly miss, evokes *lapis,* the Latin word for stone, and the Italian *lapide,* for a stone plaque. Michelangelo's *Battle* depicts the triumph not only of Greeks over barbarians and of civilization over savagery, but of stone over flesh.

The *Battle* is smaller than it seems in photographs, less than a meter in each direction. But it holds an outsized importance in Michelangelo's development, which he himself acknowledged ruefully. He kept it through his life, even as he destroyed most of his drawings and abandoned many other half-carved stones. "I remember hearing him say," Condivi recounts, "that, when he saw it again, he realized how he had violated nature in not promptly pursuing the art of sculpture, judging from that work how much he could have accomplished. He doesn't say this to boast, modest as he is, but only because he truly grieves at having been so unfortunate, through others' fault, as to make nothing for ten or twelve years at a time." It is incongruous to hear the most celebrated sculptor in history lamenting, like the clerk who had to drop out of art school, that he was stopped from pursuing his muse—especially when he would, before the decade was out, carve both the *Bacchus* and the Vatican *Pietà.* But the detours and diversions Michelangelo suffered, partly through his own fault, partly

because of epic painting and architectural projects, and partly thanks to fickle and overeager patrons, were formidable. It's not surprising that the septuagenarian artist would look back nostalgically to a time when, unbothered by family responsibilities and snuggled in the Medici nest, he could pursue such a project without worrying whom it would please or where it would be set.

This adolescent experiment contains the seeds of much of Michelangelo's future work, and not just in sculpture. Its profusion of figures and variety of poses, contorted in struggle and agony, provide almost a rough draft of two future frescoes, the never-finished *Battle of Cascina* and *The Last Judgment*. What's most remarkable is not what Michelangelo did in it but what he left undone; its figures emerge as though tearing themselves free from the hard stone. Even the most finished foreground figures are merely chiseled in, with impressive sureness, rather than polished with pumice and emery as finished sculptures were supposed to be. The fine marks, evidently achieved with the *gradina,* a toothed chisel ordinarily used in the middle stage of carving), are the stonecutting equivalent of the free, expressive brushwork of seventeenth- and eighteenth-century painting. Richer and rougher yet is the background texture—punched out with the pointed *subbia,* the first chisel in the stone-shaping sequence—the equivalent of a free sketch with a large stick of charcoal. Imagine a roiling sea viewed from a low-flying airplane and you get an inkling of the energy of this tortured surface. Thousands of sculptors for thousands of years had roughed in their sculptures this way, but the *Battle of the Centaurs* is the first substantively finished work in which rough punching becomes a final surface—the first known deliberate use of the technique called *non finito.*

Biographers typically explain that the *Battle* was left unfinished when Medici rule unraveled and Michelangelo hurried from Florence. But that did not happen until about three years after he started it— certainly time to finish it to his satisfaction. Was he satisfied? He still prided himself on it in the autumn of his mastery, and used *non finito* to even more expressive effect in his next high-relief sculptures, two innovative depictions of the Madonna and child called the Taddei and Pitti *tondi* ("rounds," indicating their shape).

*　*　*

To APPRECIATE Michelangelo's approaches to finish, and the differences between the various tools and techniques used to shape stone, one must look back two thousand years or more, to the origins of the marble carver's art. The Greek sculptors' technique differed markedly from medieval and Renaissance approaches.[14] Like the Egyptians, Assyrians, and Babylonians from whom they learned, they relied on heavier, pointed chisels that struck the stone at right angles, splintering the surface and dislodging chips, and which did not require such hard steel or fine edges.

Later sculptors had much harder iron and steel, but they still began shaping with punches before proceeding to flat cutting chisels. In the hands of a master, this initial shaping can be almost blindingly fast work. Michelangelo could shape stone with a speed and precision that seemed to his contemporaries preternatural; if there was a devil in the stone, surely he had sold his soul to it. When he was past the age of sixty, a French visitor, Blaise de Vigenère, marveled that he could

hammer more chips out of very hard marble in a quarter hour than three young stonecarvers could in three or four, which must be seen to be believed. And he went at it with such impetuosity and fury that I thought the whole work must go to pieces, knocking off with one blow chips three or four fingers thick, so close to the mark that, if he had gone even slightly beyond, he ran the danger of ruining everything.[15]

I enjoyed a humbler demonstration of such an attack in a bucolic setting: a backyard garden carved into a steep ridge just above the village of Bedizzano, on the road that climbs from Carrara to the quarry village of Colonnata. There, Luigi Ravenna had taken a break from carving funeral stones in his shop and invited a few friends over to share in the autumnal bounty: figs, filberts, and persimmons from the orchard; chestnuts from the surrounding forests, roasted over a wood-scrap fire; and of course, wine made from his own grapes. As the quarry-scarred cliffs across the valley turned pink and ocher in the late sun, the talk turned, inevitably, to marble. Upon learning what I was interested in, Luigi and one of his mates, a retired *cavatore* named Giuseppe Testi, fell into an argument that soon escalated to shouting and glass waving. At issue: just what kind of stone did Michelangelo

carve, and at which quarry did he find it? *"A Polvaccio,"* Giuseppe declared, echoing the experts. "To Polvaccio he went, for *statuario!"* But Luigi insisted he used *ordinario* from Canalone, up past Colonnata. Perhaps he used both, at different times and for different projects. They agreed on one point: "He did *capolavori*"—masterpieces. "He knew the work."

The talk turned to that work, and Giuseppe recalled the old days in the quarries. He's a slight, white-haired man who, like many who've survived those days, looks older than his years (then sixty-two). But he's still alert as a hawk and wiry and spry, save for a trick knee that he broke "stopping a kid from falling off the mountain." He saved the lad's life, and so feels pride rather than shame when the knee goes out and he tumbles to the ground. "I have upheld the pride of my place, of my *razza,* of my father. I do not yield to anyone in the world."

Bad knee or not, he would walk every day to the *cave* "up there"—he pointed up what seems an impossible slope, rising as much as fifteen hundred meters in elevation. He'd started at the usual early age, as soon as he could leave school, and received the usual initiation: "They'd give a kid, a thirteen-year-old, a stone and say, 'Make this smaller, like this.'" His specialty was *riquadratura,* "squaring"—trimming the rough stones into rectangular blocks that could be easily roped, dragged, stacked, and sawn. In his day, before the advent of diamond-studded *diamante* saws, the most efficient tools for this task were ancient ones, hammer and chisel. Using them, the *riquadratori* achieved machinelike precision: "We'd be told to make forty-five blocks the same size, and there wouldn't be a gram's worth of difference between them." And "squaring" didn't mean just squaring: Giuseppe, warming to the subject, grabs my notebook and draws the outline and measurements necessary to produce a precise octagonal block with a square hole in the center as a base for a column.

But some things must be shown, not told. He suddenly leaps up and, it seems out of thin air, grabs a short-handled mallet and a small pointed chisel—ridiculously undersized tools, you would think, against big stones. He pounces, bad knee and all, on a foot-thick block of stone at the side of the garden. "First you must mark *la tariffa,"* he hollers—the "tariff," or guideline—and by the time he's said it a line has appeared, scribed with quick light taps in a perfect perpendicular across the block. "You must watch the stone, see which way it wants

to break." Belying his words, he looks back at me and lectures, even as he swings unerringly, fast as a drummer, in alternating oblique strokes from left and right. I believe he could have closed his eyes, or drunk another liter of wine, and still hit true; he seemed to see the stone, and the hammer and chisel, with his fingers. Chips flew, and the block was well on its way to becoming two.

The chisel marks on Michelangelo's sculptures, cutting from right and left in crosshatched alteration, suggest that he was ambidextrous with hammer and chisel, holding either in either hand as occasion required. After seeing the old *riquadratore* attack his block, I wonder if Michelangelo learned the trick in Carrara.

ROUGH CARVING might be fast work, but the next stage for the Greeks was excruciatingly labor-intensive: to finish shaping and to smooth the rough, pockmarked surface left by the punch with pumice and emery. Perhaps a ready reserve of slave labor made such efforts possible; you get an inkling of what they can entail watching Robert Gove spend weeks smoothing and subtly shaping one of his streamlined abstractions. "Ninety percent of my time is just spent sanding," Gove says with something between pride and resignation. As a Zen Buddhist, he cherishes this seeming drudgery as meditation. But such patience did not come naturally to Michelangelo or the old Greeks.

Unfinished early Greek sculptures bear vivid evidence of the punch-and-polish technique, with a pattern of holes that looks oddly sponge-like. Even finished figures bear traces of the punch, where it bit deeper than the subsequent smoothing. The head-on technique shows in another way: punching bruises the marble, dulling the translucence of its crystals, an effect somewhat like the crackle pattern of a shattered windshield. Thus the peculiar quality of archaic Greek sculptures, what one scholar celebrates as "velvety depth" and "bloom" but others see as dullness.[16] For the early Greeks, this dullness would have been an advantage; they painted their statues, and bruised surfaces absorb paint better.

The Romans, who had plentiful iron, adopted the full range of chisels later used by Renaissance and modern carvers: the pointed *subbia;* toothed (or forked) chisels, including the standard three-toothed *gradina* and the two-toothed *calcagnuolo* for rougher work; the curved

tondino; and the slightly flattened *unghietto,* "fingernail." But they used these differently and, following the Greek model, brought their works much farther along with the speedy pointed chisel. Peter Rockwell, an American sculptor living in Rome, conducted an exacting analysis of the chisel marks in various Roman sculptures, including Trajan's famous column. He found that the Romans used the *gradina* sparingly, largely to smooth out rough spots left by the pointed chisel, almost as though it were "a rough-working flat chisel rather than a separate tool with a function of its own."[17] By contrast, Renaissance and modern carvers, including Rockwell, rely on toothed chisels to model their forms, and use flat chisels, which do not bite as deeply, largely to smooth them. Given these and other differences between ancient and modern techniques, Rockwell doubts "that it is possible to make a technically accurate fake of an ancient marble carving."[18] Even if we copy their forms perfectly, we don't, and can't, carve the way the Romans did, and the surfaces will show it.

Michelangelo helped bring about the shift to the toothed chisel; so adept was he with it that he would dispense with flat chisels and finish his pieces, or at least bring them to their last state of *non finito,* almost entirely with toothed ones. In 2003, in connection with the much-ballyhooed restoration of his *David,* Italian researchers conducted a minute examination of four *non finito* surfaces—David's hair, the sling strap across his back, and the rock and the tree trunk at his feet. They found marks from the *subbia,* the sharpened *subbia da taglio,* the *unghietto,* and the *gradina,* and from another, smaller-toothed chisel called the *dente di cane* ("dog tooth"). They found no evidence that Michelangelo used flat chisels.[19]

I've come to understand why he made this choice not from anything he wrote or anything others have written about him, but from the expat Iraqi sculptor Sabah Al-Dhaher, who lives and works in Seattle. Al-Dhaher says he prefers the forked over the flat chisel *because,* not in spite, of the pattern of scratches it leaves where its teeth bite the stone. "The forked chisel shows you the form," he explains. "It's like drawing on the stone. You're drawing in three dimensions." That's exactly what Michelangelo, who extolled *deseigno*—drawing—as the essence of all the arts, did. He used his chisel like a pen, and used his pen like a *gradina* in his finely hatched, richly modeled drawings.

CHAPTER 3

CITIES OF STONE

The stone that breathes and struggles,
The brass that seems to speak;—
Such cunning they who dwell on high
Have given unto the Greek.

<div align="center">

THOMAS BABBINGTON MACAULAY, "THE PROPHECY
OF CAPYS," IN *Lays of Ancient Rome*

</div>

IN 1492, WHEN MICHELANGELO was seventeen and hitting his stride, the Medici Camelot began to unravel. Lorenzo the Magnificent, whose health had never been strong, died on April 6 at the age of forty-two. Just before expiring he sullied his reputation for pagan equanimity by asking a Ferrarese monk named Girolamo Savonarola, then preaching hellfire and prophesying doom as prior of the nearby San Marco Monastery, to come to his bedside. Poliziano, who was at the scene, described their encounter as unexceptional: Savonarola called on Lorenzo to keep faith and live purely, then delivered his blessing. But Savonarola's amanuensis, Fra Silvestro, gave a different account: Lorenzo was wracked with remorse at his own misdeeds, and Savonarola directed him to do three things—first, to seek God's mercy, to which Lorenzo eagerly agreed; then to return the wealth he'd misappropriated, to which he consented less eagerly; and finally to restore the liberty he'd stolen from the Florentines, at which the Magnificent One balked.

Even assuming that Savonarola and his followers concocted this im-

probable account, the fact that they could spread such a tale did not bode well for the Medici. Lorenzo's eldest son, Piero, succeeded him as civic godfather but never filled his place. Lorenzo was a scholar and a diplomat, canny and ingratiating, who ruled the city discreetly by pulling strings rather than throwing his weight around. But Piero, just twenty-two at the time, was brash, hotheaded, and overbearing; even in a childhood depiction by Ghirlandaio, within a revealing Medici family tableau in the Church of Santa Trinità, Piero glances scornfully at the viewer, his jaw set pugnaciously, while his tutor, Poliziano, and brother Giovanni (the future Pope Leo X) pray earnestly and his cousin Giulio (the future Clement VII) looks about quizzically.

Young Michelangelo stayed on, working under Piero's patronage and sitting at his table as he had at Lorenzo's. But the Platonic Academy had become a frat house. When a heavy snow fell, Piero had his resident sculptural prodigy make a giant snowman ("Very beautiful," rhapsodizes Vasari, who never saw it)—not the most dignified commission, but the only one Michelangelo received from Piero, and one he recalled fondly in his old age.

Piero was likely no worse than the run of dukes and princes in those Italian cities where dukes and princes ruled, and he was certainly milder than, say, bloody Cesare Borgia and the notorious duke of Calabria. But the Florentines were not used to being ruled overtly, and Piero behaved unforgivably like a prince, lording it over them as his father, grandfather, and great-grandfather never had. Worse yet, he botched his diplomatic responsibilities, with disastrous results. His father, Lorenzo, had juggled ties with Milan and Naples, the two leading powers in Italy, to keep them and the peninsula at peace. But Piero tilted toward Naples, alarming Milan's duke, Lodovico Sforza, who appealed for help to his ally France. In 1494, a large French army marched into Italy, starting a cycle of foreign invasions and counterinvasions that would devastate the peninsula over the next four decades. Piero bought peace by ceding all Florence's outlying fortresses to the French, leaving the city fatally weakened.

His fellow Florentines were outraged. Savonarola's sermons had already roused resentment of the Medici and set off a puritan backlash against the lax ways they personified. Revolt was in the air, and Michelangelo feared being caught on the wrong side of it because of his association with Lorenzo, Piero, and their protégé Poliziano. He

was initially drawn to Savonarola's dire preachings, as were many of Florence's restless artists and intellectuals, but dark forebodings, which he later credited to a dream recounted by a friend, overcame this attraction. In October 1494 he fled, first to Venice. His apprehension proved prescient: the next month the Florentines drove out the Medici, and Savonarola became the new boss of the city. Florence's leading painters—Fra Bartolomeo, Lorenzo di Credi, even Botticelli—recanted their attachment to their art and tossed their works onto the prior's Bonfire of the Vanities.

AS HIS TWENTIETH BIRTHDAY approached, Michelangelo had no big commissions requiring special stones—nothing except big dreams and precocious talent. After fleeing Florence, he washed up briefly in Venice, but that floating world of mists and masques was not for him. He decamped to Bologna, but fell afoul of its authorities for entering without the proper pass mark, a red wax seal stamped on the thumbnail. Once again, a father figure appeared in Michelangelo's time of need: a Bolognese dignitary named Gianfrancesco Aldovrandi, who, "having recognized that he was a sculptor"[1] and hence respectable or at least harmless, persuaded the authorities to release him and took him in for a year.

Aldovrandi helped Michelangelo secure his only commission during that period: carving three small figures to fill gaps in the ornate tomb at the Church of San Domenico. Once again, as in the *Madonna of the Stairs* and the *Battle of the Centaurs*, Michelangelo entered into a great sculptural tradition, collaborating across the decades with two of his foremost predecessors. Nicola Pisano, the great Pisan master who bridged the transition from medieval to Renaissance sculpture, had begun the tomb in the fourteenth century, and the near-great Niccolò dell'Arca had continued it. Michelangelo's three little figures fit handily in the ornate scheme, but with their barely contained energy seem to strain to break free. One especially, a slightly built but doughty *Saint Proculus* with clenched fist and jaw, has been taken for a self-portrait, though it scarcely resembles the portraits and self-portraits of later years. *Proculus*'s determined stare and pugnacious stance instead anticipate Michelangelo's later republican icons, *David* and *Brutus*. If this is indeed a self-portrait, then it shows the artist

as an angry young man, ready to batter down any door in his way.

Perhaps Michelangelo was angry at the Bolognese sculptor who, as Condivi recounts, charged that he had stolen a promised commission and threatened to take revenge. By late 1495, Bologna had become dicey for Michelangelo, while Florence had settled down; it was time to go home. But art was not esteemed in Florence under Savonarola's austere rule as it had been under the Medici, and Michelangelo executed just two small sculptures in the half year after he returned there. Both were of children and both are now lost: a *Young John the Baptist* commissioned by Lorenzo di Pier Francesco de' Medici, a scion of a cadet branch of the family that had avoided clashing with Savonarola's followers, and a *Sleeping Cupid* that became the bait in a classic art fraud.

Like many art scams, this one hinged on the allure of antiquity. Renaissance patrons, like their modern counterparts, reflexively esteemed ancient works more highly than contemporary ones, and paid accordingly. But too few ancient sculptures had survived the post-Roman orgy of stone recycling to satisfy all the Florentine humanists and Roman clerics who craved them. So Lorenzo di Pier Francesco made an offer: if Michelangelo would dirty up the *Cupid,* he would send it to Rome, where it would fetch a higher price as an antique.

Many biographers gloss over Michelangelo's role in the caper, but he acknowledged to Condivi, doubtless with a sly chuckle, that he was a willing participant. It may have appealed as a challenge: could he compete well enough with the ancients to pass as one of them? He antiqued the *Cupid,* and off it went to Rome. A Roman dealer cheated him, paying just thirty ducats and arranging to sell it to a renowned collector, Cardinal Raffaello Riario, for two hundred—two or three years' wages for a skilled craftsman. But the cardinal, hearing rumors of the scam, traced the *Cupid* to Michelangelo and got his money back from the dealer. Rather than holding a grudge, he gave Michelangelo an entrée and a place to stay in the Eternal City, where bigger opportunities awaited.

It's at this point that we start to hear Michelangelo's story in his own words, rather than filtered through Condivi and Vasari: the earliest of nearly five hundred of his letters that survive is dated July 2, 1496, a few days after he arrived in Rome—a copy, addressed to his fellow Medici protégé Sandro Botticelli, of a letter he'd sent to Lorenzo

di Pier Francesco. In it, Michelangelo recounts how, thanks to Cardinal Riario, he once again faced the challenge of matching the classical masters: Riario showed him his collection of ancient sculptures and "asked me whether I had courage enough to attempt some work of art of my own. I replied that I could not do anything as fine, but he would see what I could do. We have bought a piece of marble for a life-sized figure and on Monday I will begin working."[2]

The work that he began then and finished by the following summer was an audacious one: a *Bacchus,* slightly larger than life, lurching perilously in his cups but still holding his drinking cup high. An impish faun—a young one this time—gambols behind the wine god, stealing the grapes that slip from his cornucopia. *Bacchus* is an original and unsettling mix of classic idealization and sardonic realism, celebrating the freedom and abandon of youth and at the same time foretelling the reckoning of age. This Dionysus is no abstract god of fruitfulness but the incarnation of dissipation. He is not the fat buffoon of other artists' depictions but a handsome, robust youth starting to go to seed—the classical male ideal, softened and feminized.

The *Bacchus* may be self-revelatory (Michelangelo was no stranger to the grape, and in his later years received prodigious shipments of Trebbiano wine from home, which he sometimes shared with the pope), but from a technical view, it was a marvel: the first oversized grouping carved from a single block of stone since ancient times, a stunning re-creation of the classical model, at once harkening back to antiquity and boldly subverting the antique model. It seems all the bolder when you consider that an unknown twenty-two-year-old had carved this louche, unsettling, and rather androgynous icon of indulgence for a senior member of the Curia—and gotten away with it. Indeed, it seems in the end to have been too much for Cardinal Riario, but Michelangelo's friend Jacopo Galli gladly stepped in and took it off the cardinal's hands.

For the artist himself, the amazing *Bacchus* was a bitter disappoinment, for the most banal but irremediable of reasons: a faulty stone. His time in Lorenzo de' Medici's sculpture garden had been an idyll in practical as well as aesthetic ways; Agnese Parronchi, a Florence-based art restorer who recently cleaned the *Madonna of the Stairs* and the *Battle of the Centaurs* and knows the stone they're carved from as intimately as anyone since Michelangelo has, confirms that "they're beau-

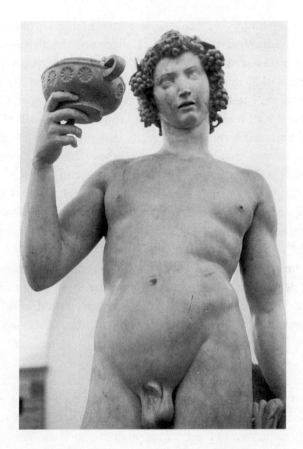

Michelangelo's *Bacchus* (marble, 1496–97).

tiful pieces, *statuario* certainly, from Carrara, without any flaws."
Fending for himself on the Roman stone market, Michelangelo did
not fare so well. A long vein runs down the backs of Bacchus and the
faun, and stains that are not wine mar his right thigh and left cheek.
You could, generously, call these splashes spilled by the tipsy god, or a
flush brought on by his indulgence. But Michelangelo knew better,
and fumed; late in life, he would smash sculptures when lesser flaws
appeared, but now, committed to the commission, he did not have
that option. He could only carve and polish the stone, flaws and all,
and pray for better blocks to come.

Such flaws have been the sculptor's bane ever since the first anony-
mous obsidian flaker cursed and tossed a ruined hand ax out of the

cave. And they dogged Michelangelo's career from beginning to end; that his ambitions and standards ran so high only made him more vulnerable to the hazards of the stone. In August 1497 he wrote from Rome to his father in Florence that he had undertaken to carve a figure for Piero de' Medici and paid five ducats—about $750 today—for the necessary marble. But Piero "hasn't done as he promised," so "I'm working on my own and doing a figure for my own pleasure."[3] Pleasure soon turned to disappointment when the block proved bad. "That money was thrown away," he lamented, and the stone with it— a bitter pill for an artist as zealous and as tight with his cash as Michelangelo. He laid out five ducats for another block, which he may have used to carve a life-sized *Cupid* or *Apollo,* with bow and quiver, for Jacopo Galli, but it was lost long ago.

For his next commission, he was determined not to settle for whatever block a gullible patron or shady Roman stone dealer might provide. If a suitable piece of the mountain would not come to Michelangelo, then Michelangelo would go to the mountain.

THE FIRST STONE WORKERS, like sculptors and builders today, faced a devilish trade-off when they chose their materials. At one end of the scale were sedimentary stones deposited when watercourses dried or minerals precipitated to the bottom of them, such as sandstone, limestone (either calcite, composed of calcium carbonate; or dolomite, calcium magnesium carbonate; or some combination of the two), and gypsum. They could be easily worked, but because they are soft or friable they tend to look dull and not take fine detail (alabaster, a metamorphosed, carvable form of gypsum, is an exception). They may be fine for building a giant Sphinx, but not for a portrait bust. And they yield just as easily to various other assaults, from water and acid to the scratch of fingernails.

At the other extreme are hard, silicon-bearing igneous rocks forged in furnaces of magma: basalts, porphyries, quartzes, feldspars, and granite (formed from quartz and feldspar). These tend to last and take a fine, shiny polish, but they're painfully hard to work, especially for artisans wielding only sand, soft metals, and other rocks for tools.

And then there is the happy medium, hard enough to hold up reasonably well, able to take fine detail, and yet soft enough to be carved

with metal tools. This is the crystalized, or partly crystalized, metamorphic rock that results when limestone gets squeezed under tremendous pressure, as when mountains and other geologic masses roll over one another: marble.

Hard as it feels to the touch, marble is actually a relatively soft stone, as untold homemakers have learned to their regret when their marble counters get scratched and stained. Hardness is commonly measured by the "Mohs scale," devised by the German mineralogist Friedrich Mohs. Or rather it's *compared* according to Mohs' scale, which does not quantify hardness but merely lays out a scratching order; even this is a matter of averages, since some stones, such as limestone and marble, vary widely in hardness, according to their structures and impurities. Everything scratches talc and graphite, or turns them to powder, so they start the Mohs scale at 1. Diamond scratches everything else, so it tops the scale at 10. Below diamond come other gemstones: corundum at 9, topaz at 8. Then, at Mohs 7, comes quartz, or silicon dioxide, the hardest common rock, as hard as high-carbon tool steel. Feldspar rates a 6, soft enough to be scratched with a good knife but hard enough to scratch glass, which has a hardness of 5.5. Granite and gneiss range between Mohs 6 and 7, depending on how much quartz and feldspar they contain. Down it goes to dolomite marble at 4, calcite marble and limestone, which rate just 3—softer than copper—and, at Mohs 2, alabaster and gypsum, or calcium sulfate, which you can scratch with your fingernail.

Most *true marble* is formed from calcite, the rest from dolomite. But the nomenclature gets murkier; as the term "true marble" suggests, many other minerals sometimes pass for marble. Just about any rocks that can be cut, shaped, and polished—from soft alabaster (crystallized gypsum) to hard granite and serpentine—are sometimes labeled "marble," often by the same writers who harp on the need to keep the terms straight. Decorative function trumps mineralogical form; if it can be polished to shine like marble, someone will surely call it marble.

It was likely the shine of river-polished scraps of marble, washed down from upland deposits, that attracted the first humans to use the stuff. Prehistoric peoples fashioned ornaments, totems, and small vessels from marble long before they took up quarrying, but marble was not the foundation stone of art and civilization. The great early Middle Eastern civilizations, from Egypt to Ur to Harrapan, built with

marble blocks but tended to use other stones, both softer and harder, for their art. The Assyrians carved their vast reliefs and winged gods from soft alabaster; the Babylonians assembled enormous murals of enameled brick. The Egyptians carved their gods from harder, darker, more colorful stones—granite, schist, basalt, obsidian—and from softer ones: sandstone, limestone, and, for smaller pieces, "calcite alabaster" or "onyx marble." (Unlike true alabaster, this soft, translucent stone is composed of calcium carbonate, as are limestone and marble. But it forms in different fashion, precipitating out of underground water that percolates into caves and springs.)

Lacking large supplies of iron, the Egyptians had to cut and shape their hard stones with abrasives such as quartz sand and emery, perhaps using metal blades to push abrasive slurries into the stone. The difficulty of such techniques dictated the simplified, stereotypical features and static, symmetrical poses, with no openings between the limbs and torso, that became strictly codified in the Early and Middle Kingdoms. For their portraits and humble genre figures, the Egyptians used wood and limestone, coated with plaster and painted in naturalistic color (for example, the famous bust of Nefertiti). Limestone was much easier to work than granite, but could not take the detail or delicate shaping of marble—again, forcing simplicity on the sculptor.

MARBLE CULTURE BEGAN, AS DID SO MUCH ELSE, IN GREECE— but long before the Greeks arrived—on Naxos, Paros, and the other Cycladic Islands in the Aegean Sea, which would later provide Greece's finest stone. More than five thousand years ago, the Cycladic Islanders began working their plentiful white stone into graceful, expressive, and precociously modern-looking figurines. Their most characteristic figures, simplified female nudes that appear to have been cut out in outline and shaped with abrasives rather than carved with hammer and chisel, suggest Modigliani, Picasso, and Matisse— whom they influenced.[4]

Two thousand years later, the peninsular Greeks began developing a sculptural art unlike any before. Succeeding cultures would strive for more than two millennia to emulate its representational, expressive, and idealizing powers, which reflected both proverbial Greek energy and invention and the geological resources of their rocky islands and

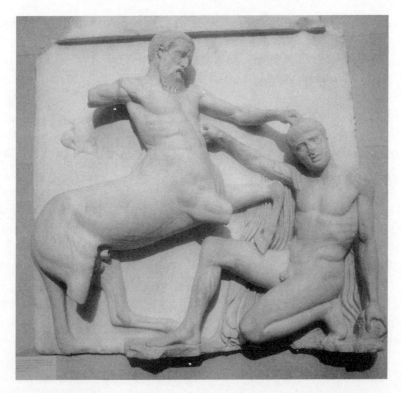

Greece's glory, a Lapith and centaur from the Parthenon frieze.

peninsulas—supply-side economics at work. *La peninsula di marmo,* Italian chroniclers called Greece, the ultimate compliment from another marble-rich, marble-obsessed peninsula.

Beginning in the first millennium B.C.E., the Greeks developed a wide ring of quarries on the islands and the Peloponnesian mainland and, especially, in Asia Minor. They perfected the Egyptians' laborious method for separating a block from the surrounding stone, by hacking out trenches around its sides with picks and hammers, then splitting it off at the bottom with iron wedges or expanding wooden wedges soaked in water. (Freezing water inserted in cracks and wedge holes also served to split away blocks.) Not coincidentally, Athens, Sparta, and many lesser city-states had quarries nearby—a circumstance the Romans, who imported their marble from the Apuans and even more remote sources, could only envy. The nearby Pentelikon quarries enabled Athens to build the Parthenon and other monu-

ments on a surpassing scale, in solid marble rather than the cladding that later marble cultures would employ.

Commercial-scale quarrying arose in the seventh century B.C.E. on Naxos. An imposing relic of that era still stands, or rather lies, in a cutout trench there: a roughed-out statue, variously credited as depicting Apollo or Dionysus (both gods associated with the island, though only Dionysus is commonly shown with a beard, as on this statue). Whichever god it depicts, it is enormous, about ten meters long—nearly twice the height of Michelangelo's *David*.

Colossal size is one thing, but Naxos's stone was too coarse-grained for fine sculpture. However, a close-grained, translucent, bluish white stone called *lychnites,* the first true *statuario,* emerged to fill the bill in the sixth century B.C.E., on the nearby island of Paros. The Greeks typically explained this treasure with a charming tale, and as usual, it concerned an indiscretion of Zeus, the wayward king of the gods. It seems that he fell for a Parian nymph named Ypsia, who was famed for the beauty and purity of her skin. Silly girl, she not only vaunted Zeus's affections but boasted that her complexion was fairer than that of Zeus's jealous wife, Hera, who sent the serpent-headed Gorgons to turn Ypsia into stone. Zeus had to allow Hera her vengeance, but granted his loose-lipped nymph two consolations: that her beauty would be forever preserved in her island's stone, and that she could return on full-moon nights and dance with her sister nymphs. This was not the last time white marble would be associated with the moon.

Parian stone was the sculptural standard for half a millennium and the stone of choice for elite Roman portraits, though Apuan marble was much closer. Even today Paros's quarries, which reopened in the early 1800s after many centuries of inactivity, have their partisans who claim its *statuario* is unsurpassed.[5] If unblemished brilliance were the sole criterion, the skim-milk-colored Parian stone and pure, Ivory-soap white marble from the island of Thasos, at the north end of the Aegean Sea, would take the prize. Blocks of these Greek stones gleam preternaturally in stoneyards and at trade fairs, so uniform they seem industrial products rather than natural accretions, and point up the tones and swirls that tint even the whitest Carrara stone. But purity isn't everything; the famous Paros lignite can be carved as finely as Carrara *statuario,* but it is more brittle and breakable.[6] Thasos produced larger blocks of astonishing purity, but its stone is too hard for

detailed carving. Carrara's *statuario* still takes the prize in most carvers' view for carvability, durability, and resilience. Even its lightly mottled tones are in the end a plus; their warm glow serves the simulation of living skin and flesh better than the stark, cold Greek marbles, which impress at first but soon come to seem monotonous.

As the Romans absorbed the Greek cities into their orbit, they also absorbed Greek marble culture, importing Greek sculptors and stonecutters and Greek marble. They shipped Paros stone across the empire, along with the fruits of new quarries they opened in the old Greek territories on Asia Minor. They also opened new quarries on the northwest shore of the Italian mainland, where a strange mass of white mountains loomed over the harbor where the Magra River meets the Ligurian Sea—a site the Greeks called Harbor of Selene, after the moon goddess Selene, and the Romans named Luna—Luni in modern Italian. Sounds simple, but Luna's alleged namesakes are more numerous and tantalizing than that. Some scholars have credited the name to an Etruscan goddess named Losna who bore a crescent emblem. George Dennis argued that *luna* would have been the Etruscans' word for "port," since this was the greatest of their ports and their others were named Pupluna (Populonia) and Vetluna (Vetulonia).[7]

Carla Zummelli, a helpful guide at the ruins lately unearthed at Luna, posits that it was named thus because the country was rich in game and Artemis/Diana, the goddess of the hunt, was associated with the moon. Luna and its wildlife are long gone, but Carrara, the marble mecca that succeeded it, remains.

CHAPTER 4

THE MAGRA'S MOUTH

CARRARA, dead are the bishops and counts
of Luni, and scattered are their tombs;
the Spinola, Castruccio Antelminelli,
the Scaligerie and Visconti;

and Alberico, who gave you fountains,
all your ancient lords and later masters.
Instead, over these cities reign
fair heroes born in your mountains' womb,

who, armed with mighty lungs,
cast on you from the highest peak
a shadow vaster than
the shadow of Mount Sagro.

And it is not holy Ceccardo
who is your patron saint
but only Buonarroto,
the starving martyr of your slopes.

GABRIELE D'ANNUNZIO, *Le città del silenzio*[1]

T HE FIRST-CENTURY GEOGRA-
PHER STRABO praised this har-
bor at the mouth of the Magra River as "both very large and very
beautiful, since it includes within itself several harbors, all of them
deep up to the very shore—just such a place as would naturally be-

come the naval base of a people who were masters of so great a sea for so long a time." He meant the Etruscans, Rome's predecessors as masters of both northern Italy and the Ligurian Sea, who sailed from there to trade with Corsica to the southwest, Genoa to the northwest, and France and Spain beyond. The Magra marked the border of their territory, and Luna was their last outpost along the coast.

The Etruscans were master sculptors, from whom the Romans learned much, but they were best known for their work in ceramic and bronze and the soft alabaster of Volterra. They were also the most ardent and prolific devotees of the cult of the afterlife since the Egyptians, safeguarding and memorializing their dead in alabaster sarcophagi topped with effigies of the deceased couples whose remains resided within, lolling and grinning as though at a picnic. Historians long believed that they did not avail themselves of the marble riches that lay so close at hand, and marveled at the fact. One influential chronicler, George Dennis, wrote in 1848 that marble "does not appear to have been known in the time of Etruscan independence, for we find scarcely a trace of it in the national monuments; and surely a people who made such extensive use of alabaster, and executed such exquisite works in bronze, would have availed themselves of this beautiful material, had it been known to them; yet, on the other hand, it is difficult to understand how its *nivea metalla* [mineral snow] could have escaped their eye. It does not seem to have been discovered much before the Christian era."[2]

This assertion is not only "difficult to understand" but outright wrong, though it was repeated as recently as 1978 by another prominent authority.[3] We now know that the Etruscans did indeed know and use marble, in a small share of their sculptures, building decorations, and *cippi,* column-shaped tombstones—one more aspect of this enigmatic culture that has yet to be fully deciphered and appreciated. And they obtained it from the Apuan mountains—certainly, at the least, from the region of Pietrasanta and Seravezza to the southeast. One self-taught rock hound, a Carrarese sculptor and marble artifacts vendor named Luigi Monfroni, has claimed for years to have found Etruscan quarry traces at a site called Cava Tagliata above Torano; get him started and he pulls letters of attestation from his portfolio and scraps of ancient (he says Etruscan) walls from the back of his jeep. But Monfroni has gotten a chilly reception from academic authorities,

who resist crediting the Etruscans as Carrara's first *cavatori*. One such authority contends that the Etruscans need not have quarried at all; rock slides would have supplied marble for their *cippi*.[4] A microstructural analysis of ten *cippi* in Pietrasanta's archeological museum points toward Ceragiola, near Seravezza, rather than Carrara's basins as the likely source of the stone.[5] But recent carbon-14 dating of rubble layers at Fossa Carbonera, a quarry site above Fantiscritti in the Miseglia basin, found "evidence of a probable pre-Roman phase of extraction activity at Carrara."[6] In other words, someone dug here at least as long ago as the third, perhaps even the sixth, century B.C.E., long before the Romans founded Luni. At this rate of discovery and revision, Luigi Monfroni's outsider archaeology may become textbook orthodoxy in another decade.

But it was the port, not the stone, that first brought the Romans to the Magra's mouth. In 195 B.C.E. the Roman consul Marcus Porcius Cato, the scourge of Carthage, gathered a fleet at Luna to sail against the Carthaginians in Spain. Soon after, the Romans finally overcame the long-running resistance of the indigenous Liguri, who had reoccupied the Magra delta as Etruscan power waned. The Liguri, famously determined fighters, held out longer against Roman might than many more distant and numerous peoples. The Romans could overwhelm but could not pacify them, so they dealt with them as Stalin would with the Chechens and Jacksonian America would with the Cherokees and Seminoles: they rounded up forty-seven thousand men, women, and children and deported them to Sannio, far to the south, near present-day Naples. Tradition has it that the Romans also packed up the more docile residents of Sannio and settled them near Massa.

WITH THE INCONVENIENT LIGURI out of the way, Romans rich and poor flocked to the Magra delta. Two thousand of them established a new town on the standard provincial plan in 177 B.C.E., and soon raised it to a thriving trade center. Luna was famous for its wine, deemed the best in Etruria, and a cheese made from the spicy-flavored milk of a distinctive local breed of black sheep, which still graze the fields around the ruins. According to contemporary accounts, this cheese was aged in wheels weighing up to half a ton,[7] which may have inspired the familiar Parmesan wheels produced at Parma, on the

other side of the mountains. I can't help wondering if these weren't in turn inspired by the big white blocks of another product shipped through the port, Apuan marble. Certainly they suited the work of the quarries; a single wheel, it's said, could feed a thousand slaves. And the Roman quarry masters had plenty of slaves to feed.

Large-scale quarrying did not begin immediately at Luna; republican Rome still depended on Paros and other Greek quarries for its marble, just as it depended on Greek artisans to shape it. Soon enough, however, the Romans noticed what a rich marble resource they'd landed on. They began quarrying in the early first century B.C.E., not in the Apuan basins but in a smaller, older deposit at Punta Bianca, the steep promontory at the tip of the Spezia peninsula, across the Magra River from Luna. Punta Bianca marble is fine-grained and, as its name suggests, very white, but recent research at the University of Pisa shows that it's also infected with more impurities—mica, aluminum oxide, silicon dioxide, the iron compound ankerite—than Apuan, and especially Carrara, marble.[8]

The resourceful Romans soon moved on to the better and much larger, though less easily accessible, deposits above what's now Carrara. The first apparent references to those deposits emerge in the middle of the first century B.C.E.; the earliest Roman works identified as coming from them are the Pyramid of Gaius Cestius, in 12 B.C.E., and the Altar of Peace in 9 B.C.E. [9] Exploitation ramped up quickly after that, reaching a level that would not be matched until the full-tilt industrial quarrying, aided by explosives and railroad engines and heliocoidal saws, of the nineteenth and twentieth centuries. Pliny credits, or blames, a certain Mamurra, Julius Caesar's chief engineer, with setting the style and becoming "the first man in Rome to cover with marble veneer whole walls in his house." Not only that, reports Pliny, but Mamurra "was the first to have only marble columns in his whole house and . . . these were all solid columns of Carystus or Luna marble."[10]

But it was Octavius, Caesar's heir, who launched a full-tilt marble boom. After establishing his rule in a series of civil wars and adroit political maneuvers, Octavius, renamed Emperor Augustus, needed to establish his own legitimacy. He chose the same strategy another upstart Italian autocrat would settle on 1,965 years later: to remake Rome along the lines of an imagined golden past. For Benito Mussolini, that would mean recapturing the glory that was imperial

Rome; Octavius/Augustus looked to the glory of Greece. And both chose the same stone medium to enshrine their reigns.

Augustus is famous for boasting that he "found Rome a city of bricks and left it a city of marble,"[11] but it would be more precise to say he left it a city of brick and inexpensive local stone, clad in costlier white marble and buff-colored travertine. Thus did the practical Romans mimic the grandeur that the Greeks achieved with solid marble. This practice would prevail in almost all European construction, from Gothic cathedrals to Renaisssance palaces, until the early 1500s, when Michelangelo Buonarroti would try to match the Greeks and build, on a grand scale, in solid marble.

Augustus's building program was prodigious by the standards of any age: eighty-two existing temples restored and many new ones erected; a great library and a grandiose mausoleum; a new forum, portico, and Altar of Peace, plus theaters, baths, parks, and gardens—and a hundred-foot-tall, travertine-covered firewall separating this "city of marble" from the firetrap red-light district of Subura.[12] This travertine, whose distinctive "wormhole" texture still covers everything from window ledges to subway stations in Rome, came from nearby Tivoli. But those Romans who could afford to imported their stone from the new city of Luna. There, wrote Strabo, "the quarries of marble, both white and mottled bluish-grey marble, are so numerous, and of such quality (for they yield monolithic slabs and columns), that the material for most of the superior works of art in Rome and the rest of cities are supplied therefrom."[13]

The Romans continued carving statues, in greater numbers even than the Greeks, often copying Greek originals. But the most prominent and characteristic of their "superior works" were the great columns and arches the emperors erected to celebrate their triumphs, which were exhaustively recorded in carved friezes. White Apuan marble was the perfect medium for these, as it would be for so many other official art forms. One quarry, Polvaccio, where Michelangelo found the stone for his Vatican *Pietà* and *Moses,* is also reputed to have supplied an inordinate share of Rome's greatest monuments: Trajan's Column, the arches of Titus and Septimus Severus, the Palatine *Apollo,* and a statue of Hadrian's favorite Antinous as the Egyptian god Osiris.[14]

Many of the quarries' finest fruits met an invisible end, in the holds

of stone-weighted ships sunk in storms and on reefs. One wreck off Saint-Tropez has yielded the drums and bases of fifty-foot columns of Luna marble, shaped at the quarry to reduce their shipping weight. At the quarries themselves, artifacts worked by Roman hands still turn up by the ton, or many tons. The first stones you see upon entering the sprawling stone yard of the Barattini family's Cave Michelangelo, one of the leading marble firms, are not raw blocks going to the diamond saw or sliced slabs coming from it. They are hand-chiseled blocks and unfinished Roman sarcophagi that were set aside nearly two thousand years ago when a stone proved flawed or a client defaulted.

Other quarry villages are named after the Roman generals who founded them: Torano after Taurus,[15] Bedizzano after Bizerius. But Colonnata has been variously traced to *colonia,* for a slave "colony," and *columna,* "column." The latter derivation would reflect the fact that the Colonnata basin produces the hardest, strongest marble, suitable for heavy structural duties. Every once in a while, its slopes still yield up proof that the Romans were well aware of that fact.

ONE DAY IN CARRARA, Giancarlo Dell'Amico, whose family workshop fabricates the diamond-saw wire used to slice blocks off the mountains, called and asked if I felt like taking a little ride to the *cave.* He had to take some *diamante* up to a quarry that had just made a notable, though not a gainful, strike. Up we drove in his low-slung station wagon (which, like many a little Fiat and even a few Vespas in Carrara, had carried heavier loads and negotiated more mountain tracks than most SUVs in the United States). At the small Artana B quarry, below Colonnata, we met Luigi Vernazza and his son, who had worked Artana for most of their careers. One day they scraped back the brambles and *ravanetti* to cut a new facet in the cliff and found the pieces of two Roman columns that had broken at the start of their long route down to the temple or villa they were intended to uphold.

Artana B's operators had set these columns safely aside, but not every quarry is so solicitous of artifacts and not every discovery can be conveniently moved out of the way. Often, when the *cavatori* find ancient quarry remnants, they rush to cover them over before the *beni*

culturali (cultural resources) authorities show up and order them preserved for studying, documentation, maybe even (shudder) posterity. A few months after the columns showed up, one of the sculptor Robert Gove's ex-*cavatore* buddies told us of a bigger archaeological find that had just been made up the ridge from Artana, in the mammoth quarry complex called Gioia (Jewel): an entire wall that the Romans had hacked out of the rock by hand—one side of a deep trench made to separate a desirable block from the mountain. After cutting out the trench—deeper than a man's height, and in solid stone—the Romans packed it with wood, then poured in water. The wood expanded as it absorbed the water and split off the block, which might have weighed thirty tons.

We headed for Gioia two days after getting the news; already, Gove feared, we would be too late. It was Saturday morning, and only a skeleton crew was working, dispatching the heavy rock moving that would be too hazardous with the full complement around. We trotted up the last length of road just before a front loader overhead tossed a load of rubble down the ridge. Another front loader operator warned us with unmistakable gestures to get the hell out of there; this was no place for anything softer than marble to amble about. Unfortunately, the only routes up or down were blocked by his boulder-slinging buddy. But Gove, an old hand at such incursions, had a solution: he asked the operator if he would raise us above the twenty-foot cutaway rock face and past the danger zone in his steel shovel.

You would hardly expect a heavy-equipment operator in an American quarry to give such a lift to unauthorized strangers, scruffy foreigners no less. But this was Italy, where, absent a reason not to, people tend to oblige. (I still treasure the recollection of a bitterly cold winter day in Venice, when half the great Accademia museum was closed for lack of heat; its managers opened up the Giovanni Bellini room for a brief private viewing after I explained that I'd written on Bellini's paintings and dreamed of seeing them in his native city.) Without a word, the operator dumped his load of rocks, wheeled back, and lifted us up the cliff.

Eventually we found the Roman trench wall, or what was left of it. Sure enough, the quarry crew had cut it out and tipped it over, like any other giant block, and only a *subbia*-chiseled edge was visible. Gove cursed at not coming sooner. I just savored the ride.

* * *

ROME'S MARBLE BOOM, and the lust for display that fueled it, did not delight every Roman. To those who upheld stoic austerity and traditional patrician restraint, richly marbled walls epitomized the decadence and headlong consumption rotting at Rome's core. For Pliny, it prompted conservationist musings that seem prescient today—save that the endangered species for which he pined were stones rather than living creatures:

> Everything [else in nature that] we have investigated may be deemed to have been created for the benefit of mankind. Mountains, however, were made by Nature for herself to serve as a kind of framework for holding firmly together the inner parts of the earth, and at the same time to break the force of the heavy seas and so to curb her most restless elements with the hardest material of which she is made. We quarry these mountains and haul them away for a mere whim; and yet there was a time when it seemed remarkable even to have succeeded in crossing them. Our forefathers considered the scaling of Alps by Hannibal and later by Cimbri to have been almost unnatural. Now these selfsame Alps are quarried into marble of a thousand varieties.
>
> Headlands are laid open to the sea, and nature is flattened. We remove the barriers created to serve the boundaries of nations, and ships are built especially for marble. And so, over the waves of the sea, Nature's wildest element, mountain ranges are transported to and fro. . . . When we hear of the prices paid for these vessels, when we see the masses of marble that are being conveyed or hauled, we should each of us reflect, and at the same time think how much more happily many people live without them. That men should do such things, or rather endure them, for no purpose or pleasure except to lie amid spotted marbles, just as if these delights were not taken from us by the darkness of night, which is half our life's span![16]

Such jeremiads did not dampen the demand for elegant stone; Pliny would turn over in his sarcophagus if he knew that his writings would help inspire a new mania for marble (and a new boom for Carrara) in

the fourteenth and fifteenth centuries. By lending a classic imprimatur to the taste for polished stone, he perpetuated what he deplored.

To feed their stone lust, the Romans assembled a United Nations of toil. Some authorities consider the Carrarese the descendants of Phoenician slaves brought to quarry marble, but Phoenicians weren't the only far-off people the Romans transported here. Beside Fantiscritti, at the junction of the roads and tunnels connecting Carrara's three main marble basins, I met an ex-*cavatore* named Walter Danesi who had built his own priceless quarry museum. Rusted saws and chains and chisels jostle there with life-size marble statues of the men who hewed the blocks in the old days, the oxen that hauled them, and the women who hauled the bread, wine, sand, and water that kept the men and their abrasive saws working. All are exhaustively explained with handwritten multilingual signs. "I'm named Danesi because my ancestors were Danish mercenaries," he explains. "The Romans brought them here to fight the Liguri. The Danes weren't brought to work in the mines, but many others were."

Whatever they came to do, the peoples to the north certainly contributed their share to the local gene pool. Scan a crowd of Carrarese and you'll see a panorama of Mediterranean and European physiognomies, liberally sprinkled with blue and gray eyes and red and blond hair. Carrarino, the clipped, guttural local speech, bears scant resemblance to any neighboring dialects—Massese, Spezzese, Lucchese— much less to the Toscano that, thanks to Dante and Petrarch, became the beta version of modern Italian. People living ten miles to either side avow they can't understand Carrarino; one day, riding back to Carrara after a day trip to the Cinque Terre, I fell into a chat on the subject with the Spezzese and Livornese in the neighboring seats, plus one Genovese woman who is married to a Carrarese—and got an earful. "*Brutto, brutto!*" exclaimed one. "It's the ugliest dialect in all Italy," said another. "Hard and closed, just like the people!" I mentioned the Belgian writer Dominique Stroobant's contention that Carrarino is related to the Venetian dialect.[17] "No, no!" one woman exclaims. "*Il dialetto veneziano* is soft and musical, not at all like Carrarino!"

Alfonso Nicolazzi, a printer and anarchist organizer from northeast Italy, found that he could understand Carrarino when he arrived, so closely did it resemble the Lombard dialect he grew up with. What's the common thread? For all their tonal differences, these all belong to

the broad family of northern Italian dialects called *settentrionali*. Whether in percussive Carrarino or singsong Venetian fashion, they tend to clip off the final vowels or syllables of words; a Venetian palace is a *ca*, not *casa*. This correspondence reflects Carrara's crossroads location at the junction of two north-south trade routes, and the fact that so many northerners—from Lombardy, Piedmont, even the Veneto—came to work in the quarries. And so "it developed as an island, both economically and psychologically," concludes Stroobant, sharing little with its Tuscan and Ligurian neighbors.

Perhaps my judgment has been warped by too many glasses of cheap wine with Carrara's *cavatori*, trying and failing to understand their stories but enjoying the snatches that occasionally come through or that someone translates into mainstream Italian. But I've come to appreciate the oddly apt music of Carrarino. With its clipped endings, hard consonants, slight nasality, and, above all, pinging, percussive rhythms, it sounds like chisels tapping against stone. Carrarino seems to have evolved on the job. Working furiously amidst billowing dust and spewing sand and water, the *cavatori* could not afford to waste breath or open their mouths any more than they had to. The broad, open vowels of *bel canto* Italian wouldn't do. And so they clip their vowels and grunt through nearly clenched teeth. Instead of *"Vorresti qualche cosa?"*—"Would you like something?"—a Carrarino host might ask, *"T'vo' qual' co'?" "Al tir pu un pel de moza che cent par de bo,"* goes a typically salty and resonant Carrarino proverb: "One pussy hair can pull more than a hundred pairs of oxen."

Mechanization has largely eliminated this impetus; it takes far fewer people to quarry the stone, and they work alone, often in sealed cabs, amidst roaring machines, communicating by cell phone and hand signals. Here and throughout Italy, despite official efforts to preserve dialects and encourage new writings in them, the local speech is slowly fading. Italy is the most linguistically diverse nation in Europe; the Ethnologue database of world languages credits it with thirty-three "spoken living languages," not counting recent immigrants, and no one can count all its dialects.[18] But Italian speech is fast becoming *italianizzato;* young people learn the homogenized pattern, with a heavy dose of Americanisms, from television, radio, and school. And Carrarino, like other dialects, is increasingly the speech of the old.

Mó t'arranz'—so much the worse—if it passes; Carrarino is so rich

in vocabulary and nuances that Luciano Luciani's comprehensive *Vocabolario del dialetto carrarese* runs to 1,766 pages. There is a correspondence, as the symbolists would say, between the speech of the quarrymen's tongues and the work of their hands, as though they could write poems with hammers or split stone with words. When you think about it, that's what Michelangelo did in his clipped, faceted verse.

THE SWEAT OF PIEDMONTESE, Longobards, Phoenicians, and Greeks made Luna rich. Its citizens built a fully appointed indoor theater, an amphitheater with room for seven thousand gladiatorial fans, and splendid mansions known today by their decorations: the Dome of the Frescoes, the Dome of the Mosaics, the Dome of Oceanus (after an imposing mosaic dedicated to the ocean god, whose favor was needed to get the marble to foreign markets). Luna was so impressive that centuries later, when the Viking raider Hastings reached Italy, he mistook it for Rome. Tiberius, Augustus's successor, nationalized many stone quarries around the empire and asserted imperial claims over the new quarries being opened in North Africa. Luna's *cave* were already established in private hands, and Tiberius let its anxious quarry operators be. But he nevertheless raised a specter that still haunts some in Carrara; nearly two thousand years later, I heard one marble entrepreneur rail that "the government is *still* trying to expropriate the quarries!"

CHAPTER 5

THE CARDINAL'S *PIETÀ*

THE HILLS ARE FULL OF MARBLE
BEFORE THE WORLD BLOOMS WITH STATUES.

PHILLIPS BROOKS

MICHELANGELO SOON GOT THE chance to test his determination to carve only the best stone, meaning the best stone he himself could find on the Apuan slopes. In 1497 another powerful prelate, Cardinal Jean Bilhères de Lagraulas, also known as Jean Villiers de la Groslaye, the abbot of Saint-Denis and King Charles VIII's ambassador to the papal court, sought a life-sized *Pietà* with Mary holding the dead Christ "large as an actual man," to grace what would be his own tomb in the Chapel of the King of France at the south end of Saint Peter's Basilica. Then as now, contracts were often finalized well after the projects were begun—typically when the stone, the most unpredictable variable, was safely in hand. And so the contract for the *Pietà*, for 450 papal ducats (around $70,000 today), was not signed until the next year, in August 1498—and not by Michelangelo but by the faithful Jacopo Galli, acting as his guarantor. In the contract, Galli promised much on his twenty-three-year-old friend's behalf—that his opus would "be the most beautiful work that has been done in Rome, so that no other *maestro* could do it better."[1] Surpassing work called for surpassing stone, and since coming to Rome, Michelangelo had been repeatedly betrayed by flawed marbles quarried by others. It is unlikely that a block large enough for the cardinal's statue could have

been procured there anyway. And so he set off for the motherlode—
the first step in the creation of one of the world's most cherished mas-
terpieces, and in making Michelangelo its most celebrated sculptor.

Many biographers, beginning with Condivi and Vasari, place
Michelangelo in Carrara for the first time nearly a decade later, when
he sought marble to build Pope Julius II's tomb. But several docu-
ments safeguarded in the state archives of Lucca and Florence show
unequivocally that he came to seek the *Pietà* stone in 1497. On No-
vember 18 of that year, Cardinal Bilhères wrote to Lucca's Council of
Elders that he had commissioned "Michelangelo son of Lodovico,
Florentine sculptor and bearer of this letter," to carve "a marble tomb-
stone showing a Virgin Mary robed with the dead Christ nude in her
arms," begging the *anziani* to show him every assistance.[2] How much
they could do was unclear, since Carrara lay outside Lucca's writ; per-
haps it was also outside the prelate's orbit, and so he appealed to the
closest authorities with whom he had influence.

That same day, Michelangelo drew two payments from his Roman
bankers, Baldassare and Giovanni Balducci, presumably from funds
deposited for him by the cardinal. One payment, of twelve ducats and
change, was to purchase *"uno chavallo leardo per andare a charrara"*—"a
dapple-gray horse for the trip to Carrara." The other, of five ducats,
was "to spend along the way." By December he had located a suitable
block at the ancient quarry named Polvaccio, which lies where today's
paved road ends, three-quarters of the way up the Torano basin—a
steep hike in Michelangelo's day and an arduous descent with a large
block in tow. We know this was the site because of rare documenta-
tion: a letter written nearly twenty-seven years later by another stone-
cutter, Michelangelo's trusted on-site foreman Domenico di Giovanni
da Settignano, better known as Topolino, "Little Mouse." In 1524
Topolino, seeking stone for Michelangelo's monumental projects in
Florence and Rome, triumphantly informed his master that the crew
had found "some marbles on the slopes of Polvaccio, that difficult
spot where you know they are of good quality," including one "beau-
tiful" block fit for the figure of a pope that one crew member had un-
covered "right under the [source of the] Pietà that you made in
Rome."[3] The fame of that block lived on in Carrara twenty-six years
after it was quarried.

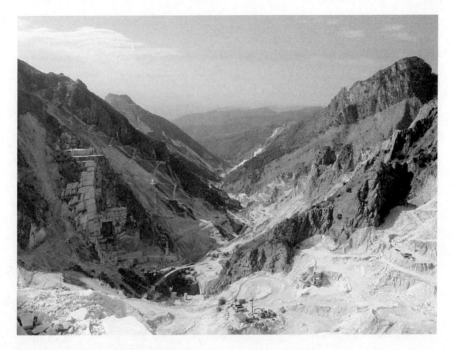

Polvaccio, the source of the *Pietà* block, today.

* * *

LATER AGES have affirmed Michelangelo's choice of Polvaccio marble for his most demanding projects. The geologist Emanuele Repetti, writing more than three hundred years later, hailed this *"statuario purissimo"* and called it all the more singular for occurring in a quarry surrounded by the *marmo ordinario* of the Battaglia, Crotta Colombara, Il Ronco, and Fantiscritti quarries. He suggested that Pliny had Polvaccio in mind when he reported in a famous but elusive passage that a marble had been found near Luna so brilliantly white, *"tantum candido,"* that it surpassed the hallowed stone of Paros. Repetti went on to enumerate Polvaccio *statuario*'s virtues in the sort of superlatives usually reserved for women, wine, and God: "a tight, closed grain, *finissima* crystallization, *vivacissimo* brightness, airy semitransparency, marvelous pliability in every sense under the chisel, hardness and specific gravity surpassing every other marble save *bardiglio*, a

greater capacity than any other to resist the intemperance of the air and the erosion of the centuries—all in the highest degree."[4] Furthermore, Polvaccio's stone had fewer metallic veins than other marbles, and these were shallower and more widely spaced. This meant larger unbroken blocks of it could be cut—precisely like the oversized block Michelangelo found for his *Pietà* and a particularly celebrated block that Canova used in Repetti's own time for a *gigante* acquired by the Duke of Wellington.

But 150 years later, in the 1970s, the quarry that supplied Michelangelo had fallen into such ruin that no one bothered bidding for its concession. Then a colorful *cavatore* named Furio Nicoli, who drove to the quarries in a Citroen 2CV converted to four-wheel drive with engines front and back, gambled on Polvaccio and, after clearing away the centuries' rubble, struck paydirt; he revived the concession and later sold it to Franco Barattini. Nicoli's secret, says Dominique Stroobant, was that "he was the only one who believed Repetti" when Repetti praised Polvaccio.

Nevertheless, Repetti did acknowledge one fault in Polvaccio's *statuario:* occasional tiny grains of hard emery that would stop sculptors dead in their attacks. And he suggested that this mischievous property gave the quarry its name: the sculptors would exclaim, *"Polvaccio!"* ("Lousy powder," from *polvere*)—the sort of expressive suffix that is one of the Italian language's glories—upon hitting the stuff. Gradually, the term extended to the stone itself, then to the quarry.[5]

The tradition continues; I saw one American sculptor curse like a movie mobster over a block of rare cream-colored *statuario* he'd bought from Polvaccio that looked gorgeous but proved fatally flawed within. And other marble firms keep seeking a better *statuario,* just as in the old days; one, Furrer, has lately uncovered beautiful clear white stone at its Cava Calocara, looming just above Carrara.

Nevertheless, Polvaccio's *statuario* is as prized today as it was in Michelangelo's time, and unlike the depleted veins at many other *cave,* it's still available. But bright white *statuario* is growing scarce, and it takes more than money to obtain the best blocks: to the chagrin of other, less favored sculptors, these go to the grand old man of local sculpture, and last survivor of the generation that first wedded marble and modernism, Gigi Guadagnucci. "The Polvaccio *statuario* of Franco Barattini is the best in the world," he says flatly. "It's not

whiter than some others, but it's stronger, it takes work better." Guadagnucci should know; he's still carving stone at ninety, two years past the age when Michelangelo gave up the chisel and the ghost, and his winglike abstractions push marble to its technical limits, with knife edges so thin they're nearly transparent. Barattini, who operates Polvaccio today, cheerfully exploits both the Gigi and the Michelangelo connections; he's named his operation Cave Michelangelo.

NOW THAT HE HAD secured the block of his dreams, Michelangelo could take a break and rejoin his father and brothers for Christmas; on December 29, 1497, the Balducci records show him back in Florence, receiving a twenty-ducat cash payment via the Strozzi bank. Another 130 ducats were credited to him at the Buonvisi bank in Lucca, evidently for the extraction and transport.[6] It was an extraordinary sum for a block, two years' wages for a skilled artisan. But this was no ordinary stone.

Michelangelo returned to Carrara to arrange for it to be rough-hewn and hauled down to the sea, where it would be loaded on a boat for Rome. For these tasks, he brought along trusted expertise: the Balducci books show two payments, totaling more than fifteen ducats, for a *"maestro Michele Scharpellino."*[7] This was Michele di Piero Pippo, also known as Battaglino, "Little Clapper," an old family friend from Settignano. Michele, eleven years older than Michelangelo, was a valuable aide on the young prodigy's first quarry foray and on expeditions to come.[8] By March 10, things seemed to be in hand; an acquaintance spotted Michelangelo, newly returned, in Rome.

Then, as would happen so often when Michelangelo tried to ship marble from Carrara, a spanner fell in the works. Cardinal Bilhères wrote to Carrara's Marchese Alberico Malaspina promising to pay for the block and asking him to release it for shipment. In April the cardinal wrote the Florentine Signoria complaining that "one of ours" was being hindered at Carrara and begging the Florentines to persuade the marchese to remove any obstacles and, for a suitable price, let the marble be shipped. The British art historian Michael Hirst, who has made the closest study of the *Pietà* block's provenance, surmises that the hangup was over the *gabella*, the duty that Alberico had slapped on

marble exports. Evidently the tariff was finally paid, and in mid-June, seven months after Michelangelo first set out for Carrara, his long-awaited stone arrived at Rome.

These exertions over a single block were just a foretaste of what Michelangelo would endure when he tried to transport the marble for scores of statues, but they give an idea of what it took to get marble matching his ambition. Was it worth the effort? The stone itself, of a size and quality not seen in the capital since ancient times, became a legend in its own right. Even the cynical Romans marveled when they saw this enormous block—*"bianco et senza vene, macchie et peli alcuni"* in Topolino's words, "white and without any veins, marks, or hair-lines"—unloaded onto the Tiber quay. They would marvel even more a year and a half later, when the twenty-four-year-old prodigy had fin-ished carving it.

Even sealed like a mafia-trial witness behind bulletproof glass (to guard it from further assaults like the sledgehammering it received from a deranged Hungarian geologist screaming, "I am Jesus Christ!" in 1972), the Vatican *Pietà* is astonishing at first sight. There is a superficial solemnity to its pyramidal form and an exquisitely calibrated rhetoric to each gesture of its figures: Mary's upturned left hand and downcast head, marked with the faintest incision to suggest a transparent veil; the tender but strong fingers of the right—her hands are very large, larger than her son's—with which she clutches his body; the dancer's grace, even in death, with which that lithe body slumps across her lap. All are eloquently refined, and at the same time subsumed in the symphony of heavy, rhythmically creased and gathered robes cascading down the mother's shoulders and rising like a cresting wave beneath the son. And then there is its seductive finish—every surface polished to the same maximal liquid luster with the materials recommended by Vasari: "pumice, chalk from Tripoli, leather, wisps of straw."[9]

Michelangelo would never again invest so much finish in a surface. He would come closest five years later in the *Bruges Madonna,* a natu-ral companion to the Vatican *Pietà* that is much less widely known be-cause of its exile in darkest Belgium, but which has a much greater gravity, sorrow, and expressive (rather than decorative) vitality. The Bruges Mary and her toddler son both look sadly downward, at once past and through the viewer, as though apprehending the agony and sacrifice to come. Their features are fully modeled, right down to eye-

brow hairs, rather than exquisitely engraved in the stone; they seem to be made of flesh rather than fine china.

The Mary of the Vatican *Pietà* is almost an ingenue, as young as or younger than the Bruges Mary though she would be nearly thirty years older. Condivi, the eternal straight man, reports that when he asked about this anachronism, Michelangelo replied, "Don't you know that chaste women remain far fresher than those who are not? So much more a virgin, in whom not for a minute has the least lascivious desire that might alter her body ever entered." Some biographers, equally lacking in irony, have taken this remark as solemn evidence of Michelangelo's own celibacy and abhorrence of carnal relations, rather than a conceit typical of his sarcastic wit.

In the end, however, the Vatican *Pietà*'s undulating rhythms, unremitting luster, and perfectly modulated pathos are its undoing. The eye glides and slides along its liquid surfaces and dancing folds of simulated cloth, never quite attaching anywhere; the matchless virtuosity of this, the only work Michelangelo ever signed, ultimately overwhelms its meaning. The sculptor has been seduced by his stone, just as he seduces us with it.

FOURTEEN CENTURIES EARLIER, a different sort of marble seduced affluent Romans. As imperial lifestyles grew ever more lavish, tastes shifted and dignified marble from Luna had to share the market with more colorful and heavily patterned stones from elsewhere. It is a cycle that has repeated itself again and again: Greek taste shifted from white marble in the classic age to colored stones in the Hellenistic; the austere stone of Gothic churches and the Renaissance gave way to the gaudy palettes of the sixteenth and seventeenth centuries; white and gray marble came back in vogue during the eighteenth- and nineteenth-century neoclassical revival, but tastes turned again to color in the late twentieth. Trouble is, the same impurities—flecks of metal, veins of impounded mud—that give color and pattern also break up the stone's calcite-crystal structure and weaken it, making it useless for sculpture and for outdoor use. Many Italian church altars are lurid symphonies of green, gold, red, black, and purple marble, while the saints nestled in them and the portals and cornices outside are of simple white Carrara stone.

You can get a vivid sense of how the marble solar system is laid out at Carrara's sprawling, ramshackle, but richly informative Museo del Marmo.[10] Hundreds of yard-wide polished stone panels line the walls, a head-spinning spectrum. First come the Carrara varieties, as subtle and elegant a study in almost monochromatic variations as a Whistler *Nocturne:* pure or ever so faintly flecked *bianco;* lightly veined *bianco venato; bianco brouillé,* swirling like the smoke from a cigar; warmly glowing *bianco gioia;* twisting *arabescato. Cremo* varieties, as the name suggests, have deeper and warmer golden casts. *Bardiglio* is dignified gray, sometimes solid as a new paint job on a battleship, at other times swirled or streaked with white in the patterns called, poetically, *fiorito* and *tigrato*—flowery and tiger-striped. *Calacatta* stone is thickly swirled, like fudge-ripple ice cream, but with more delicate, almost metallic gold and bronze green and an almost purple gray like tarnished silver. *Cippolino* ("little onion") has lovely pinstripes of pale green and white, like the layers of a crosscut onion; *zebrino* shows a similar pattern of gray and white stripes.

Then the museum's stone selection widens, in a progression outward from the Apuan heartland. First it leads to the stones of the neighboring Tuscan and Ligurian provinces—Lucca, La Spezia, Siena. The colors become progressively more saturated, the patterns more pronounced: mauve *fior di pesco classico* ("classic peach flower") and dark-rippled *bardiglio imperiale* from Massa; rich *rosso venato* and *rosso levanto* from Liguria; richer yet, *calacatta vagli rosato, valle venato fantastico,* and *rosso rubino pontestazzemese* from Stazzema; and from Siena Province, *rosa montarrenti* and gray-green *etrusco venato,* streaked with white and flecked with black hairs. Verona Province produces oxblood deep reds—*rosa corallo* and *rosso asiago.* Valle d'Aosta and Val Malenco are the heartland of endless variations of green and black serpentine; one, *serpentino verde romano,* is an astonishing mat of superfine, supersharp hatching in green, black, maroon, gray, and white—like a bear's furry coat, or a conifer forest accented with snow. Move out farther yet from the Carrara bull's eye and you reach the pure, gleaming blacks of Belgium and the regal maroons of France. Farther yet and you're in psychedelia: astonishing Egyptian *brescia verde,* the exotic extravagance of lightning-streaked *bigio morato* and other Turkish patterns, as mindspinning as a rug bazaar. The lurid assortment recalls the near-endless range of colors and patterns bred into roses—except that rose growers

have never been able to breed a blue rose (though gene splicers hope to assemble one), while the wildest stone of all, *azul bahia* granite from Brazil, is intensely ultramarine.

Against these and hundreds of other lurid patterns, Carrara's delicate creamy whites and smoky grays seem painfully restrained, like go-to-church clothes at a carnival parade. But restraint is their strength; the impurities that give exotic marbles their swirling colors also give them faults and fissures, make them tender against the weather and friable against the chisel. The red Siena marble on Florence's Santa Maria del Fiore Cathedral is dissolving in the exhaust of ten thousand Vespas, while the Carrara *bianco* beside it holds firm.

THE TASTE FOR EXOTIC STONE spread even to Luna, whose wealthy citizens spent earnings from white Apuan marble to import polychrome marble from the eastern Mediterranean for their elaborate inlaid floors. Then the trade that made such coals-to-Newcastle luxury possible collapsed with the empire. Beginning in the fourth and fifth centuries C.E., the marble quarries in Lunigiana and other parts of the empire fell gradually into idleness and disrepair, as invasions swept through from the east and north. Not that the Italian and other early Christian peoples ceased using marble—but why go to the trouble of quarrying it when so many pagan relics waited to be recycled? Temples and palaces were plundered to pile up fortifications against the invaders and create such masterworks as the Orvieto cathedral's façade reliefs and Nicola Pisano's pulpit in the Pisa baptistery.[11] The recycled stone might travel surprising distances; the marble cladding of Rome's Colosseum went to build not only the Cancellaria and Palazzo Farnese in Rome but Saint Mark's in Venice.[12] Some of the porphyry decorating Venetian palaces made a boomerang journey back and forth and back again across the Mediterranean; quarried and shaped into columns in Egypt, it was exported to Rome, then transported from withering Rome to ascendant Constantinopole, then looted by crusaders, taken to Venice, and cut into disks.[13]

In other places, artisans would recycle old works even when new marble lay almost at their feet; at Aphrodisias in Asia Minor, less than two miles from one of the world's finest *statuario* quarries, fourth-century sculptors carved new visages onto earlier portrait busts. And

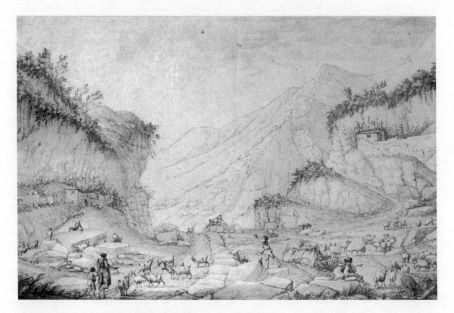

A pastoral scene in the neglected quarries, by the early nineteenth-century Massese artist Saverio Salvioni.

the practice continued into the twentieth century, when the grand spiral stairway into the Vatican Museums was lined with *cippolino* sawn from ancient columns.[14] Statues and other artifacts that did not lend themselves to reuse could be baked to make lime for cement; piety and practicality coincided, since burning also exorcised the devilish magic believed to infuse the eerily lifelike ancient figures. So much for one architect's confident assurance that "marble slabs are not worth stealing, as they cannot be put into the melting pot."[15]

Fresh marble continued to be quarried, in small quantities, for one resonant use: sarcophagi for the dead. The ancient authorities differed as to whether marble helped preserve cadavers or sped their decomposition. But the pagan pickings were plentiful around Luni, as Luna came to be called, and in the fifth century some were used to erect a Christian basilica. The city's capitol was looted to build a medieval fish market. Luni nevertheless survived the upheavals, and after the Western empire unraveled it found new life as a naval base for the Byzantine empire. It also survived sackings by Vandal and seventh-century Longobard raiders, and by the Saracens in the ninth. Its bishops emerged as temporal rulers and were titled counts under the Holy Ro-

man Empire. In 963 Emperor Otto I invested the reining Bishop Adalberto with authority over "the court of Carrara [or *Curtis Cararie*], together with the cottages and workshops, the cultivated fields and vineyards, the meadows, pastures, and woods, the torrents and cascades, the mills and fisheries, the hills and valleys, the plain and the mountains, together with the servants, male and female, native and adopted, with all their goods and persons, and all that pertains to the Church of Luni."[16] This exhaustive inventory, the first known reference to Carrara, makes no mention of the stone that had been the base of the region's wealth. The marble trade that had built Luni was not only quiescent, it was forgotten.

Soon enough, Luni would wither, the marble quarries would revive, and Carrara would grow with them. Silt from the Magra River obliterated the port that was Luni's reason to be and left it sitting a mile inland, amidst a malarial marsh. The inhabitants decamped to healthier upland ground, and the reining bishop finally moved his throne to the market town of Sarzana, seven miles up the Magra, in 1204. But he and his successors continued to rule as "bishops of Luni," and the doomed city's memory still survives in Lunigiana, the evocative name of the region that stretches up the Magra valley from Luni, across the Apuan Alps from Carrara, where Michelangelo would come three centuries later.

THE LINGUISTIC ORIGINS proposed for the name Carrara are as numerous and as colorful as the suspects in an Agatha Christie novel. But they all go back to a common source, the marble. Emanuele Repetti concluded that Carrara's name and those of its stream, the Carrione, and main road, the Via Carriona, all derive from the old Latin term *carrarae*, "quarry," via the French *carrière*.[17] If so, "Carrione" would have come first; "Carrara" seems to have first referred to the lands along the Carrione, before the town developed.[18] Even today, the Carrione watershed defines the territory administered by the *comune* of Carrara.

A less likely hypothesis traces "Carrara" to the Latin *quadraria*, from which the Italian *squadratura* and *riquadratura* (squaring stone blocks) also derive. Other authorities have traced "Carrara" back to pre-Roman languages, such as the Celtic *kair*, for "stone," whence come the Provençal *cairrar*, "quarry," and French *carrière*. Gino Bottiglioni ties it

to the ancient Ligurian *kara,* likewise "stone," which with the suffix *aria* would mean "place of stone." The Etruscan scholar Wilhelm Wanscher credits an Etruscan word with Egyptian roots (*kar,* for "temple," and the sun god Ra): *Kar-Ra,* "temple of the sun." This corresponds to Wanscher's improbable parsing of another mystery of the local geographic lexicon: he traces "Apuan" to the Egyptian *api-an,* "the winged sun returns."

Another leap of long-distance etymology derives "Carrara" from the Indo-European *kar,* the ancestor of the English "hard," and *karrikâ,* "stone,"[19] whence come the Welsh *carreg* and Irish/Scottish Gaelic *carraig,* related to English "crag." Less exalted theories ascribe "Carrara" to *carro,* "cart," referring to the heavy oxcarts used to haul blocks down from the quarries. A quaint, if implausible, elaboration on this theme is credited to Saint Jerome, the fourth-century hermit scholar: it combines *carro* with *Iara,* a corruption of Luna. Ergo, cart from Luna.

This jibes with a myth of Carrara's origin recorded by the indefatigable Beniamino Gemignani—a tale that recalls the fabled founding of Rome by the Trojan prince Aeneas, except that Carrara's founders are Greek rather than Trojan refugees. It seems that a shipload of these poor souls, narrowly escaping the destruction of their city in a civil war, wandered far in search of a place where they could live safely and peacefully—all the way to Eritrea. They asked the renowned Eritrean Sibyl (whom Michelangelo so memorably depicts on the Sistine ceiling) where they should go. She advised them to sail until they found "beautiful, high mountains coming right down to the shore. Stop at those mountains and build your city of their stones. All the world will come to know this city, and its symbol and its strength will be the cartwheel."[20]

Carrara itself sits in its narrow valley like the hub of a cartwheel. Its spokes are the even steeper and narrower valleys that radiate out into the marble mountains, to the villages of Torano, Miseglia, Bedizzano, and Colonnata, established by the Romans as quarrying outposts, and Gragnana, Castelpoggio, Codena, and Bergiola Foscalina in the wooded foothills. This topography makes Carrara the natural center—the choke point—on the route the quarried marble must travel to the sea. The town coalesced around a tiny ancient village called Vezzala, which served as a central exchange and depot and, in time, a

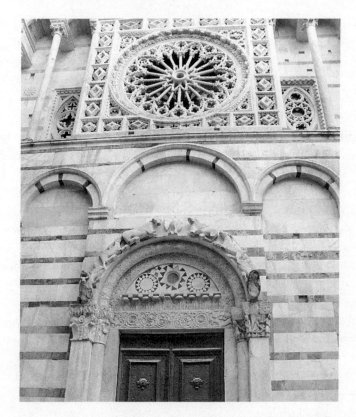

Carrara's Duomo di Sant'Andrea with its "cartwheel" window.

command center over the frontline villages in the war between man and mountain.

And sure enough, Carrara's emblem is the cartwheel, and it permeates daily life. Its civic motto is *"Fortitudo mea in rota"*—"My strength is in the wheel." Its downtown piazzas are paved in giant cartwheels of gray and white marble, which can be fully appreciated only from overhead. Across from Carrara's twelfth-century duomo, a modest *cantina* where *cavatori* and ex-*cavatori* gather has no sign; only a red wooden cartwheel, fading to pink and inscribed with that motto, hangs beside its door. Even the unusually ornate rose window on the façade of the duomo, an outsized extravagance in a small city's midsized church, has the radiating spokes and hollow hub of a cartwheel.

The duomo, a Romanesque gem, was the first church to be built

and decorated almost entirely with marble from the local quarries: *bianco ordinario, bianco venato,* and *statuario* from the Torano and Miseglia basins, gray *bardiglio* and *nero di Colonnata* from the Colonnata basin.[21] The animal frieze along its long east cornice—gleefully caricatured boars, deer, dogs, and lions chasing one another in a proto-Darwinian food chain—is a delightful touch of medieval whimsy. And one pair of sculptures inside, composing a delicate, dancelike *Annunciation,* is, by various accounts, a masterpiece of Pisan Gothic, softened by French influence, or an anomaly from the Mosan region of Flanders, carved there in Carrara marble and then transported here.[22]

Carrara's duomo was hardly the last or best customer for its marble; beginning in the eleventh century, an explosion of church and cathedral building throughout the region spurred a revival of the quarries. Nearby Genoa and Pisa, rich from maritime trade, led the way, and Pisa's great cathedral, baptistery, and leaning tower kept the marble masters busy for decades. But the hunger for the stone trickled down to humbler parishes; at Fosdinovo and at Corniglia in the Cinque Terre, churches of white marble, surrounded by gleaming marble pavement, seem luminous and otherworldly—a teasing evocation of heavenly bliss.

IN THE EARLY THIRTEENTH CENTURY, Carrara incorporated as a *comune* (municipality) within the dominion of the bishop-counts of Luni. But the bishops' grip loosened in the early fourteenth, and Carrara and its marble passed, via inheritance, bequest, usurpation, conquest, and outright sale, from one absentee overlord to another— from Lunense to Pisan to Lucchese hands; to Gherardino Spinola of Genoa; to the Rossi of Parma; to the local warlord Spinetta Malaspina; to Mastino della Scala of Verona; to the Visconti of Milan; back to Lucca; to the Malaspina of Fosdinovo and their Florentine backers; to a seesaw struggle between Lucca, Florence, and Milan; then another struggle between the Fosdinovo Malaspina and the Sarzana Campofregoso clans—a musical-chairs game nearly as frantic and, ultimately, inconsequential as the turnover of Italian governments in the decades after World War II.[23]

Meet the new boss, same as the old boss. This rapid succession of nominal rulers seems to have instilled a deep disregard for kings and

bosses generally; the anarchist motto "Neither masters nor slaves" is a mantra in Carrara, and a marble plaque downtown proudly proclaims that in Italy's 1946 plebiscite on whether to retain the monarchy, all but 3,788 of 33,417 Carrarese voted for a republic instead. Through all these upheavals they steered their civic ship, stubbornly preserving a measure of autonomy and stability and rebuilding a marble industry that had languished since Rome's collapse. In 1385, when Gian Galeazzo overthrew his unpopular uncle to become duke of Milan, the Carrarese offered themselves as his subjects—on condition that if it didn't work out, they could call the whole thing off.

By that time, the quarrying had revived to such a degree that a trecento Florentine poet, Franco Sacchetti, could joke that marble figures were so numerous around Carrara that a visitor could confuse them for real people.[24] The quarries themselves, which numbered around twenty by the end of the quattrocento, remained the property of the *vicinanze,* a term that resonates deeply here even today. *Vicinanza* means literally "vicinity" and corresponds more or less to our "neighborhood," but with a much larger weight of tradition, obligation, and mutual support. It referred specifically to the various quarry villages, each with its parish church and cadre of stone workers. The families of each *vicinanza* together owned an indivisible legacy of land called the *agre,* which presumably included the quarries. Marble masters would develop a quarry under the *vicinanza*'s aegis, rather than holding title themselves.[25]

In the mid-1400s, these masters formed a guildlike corporation, the Ars Marmoris, dedicated to developing the quarries and, especially, keeping outsiders out of them. The marble masters worked together on terms that were notably egalitarian, at least in principle. All partners in a quarry *società* shared equally in the risks, rewards, and labor. If one could not meet his work duties, he sent an apprentice or another *cavatore* in his place. If he failed to do so, he had to make up the days later, pay a fine, or lose his spot in the *società.* But this "façade of equality"[26] was already beginning to erode when Michelangelo arrived. The special difficulties of extracting, transporting, and selling marble encouraged more division of labor and undermined the cohesion of the Ars Marmoris. Quarry concessionaires became more and more like proprietors elsewhere, hiring wage workers rather than sharing duties and income with associates.

By then, Carrara had come under more stable, less distant over-lords. The Malaspina (Bad Thorn) were a powerful feudal clan that fought its way to the top of the heap of rival families, often little more than brigand bands, that had contested the territory ever since the breakdown of imperial order. Their imposing castles and colorful history spread throughout the surrounding region of Lunigiana. Even today the castles (or their picturesque ruins) punctuate the hilltops ringing the marble mountains; you're rarely out of sight of at least one, and fifteenth-century travelers would rarely have been out from their surveillance. One of the more picturesque ruins, the Castello di Moneta (Money Castle), caps the ridge overlooking the medieval village of Fossola, now a neighborhood of Carrara, where I found my digs. Another, intact right down to its courtyard frescoes but eerily empty (it's now being readied for tourists), looms fiercely above the center of Massa.

In the late 1400s, Giacomo Malaspina, the marchese of Massa, gained control of Carrara and managed to hold it and pass it to his son Antonio Alberico, even as Genoa, Florence, and Lucca grabbed nearby towns and circled for the kill. Alberico fended them off, over-came a challenge by his own brother, and actually found time to un-dertake some civic improvements.[27] To exploit the marble resource to its fullest, he struck a concord with the jealous local operators, reorganized the quarry labor system, and imposed a hefty tariff on marble exports.[28] He may have been greedy, but he was also capable and cultivated, a humanist prince somewhat on the old Medici model—the sort of host Michelangelo could feel at home with when he came seeking marble.

The descendants of the *vicinanze* still nurture a defiant spark. The sculptor Patty Matilde Nicoli, a scion of Carrara's oldest and most prominent marble studio, recalls the time her father, Gino, drove up to an anarchist-operated quarry seeking a particular marble. As he approached, hail seemed to fall around his car, though the sun was shining; the *cavatori* above were throwing rocks and rolling boulders at him. When he remonstrated, the foreman replied, "It's not our fault if you drive the same kind of car as the state inspector. We told him we'd kill him if he came up here again."

This is Italy's Wild West—a land of quick riches and long, slow poverty, remote though not distant from the main urban centers.

Viewing nineteenth-century photos of *cavatori* on the town, you could easily mistake them for American cowboys and desperadoes of the same era, with the same handlebar mustaches, thick-heeled boots, and wide-brimmed hats. They strike the same swaggering poses, and they would carouse in the same rowdy fashion; after the last war many even carried guns at their sides. You can get a small taste of the old days at Bar Vittorio, where the *pensionati* from the quarries gather to lift little sixty-*centessimi* glasses of wine, slap down cards, and roar and banter like a golden-years frat house. But this is nothing, laments the white-haired publican, Vittorio Dazzi. Today his is one of a handful of old-fashioned *cantine* left, and all empty out by suppertime. But before the quarries cut their workforces, he recalls, "there used to be a hundred places, all full, all night long." He shakes his head over the vanished competition and the many customers whom his wine helped ease to their last call. "So many gone, so many gone."

Still, Carrara remains the local odd burg out. The stock explanation, which I first heard from Luigi Brotini, is that while the Massese to the south and Liguri to the north were *contadini,* thrifty, cautious peasants, the Carrarese were miners, living by booms and busts, either awaiting the next big strike or blithely spending from the last one. And they did it in style, cutting *una bella figura* outside even if they had no food at home. Antonella Cucurnia, who grew up in Carrara in the 1940s and 1950s, recalls how finely even ordinary working people would dress just to go to town, or shopping, or—especially—to the opera. The opera was Carrara's passion and pride. Charles Dickens recounted visiting soon after "a beautiful little theater," the Teatro dell'Accademia degli Animosi, opened in 1840, as a social as well as cultural mecca for the emerging marble bourgeoisie who funded it. "It is an interesting custom there," he noted, "to form the chorus of labourers in the marble quarries, who are self-taught and sing by ear. I heard them in a comic opera, and in an act of 'Norma'; and they acquitted themselves very well; unlike the common people of Italy generally, who (with some exceptions among the Neapolitans) sing vilely out of tune." One of those full-throated stoneworkers was Aristide Mazzei; my grandmother said that before he emigrated to America, her father sang in the chorus in Carrara.[29]

Evidently the clipped tones of Carrarino had not killed the *cavatori*'s capacity for bel canto. Perhaps the danger of the quarries and the

perennial gamble of the stone trade instills a capacity for outsized emotionality, flamboyant expression, and aesthetic appreciation. Over a glass of wine, the Carrarese poet and chronicler Antonio Doretti recalls how "the men who came from the *cave* would eat a piece of bread with oil and *baccalà*, then run to the opera. They were slaves to opera."

In 1892 the marble barons funded a new and bigger opera house, the Teatro Politeama Verdi, on the central Piazza Farini (now called the Piazza Matteotti and used as a parking lot). Its acoustics were among the best in Italy, and its audiences were considered among the most demanding and discerning. Carrara became one of three prime spots, along with Parma and Reggio, to catch a rising star or a masterpiece in the making. Ambitious new productions would often try out here; if they were good enough for Carrara, they were ready to move on to La Scala and the other great halls. Puccini himself conducted *Tosca* here in 1901.

Today the Teatro Animosi, its neoclassical façade and marble interior beautifully restored, hosts a smorgasbord of drama and music. The Verdi Theater, battered by heedless renovation, survives as a movie theater; its ornate lobby ceiling celebrates Donizetti, Bellini, and Verdi, but the posters below announce the latest action spectacle from "the creator of *The Mummy* and *Mummy II*." The International Anarchist Federation, which is headquartered here, has made the ballroom and halls above the theater into an international anarchist study center, or will when it can renovate it; for now, the anarchists' large, crudely painted sign hangs like a strike banner below the upper windows, above the city's central piazza.

Still, on a quiet night—and silence falls quickly over Carrara these days—you can almost hear the strutting tenors and doomed sopranos singing their hearts out, while Puccini slashes the air and the marble barons in their boxes and the *cavatori* on the main floor, all wearing their finest suits, debate the qualities of this soprano and that aria. I can't help thinking of the opera house built in Manaus, Brazil, at the height of the rubber boom, where the rubber barons and the tappers assembled in their best suits, with nothing but the Amazonian jungle for a thousand miles around.

CHAPTER 6

DAVID AND
THE ORPHAN STONE

HOW COULD MICHELANGELO follow an act like his *Pietà* for Cardinal Bilhères? Florence, his hometown, had the answer—an inauspicious-sounding essay in civic boosterism and patriotic propaganda. Everyone today knows that politics makes bad art. But this political commission would produce a masterpiece that still thrills and astonishes—one that is not merely Michelangelo's best-known statue but the most famous sculpture ever executed by any hand. Not to mention the first true stone colossus created since the fall of Rome; the work that inaugurated the High Renaissance; and of course, "the most beautiful man in the world," as newspaper writers still call the *David* five hundred years later. All from a block of marble that was too tall, too shallow, and too soft, which had, according to its owners, al-

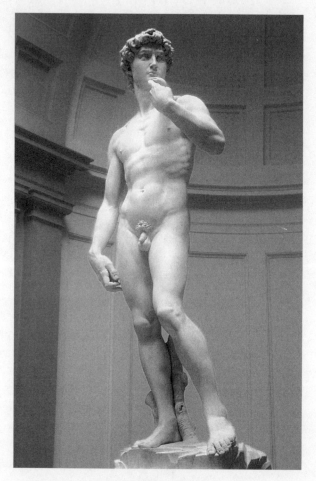

What became of the odd-shaped block
Agostino di Duccio quarried (marble, 1501–1504).

ready been *"male abozatum"* (badly blocked out)[1] by a lesser talent and
"cooked" by decades of exposure, and whose completion had eluded
two previous generations.

For thirty-five years this imposing white elephant had languished in
Florence's cathedral courtyard, defying all efforts to shape it. The idea
of erecting a marble *David* on the cathedral façade went back much
further—perhaps to the 1300s, when the cathedral Operai (overseers)
first contemplated a series of twelve marble prophets to grace the but-
tresses around the duomo's choir. In 1408–9, Nanni di Banco and the
great Donatello produced the first of these, a life-size *Isaiah* and

David, respectively. But these proved too small to be visible fifty-five feet up on the buttresses, and Donatello's marble *David* (not to be confused with his better-known bonneted, bronze *David*) was installed in a more appropriate site at the Palazzo Vecchio, where it assumed a new, civic significance.[2] In 1412 Donatello was signed to produce another, larger *David* for the duomo. The marble was ordered and the design drawn up, but the project appears to have been abandoned—perhaps one of the many that Donatello, who was nearly as prone to overbooking as Michelangelo, never got around to.[3] Donatello and his friend Filippo Brunelleschi then designed a statue of Hercules, another champion of freedom whom the Florentines considered a pagan quasi-prophet. It would be assembled from gilded metal plates wrapped around ordinary building stone, in conscious emulation of the Colossus at Rhodes. This project likewise lapsed, and with it the plan to ring the duomo with prophets.

In 1464, however, a colossal cathedral *Hercules* was realized, in terra-cotta, by Donatello's former protégé Agostino di Duccio. Agostino was next commissioned to complete the project that Donatello had been obliged to drop nearly fifty years earlier, an eleven-foot marble *David.* One expert, Charles Seymour, argues that he was actually acting as sculptural "amanuensis" for the seventy-eight-year-old Donatello, who had recently returned to Florence after many years away and was eager to see his early dream fulfilled.[4] Indeed, Agostino seems an unlikely choice for such an unprecedented, high-profile work in the round; he was primarily known for relief sculptures, and had returned to Florence only the year before, after being banished twenty years earlier for stealing silver from a church.[5]

The colossus was originally to be assembled in the old Roman fashion, from multiple pieces of stone—four, according to the contract, though six seems more likely if the trunk, head, and various limbs were each a piece. Somewhere along the way, with no recorded explanation, it grew into a much more daunting challenge: a giant figure carved from a single block.

Agostino set out for Carrara to find a suitable stone. Unfortunately, when it came to quarrying marble, Agostino was no Michelangelo. Rather than going to the more remote Polvaccio quarry, the *statuario* motherlode where Michelangelo later found the superb stone for the Vatican *Pietà,* he found an enormous block—nine *braccia* long, but

awkwardly shallow and merely *ordinario* stone—at Fantiscritti, the old Roman quarry at the center of Carrara's marble basins. Somehow, he got it back to Florence in one piece—barely. Apuan marble was shipped up the Arno to Florence on ox-dragged barges. For most of the year, the river was too low to let laden barges pass easily, so shippers waited until the rainy season, from December to May. The block arrived in Florence in early December 1466, which means it was shipped when the river was still dicey. Recently discovered transport records show that it had to be unloaded early, before reaching Florence's river port, Signa, and continue by oxcart.[6] The oxcart fell into a ditch and the block had to be hauled out of the mud. The art historian John Paoletti suggests that this fall, rather than later abuse, may have caused the hairline cracks in the *David*'s legs that bedevil its custodians today, and may also have discouraged Michelangelo's predecessors from undertaking the sculpture.

And then, on December 20, 1466, again with no recorded explanation, Agostino di Duccio was released from his contract and the project was dropped. The conventional view is that he had botched it so badly that either he threw up his hands or the Duomo Operai sacked him. This impression stems from the confused account of Condivi (who also mistakenly reports that a nameless craftsman had brought the block, badly roughed out, from Carrara "a hundred years earlier"). But as Paoletti notes, Agostino would have had little time—at most two weeks—to do the damage. He suggests that the work was actually not begun till 1476 or 1477, when Antonio Rossellino, a more accomplished sculptor than Agostino, got the job for a short time. Whether or not *he* damaged the block, Rossellino got nowhere with it.[7]

Charles Seymour, finding "no hint of failure or of official recrimination" in the record, proposes a different reason the project was dropped: Agostino's old master, Donatello, its secret auteur, died that year.[8] Nevertheless, the record does include one "hint of failure": the contract assigning the project to Michelangelo in 1501 noted that the block had been "badly roughed out."[9]

Either way, the account, as usual, redounds to the glory of Michelangelo.

* * *

IN 1466, the same year Agostino started and stopped the job, the Medici put down an attempted coup incited by the republican fire-brand Niccolò Soderini. In the overheated climate of the time, Pao-letti suggests, the duomo colossus might have seemed a provocative "republican expression"—which is just what it would prove to be when Michelangelo completed it thirty-eight years later. And so the project was squelched.

The block then sat in the duomo yard, getting ever more *cotto* (cooked), until the turn of the century, when the idea of a colossus gained new urgency. Florence had only lately emerged from the trauma of overthrowing the Medici, burning books and paintings with Savonarola, and then burning Savonarola himself. The reborn republic had a broader, more democratic voting franchise, but it needed all the help it could get. Wolves were circling: Spain, Germany, France, the church, the ambitious warlord Cesare Borgia, even the old Florentine aristocracy. Any of them might attack the fragile republic. Its leading policy wonk, Niccolò Machiavelli, urged that it abandon the tradi-tional, ineffective, and often dangerous practice of hiring loose-cannon mercenaries and form a loyal citizen army. No longer able to survive by juggling alliances, as Lorenzo de' Medici did so artfully, Florence had nowhere to turn except the Florentines. Art, in this art-intoxicated age, was a key medium of propaganda and consciousness raising. And that was where Michelangelo came in.

In summer 1501, the Arte della Lana, the wool association that was Florence's most powerful guild and the duomo's main patron, revived the prophets project. Again the Duomo Operai pondered what to do with the giant orphan block. The wool merchants and weavers had a special attachment to the chosen subject, David, the shepherd who guards the sheep that were the source of their wealth. But whom to assign it to?

Vasari recounts that Pietro Soderini, "who about that time was elected *gonfaloniere* [Florence's chief executive] for life, had often talked of assigning it to Leonardo da Vinci." But Soderini was not elected until the next year, and Leonardo, who was unproven at mar-ble and wary of such dirty work, seems an unlikely choice. Another sculptor, Andrea Contucci, was, however, angling for the block when Michelangelo stepped forward and got the job. Twice burned, the

cathedral authorities watched anxiously as the returned prodigal son set out to salvage the troublesome stone.

JOURNALISTS OFTEN TAKE Michelangelo's poetic conceit of the *concetto* bound within the stone as a literal description of his method: He approaches the block in a sort of Zen state, mind empty, waiting for it to show him the figure inside. Then he goes at it as spontaneously as a jazz improviser, tearing away marble in a hammering fury. Many modern sculptors do indeed undertake such "direct carving"—not in a fury, but without models or preparatory drawings. But this was not how sculpture was done in the Renaissance.

The authors of the best-known Renaissance treatises on artists' techniques, Vasari and the goldsmith-turned-sculptor Benvenuto Cellini, outline a much more deliberate procedure.[10] Before ever setting chisel to marble, sculptors should first make a fully thought-out small model in wax or clay—"about two palms high," writes Cellini—and then a second one, actual size and even more painstaking, usually in clay. Because it remained pliable, but also subject to the vagaries of heat and cold, wax offered the most flexibility—the sculptor could adjust his model even as he worked at the final piece—but the least permanence. He would render the wax even more pliable by melting it and adding small quantities of animal fat, turpentine, and pitch; the turpentine lent tenacity and the pitch blackened the wax and helped it set up. He could adjust this tone by adding other pigments, most often red earth, vermilion, or red lead—hence the burnt sienna tone, like earwax, of so many surviving models—but also white lead or verdigris for green. He might first build an armature of wood or iron wire and then spread the wax over it; this enabled the model to stand on its own, but locked him into the form.

Clay models could be *terra secca* (mere "dried earth," and thus susceptible to water and breakage) or *terra cotta,* fired. The firing subjects the clay to a fast-forward metamorphosis, in effect reversing the long erosion that ground rock down to clay and reconstituting it as stone. And so terra-cotta can be as permanent as stone—more resistant, indeed, to weather and other abuses than marble. But clay shrinks as it dries, and so would crack if stuck like wax to a rigid armature. Any but the smallest solid clay pieces likewise crack or explode when fired,

because the water trapped inside even after drying turns to expanding steam. The sculptor shapes a piece in solid clay and then, if he intends to fire it, hollows it out, either from the back or bottom or by cutting it in half with a taut wire, scooping out the excess, and welding the two halves back together with a slip of wet clay. To help water escape and prevent cracking, sculptors (and potters) mix ground-up previously fired clay, now called "grog," into the wet clay.

The full-sized clay model could not be built solid, because of weight if for no other reason. So it was built around a wood frame wrapped with hay or tow, which let the clay shrink as it dried. Horsehair or cloth strips would be mixed in the clay to keep it resilient; Vasari also recommended mixing in a bit of baked flour, which slowed the drying.

All this would seem to violate one of Michelangelo's few explicit artistic dicta: that sculpture proceeds by "taking away," while "adding on" belongs to painting, even if it's done by adding clay or wax.[11] The distinction is partly artificial: modelers build up shapes and then cut away to refine them. But it reflects a deeper principle, which derives from the Neoplatonic philosophy Michelangelo absorbed as a youth and at the same time rebuts Plato's dismissal of the plastic arts as mere "imitation." Taking away is an inquiry, a philosophic endeavor—stripping away excess to get at the truth. Building up, whether with paint or clay or with wax preparatory to bronze casting, is laying up illusion and artifice.

Even for sculptors today, the distinction is not academic, and how they come to terms with it may illuminate Michelangelo's views. "I've seen it with students," says Kyle Smith, an expat sculptor who teaches novice marble carvers (many of them sculpture tourists from America) at her studio in the hillside village of Valdicastello, fifteen miles south of Carrara. "There are people who take away to find the form. Other people need to build up to find it. The processes are different. With clay you work so fast you don't think about it. With stone, the creative moment is prolonged for such a long time, the process of carving enforces a different sort of perception. It's sort of a dialogue with the stone. The stone, with its character and grain, *tells* you things."

Sometimes it speaks literally and audibly. Nearly 450 years ago, Cellini wrote that a flawed block "rang false beneath my strokes."[12]

Erico Tonini, third-generation heir to a family marble business in Carrara, showed me how to listen to your stone. "This is *bianco* from our quarry at Fantiscritti, very *secco* [dry] and *resistente,* with very fine grain," he said, rapping an upright white slab; it rang with a metallic, almost bell-like tone. "This one from Gioia is coarser-grained, more fragile." He rapped and got only a dull thud, as from concrete.

Cellini was a great advocate of precise models, and his own labored, virtuosic work shows it. But he, like Vasari, acknowledged that

> many strong men have gone straight for the marble with all the fury of a chisel, preferring to work from a small and well-designed model, but, notwithstanding, they have been less satisfied with their final pieces than they would have been with full-sized models. This was noticeable in the case of our Donatello, who was a very great man, and even with the wondrous Michelangelo, who worked in both ways. But it is perfectly well known that when his fine genius felt the insufficiency of small models, he set to work with the greatest humbleness to make models of the size of his marble; and these have been seen in the Sacristy of San Lorenzo.[13]

But if Michelangelo made as many full-size models as Cellini claims, it's odd that only one has been preserved, for one of the never-executed "river gods" for the San Lorenzo tombs. His models were highly prized in his lifetime, but only a handful of small ones in clay, terra-cotta, and wax, rough but surging with life and movement, survive. Surely the large ones would also be treasured by any who could acquire them. It's also questionable whether Michelangelo's work suffered when he skipped the full-sized model; he could hardly make such a model for the giant *David,* and according to Vasari relied on a small wax model.[14] His preparations varied according to circumstances and, perhaps, how confident he was of the form in his head—just as when, in painting the lunettes below the Sistine ceiling, he dispensed with drawing cartoons and outlined his figures directly on the fast-drying plaster.

At the same time, as Vasari reports, Michelangelo also used small models in his painting, moving them about to adjust shadows and foreshortening and try poses he could never have achieved with live models, most notably in the flying angels and demons and falling

souls of *The Last Judgment*. This explains the outward paradox of the allegorical figure representing Painting that sits athwart his tomb at the Church of Santa Croce, holding a small sculpted model.

WITH ALL FLORENCE WAITING, Michelangelo had to conceive a figure that would fit the rough form that Agostino di Duccio or another hand had already hacked out. Exactly how he did this remains something of a mystery, because he built a wooden screen around the block in the duomo workshop and, as Vasari recounts, "worked without anyone seeing it." But some clues can be drawn from the sculpture's unusual form and the marks on its surface. The block was extremely shallow, with a width-to-depth ratio of about seven to four. This explains why David's upper body leans forward slightly: to fit it in the block, Michelangelo had to position it above the extended left leg and feet; there was no room for the figure to toss his head back.

Some modern critics assail this flattening of the figure as a fatal accommodation, conducing to what one calls "a very shallow view of humanity."[15] But it is a classic instance of necessity begetting invention, and expression: the flattened frame and forward tilt give the *David* an anticipatory tension, as though he pushes against an invisible barrier, gathering strength before springing through it.

The block's limits even define David's distinctive hairstyle, which sweeps forward like a ship's bow to a pointed, bill-like forelock. When the statue is viewed from above, it becomes evident that the head had already been roughed in as a square, facing directly forward and bound by the block's shallow depth. Rather than carve a squat, flat face, Michelangelo turned the head on the diagonal, making maximum use of the limited stone available, with nose, chin, and forelock pointing to one corner.[16] This dictated the odd hairstyle, but it also let Michelangelo achieve the *David*'s iconic long profile. And most important, it enabled him to inject life into the stiff, frontal form that Agostino di Duccio or whoever had roughed out. From a soldier standing face-front at attention, he formed a coiled, animate young athlete stepping right out of the block. As Vasari said, he did indeed bring the dead to life.

But for better or worse, he could not make this teenage Lazarus a highbrow; whoever got to the block first had allotted too little height

to the head. Michelangelo emphasized David's youth with oversized extremities and facial features but had to scrimp on brow and cranium, though he used every last centimeter of stone. As Condivi writes, "Without adding any other pieces, he extracted this statue so precisely that the old rough surface of the marble still appears on the top of the head and on the base."

PERHAPS IT DID THEN. But on March 8, 2004, when I was able to clamber up the restorers' scaffold and peer closely at *il gigante,* that old rough surface was difficult to discern, so much had wear and weather roughened all the top of the head, as well as other exposed horizontal surfaces.

That wear was, indirectly, the impetus for this rare bird's-eye—or more precisely, circling fly's eye—view of the world's "most beautiful man." The Accademia di Belle Arti had just held a lengthy show-and-tell, complete with computer-graphics video, CD-ROM handout, and many words from the leading local art powerhouses. The occasion was the release of the massive and (like almost every volume emanating from an Italian cultural institution) gorgeously printed midrestoration report—in English!—on the statue's condition and what its cleaning had disclosed. The press hordes were doing their clomp-through, three at a time up and down the elaborate metal scaffold that wrapped like a curtain wall halfway around the *David.* At one point a second threesome grew impatient and stormed the gate, making the scaffold quake like an elm in a gale. I shuddered to imagine that night's news flash: "Media scrum brings down *David.* Scaffold collapse destroys five-hundred-year-old art treasure." But miraculously, the trembling scaffold never touched the marble; no doubt these tolerances were calculated in its design.

I'm glad to say the press did not knock over the scaffold, and I resisted the temptation to touch the world's favorite statue. Still, the feeling of peering, close enough to spot a hangnail, into *il gigante's* cuticles, pectorals, nostrils, and armpits was uncanny and unsettling. I have seen giant statues—Ras and pharaohs in museums, Buddhas and Vishnus in Thailand, Cambodia, Sri Lanka—up just as close, and have not always resisted the temptation to touch. But I never feared they would stir and walk off while I hung from their necks. Viewing the

David at close range, you appreciate the command of form, proportion, and movement that so awed Michelangelo's contemporaries. Surely he had a third eye, and a fourth and fifth, floating ten yards to each side of the stone and guiding him as he worked.

The result Michelangelo extracted from this shallow, unpromising block of brittle stone was an unprecedented tour de force. But one question nags: was the outcome actually *aided* by the roughing-out that Agostino, or perhaps other hands, had already done? It seems that the gap between the legs and the limits of the chest and shoulders had already been cut away. Michelangelo was thus constrained as to the figure's dimensions, and could not exercise the preference for massive, muscled forms he had already hinted at in the *Madonna of the Stairs* and would soon indulge on the Sistine ceiling. The *David*'s gracile qualities, the lithe adolescent body against the oversized head and hands—like a puppy's paws—are what make him so persuasive and moving; he may be seventeen feet tall, but he really is a man-child facing perils much larger than himself.

The Duomo Operai and Florentine republic got much more than they had bargained for from this hometown prodigy who had never executed a public sculpture in his hometown. They responded by raising the bargain, in a modest way: they had originally signed Michelangelo up for two years at just six ducats a month, less than an artisan's wages; halfway along they raised the contract to a flat four hundred ducats. But Michelangelo's achievement raised another question: where to put this splendid *gigante*? Clearly a high perch atop a cathedral buttress, as originally planned, would waste such a marvel. It was also clear from the *David*'s level rather than downward gaze, and from the care Michelangelo lavished on facial expression, and on details such as toes and the inward-curling fingers of the right hand that would be invisible from below, that he had not intended it for a high height.

And so the Operai convened a thirty-five-member commission to determine a location. This dream team included many of the most illustrious names of the most illustrious era of European art: Botticelli, Leonardo da Vinci, Perugino, Filippino Lippi, Piero di Cosimo, Andrea della Robbia. The painters far outnumbered the sculptors. Their deliberations are better remembered than most major ecclesiastical and political conferences. As if the aesthetic concerns and personal jealousies

involved weren't enough, the choice of placement was politically fraught. One craftsman on the commission suggested a more visible location at the duomo, say over the main door; this would preserve the original ecclesiastical intent. But nearly everyone else wanted it set in the Piazza della Signoria, the center of Florence's political life, near the civic palace where the newly democratized Great Council met.

The symbolic shift, from the sacred to the secular, was unmistakable. Lorenzo the Magnificent's Platonic Academy might be just a memory, but the neoclassical spirit was still in full pre-Reformation flower, and no other artwork had recaptured, amplified, and enriched the classical ideal as the *David* had. Also, having just gotten rid of fire-and-brimstone Savonarola, the Florentines were in no hurry to mix politics and religion again.

But where at the Piazza della Signoria? The woodworker-architects Giuliano and Antonio da Sangallo (who would construct the ingenious wheeled suspension system that would safely move the delicate statue) proposed the most sensible and most popular choice. Noting the fragility of the colossus's sun-softened marble, they proposed housing it safely in the roofed Loggia dei Lanzi, on the piazza's south side, where many of Florence's greatest sculptural treasures stand and many of its thousands of international students flock at night to drink beer and make out.

If the majority had won out, *David* might stand in the loggia today, safely covered but open to view, still manning his civic post. But the authorities did what authorities usually do with such advice: they said, "Thank you," and did what they were going to do anyway. They bumped aside Donatello's *Judith* (another popular emblem of patriotic fortitude, but much smaller and grimmer than the *David*) and set the new civic mascot on the balustrade by the door to the Palazzo Vecchio. There, no one could miss the message: this was a city ready to defend itself against tyranny.

This message is highlighted in the striking 1510 *Portrait of a Man in Armor* by Francesco Granacci, the Florentine painter who introduced Michelangelo to Lorenzo de' Medici's sculpture garden when both were Ghirlandaio's apprentices. In the foreground, a doughty youth draws his sword, ready to defend his homeland. Behind him stands the *David*, echoing his determination.

Michelangelo, the once and future Medici protégé, seems to have

had no doubts about that message. He declared his solidarity with the cause in a wonderfully succinct epigram scribbled on a sheet of preparatory sketches:

Davicte cholla fromba　　David with the sling
e io chollarcho　　　　　and I with the bow
Michelagniolo.　　　　　Michelangelo.

Some of the best minds in art history have beat themselves senseless trying to interpret these cryptic lines: the *archo—arco* in the modern spelling—was Cupid's bow, they argued, or the bowed frame of a harp, or the bow that shoots the arrow of reason, or the bow of genius drawn against Michelangelo's rival Leonardo (though their active rivalry was yet to come). Finally, Charles Seymour blew away these suppositions with an explanation that had waited 555 years to be voiced: Michelangelo referred to the bowlike running drill that was an essential tool in fifteenth-century sculpture.[17] Used to achieve deep relief and shading, it became a cheap device, or vice, for some sculptors, who would drill hair and fabric folds until they looked like Swiss cheese. Michelangelo's use of it was always judicious, however, and the oath he takes upon it is stirring: just as David offered his sling, and his life, to defend his homeland, so Michelangelo offers his art and, presumably, his life.

Today, when sculptors hold an armory of air-powered tools, Michelangelo's *archo* might seem hopelessly archaic. But like other hand tools, the *arco* or (as it's also called today) *violino* still grants patient workers benefits that power tools can't. The young sculptor Susanne Paucker did not know that Michelangelo had invested such meaning in the bow drill; she had taken to using it for its own sake. "The power drill burns the marble and leaves it *cotto*," she explains. "The *arco* leaves it fresh."

And so reverence for liberty and reverence for stone coincide. Soon enough, however, Michelangelo would contravene his oath and once again serve Medici masters. But never again would he enjoy such untainted success in a major sculptural project—such a happy confluence of patronage, circumstances, and his own talent and judgment. Only in painting would he reach another such triumphal finish; his efforts to create great sculptural ensembles would become decades-

long, off-and-on ordeals, resulting in unfinished, unexecuted, or sadly compromised masterpieces. His major undertakings seemed to fare better the less auspiciously they began: the *David,* carved from a hand-me-down stone; the Sistine ceiling, begun under protest and duress; Saint Peter's Basilica, where he salvaged an enormous boondoggle.

LIKE SCULPTOR, LIKE SCULPTURE. If statues could suffer, *David's* tribulations would be unmatched in the annals of art.[18] His torments began before he was finished, at midnight on May 14, 1504, when a forty-man moving crew smashed open the wall around the duomo workshop and, with excruciating care, rolled him out for the five-block, four-day journey to the Palazzo della Signoria. Pro-Medici partisans pelted the republican *gigante* with rocks, obliging the authorities to set an armed guard around him.

In 1512, when the republic fell, the Florentines noted various portents of divine wrath, the most striking being a bolt of lightning that struck the statue and jolted its base; some later observers blamed this for causing the cracks in the statue's ankles. When the republic was restored in 1527, urban unrest again struck Florence's civic mascot. A pro-Medici mob stormed the palazzo behind the *David,* where the republican *popolani* had barricaded themselves. When they ran out of stones to drop on their attackers, the barricaded populists tore out window tiles and grabbed furniture, anything that might serve as a projectile. As Vasari, then a lad on the scene, tells it, a flying bench hit the *David,* breaking the left arm off into three pieces; three days later, those pieces still sat on the pavement, so Vasari and another young artist-to-be, Francesco Salviati, gathered them up and gave them to Salviati's father, who later passed them to Duke Cosimo de' Medici. They were not reattached until 1543, which suggests that the Medici, who regained power yet again in 1530, were in no hurry to restore this crippled republican symbol.

Florence finally settled into a stable despotism, and no more stones or benches flew. But rain, wind, pollution, and the occasional ice storm pelted the exposed *gigante,* further eroding the already *cotto* marble. According to nineteenth-century records, a broken gutter doused it with a concentrated, protracted stream. Recent examination found no evidence of the focused erosion such a leak should cause,

but did find rust traces that might have come from the gutter.[19]

The nineteenth century was an age of sweeping art "restoration," and the long-suffering *gigante* inevitably came under the restorer's swab. In 1812 it received what was then standard treatment: a mild cleaning and a refresher coat of beeswax, perhaps mixed with linseed oil, such as Michelangelo himself probably applied. Such applications sealed the porous stone and infused it with the rich patina, sometimes accented with tea, tobacco juice, and other stains, so evocative of human flesh and so characteristic of Renaissance and Baroque sculpture. Stone carvers in Carrara still treat their tombstones and other productions thus; otherwise, as Carrara studio proprietor Carlo Nicoli says, "marble looks dead, like a ghost."

But tastes change. The Enlightenment and neoclassical revival brought a fashion for whiteness in everything from powdered wigs to racial ideology. In place of Michelangelo's monumental Madonnas and Bernini's Baroque fantasies (both sealed and toned), patrons craved Canova's airy, elegant, and starkly white nymphs. Instead of waxing their sculptures and letting them accumulate protective patina, nineteenth- and twentieth-century sculptors sent them out bright and raw.

We still struggle with this white-is-right legacy, in preservation as in politics. The consequences show starkly in Florence's Museum of the Duomo, which houses sculptures removed from the cathedral façade. By the time they went inside, an untreated *Adam* and *Eve* carved in the 1880s were badly corroded, their noses and fingers lost to the mineralogical equivalent of flesh-eating bacteria. By contrast, the prophets that Donatello carved 450 years earlier stood crisp and intact under the dark crusts formed by their wax and oil finishes. Likewise, patches of untreated marble inserted into the gothic façade of the Palazzo della Fraternità dei Laici in Arezzo in the mid–nineteenth century have rotted away, while adjacent medieval carvings are intact.

Such lessons did not trouble Aristodemo Costoli, the sculptor contracted to clean the *David* in 1843; with official approval, he washed it with a 50 percent solution of hydrochloric acid, about twice the strength of the commercial muriatic acid used today to etch concrete. Sure enough, this bath left the statue bleached, pitted, and porous. Recognizing how vulnerable it now was, its custodians decided to make a plaster cast for backup should disaster strike—a strategy akin to deep-freezing the gametes of endangered species in hopes of some-

day cloning or retrobreeding them back into existence. The trouble with such strategies is that they afford an easy buyout from the hard work of conservation, and often leave the masterpieces or natural marvels they propose to save even worse off. (A grandiose scheme to capture some of the last severely endangered Sumatran rhinoceroses and breed them in captivity produced no offspring and many dead and dispersed rhinos.) The weight of the plaster strained, and perhaps cracked, the *David*'s delicate ankles and left traces of corrosive gypsum on its skin.

Clearly, *il gigante*'s patriotic vigil was nearing an end. Left untouched, he might hold his post today, but reckless cleaning had spoiled that chance. Successive committees debated, excoriated Costoli, and reached the inevitable conclusion: on July 30, 1873, Michelangelo's *gigante* was wheeled to a custom-built rotunda at the Medici-founded Accademia. The world's most prominent and potently symbolic public sculpture became a museum artifact, a lure for paying tourists; a marble copy, expertly done but conspicuously a copy nonetheless, was installed at the original site.

Then, 130 years later, the debates resumed. *David* became the latest in a string of big-ticket art restorations of doubtful necessity but irresistible glamour, marking the confluence between the cultish discipline of restoration and the modern cults of technology and celebrity. Florence's culture chiefs, like the Vatican officials who oversaw the earlier restoration of the Sistine Chapel frescoes, rejected calls for a more limited approach and opted for an all-over cleaning with wet compresses (but without the potent alkaline cleaning gel used in the Vatican). As he had then, a prominent Michelangelo scholar named James Beck mustered a petition full of distinguished signatures urging a moratorium pending an independent review. Once again, the authorities pushed ahead, appealing to the press and public with close-up tours, flashy multimedia presentations, and exciting historical and technical "discoveries."

This time, however, the story took a different twist. Antonio Paolucci, the superintendent of the Florentine museums, had selected Agnese Parronchi, a top restorer acclaimed for her superbly harmonious cleanings of Michelangelo's *Battle of the Centaurs* and Medici tombs. Even Beck cheered the choice. But after inventorying the *David*'s condition in hundreds of photographs, Parronchi urged a dry

An unsealed nineteenth-century insert (left), beside intact medieval stone
at the Palazzo della Fraternità dei Laici in Arezzo.

cleaning, with soft brushes and motorized erasers—a minute,
painstaking process assuring maximum control. (I later stopped by
Arezzo to watch her give this treatment to the ornately carved Laici
Palace, the job she'd undertaken in place of the *David*. It was like per-
forming dentistry on a cliff.) Paolucci insisted she use wet packs. Par-
ronchi refused, defending her professional autonomy and pointing
out that water, "the great enemy of marble," could leach corrosive
gypsum on the surface into the stone and make *David* look flat and
uniform.

This impasse provided just the soupçon of conflict an art story
needs to make the front pages, but the outcome was anticlimactic.
The crusty, sometimes hyperbolic Beck never stood a chance against
national pride and the gracious, enthusiastic art chiefs. They dug in
their heels as their Vatican counterparts had, denounced Beck for
grandstanding and "antirestoration terrorism," and found another re-
storer to do the wet cleaning. As usual, the media hailed the result.
Some even declared the statue returned to its "pristine state"—an im-

possible notion with any artwork and especially absurd with one as degraded as the *David*. But the official report was more muted: after $300,000 worth of cleaning plus $200,000 for research and publications, "the surface looks more regular and more balanced in its relations of light and shade." Paolucci undercut even that modest boast, calling it an "invisible restoration" to all but expert eyes. "The *David* is the same as ever," he proclaimed. "This is exactly the result we wanted" from an "intelligently minimalist intervention."

In fact, the result was striking. After cleansing mud packs and spot-dabbing with mineral spirits, its many pocks and seams patched with marble paste, the *David* emerged more balanced and elegant, its forms uncluttered with stains. But there was a trade-off. Before, one could squint and imagine a living figure, smeared with the grime of battle, ready to step off his pedestal. Now his puttylike skin resembles the plaster models by later sculptors that fill an adjacent hall (and which naïve tourists assume are also Michelangelo's). The traces of his messy past have been gently removed, and he seems more like a statue—a statue out of time.

CHAPTER 7

THE PAINTER AND
THE SCULPTOR

THE SPECTATOR CAN MOVE AROUND A SCULPTURE
(INDEED IS EXPECTED TO DO SO), BUT A PAINTING
HOLDS HIM IN ITS GRIP.

MARY MCCARTHY, *The Stones of Florence*

THE *DAVID* SEALED MICHELAN-
GELO'S reputation as the lead-
ing sculptor of his day. Even before finishing it, he was swamped with
commissions. In May 1501, still hungry for work (and three months
before signing the *David* contract), he had accepted another big job: to
carve fifteen small statues, similar to the three he'd done in Bologna,
for an ornate altar in the Siena cathedral. The pay, five hundred
ducats, was respectable, and the patron was powerful: Cardinal
Francesco Todeschini Piccolomini, the future Pope Pius III. But the
project, filling the gaps in another sculptor's design, was uninspiring,
and not just for Michelangelo: Pietro Torrigiano, the outcast who had
broken Michelangelo's nose a dozen years earlier, had also taken the
job, but started just one saint before dropping it.[1] Michelangelo's con-
tract specified that he would finish the figure begun by his old neme-
sis. Michelangelo never got to it, or to ten of the other Piccolomini
figures; he delivered four, ably done, in 1504, but eventually let the
contract lapse.[2]

By then, even before he finished the *David,* he was taking on more commissions than any one artist could possibly finish. In 1502 he started on a smaller *David* in bronze, which the *gonfaloniere,* Pietro Soderini, and the Florentine Signoria needed to placate a powerful French general who had admired Donatello's famous giant-slaying imp. In short order he also executed the solemnly reposed *Bruges Madonna* and the semifinished Pitti and Taddei *tondi,* brilliantly economical and expressive uses of circular form, high relief, and chiseled texture. "So that he might not entirely neglect painting," writes Condivi, he produced his only finished easel painting to survive today, the *Doni Tondo*—a striking, if unsatisfying, study of the Holy Family, radical in its fluid forms and rich modeling but Gothic in its stark, bright colors, especially the Virgin's signature blue robe and pink tunic. And he began carving a life-size *Saint Matthew,* the first piece in the largest commission he had received thus far, one that would set his work directly against Donatello's.

On April 24, 1503, the Duomo Operai, with Soderini's encouragement, contracted Michelangelo to carve twelve apostles in marble, each four *braccia* (about seven feet) high—one a year for forty-eight florins, about $7,200, over the course of twelve years.[3] They got a bargain by signing this rising star, before he finished the *David.* Their contract contained one unusual provision that Michelangelo doubtless found congenial, and perhaps even suggested himself: that he go personally to Carrara to obtain the necessary marble.

This second journey to the quarries is one of the most shadowy episodes in Michelangelo's history; most biographers make no mention of a trip in 1503–4, and no correspondence from the period survives. It seems remarkable that the sculptor, still immersed in his *gigante* and about to start so many other commissions, would find time to return to Carrara. But it also seems inconceivable after his disappointments in buying marble off the rack and his stunning success in finding the *Pietà* block that he would leave the job to anyone else. The surest clue to the mystery lies in an account Michelangelo gave twenty years later, enumerating the Florentine contracts he had to abandon when Pope Julius II summoned him to Rome: "And of the twelve Apostles that I still had to do for Santa Maria del Fiore, one was blocked out, as one can still be seen, and I had already transported the greater part of the marble."[4] From this it seems evident that

Michelangelo was rock hunting again at Carrara even as the *David*'s dust was settling.[5]

He was getting to be an old hand on the Apuan marble trail. And he was setting a pattern of starting projects that he would never finish—a failing that also marked a breakthrough. In blocking out that one apostle, he had achieved a new kind of raw, unfinished masterpiece and, inadvertently or deliberately, inaugurated a sculptural style with which he would be inseparably associated: the *non finito*.

Art historians often explain Michelangelo's *non finito* as an unintended consequence of his overcrowded schedule, overeager patrons (especially popes), and a rush to start new projects before finishing those at hand. Liebert, Michelangelo's psychoanalytic biographer, argues that he did not finish two-thirds of his sculptures because to do so would have been too painful: marble and the Carrara quarries were a "security blanket" for this motherless child, a "comforting substitute for the absent mother." Finishing a statue would "sever his bond with the block of stone" and might reawaken his "early, profound separation anxieties." And so he "avoided the pain associated with that sharp end."[6] You needn't buy the whole Freudian construct to see that Michelangelo did cherish a particular attachment to the stones themselves; after the breathtaking finish of the Vatican *Pietà*, Michelangelo stepped out from Pygmalion's traces. Rather than polishing stone until it rippled like flesh, he chose to reveal it as stone.

In the Taddei and Pitti *tondi* especially, he seems to revel in his bold, expressively varied chisel marks and the rhythmic interplay of textures. Can such works be called "unfinished"? Both were delivered to the clients who commissioned them, whose names have been immortalized as a result; Taddeo Taddei and Bartolomeo Pitti did not send their prizes back for polishing. Vasari writes that both *tondi* were "highly admired and appreciated" and praises the "perfection" of the even rougher *Saint Matthew*. Michelangelo, the former supreme polisher, had established the *non finito* and the notion of the intimated and unseen as aesthetic principles.

Saint Matthew is much more, and much less, than your usual unfinished statue. Another Renaissance sculptor would have shaped the entire figure roughly, as though it were wrapped in heavy bandages, and then modeled and detailed each part. He would have used plumb lines and calipers to transfer measurements from his model to the

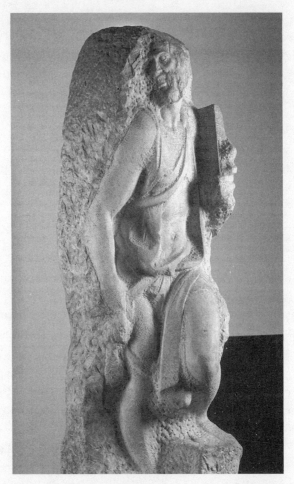

Michelangelo's eloquently unfinished *Saint Matthew* (marble, 1505–1506).

final stone, and to double-check measurements as he carved. Michelangelo discloses something very different in the *Saint Matthew* and four later unfinished figures carved from similarly sized Carrara blocks, the haunting *prigionieri*—so-called "Slaves"—that now stand with it in the foyer of Florence's Accademia di Belle Arti, an honor guard for the *David*.

Instead of working around these figures, he worked *into* them, modeling each layer—first a thrust-forward leg, then a straining abdomen—before proceeding to the next. In one, infelicitously called the *Blockhead Slave* ("*Atlas Captive*" would ring better), he has worked

in from two sides, front and right, leaving the figure still walled in behind his back and sandwiched between raw stone top and bottom—a potent image of confinement and oppression. But *Saint Matthew* and the remaining *Awakening Captive* show Michelangelo's approach in its purest, starkest form. In both he has carved down into the stone (and then, in the *Awakening Captive,* begun working around to the right). The figures stand—or, it seems, lie, as in pools of lava—in frontal view, save that their heads twist expressively to the right, struggling, as one scholar has written, "to free themselves from the marble matrix."[7] The saint, tense and coiled, is about to tear himself free; the captive, his shoulders slumping in resignation or exhaustion, sinks into the rising flood. Their struggles, painful and exhilarating to view, evoke both birth and death. They are captives of matter and spirit at once.

Vasari, a painter rather than sculptor, saw in this straight-in approach a foolproof technique that "serves to teach other sculptors how figures can be carved out of marble without making any mistakes, always benefiting by removing the stone judiciously and remaining prepared to step back and change course as necessary." The modern stone sculptor Peter Rockwell, who knows better the art whereof Vasari speaks, sees nothing safe or easy about Michelangelo's approach in these unfinished pieces: it is "an uncomfortable and difficult technique for roughing out a statue, as well as being unusual for the period and unusual for Michelangelo himself. . . . It is a revelatory sequence rather than a practical one."[8] Rather than the risk-free strategy Vasari imagines, it is a leap into *pietra incognita*. Michelangelo was exploring, not just designing and executing, living up to his poetic conceit about finding the idea hidden in the stone.

The difference is familiar to anyone who has attended a life drawing class. Some students will carefully sketch out the form, making sure of their proportions before progressing to the modeling and detail. Their drawings always fit together and fit on the page, but they often look wooden. Others begin at a point and just draw, dipping in and out of details as they go. Their figures often run exuberantly off the page and out of proportion, but they live and breathe.

Just so, Saint Matthew pushes against the confines of the block. The unbalanced Awakening Captive would surely fall backward if freed to stand alone. And did Michelangelo leave the *Atlas Captive*'s head a block because he hadn't left enough stone to carve it? He did

not leave enough for the right arm of the *Defiant Captive,* one of two more-finished *Captives* now in the Louvre, and so it is usually photographed from its left.

The analogy to drawing is apt, because Michelangelo's "revelatory" approach derives not from sculpture in the round but from that two- and three-dimensional hybrid, relief carving. In *Saint Matthew* and the *Captives* he has gone back to his Rosebud, the *Battle of the Centaurs,* the youthful relief in which he found his sculptural voice. He also harks back much further, to the imperial Romans who perfected the art of high relief. In masterworks such as Trajan's Column, they worked as he did, carving into the stone in successive planes and leaving the background raw.[9] This approach had already seen one revival, when Nicola Pisano, the great pioneer of the Pisan proto-Renaissance, carved his Pisan baptistery pulpit, and when Nicola's son Giovanni applied the plane-by-plane technique to sculpture in the round. It faded into obsolescence over the next two centuries, until Michelangelo revived it. And so he was a throwback as well as a revolutionary.

IN KEEPING WITH the relief tradition, nearly all Michelangelo's sculptures have a principal view, a front, back, and sides—even when they are not set in a niche that requires such a focus. Just one small model, for a never-executed *Hercules and Cacus,* and one marble group, the twisting *Victory* conceived for Julius's tomb and consigned to Florence's Palazzo Vecchio, offer plausible multiple views. But Michelangelo's successors would elevate multiple views to a new orthodoxy, substituting fluid 360-degree movement for the focused emotional intensity of his figures. We wander exhilarated around Giambologna's *Rape of the Sabines,* Bernini's *Daphne and Apollo,* or Canova's *Eros and Psyche,* savoring their fluid motion but never finding any single view to match a face-on confrontation with Michelangelo's *Moses* or *Dawn.*

Technology sounded a knell for the revelatory approach in the eighteenth century, with the invention, in France, of the pointing machine (or, as it's called in Carrara's studios, *i punti,* "the points"), which made copying more precise and models more important. Before, using calipers and plumb lines to transfer measurements, sculptors still had to eyeball in large measure. The *punti,* speedily adopted and refined in Italy, took the guesswork out. The "machine" attaches to a T-shaped

frame that rests in three holes drilled in the plaster model and, correspondingly, in the block to be carved. A multijointed arm records the precise location and depth of a point on the model or original artwork; thanks to a slip joint, the sculptor (or copyist) can successively lower the pointer and carve to precisely the same spot in the stone. Transfer enough points and you have a rough but accurate copy. Adjust the distances with each point you transfer and you can expand a model to any size, using the *punti* as a three-dimensional pantograph.

The process is not entirely mechanical; a carver must still fill in the details and finish, the nuance and expression, what Robert Gove calls "the music between the points." But it was a big boost to organized

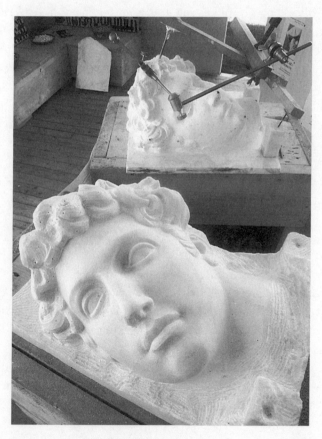

Copying a model with the *punti*.

production. Sculptors could send their small models to the workshops of Carrara and Pietrasanta to be translated into marble. They could sculpt in stone without ever touching a chisel.

This spurred a lucrative business for the artisans who did the copying, an explosion in both the volume and the quality of marble craft, and a flood of statues—nymphs and Madonnas, portrait busts and copies of Michelangelo's *Pietà*—spreading through the world's churches, gardens, and grand halls. All this provoked a modernist backlash, a weary disdain for academic tradition and for marble itself, and a hunger for direct, individual expression.

By that light, Michelangelo's *Captives* and other *non finito* figures seem precociously modern, as direct and personal as a canvas by Soutine or Pollock. And unlike, say, the unfettered paint strokes of elephants or small children, their *non finito* energy cannot be easily dismissed as inadvertent. In *Saint Matthew,* and even more with the *Atlas* and *Awakening Captives,* Michelangelo went to considerable trouble to preserve the stone matrix enfolding the anguished figure. At a certain point, after defining the frontal view, it would be easier to knock away the block's residue and continue rounding the figure. Instead he kept carving, at greater effort, *into* the block. He did not want to break the stone's shape, to reduce it to a streamlined human silhouette. He saw that the power of what he had done lay partly in what he had not done, in the stone he had not removed.

WHATEVER HE MAY have intended, circumstances and Michelangelo's own outsized ambitions conspired to keep him from finishing two-thirds of the pieces he began, and even from sticking at his cherished marble. After he completed the *David* in 1504, another patriotic art project beckoned, in paint rather than stone, a medium he faced both eagerly and with trepidation.

In the face of gathering foreign threats, the Florentine republic had done away with its musical-chairs system of government, which guarded against dictatorship by imposing a two-month term limit on the *gonfaloniere,* and elected Pietro Soderini *gonfaloniere* for life. In addition to being steady, honest, experienced at diplomacy, and widely respected, Soderini possessed one surpassing qualification in dynasty-phobic Florence: he was childless and could not pass power on to any

progeny. As things turned out, he would not have had the chance anyway.

Soderini comes off in the annals as a cloddish natterer, thanks to an anecdote perpetuated (and perhaps fabricated) by the Medicean spin doctor Vasari.[11] It seems the *gonfaloniere* was delighted with the almost-finished *David,* save that he thought its nose too thick. Michelangelo, ascertaining that from where Soderini stood he couldn't actually see the nose, discreetly scooped up a bit of marble dust and let it fall while pretending to tap the stone. "I like it better now," said Soderini, though nothing had changed. "You've given it life." Michelangelo smiled to himself, "feeling compassion for those who, while seeming to understand, don't know what they're talking about."

But Michelangelo was scarcely one to suffer fools, or at least educated fools, compassionately. And Soderini was no fool about art. If fortune had been kinder and his projects for Michelangelo had not been interrupted, he might be remembered as a patron on the order of Julius II and Lorenzo de' Medici.

In 1504, Soderini and his counsellor Machiavelli were still scrambling to raise civic spirits and show a strong Florentine face to the world. They turned once again to Michelangelo. Soderini and the Signoria had commissioned Leonardo da Vinci, the most celebrated painter of the day, to paint a giant fresco in the vast Council Hall of the Palazzo della Signoria. Then Soderini got an inspired notion: to have Michelangelo paint the other half of the long wall that stretched behind the council's and *gonfaloniere's* seats. Just luring back Leonardo, a son of Florence who had been off serving Milan's Sforza dictators, was a coup. Having Leonardo and Michelangelo compete at patriotic subjects would be a bigger one.

It was a contest with philosophical as well as artistic implications, as the well-read Machiavelli may have realized. Michelangelo and Leonardo stood, and still stand today, as two defining poles in Western art, corresponding to Plato and Aristotle in philosophy. Michelangelo, steeped in neo-Platonism, is the consummate idealist, pursuing essential forms in a dialectic of stone and chisel. Though Raphael portrays Leonardo as Plato in *The School of Athens,* he is actually the Aristotle of the plastic arts: the polymath natural philosopher, seeking to comprehend all nature through observation and the syllogism of chalk and paintbrush.

Though he was Michelangelo's faithful friend, Soderini proved ruthless and canny about whipping up the competition. Each artist set out to paint a triumphant episode of Florentine military history, but there the resemblance ended. Leonardo chose a battle—at Anghiari, where Florence had repelled a Milanese mercenary army—in full fury, a roaring tumult of men and horses on a scale not attempted since Paolo Uccello's triple *Battle of San Romano* nearly a century earlier. Unlike Paolo, Leonardo had the *sfumato* technique to render the actual atmosphere, the dust and tumult and confusion of battle. He also had an abiding fascination with violence and disorder, revealed in his drawings and notebooks, coupled with a loathing for war that had not found an outlet in his painting.

Michelangelo chose the same unconventional narrative approach he'd taken in the *David*. Rather than painting the action during battle or the triumph afterward, he determined to capture the anticipation beforehand, the panic and steeling of nerves before the arrows flew. He would show Florence's defenders with their pants literally down— relaxing in their cherished Arno, the lifeline that runs to Pisa and the sea, when Pisa's English mercenaries stage a surprise attack (offstage) and the Battle of Cascina begins. The sturdy Florentines grab their clothes, like lovers caught frolicking in a glen, and rush to defend their city.

Michelangelo could thus play to his strongest suit, the male nude, with naturalistic justification; no need to introduce nude gods and satyrs as painters so often did. And he could suggest the drama and danger of war without showing combat outright. For all the much-noted "violence" of his contorted figures and exaggerated gestures, Michelangelo avoided the explicit violence that had spiced Renaissance art from the beginning, and which would become a mania in the next century. He showed David without Goliath's head and Judith after rather than during the beheading of Holofernes; he made Jesus' wounds nearly invisible in his *Pietàs*; and he shunned the flagellated Christ, the bristling Saint Sebastian, and other popular icons of sacred agony.

At the same time, he could deliver an especially timely message as the city girded for yet another showdown with its perennial adversary Pisa. His *Battle of Cascina* was a ringing endorsement of the citizen militia that Machiavelli craved to establish, and a warning of the dan-

gers of complacency. Or it would have been, if he'd ever gotten to paint it.

The surviving relics of Michelangelo's and Leonardo's designs leave us to mourn what might have been had this cinquecento clash of titans not ended in a double default. Leonardo, the premier artist-scientist, had no patience for fresco's rigors and limitations, and a knack for wrecking his masterpieces with technical experiments; his restless ingenuity had already nearly doomed his *Last Supper* in Milan. He painted the *Battle of Anghiari* splendidly, but in an experimental oil-and-wax medium that he derived from misreading a warning by Pliny against using encaustic (wax) on walls. When the paint would not dry, perhaps because the wall behind was damp, Leonardo set out firepots to speed it. The result was disastrous: the top of the tableau darkened badly, and the bottom melted and ran.[12] Decades later, at the direction of Florence's Duke Cosimo de' Medici, Giorgio Vasari painted over Leonardo's marred masterpiece with his own turgid but technically sound frescoes. This conveniently effaced the last traces of the republican project.

Michelangelo, who confined his innovation to design and stuck with safe techniques, had only gotten as far as drawing the enormous *cartone* for his wall when Pope Julius II summoned him to Rome and to a commission that would bedevil him for the next four decades. But the cartoon further elevated his already soaring reputation. As Vasari tells the tale (which Condivi, presumably at Michelangelo's prompting, passes over), Michelangelo finished the design as a showpiece in itself. The result was a huge hit: hung in the palazzo's Hall of the Pope, it became a mecca for charcoal-wielding pilgrims from near and far. A Who's Who of early cinquecento art, including (among many others) Raphael, Andrea del Sarto, Jacopo da Pontormo, Ridolfo Ghirlandaio, Rosso Fiorentino, and Baccio Bandinelli, came to pay homage and copy figures that, Vasari proclaims, neither "Michelangelo's hand nor any other" could ever surpass.

Unfortunately, we know the *Battle of Cascina* largely through a stiff, fussy copy of its middle section by Michelangelo's friend Aristotile (Bastiano) da Sangallo. Aristotile's version seems a contrived, overextended anatomy exercise, an assemblage of excited figures with little coherent drama. It lends credence to the jab, couched as a general admonition, that Leonardo hurled at Michelangelo: "O anatomical

painter, beware, lest in trying to reveal your nudes' emotions with too sharp a delineation of bones, sinews, and muscles you become a wooden painter."

However, the handful of surviving preparatory sketches by Michelangelo himself offer an aching contrast to Aristotile's stolid rendering and a teasing hint as to why the cartoon so awed Michelangelo's peers. Their figures are intimate and animate and at the same time monumental: sculptural in the fullest sense. Indeed, Michelangelo's *Cascina* design seems to owe more to sculpted friezes and his own *Battle of the Centaurs* than to painterly custom. It makes no more concession to landscape than his sculptures do: the rocky shelf on which its figures stand scarcely resembles the Arno's lush shores; it is a larger version of the same crisp rocks that form Michelangelo's sculptural bases. Perhaps he was relieved at not having to translate this sculptural conception into the alien medium of paint.

"COMPARISONS," the old Renaissance saying goes, "are always odious." But the High Renaissance was obsessed with *paragoni,* as comparisons are called—and it is telling that the English term "paragon," meaning an ideal example or model of excellence, stems from the same root. Rivalry is the mother of excellence, and the Renaissance extolled excellence above all else.

Michelangelo pretended, and doubtless tried, to stand aloof from such *paragoni.* But he fixated on them just as his rivals did, as when he aspired to match or surpass the ancient masters and when he agreed to duel with Leonardo on the latter's own turf. His letters, and the biographies by Condivi and Vasari, deprecate the papal architect Donato Bramante and his protégé Raphael for *their* supposed relentless (and, of course, futile) efforts to outdo, undo, and undermine the true master. "Raphael had good reason [to envy me]," Michelangelo wrote peevishly twenty-two years after that artist's early death, "since what art he had, he got from me."[13] He had no such harsh words for the sculptors of his time, perhaps because he knew none were real rivals. But he was not so sparing of the past master who was a formative influence: Donatello's work would be beyond criticism, he once told Condivi, save for its lack of finish, which made it look better from afar than close up. This is a curious remark from the master of *non finito,*

Stone carvers at their sweaty, dusty labors in their tabernacle at
the Orsanmichele, Florence's church of the guilds.

and not really apposite; many of Donatello's most famous figures
were meant to be viewed high up on Florence's duomo.

Leonardo made no pretense of eschewing odious comparisons; his
Treatise on Painting is crammed with *paragoni*, always extolling paint-
ing at sculpture's expense. His best-known brief against sculpture is
singularly prissy: that it is dirty. "The painter sits at perfect ease before
his work, nicely dressed, and lifts a light brush full of lovely colors,"
wrote this suave and courtly painter. His home "is clean and full of
lovely pictures. Often he is accompanied by musicians, or by readings
of various beautiful literary works, which are a great pleasure to listen
to without the interference or distraction of hammering and other
noises."[14] All this to relieve the "mental labors" of an art that lay at the
root of all the arts and sciences; in Leonardo's time, art and science
had not yet signed separation papers.

The sculptor's labors, by contrast, were brutish and coarse: "He
works by force of arm and blows, taking away the excessive marble or
other stone in which the figure is enclosed, an utterly mechanical ex-
ercise often accompanied by much perspiration mixed with dust that
turns to mud, with his face so pasted with marble powder, like flour,
that he looks like a baker, and covered with little chips as though

caught in a snowstorm; and his home is soiled and filled with chips and stone dust." The jibe at Michelangelo, who was both celebrated as the prince of sculptors and known for his unkempt, parsimonious ways, was unmistakable; why, he and his sweaty assistants had even been known to collapse four to a bed, like beasts in a paddock, exhausted from their rough labors.

This cheap shot seems to have been payback for an equally cheap one on Michelangelo's part. Where Michelangelo insisted he was merely a sculptor, and continued signing his letters *Michel Agniolo schultore* for fourteen years after he painted the Sistine ceiling, Leonardo claimed mastery in all the arts. "I can carry out sculpture in marble, bronze, or clay," he wrote to the duke of Milan, seeking employment. But his sculptural career proved even more star-crossed than Michelangelo's. His masterwork was to be a bronze colossus on a scale unseen since antiquity, commemorating the late Duke Francesco Sforza I. But then a French invasion overthrew the Sforza and Leonardo returned to Florence. The French soldiers gleefully used the giant clay horse he'd modeled for target practice. Michelangelo did not let Leonardo live this down. One contemporary recounted how one day several gentlemen were loitering in Florence's Palazzo Spini "debating a passage of Dante" when Leonardo and Michelangelo both chanced to pass by. The Dante fans hailed Leonardo and asked his opinion. "Michelangelo will explain it to you," Leonardo said, trying to escape. Michelangelo, thinking Leonardo was mocking him, snapped, "You explain it yourself, you who have made the design of a horse to be cast in bronze but who was unable to cast it and abandoned it in shame." No wonder Leonardo, left "red in the face by his words," held a grudge against sculptors.[15]

Leonardo also leveled a more serious brief against the sculptor's art: that it is not really his but is "created by two hands, that of nature and that of man, but much more by that of nature." Such words may seem surprising, coming from an artist-scientist who extolled the observation of nature and upheld painting because it perfected that observation. But for Leonardo, painting and study were means to master nature, not to collaborate with it.

Today, many artists think otherwise. They accept, even court, serendipity, reveal their materials, and explore those materials' intrinsic qualities rather than trying to transform them into something very different, as when Leonardo turned oil and mineral pigments into the

Mona Lisa. One artist, Andy Goldsworthy, makes sublime, ephemeral sculptures out of leaves, twigs, icicles, dirt, and other bits of landscape. He calls one of his collections *A Collaboration with Nature.*

Michelangelo showed as little interest in hills, dales, and trees as any artist of his time or since; whereas Leonardo and other contemporary painters set their subjects against detailed landscapes, he harkened back to the minimalism of earlier centuries. His landscapes are rudimentary to nonexistent, bare stages for the human drama that was his exclusive concern: rock formations recalling, in miniature, the *cave* of Carrara. Even his Garden of Eden is the same blasted landscape, with a withered tree instead of a stump. In the earlier *Doni Tondo,* he does include a rudimentary conventional landscape in the distance, but the more visible middle ground, where his signature nude youths loll, looks like a quarry pit.

Still, Michelangelo would have understood what Goldsworthy was getting at. He described his own work as a collaboration not with an abstract "nature" but with nature in its most concrete form, the stone itself, in which the *concetto* lurks. That notion, with its Neoplatonic roots, underlay his defense of sculpture, which was as absolute as Leonardo's attack on it.

THE DEBATE did not end with Leonardo's death in 1519; it reverberated for decades, becoming a fixation of Renaissance intellectuals. In 1547 the humanist scholar Benedetto Varchi surveyed leading painters and sculptors on the merits of the two arts. Not surprisingly, the sculptors tended to exalt sculpture and the painters belittled it. One painter, Jacopo da Pontormo, did salute sculpture as a "noble and everlasting" art, but then echoed Leonardo: "For this everlasting quality sculpture is indebted to the quarries of Carrara even more than to the skill of the artist. For it is there that the great masters found the marble which contributed so much to their glory and fame and the honours awarded for their skill."[16]

Michelangelo, then seventy-seven, had plainly wearied of the debate, but still would not concede the point. He recounted how he had long believed that "painting may be considered better the more it approaches relief, and relief may be considered worse the more it approaches painting," and that "sculpture is the lamp of painting,

related to it as the sun is to the moon." Not just any sculpture: "I mean by sculpture work which is fashioned by dint of taking away; what is done by adding is similar to painting."[17] Only carving deserved the name, and even filling faults in the stone compromised that principle.

Michelangelo then tipped his hat to Varchi and called for a truce: "Now having read your treatise where you state that, in philosophical terms, things that have the same end are the same, I've changed my mind. . . . It's enough that sculpture and painting spring from the same intellect, and so can make their peace and put all these disputes behind them." But it was a backhanded concession: the two arts would be equal, he declared, if "better judgment used to surmount greater difficulties, obstacles, and toil does not produce better results." But since sculpture plainly demanded greater toil and trouble than painting, it remained the superior art. And, he concluded snippily, "If the fellow who wrote that painting is nobler than sculpture"— Leonardo—"understood as little of the other things he wrote about, then my housemaid would have written much better." Sculpture and painting might make their peace, but artistic feuds were forever.

CHAPTER 8

THE TOMB OF DREAMS

I am cold, dead stone within living stone,
Disguised as a man who thinks and weeps and writes.

FRANCESCO PETRARCH, CANZONE 129

POPE JULIUS II HELD HIGH AM-
BITIONS in art patronage, as in
everything. The glory of Michelangelo's *Pietà* endured in Rome, and
the fame of his new *David* had reached there, and so it is not surpris-
ing that Julius would summon this rising star, as he did in early 1505.
And thus the *Battle of Cascina* fresco was interrupted, never to be re-
sumed—or so the tale is usually told. But there is also a little-explored
political subtext, from which a tantalizing question lingers: did anti-
republican machinations lead to the abandonment of Leonardo's and
Michelangelo's patriotic murals for the hall of Florence's Great Coun-
cil, and the eventual destruction of their traces?

The Soderini government had conceived the frescoes to inspire and
help legitimize the fragile republic. But powerful enemies were mus-
tering against it and the *gonfaloniere*—not only foreign powers and re-
gional rivals but many of Florence's own aristocrats. Soderini himself
was a scion of one of the oldest patrician families, but he refused to be
their instrument. Instead he sought to balance the interests of the
elite and popular factions and to shore up the republic's security by
raising taxes and replacing unreliable mercenaries with a citizen mili-
tia, Machiavelli's great cause. These measures alarmed his fellow

grandees, who saw him as a class traitor and loathed the democratiz-
ing institution of the Great Council.[1]

Among those disappointed patricians were three powerful banker
cousins, Jacopo, Alamanno, and Giuliano Salviati. Jacopo, enormously
wealthy, was married to Lorenzo de' Medici's daughter and thus
would be Pope Leo X's brother-in-law. (A devoted friend of Michelan-
gelo, he would also play a central role in the sculptor's vast star-
crossed San Lorenzo project for Pope Leo.) Alamanno was especially
prominent in Florentine political and cultural life; Machiavelli dedi-
cated a book to him, and after his death the historian Francesco Guic-
ciardini (who was also his son-in-law) hailed him as "without compare
the foremost man of the city." Alamanno and Jacopo had helped get
Soderini elected *gonfaloniere,* and Alamanno played a leading role in
the administration's great triumph, the reconquest of Pisa. But the
Salviati grew increasingly alarmed at the republican government's
populist turn, and found common cause with the pro-Medici diehards
who waited to tear it down. Guicciardini lamented that his own father
opposed his marrying Alamanno's daughter because Alamanno had
so "set himself against the *gonfaloniere* and begun mixing in sedition"
that a dangerous showdown seemed inevitable.[2]

As that showdown approached, Michelangelo seems to have be-
come an unwitting pawn in the rivalry between the rich banker and
the newly populist chief of state. As Florence's premier artist, he was
a valued weapon in the government's battle for hearts and minds
within the city and respect outside it; losing him would derail the *Bat-
tle of Cascina,* the bronze *David,* and other projects that Soderini envi-
sioned for him. And Alamanno Salviati may have played a pivotal,
though long overlooked, part in securing a papal commission for
Michelangelo, packing him off to Rome, and sinking Soderini's plans.

One link in the chain has long been recognized: the architect Giu-
liano da Sangallo, an old friend and mentor to Michelangelo, had
served the future Pope Julius—Giuliano della Rovere, cardinal of San
Pietro in Vincoli—for years. In 1503, when Julius ascended to the pa-
pacy and Giuliano went to kiss his feet, his old client lifted him up and
appointed him superintendent of buildings for the Vatican. Hence-
forth, Michelangelo would have an important friend at the papal
court.

Giuliano da Sangallo is widely credited with giving Julius the idea

of commissioning Michelangelo to design his tomb; he was well known for steering commissions to his old Florentine colleagues (who also tended to be the ablest artists and craftsmen in Italy), and attracted an entire Florentine expat community to Rome. But one authority suggests that Alamanno Salviati planted the idea of hiring Michelangelo.[3] Salviati certainly had the motive and the opportunity; he had known Sangallo at least since 1492, when he and his cousins funded the construction of one of Giuliano's designs. And he performed much more than a banker's usual role in closing the deal between Michelangelo and the pope—a transfer not just of funds but of allegiance.

Records uncovered in the Salviati archive[4] show that on February 25, 1505, the Salviati bank in Florence disbursed one hundred gold florins to Michelangelo on behalf of an aide to the Vatican's treasurer, Cardinal Francesco Alidosi—the first payment Michelangelo ever received from a pope, and a very generous travel allowance. Three days later he received his last payment from the republic, forty florins, the final installment for the *Battle of Cascina* cartoon. On April 28, Cardinal Alidosi sent Alamanno Salviati a draft for a thousand ducats to be disbursed as "partial payment" to Michelangelo for "a sepulchre that he is obliged to make for His Holiness." With it, Alidosi acknowledged receiving letters from Salviati attesting that Michelangelo was "a man of the greatest credibility" and declaring that "for this reason no other security is required of him," and responded that "thanks to the testimony you have given on behalf of the aforementioned Michelangelo, Our Father rests content and reposed." Though Salviati had not explicitly cosigned Michelangelo's contract with the pope, he had staked his word on the outcome, becoming in effect his guarantor. It was an extraordinary gesture, but Alamanno Salviati had a special stake in the project. Fortunately for him, he never saw how it turned out; he died long before the sepulchre reached its bitter denouement.

MICHELANGELO ARRIVED IN ROME in the midst of a papal whirlwind; in his first two years on Saint Peter's throne, Julius had embarked on a career that would prove extraordinary even by Renaissance standards. The similarities between him and Michelangelo are a favorite trope of biographers and novelists. Like Michelan-

gelo, Pope Julius was a man of ferocious energy and determination who rose from humble beginnings—his grandfather and father were fishermen—to extraordinary achievement, albeit with a very large boost of nepotism. His even more overachieving uncle Pope Sixtus IV (the namesake of the Sistine Chapel) gave cardinals' hats to Julius and five other sons and nephews. Julius, like Uncle Sixtus but unlike Michelangelo, was also a man of prodigious appetites, for food, drink, women (at least in his youth—he fathered three daughters and eventually died of syphilis), young boys (or so his enemies claimed), art, and monuments to himself. He was even more feared for his *terribilità* than Michelangelo; he kept a stick handy to knock around painters, cardinals, and other lackeys who vexed him.

It's hard to imagine such qualities in the Julius of Raphael's famous portrait: a broad-framed but weary old man, hollow-cheeked and anxious, watery eyes musing on a lifetime's sorrows. The wispy white beard of the portrait's Julius (which he did not grow until his last years) reinforces the impression of frailty, but it actually tells a very different tale. Saint Peter may have had whiskers, but his successors did not, and Julius bucked a thousand-year tradition when he grew his. Around 503 C.E. a synodal decree enjoined clerics from letting their hair or beards grow freely, and whether 'twas holier to shave or go shaggy became a flashpoint in the long dispute and eventual schism between the clean-shaven popes of Rome and the bearded patriarchs of the East. In 1119 the Council of Toulouse threatened excommunication to any cleric who "like a layman allowed hair and beard to grow."[5] But for Julius, the warrior pope, pious tradition paled against a more urgent cause, the liberation of Italy from foreign overlords and the reconquest of Bologna and the other provinces that had managed to free themselves from papal domination. And so he took up the sword and, later, set aside the razor, vowing never to shave until he had driven all invaders and occupiers from the peninsula.

IT WAS ONLY NATURAL that the pope who cast such a long shadow across Italy in the early sixteenth century would try to cast one over the centuries to come, and that he would choose marble as the medium in which to do it. Julius would later force Michelangelo to execute a giant bronze statue of his imposing self to commemorate

his conquest of Bologna. But bronze monuments were too readily prey to whims and wars—too easily melted down for bells and cannon and other useful objects, as the unbowed Bolognese would teach Julius.

Marble, by contrast, conferred at least some hope of permanence, an intimation of immortality. Expounders of nearly every faith and ideology have chosen it for their temples, both sacred and secular. It is the stone of nobility and theocracy, of democracy and plutocracy, the rock of Peter's church and of classic paganism. It is the building block of the Parthenon, the Taj Mahal, and Washington, D.C., the rock upon which the Greek miracle, the Italian Renaissance, and the neo-classical revival were built. A monument is not entirely monumental unless it is executed in marble. National icons—Lincoln and Jefferson, David and Caesar—achieve a deific dignity when carved in white stone. Marble's icy purity legitimizes erotic art, even in puritan periods; witness the innumerable languorous but divine nudes of antiquity, the Baroque age, and the Victorian neoclassical revival, which could never have been put over in wood or clay. In marble they seem chaste and sensuous at once.

Common though it is, marble has come to emblemize luxury, power, and grandeur—in architecture, art, decoration, even urban planning. Every form of political authority seeks legitimacy in marble—especially in Carrara marble, which graces every sort of prepossessing structure. Cruise ships and Manhattan penthouses, sprawling Saudi mosques and oversized busts of Saddam Hussein, Saint Peter's Basilica and Tsar Nicholas's private shrine, Bangkok's century-old Wat Benchamabophit (Temple of the Fifth King) and London's new Shri Swaminarayan Temple, the extravagant palaces of the emir of Kuwait and the president of oil-rich Gabon, the Teatro Amazonas opera house and the National Gallery of Art, the Amoco Building in Chicago and the Grand Hotel in Siem Reap, Cambodia—all flaunt their grandeur and their builders' aspirations to immortality in gleaming Carrara marble. Morocco's medieval sultans traded precious date sugar pound-for-pound for Carrara marble to line their palaces and fountains. France's monarchs tried to monopolize it; until the Revolution, white marble fell under exclusive royal prerogative and could be imported and used only with special dispensation. Napoleon was an even greater builder of monuments and consumer of marble; so precious were the Apuan

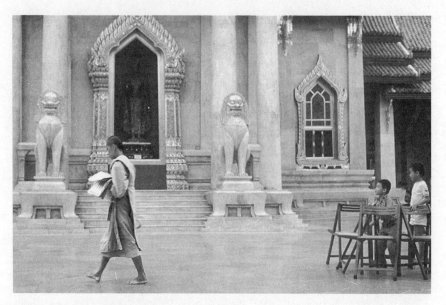

Wat Benchamabophit, Bangkok's temple of Carrara marble.

quarries to him that, to look after them, he installed his own sister Elisa as resident princess of Carrara.

Mussolini, determined to recapture the glory that was Rome, pursued marble as zealously as any other tyrant. He built a "new Rome"—EUR, Esposizione Universale di Roma, a gleaming, if grim, marble edge city—to embody Fascist ideals and host a 1942 world's fair (preempted by war). At EUR's Foro Mussolini, now the Foro Italico, he built a Stadio di Marmo ringed by sixty neoclassical marble statues of athletes. The forum's centerpiece is a stark obelisk cut from a single fifty-six-foot, three-hundred-ton block taken from the Carbonera quarry above Fantiscritti in 1926—the largest block of marble ever quarried at Carrara or anywhere else. Even today, despite their deeply anti-Fascist feelings, locals refer to it with a mixture of awe and pride as simply *"il monolito,"* the monolith. It weighed too much for any railroad, truck, or other axles to bear, and so was slowly slid down the mountain, through the city, and down to the port enclosed in a fifty-ton protective casket of timbers built around it on the spot, mounted on sled runners shaved from entire tree trunks and dragged over an unbroken succession of wooden rollers lubricated with thousands of pounds of green soap. Thousands of meters of steel cable anchored

its descent to the road, and more than sixty long-suffering oxen dragged it the rest of the way.

On the eve of war Mussolini commissioned twin *giganti,* taller and much more massive than the *David,* by Fausto Melotti, a once and future abstractionist who detoured into the Fascist version of socialist realism in the 1930s. Both were executed in Carrara's Nicoli studio, now the last of the old *laboratori* still going in the historic city core. One, a heroic male figure, was sent off to Rome. The second, *Alma Mater,* a twenty-foot matriarch sitting majestically upright, half nude, with drapery cascading over her legs and an oddly undersized toddler perched on her knee, was on its way there when fighting broke out; it sat out the war on the roadside, at which time, the client being indisposed, Gino Nicoli retrieved it. Today *Alma Mater* presides over the studio's busy *artigiani* and their clouds of marble dust, the grandest of Carrara's many orphan sculptures.

THERE IS SOMETHING about all that marble waiting in the hills that encourages grandiose notions, in sculptors and popes as in dictators. Julius's tomb was an enormous undertaking, and it would trigger a vastly larger one, the construction of Saint Peter's Basilica, the largest church in Christendom. But the record of Michelangelo's first design for it and his first trip seeking marble for it—his longest sojourn ever in Carrara—is dismayingly thin: two brief contracts he signed with local boatmen and *scarpellini* at the end of the expedition and one letter he wrote soon after. No contract, nor any sketch of the tomb, survives from that year; 1505 is Michelangelo's *annus secretus.*

What we know from Condivi and Vasari is that the tomb was first conceived as an immense marble sepulchre, twenty-five feet wide by forty deep. Inside would be an oval burial chamber with the pope's sarcophagus in the middle. Outside, the tomb's first level would present a panorama of subjugation that cannot help but convey sadomasochistic overtones today. Eight arched niches, two on each side, would apparently contain triumphant robed, winged female Victories standing above collapsed or cringing male nudes.[6] These niches would be flanked by herms, architectural and ornamental busts emerging from the wall and supporting the cornice above—a motif associated with Terminus, the god of death, as befits a tomb. The herm heads,

beardless and youthful in one surviving drawing of an early design, became bearded, aged, and grotesque in the truncated version of the tomb that was finally assembled four decades later—an indication perhaps of Michelangelo's changing attitude toward the project.

Beneath the herms and beside the niches, the nude *prigionieri*—variously translated as "Prisoners," "Captives," or, evocatively if less accurately, "Slaves"—were to writhe in contorted agony on projecting pedestals. Condivi, writing for Michelangelo, says these represented the liberal and plastic arts, "denoting that all virtuosity is death's captive, together with Pope Julius, and no one will ever favor it and nourish it as he did." Vasari, who as Cosimo I's court artist was more attuned to tyrannical prerogatives, offers another, unsupported and implausible explanation: that the Captives represented "all the provinces subjugated by this pontiff" while some other, unidentified statues stood for the "ingenious arts," prisoners of death like the pontiff who nurtured them.

Above the cornice, at the corners of the ascending, receding structure, four larger sculptures were to sit: Moses, Saint Paul, and female figures representing the Active Life (appropriate for Julius) and the Contemplative Life, framed by putti-shaped caryatids. The surviving descriptions mention no effigy of the pope himself, though one seems to have been planned for the top: a *scarpellino* in Carrara would report to Michelangelo three years later that the block for a pope had been roughed out.[7]

The whole scheme, radically unlike anything built since the fall of Rome, was both wildly ambitious and novel to the point of heresy. In contrast to the wall tombs and sarcophagi to which popes and other illustrious Christians were usually consigned, Michelangelo's freestanding structure was nothing less than a pagan temple, a sepulchre for an emperor, to be erected inside the very heart of Christendom. The warrior pope applauded. Michelangelo agreed to complete the project in five years, for ten thousand ducats. This meant producing an average of eight sculptures a year, on top of procuring the marble, designing the structure, and supervising the construction. Even he could not work stone that fast. For the first time, he would have to assemble a crew and share the creative work he had always jealously guarded. But Michelangelo was no Ghirlandaio, and such delegating was not in his nature.

* * *

STILL, HE WORKED at lightning speed at the design, as he always did when seized with an idea. Condivi recounts that Julius was so pleased he at once sent Michelangelo to Carrara to quarry the necessary marble and advanced him one thousand ducats. By June 30, 1505, less than three months after leaving Florence, Michelangelo returned and deposited six hundred ducats there. He then pushed on to Carrara.

The Carrara Michelangelo found in the early sixteenth century was a much wilder, more pristine place than the one that awaits footloose sculptors today. Today the Carrione is a walled, dredged, and battered waterway. It flows white over all the marble scrap discarded by the sawing and shaping mills, then dark with the trash dumped from homes; the only fish anywhere near it are carved on marble fountains. But in 1514 it was still a living stream; the vicar of Carrara opened legal proceedings "on the abusive fishing of trout in the Carrione by certain Carrarese."[8]

The wild surroundings and mountain air went to Michelangelo's head. The accounts of this time are skimpy, but include one of the most resonant anecdotes in Condivi's entire *Life:*

> Michelangelo stayed in those mountains with two assistants and a mount, but with no provision other than foodstuffs, for over eight months. While there, he looked out one day over the whole expanse from a mountain that rises above the coast and conceived the idea of making a colossus that would be visible to mariners far out at sea. He was encouraged in his notion by the enormous mass of rock, which could be easily carved, and by the example of the ancients who, perhaps moved just as Michelangelo was after landing upon some opportune spot, or perhaps to escape idleness or for who knows what reason, left their own rough-carved memorials as mementos of their work.

Vasari one-ups Condivi by writing that Michelangelo "conceived many fantastic ideas for carving giant statues in the quarries, in order to leave there a memorial of himself, as the ancients had done."

It's not clear which "ancients" Condivi and Vasari meant. Perhaps Michelangelo was inspired by Chares' famous bronze Colossus of

Rhodes, one of the Seven Wonders of the World, or Zenodorus's enormous marble statue of Nero, which, Pliny reports improbably, stood more than a hundred feet high. But he would more likely have recalled the third century B.C.E. architect Dinocrates, who, as the architectural writer Marcus Vitruvius tells it, got Alexander the Great's attention by approaching him dressed as Hercules, club in hand and lion skin over his shoulder. When Alexander asked who this strange interloper was, Dinocrates replied, "A Macedonian architect who suggests schemes and designs worthy of your royal renown. I propose to form Mount Athos into the statue of a man holding a spacious city in his left hand, and in his right a huge cup, into which shall be collected all the streams of the mountain, which shall then be poured into the sea." The man thus depicted would, of course, be Alexander, who liked the idea; his image, atop a holy mountain at the tip of a Thessalonikan peninsula jutting into the Aegean Sea, would be visible as no other monument in the world. Alexander even foresaw a city growing below, but abandoned the scheme upon discovering that the land was too poor to support one, and instead had Dinocrates design a new city—today's Alexandria—in Egypt.[9]

Michelangelo, by contrast, never approached his papal patrons with proposals to carve their portraits atop Carrara's Monte Sagro. Indeed, when Pope Clement VII proposed erecting a fifty-foot colossus opposite the Medici Church of San Lorenzo, Michelangelo shot the idea down with the sort of sarcasm only he dared hurl at popes. Why not make it a sitting figure, he modestly proposed, hollowed out underneath to make room for a barbershop, which would help defray the expense? A cornucopia in the statue's hand could serve as the barbershop's chimney and hold a "handsome dovecot," and its hollow head could be a bell tower.[10] Thus he made his point, that what might be bold and heroic carved from a mountaintop would seem cheesy and overbearing erected in the middle of the city. Clement dropped the idea.

On his Florentine home turf, Michelangelo could be coldly critical and judicious, but in the mountains his fantasies soared. The nakedness of the marble slopes, the ways they have been stripped and hacked and faceted over the centuries, leaving their skeletal structure and musculature as visible as one of Michelangelo's hyperanatomical drawings, would surely have appealed to an artist as indifferent to lush

trees and verdant hills as he was to rich robes. At Carrara, Michelangelo found the geomorphic equivalent of the human nude that was the first and last subject of his art. Just as he saw God's will revealed in the human form, so he would have seen man's at work in the quarryscape.

Michelangelo never made his Rushmore, but he seems to have carved a smaller memento of his sojourns here in the side of the mountain, where another carver had gone long before. In the first century C.E., a slave *scarpellino* carved a curious bas-relief on a cutaway rock face overlooking the busy quarry at the middle of the Miseglia basin, the very center of Carrara's marble zone. It shows three figures, Hercules, Jupiter, and Bacchus, standing between incised columns suggesting a temple. Such votive reliefs, called *aediculae,* were common in the quarries; the slaves would pray to them on the way to their labors, soliciting Hercules' strength and Jove's wisdom to see them through and Bacchus's grace to soothe their weariness afterward, just as modern *cavatori* erect shrines to the Virgin Mary. Slaves, empires, marble barons, and divine sculptors came and went, but the *aedicula* survived,

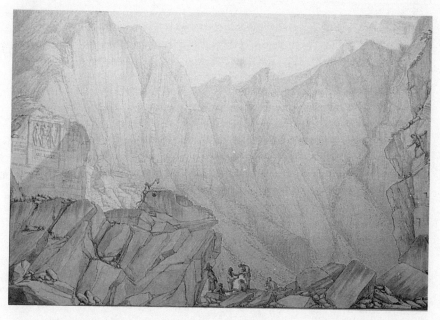

The Fantiscritti *aedicula* (left) at its original quarry site, as viewed by Saviero Salvioni in the early nineteenth century.

barely. Finally, in 1863, it was "preserved from total ruin," as its plaque says, and removed to the courtyard of Carrara's Accademia di Belle Arti.

By then it had given its name to the quarry where it stood: Fanti-scritti, Carrarino for "children" *(infanti)* and "writing." The *fanti* are the three squat, pint-size divinities, carved by amateur hands. The *scritti* are the jumbled signatures carved below and to the side by generations of sculptors on their way to the marble beds. They include some of the most illustrious tags in the history of graffiti: "Bernini," "Canova 1800" (a rough, sprawling scrawl), "Gio·Bolo·1595" (Giambologna's meticu-lous Roman letters), and those of scores of other sculptors.

The smallest signature is also the oldest, set between the club and the leg of Florence's hero Hercules: the characteristic "MB," with the right leg of the *M* forming the stem of the *B,* of Michelangelo Buonar-roti. He seems to have inaugurated the graffiti tradition—if he actu-ally carved his initials, rather than some later fan. And if he didn't, as the Accademia's custodian, Roberto Maggiani, says, *"È una bella sto-ria."* It's a beautiful story.[11]

NEARLY FIFTY YEARS LATER, Michelangelo was still plainly sensitive to the suggestion that he had come unhinged amidst the Apuan peaks. Next to the passage describing his megalomanic vision in Condivi's newly printed biography, he dictated a margin note: "This was, they say, a madness that came over me, so to speak. But if I could be sure of living four times as long as I have, it's there I would attempt this."[12]

He wasn't the last artist to succumb to "madness" amidst these mountains; Carrara brings out the inner visionary, eccentric, or crack-pot in many whom the marble lures. "It's never-never land," says Jena-marie Filaccio, a sculptor from Youngstown, Ohio, who landed here in the 1970s and became the first woman to labor with saw and chisel in the marble workshops. After two decades she fled to nearby La Spezia, a more conventional city that depends for its living on a naval base rather than surreal quarries. "I had to get away," she explains. "Carrara is just too overwhelming. You let yourself go there, forget about your health. You get a serious injury and you don't do anything about it for months. I think it has to do with the mountains being so close to the sea, the crosscurrents. The energy is overwhelming."

Others speak of the same sea-meets-mountains effect—and not just expat artists. I get to chatting with a sober businessman named Giovanni Manconi outside the plant in Avenza where he manufactures stone-working glues and abrasives. He glances dreamily up at the white mountains looming to the east and then down toward the ocean shore a half mile to the west. "They're beautiful today, aren't they?" he muses. "You know, a hundred and fifty years ago the sea used to come right up to this wall. There aren't many places in this world where the mountains and the sea come so close to each other. There's everything here. Your mind can wander—you can travel everywhere without ever leaving here." Beneath the breast of every hardheaded man of marble there beats the heart of a romantic.

Carrara wears its heart and its history on its walls, in the best and worst ways. Graffiti pocks nearly every accessible downtown surface, even City Hall—a mixture of pseudo–hip-hop tags, circle-A anarchist emblems, anti-Fascist and antiglobalist slogans, and the traditional *"Ti amo, Silvia"* sort of vows. Usually, however, the graffitists tend to spare statues and other stonework; there is some honor among vandals, and Carrara's still respect its distinctive legacy.

That legacy is writ in marble, in the scores of commemorative *lapidi* (plaques), votive icons, and strange statues that adorn nearly every suitable wall and semblance of a piazza in old Carrara. Many have landed by chance, the cast-asides and unfinished efforts of sculptors old and modern, but together they compose a sprawling chronicle. The first chapter is a single block along the ancient Via Carriona, the quarry road, where it joins the Torrente Carrione, which also plunges down from the quarries. It opens with an unfinished Roman statue set into the remains of the medieval city wall, which locals call *il Cavallo* or, in Carrarino, *il Cavàd,* "the Horse." Its rider, Marcus Curtius, was a young Roman of the early republic who made the ultimate civic sacrifice but did not endear himself to animal rightists. Sometime around 393 B.C.E., as Livy tells it, a fiery pit opened in the forum and threatened to swallow Rome. Curtius, with his horse, leapt in. The hellfires, having consumed Rome's best and bravest, were sated, and the pit closed up.

The *cavatori* adopted Curzio (as he's called in Italian) as a pagan patron saint and added another twist to his story: During the time of "one of the most vile and greedy of all the emperors," Curzio was a

soldier overseeing the wretched quarry slaves. He took their side and was clapped in irons himself. The gods, fed up with Rome's iniquity, opened the fiery pit, and out of it spread pestilence, all the way to Carrara. Curzio piped up from the galley that he knew how to save the empire from a well-deserved end.[13] His sacrifice, for the land that persecuted him, appealed especially to the Carrarese sense of doomed gallantry.

For centuries ox drivers tipped their hats to Marco Curzio as they trudged to and from the quarries. Now their descendants, driving sixteen-wheeled trucks, have been rerouted to more roundabout roads because their weight made the pavement crumble and the roads impassable. In their place, tourists hurtle past by the busful after seeing a quarry and buying their souvenirs, and do not notice *il Cavallo* at all.

One constituency attends devotedly to Carrara's outdoor marble gallery: the local anarchists, who each May 1 parade in a red-and-black-scarved mass through town. They sing the old songs and perform their answer to the Stations of the Cross, hanging a red-ribboned wreath at each of the many statues and *lapidi* that honor local labor heroes and anti-Fascist martyrs. One of the proudest shrines hangs just down Via Carriona from Marco Curzio, a stark bas-relief honoring Gisella Bianchi Lazzeri and Renato Lazzeri, "mother and son, murdered here by the Fascists on July 2, 1921," in a confrontation that began when a Blackshirt gang tore a red flower, a socialist symbol, from Renato's sister's lapel. "They lost their lives, and the people of Italy their freedom for the next twenty years."

Across the street, a bizarre trio of carved figures, muscular African men, who seem to wail and strain against their humble servitude: holding up the iron balcony of the apartment above. These bizarre caryatids, pint-size echoes of Michelangelo's *Captives*, are said to be models for "the Four Moors," four chained slaves in bronze, representing the four corners of the world, that Pietro Tacca carved for the monument to Tuscany's Duke Ferdinando I at Livorno.

A HALF BLOCK FARTHER, sitting above a clamshell fountain by the Bridge of Tears, is another sculpture, not as old as *il Cavallo* but even more worn. *La Sirena*, as it's called, was one of a slew of monuments and fountains erected during the sixteenth-century boom years. The

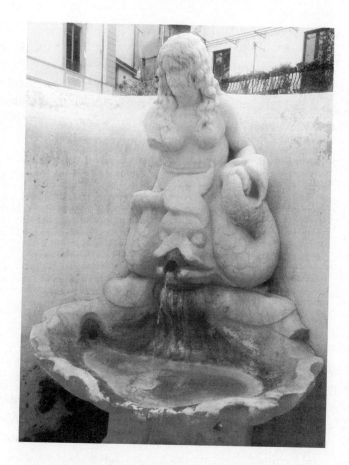

La Sirena, the discarded statue that inspired a myth.

old story behind it, still told to children today, grows out of the meeting of sea and mountains that so unnerved Jenamarie Filaccio. "It is a beautiful story at first, and sad in the end," notes Gemignani, who transcribed one version of it, "like so many stories about Carrara."[14]

The first *carrarino*, it seems, was an Etruscan soothsayer named Aronte, whom Dante mentions in his *Inferno* and who the Roman poet Lucan recounts was the only soul to remain at Luna when it was caught up in the war between Pompey and Julius Caesar.[15] As the story is told in Carrara, Aronte lived in a grotto above Fantiscritti, from which he could see "everything beautiful in the earth, the sea, and the sky." One day a siren swam up the then-limpid Carrione from

the sea and happened upon him. It was love at first sight, and they would have lived happily ever after, save for one hitch that it didn't take a soothsayer's powers to foresee: sirens don't age, but Aronte did.

Meanwhile, the siren's distraught mother learned where her daughter had gone and sent a fish to fetch her back. This finned messenger found the siren sitting beside a withered, snoring old man. At first she resisted her mother's summons, but when she looked at Aronte he seemed more decrepit than ever, and so she bade him a silent farewell and set off atop the fish. When she reached the future site of Carrara, the great god Jove appeared and asked why she'd left her husband.

"He's too old to go anywhere, and I'm through with him," she replied.

"How dare you leave a poor old man alone and miserable?" thundered Jove, and turned siren and fish into marble. And there they stand today, beside the stone span called the Bridge of Tears.

Aronte's story is a cautionary tale for every older man who flings himself after youthful beauty. Perhaps it had special poignance for the *cavatori*—prematurely aged by their labors, injuries, wine, and tobacco—and the wives who outlasted them.

The marble trade has worn hard on Carrara as well; it displays the usual dilapidation of old industrial towns, multiplied many centuries over. The stone walls of the medieval houses that crowd the Via Carriona ripple like a Looney Tunes landscape from the pounding, until 2003, of nine hundred heavy trucks a day. Tourists have called Carrara a dump at least since 1728, when the French jurist and philosopher Montesquieu spent one night here. Its "subjects are the most brutal and worst governed of all peoples," he complained afterward. "I saw not one person, neither man, woman, nor child, who was not of a matchless vulgarity. The Prince parades around like one of the princes on our stages. I would rather be an infantry captain in the service of the king of France or Spain than this miserable prince."[16] The expat German painter Georg Christoph Martini, who visited around the same time, found one thing to admire at Carrara's ducal palace: the marble tables. By contrast, when he visited the nearby marchese of Fosdinovo, Martini gushed over his villa's frescoes and fountain, his "magnificently appointed table," his silver jacket "in the latest style," and the "optimal education, good manners, and adult conversation" of his young children.[17]

A century later, Charles Dickens found Carrara "very bold and picturesque," in a harsh and (especially for the marble-hauling oxen) brutal way, but noted that "few tourists stayed." He visited "a great workshop, full of beautifully finished copies in marble," and marveled that these "exquisite shapes" could "grow out of all this toil, and sweat, and torture! But I soon found a parallel to it, and an explanation of it, in every virtue that springs up in miserable ground, and every good thing that has its birth in sorrow and distress."[18]

Even then, it took the omnivorous optimism of a Dickens to see the diamond in Carrara's rough setting. Today central Carrara has just one aged, if funkily charming, three-star inn (the Hotel Michelangelo, of course, operated by a genial, cultured gnome named Luciano Lattanzi); most tourists stay at the beach resorts to the south and zip up for a quick quarry tour. Cosmopolitan Carrarese compare their town's condition to the tidy showpieces that nearby Pietrasanta and Sarzana have made of themselves, shake their heads, and mutter, *"Carrara non è valorizzata."* It's a phrase with multiple meanings, any of which fits: Carrara isn't improved. Carrara isn't developed. Carrara isn't appreciated.

HOW UNDERAPPRECIATED Carrara's architectural and cultural legacies are comes clear in the secret chambers of the Palazzo del Medico, the seventeenth-century palace of Carrara's richest marble clan in the centuries after Michelangelo and, in the early nineteenth century, a love nest for Maria Beatrice d'Este, Duchess of Modena and de facto "queen" of Carrara. Even most Carrarese have not seen this strange treasure; I learned of it only because I happened to run into Ruggiero early one evening as he made his *cantina* rounds.

Ruggiero is a classic Carrara *figura;* in autumn he roasts and sells chestnuts on the concourse beside the Accademia, and the rest of the year he spreads good cheer and a little verse around the *cantine.* *"Il Signore delle Castagne"*—the Lord of the Chestnuts—I joke when I meet him, and he replies, "No, I'm the Lord of the Rings!" In fact, he evokes three Tolkien types: he has an elfin manner, a hobbit's height, and a wizard's billowing white beard and mane. He lived in Paradiso, Amsterdam's Haight-Ashbury, in the early seventies and wandered two years as a sadhu through India. He loves the French Symbolists, Amer-

ican Beats, classic rock, wild mushrooms, and Vedantic Hinduism. ("Not Brahmanism! That's just like the Catholic Church—organized religion.") When he learns I'm American, he recites the opening of Ginsberg's *Howl* in accented English.

Once, on a chance meeting, Ruggiero invited me to have a glass in a different sort of place, and strode over the cobblestones to the Piazza Alberica, Carrara's grandest piazza. There an immense timber door opened into a carriage-sized landing lit by a faint bulb that flickered more off than on. We felt our way up a dark stone stairway to the *piano nobile* and turned into a once-grand hallway covered by decorative frescoes and the remains of sculpted heraldic shields, ripped from their frames. The frescoed plaster was scorched, cracked, and here and there ripped away, exposing the wattling behind—the result, I later learned, of a bombing back in Red Brigade days. Inside was a plain, sprawling room, painted livid turquoise and peacock blue, filled with folding tables and pool tables, with a small bar in one corner and a large-screen TV, a bingo-ball cage, and karaoke sound system in another. This is the modern addition to the palace, an all-purpose popular entertainment center.

Off to one side, through an inserted glass door, are the palace's original drawing rooms, in nearly original condition: a regal eruption of fresco, plaster relief, and—everywhere, and in every possible color and shape—marble. Red, black, gray, green, gold marble, all heavily veined, spins in dizzy juxtapositions, capped by gleaming carvings in *bianco Carrara*—a decor worthy of the most Baroque Roman church. In a normal town, these rooms might have a ticket taker and be on the tourist maps. Here they are overflow rooms for the bingo/karaoke club. In the evening the large young Sicilian family that runs the karaoke/bingo/pool hall gathered beneath the regal decor around an enormous bowl of spaghetti. Whoever chipped in five euros could join the feed, and in the heartfelt a cappella singing session that followed. Dickens would be delighted.

Yes, says Andrea, the family's head, this is a gem that should be preserved. But as far as he knows, the *beni culturali* (cultural resources) officials have never come to see it. It's in Carrara, and forgotten.

THE BROTHERHOOD
OF STONE

A STONEMASON, AND YES, IF YOU WILL, A COLOSSAL
STONEMASON, BUT NOTHING MORE!

EMILE ZOLA, *Rome*

L ONG BEFORE MICHELANGELO passed through these moun-
tains, another genius given to passionate flights and bitter resent-
ments washed up here and saw his soul's tortured geography
embodied in the Apuan quarries. The most conspicuous evidence that
Dante Alighieri passed this way lies above a spectacle worthy of his
pen, alongside the road from Carrara to Colonnata: a sheer drop hun-
dreds of feet deep to a dark pit echoing with strange gurgles and
grinding. This is Calagio, one of the deepest quarry pits in the
Apuans, reachable by a spidery elevator precariously attached to the
rock wall. Opposite rises another sheer cliff of white stone, hatched
with black stains and wiry heather, higher than the eye can see. There,
suspended at eye level, hangs a ten-foot slab detailed to resemble
parchment, on which these lines are meticulously incised in classic
Roman letters (and of course in the original Tuscan):

> *Aronte it was who in the depths that lie*
> *Beneath the peaks of Luni, quarried by*
> *The Carrarese who dwell below,*

Had a cavern of white marble for his home,
Where, free to view the stars and sea,
His sight, unblocked, could roam.[1]

This stanza, invoking the Etruscan soothsayer (and the siren's un-lucky husband) Aronte, is from the twentieth canto of the *Inferno*, the first book of Dante's *Divine Comedy*, a poem that Michelangelo, like many of his contemporaries, knew deeply and revered. Never did a poet's words enjoy a grander or more appropriate setting. Erberto Galeotti, Calagio's then-owner, hung the giant plaque in the late 1990s. Why did he go to such trouble and expense over a scrap of verse? "Because he wrote about Carrara!" Galeotti replied, and there was nothing more to say.

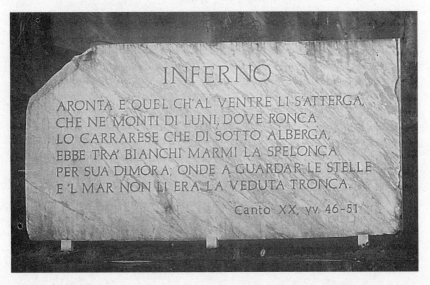

Dante's Carrara verse, hanging above the stygian depths of Cava Calagio.

Dante did not spin his description of Carrara from imagination or old books, as he did other passages of the *Divine Comedy*. He actually saw caverns open to "the sea and stars" in 1306, in the midst of his long exile from Florence. He had been a prior of the republic when violence erupted between the two factions of the ruling Guelph party—the pro-constitutional, antipapal burghers called White Guelphs (Dante's fac-tion) and the aristocratic, propapal Black Guelphs. Dante and his fellow

councillors tried to make peace by banishing troublemakers on both sides—including, to show fairness, his friend and mentor Guido Cavalcanti, to whom he had dedicated his first book. The pope nevertheless sent a French force, which restored the Blacks to power. Dante was dispossessed and exiled in 1304, on pain of burning if he returned. He drifted to Bologna, Verona, and Trevino, and finally found refuge for a year or so in Lunigiana. He followed in the steps of Cavalcanti himself, whose exile was even unluckier: Cavalcanti caught a fatal case of malaria in the marshes of Luni and was allowed to return to Florence to die.

Despite this unhappy precedent, Dante's sojourn on the Magra would prove vital to the creation of the greatest poem in the Italian—many believe in any—language. Most of the Malaspina marchesi were of the feudal, pro-imperial Ghibelline party, which battled the Guelphs throughout central Italy. But they nevertheless took Dante into their castles at Sarzana, Mulazzo, Giovagallo, and, likely, other fastnesses.[2] Fosdinovo, one of the largest and best-preserved Malaspina castles, spectacularly sited atop an Apuan foothill just six miles north of Carrara, flaunts its Malaspina and "Dante Slept Here" connections with special pride—even though Dante seems to have spent just one night there and the Malaspina didn't acquire the castle until thirty-four years later. But that date, October 6, 1306, was a big day for the Malaspina and a triumph for Dante, whose political skills proved more successful here than in Florence. The Malaspina had for decades fought the bishop-counts of Luni for control of Sarzana, Carrara, and other territories. Marchese Franceschino Malaspina, together with his cousins Moroello and Currado, deputed Dante to negotiate a peace. Off the new-minted emissary rode to the bishop's seat at nearby Castelnuovo Magra, which still presides over the hills north of Carrara. The terms Dante won favored the Malaspina strongly, setting the stage for their rise to regional supremacy, their enlargement of the Carrara marble trade, and, two centuries later, their hosting of another peripatetic Florentine, Michelangelo Buonarroti.

Afterward, the story goes, the diplomatic poet stopped for a night at Fosdinovo and inscribed an immortal stanza or two before hitting the sack. The room and bed in which he supposedly slept are still preserved as though he'd just gone down for breakfast, though the furniture appears newer. A bust of Dante tops the writing desk, and a small

fresco of the resurrection with a Malaspina devotee fills one niche. A series of much larger nineteenth-century frescoes in the castle's banquet hall recounts his local diplomatic exploits. But it was to his purported bedroom that a group of spiritualists from Rome trekked, several decades back, in a quest to raise his ghost. The newspapers reported that one séance brought loud rapping on a door, but no one was there. Finally, Dante appeared and, never one to lack for words, "replied after scarcely being begged, naturally in the vulgar tongue, to many difficult questions."[3]

Dante stayed much longer with Moroello Malaspina at his castle of Giovagallo, and developed a friendship that bridged a wide political chasm. Moroello was not only a member of the rival Black Guelph faction but one of its mightiest captains, whose exploits earned him the spooky sobriquet *Vapor di Magra* and indirectly caused Dante's misfortunes. He led the Black Guelphs to victory over the Florentine Whites in a bitter battle at Campo Piceno and conquered the important Florentine satellite of Pistoia. This upset toppled the Florentine government in which Dante served, causing his dispossession and banishment.

Perhaps Dante's famous susceptibility to female charms helped bridge the factional gap; he was taken with Moroello's wife, Alagia, whom he salutes in the *Purgatorio*. There the spirit of her uncle Pope Adrian V tells him,

> *I have a niece above who's named Alagia,*
> *who is good herself, so long as our house*
> *Does not change her by its vile example;*
> *And only she is left to me up there.*[4]

Poetry itself was a bridge across the political gulf. Moroello seems to have cherished some aspirations in that line; one sonnet survives under his name, though some scholars credit Dante with writing it for him.[5] But whether or not he versified himself, Moroello performed an incalculable service to poetry, posterity, and Dante: he helped save the *Divina Commedia* from the ash heap of lost literary projects.

When Dante fled Florence, he had written only the first seven cantos of his epic of midlife crisis. As another great author, Giovanni Boccaccio, recounted soon afterward, Dante hid these in a chest "in some

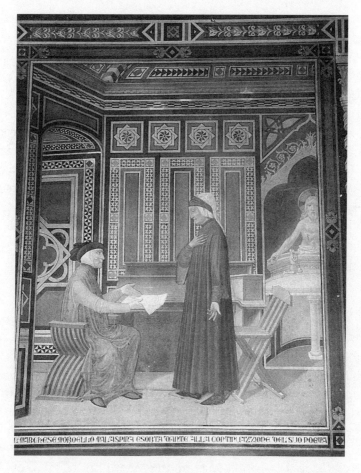

Moroello Malaspina restores the lost cantos of the *Inferno*
to Dante, in a modern fresco at Fosdinovo castle.

church or other" but believed them lost, like so much else in those tur-
bulent times. One of his friends, who was helping his wife search for
documents that might enable her to reclaim her dowry from his
seized property, found the notebook containing the cantos and, puz-
zled, showed it to another friend, the poet Dino Frescobaldi. Fres-
cobaldi sent it along to Moroello, who read it eagerly. Being "a man
of great understanding," he then summoned Dante and asked if he
knew whose work it was. When Dante claimed it, "the Marchese
begged him not to leave so sublime a beginning without a satisfactory
end." Dante rejoiced and, though he had, in despair at losing his mas-

terwork, "completely abandoned the great vision I had," he vowed to "try to recall my first conception, and proceed as I am granted the grace to do so."[6]

It's not surprising, then, that according to another of Dante's friends, the friar Ilario, he intended to dedicate the *Purgatorio* to Moroello Malaspina.[7] That dedication seems to have fallen by the editorial wayside, but in the *Inferno*, Dante heaps praise on Moroello's martial accomplishments—praise that rings all the louder because it rises from the depths of hell. There, Dante forces the sacrilegious thief Vanni Fucci to confess his crimes, and Vanni pays him back by prophesying the overthrow of Dante's faction by the mighty

> *Vapor of the Magra Vale, unleashed by Mars*
> *and wrapped in troubled clouds,*
> *who like a bitter and violent storm,*
> *will rage upon Campo Piceno,*
> *where suddenly the fog will break,*
> *leaving every White Guelph bloodied.*
> *I say this for the ill I owe to you!*[8]

Strange praise, perhaps, for the kind host who's rescued your life's work, but it seems the sort of praise the Malaspina—"great fighters and generous hosts and patrons of poetry" in one historian's words[9]—could appreciate. And anyone who has basked in December and then shivered through a wintry May on the Magra can testify that Dante knew the "troubled clouds" and "bitter and violent storms" of the local weather.

An arc of reconciliation and redemption runs through Dante's complex relationship with Moroello Malaspina. This theme is reinforced in the eighth book of the *Purgatorio,* where, among the souls saved from damnation by late conversions, Dante meets one who blesses his journey and then identifies himself as Currado Malaspina, cousin to Moroello and Franceschino. Currado asks Dante for "tidings from the Magra Vale and the lands nearby" and sends his love, "here purified," to his kin there. Dante declares that he's never been there (his passage through purgatory occurs seven years before he writes of it), but gushes over Lunigiana and the Malaspina, whose renown has traveled "through all of Europe":

The fame of your house proclaims
The glory of its lords and land alike,
Even to those who've never seen them.
And I swear, as I hope to rise on high,
that your honorable clan never neglects
the glory of the purse and sword.
Use and nature so favor them that even if
their vile chief [the emperor] bends the world askew,
still they walk straight and scorn the evil way.[10]

Currado, overcome, replies that before seven years have passed, Dante will gain a deeper sense of these matters than sermons can convey. Sure enough, in seven years he will be a refugee in Lunigiana, taken in by the Malaspina.

SOME PASSIONATE READERS have seen in Dante's many allusions to both the Malaspina and the lands they ruled a blueprint for the geography of the *Divine Comedy*. Gabriele d'Annunzio argued that Dante modeled the nine subterranean rings of hell on the quarries where "the Carrarese dig up the earth," which even in his day were an epic earthwork. After looking into the stygian pit of Calagio, I can believe it—but the *Purgatorio* shows more specific correspondences to the Apuan region.

The resemblances arise even before Dante and Virgil begin to climb Purgatory Mountain. Approaching it, Dante marvels at the soaring cliff, so steep that "the most wild and rocky waste between Lerici and Turbia is an open, easy stairway in comparison." Lerici, a cliffside fishing village turned resort, lies across the Magra River from Carrara, on the aptly named Gulf of Poets; five centuries later Shelley and Byron, another generation's itinerant laureates, would sojourn there, and Shelley would drown while trying to sail back from Livorno. After this purgative hike Dante crosses the Valley of the Princes—corresponding to the Magra Valley, with its many Malaspina marchesi—and meets Currado Malaspina. He then passes through the gate of purgatory proper, just as passing through the natural gateway of Carrara brings the traveler into the Apuan marble mountains. He finds himself on a terrace below a sheer bank rising "three times the height of a hu-

man body" and stretching far as the eye can see—a fair description of Carrara's quarry terraces. It is formed "of clear white marble and adorned with such carvings as would put not only Polykleitos [the great Greek sculptor] but nature herself to shame."

Above and beyond these explicit references, the local scholar Livio Galanti has compiled a host of less obvious correspondences between Dante's purgatory and Carrara's environs. Galanti compares the metaphysical "waiting room" of *antipurgatorio,* where penitent souls gather before ascending the mountain, to the Malaspina court, where Dante retreated again in 1312 to wait for the emperor's forces to depart so he could return to Florence. He equates the beach where Dante meets the Roman stoic Cato and the beaches where Carrara's marble was shipped overseas. And he identifies Dante's description in canto four of peasants blocking the holes in the hedges around their ripe grapes with pitchforkfuls of brambles as a characteristic trick of the Magra Valley peasants. Finally, Galanti reaches an ambitious conclusion: that Dante wrote the first eight cantos of the *Purgatorio* during his second sojourn in Lunigiana in 1313.

But perhaps the linchpin reference is the line in which Dante salutes the generosity of the Malaspina, who "never neglect the glory of the purse." My cousin Luigi, who as a Jehovah's Witness holds little truck with the Catholic superstitions that infected Dante, has another theory. "It's a good thing Dante ate well when he stayed with the Malaspina. Otherwise he'd have put Currado in hell instead of purgatory."

The Carrarese have handed down their own tales about the inspiration Dante drew from his local visits. One concerns the night he spent in Gragnana, a village on the high road from Carrara to Fosdinovo whose residents are renowned for being even tougher and harder-headed than all the other tough, hardheaded people in this region. The next morning, the observant poet saw a load of bricks fall on one thick-skulled Gragnanese, who rose grinning as though nothing had happened, inspiring the epigraph on a marble plaque found in Gragnana: "Here lived and died the hardest man in the world."[11]

Dante was sharp, one *carrarino* folk tale says, but Michelangelo was even sharper—"the smartest of all foreigners." When he lived in Carrara, Michelangelo would go out drinking and eating with the *scarpellini* and ox drivers he'd been working with all day. Because "the

Carrarese like to take everyone's measure," they would test his renowned memory with tricky questions.

One night over dinner, Michelangelo and his quarry buddies fell to debating how best to prepare cabbage. The innkeeper jotted down each one's preference: boiled, fried, stuffed, baked, raw, al dente . . . Twenty years later, Michelangelo returned to Carrara for marble and wound up at the same inn with the same crew. The host mischievously asked him how each would like his cabbage prepared. "Boiled for him," replied Michelangelo without batting an eye, "fried for him, and stuffed. . . ."

"*Porcoboia!* Son of a bitch!" the innkeeper exclaimed. Michelangelo had proven even wiser than the great Dante.[12]

IT SEEMS INCONGRUOUS to imagine the Divine Michelangelo, protégé of Lorenzo de' Medici and creator of the lofty *Moses* and *David*, debating the subtleties of cabbage with his fellow stone workers. But it's very much part of the picture of a man who, long before he landed at the Medici table and the papal court, was fostered in a *scarpellino's* home, and whose class standing was often anxious and ambiguous.

Michelangelo could be a dreadful snob and social climber, a quality inherited from his proudly idle, shabby-genteel father and sharpened by his own fierce ambition. And so with little basis he claimed descent from the illustrious counts of Canossa, rulers of Tuscany three centuries earlier. This would have made him a descendant or relation of one of the leading figures of the Middle Ages, Matilda of Canossa, "the Great Countess," who ruled half of Italy, held off imperial armies, donated the Papal States to the Vatican, and was hailed as both a warrior and a saint.[13] Some scholars identify her with the enigmatic *"bella donna"* Matelda, the radiant embodiment of the perfected earthly life whom Dante describes meeting in the Edenic garden atop Purgatory Mountain.[14] Michelangelo chose his ancestors well.

He also labored feverishly to elevate the social stature of his family. At first he had his family invest his earnings in farmland around Florence, for income. When his fortune was secure, however, he instructed his nephew and heir Lionardo to buy a mansion in the old Santa Croce neighborhood, since "an imposing house in the city redounds much more to one's credit, because it is more in evidence than

farm lands, since we are, after all, citizens descended from a very no-
ble family. I have always striven to resuscitate our house, but I have not
had brothers worthy of this."¹⁵ In his assumed role of paterfamilias,
he demanded that his brother Gismondo stop "making a peasant of
himself"¹⁶ and leave the farm where he had found rustic contentment,
"so that it will no longer be said, to my great shame, that I have a
brother at Settignano who trudges behind oxen."¹⁷ And he urged Li-
onardo to "try to be a man of honor" himself.

Michelangelo himself stoutly insisted that he had never stooped to
operating a *bottega* workshop like some artisan. Even in old age he
gloried in the recollection that, as a lad in Lorenzo de' Medici's house-
hold, he had often sat above *il Magnifico's* own sons at the dinner
table—though this reflected punctuality rather than stature, since un-
der Lorenzo's household rules the first to arrive got to sit first and
closest.

At the same time, Michelangelo could be decidedly uncouth in his
ways and manners. In his early years he was notorious for shabby
dress and poor hygiene. This too seems partly a legacy of his father,
who famously advised him to "never wash yourself—allow yourself
to be rubbed down, but do not wash." It also reflects the single-
mindedness with which he pursued his art. "Even when he became
very rich he lived like a poor man," Vasari records; he and Condivi
both recount that their idol would often subsist on just bread and
wine, nibbling without stopping his work. Condivi notes that he
would work, sleep, and rise again in his clothes and dog-skin boots,
wearing the boots so long that his skin peeled off with them.

Ardent as he was in celebrating the perfection of the human body
as the vessel and reflection of divinity, Michelangelo also had a well-
honed appreciation of that vessel's grosser aspects, which infuses his
poetry just as his devout spiritual aspirations do. In a famous verse
penned next to a sketch of himself bending back to paint the Sistine
ceiling, he lamented that exalted labor's effects on his body: "I've
grown a goiter in this ordeal, as the water gives the cats in Lom-
bardy. . . . Beard to heaven, I feel my memory squeezed within its case,
and a harpy's breast. . . . My loins in my gut, and my ass a counter-
weight."¹⁸ Less familiar, but even more vivid, are the lines he wrote in
his seventies on the infirmities of age:

In my doorway I've left giant heaps,
so whoever's eaten grapes or taken medicine
need go nowhere else to shit it all out.
I've learned all about urine
and the canal by which it exits,
the little slit that wakes me each morn.[19]

Clearly he would not find himself embarrassed or at a loss for earthy banter in the rough company of Carrara's *cavatori* and *scarpellini*.

For all his genteel aspirations, Michelangelo was a square peg in the fine society of Florence and Rome, sometimes surly and often wary and solitary. But he was also gracious and generous with the humble and needy—staking down-at-their-luck Florentine expats who came to his door in Rome, giving dowries for poor families' daughters who could not otherwise marry. And he could let down his defenses with tradesmen and artisans, who worked with their hands rather than conniving with their wealth and influence. A warm tone runs through his correspondence with the *scarpellini* of Carrara and Seravezza.

Michelangelo was especially fond of his enthusiastic foreman, Domenico di Giovanni, a fellow son of Settignano whom he addressed with affectionate grandiloquence as "My dear friend maestro Domenico called Topolino *scarpellino* in Carrara." The nickname Topolino, "Little Mouse," was actually honorific, at least in Carrara; a particularly agile *cavatore*, who could scurry up rocks and through tight passages as nimbly as a mouse, might be called a *topo*.[20] Michelangelo first employed Topolino in Florence to rough out his figures; after several months he reassigned him to the quarries, a venue better suiting his talents. But still, as Vasari tells the tale, Topolino fancied himself a sculptor, against all evidence. Each time he shipped a batch of marble to Rome, he included one or two of his own crude statues, like a roadie trying to get the star to listen to his songs. When they met again, Topolino asked the master what he thought of a figure of Mercury he'd carved. "Can't you see that this Mercury lacks more than a third of a *braccia* between the knees and the feet?" Michelangelo replied. "You've made him a dwarf as well as a cripple!" No problem, replied Topolino; he cut off Mercury's lower legs, affixed him to a new block of marble, and carved new shanks and

feet, with boots to hide the seams. Michelangelo, who never resorted to such expedients, marveled nonetheless at his unschooled protégé's naïve ingenuity.

Vasari adds that Michelangelo did see a real gift for shaping stone in another stone cutter, who never fancied himself a sculptor. And so he lured the fellow into carving a figure by instructing him one step at a time. At the end, the unwitting protégé realized what he had achieved and thanked Michelangelo: "With your help I have discovered a talent I never knew I had." Vasari writes that Michelangelo then used the figure in Julius's tomb—a claim so brazen I wonder if Michelangelo actually conned his credulous biographer with a tall tale, or told it as an excuse for the singularly crude figures another sculptor contributed. The tale nevertheless highlights one of Michelangelo's more winning qualities, his generous esteem for simple folk. The long days on the mountain were grueling and dangerous, but he found an escape from his overcrowded life and fretful ways, a fellowship of the stone, in Carrara's *cave* and *cantine*.

MANY WHO MOVE to Carrara, and some Carrarese themselves, pound their heads silly trying to understand the place, its peculiar mix of high and low culture—Dickens's opera-singing *cavatori*—and of parochialism and cosmopolitanism. Squeezed like the sand in an hourglass within its narrow valley, open to the sea at one end and crashing against the marble wall of the Apuans at the other, it looks outward and inward at once. Geography and history conspired to cut it off from its neighbors, and at the same time link it to much more distant places. With marble—and everything in Carrara eventually comes back to marble—distance was measured in water, not land miles. It cost as much to ship stone around the Italian peninsula and up the Po River to Milan, a hundred miles away as the magpie flies, as to ship it to London.

After twenty-one or (depending on those enigmatic Etruscans) twenty-three centuries of quarrying, Carrara's may be the oldest economy in the world still based on the extraction and export of the same single natural resource; its quarries were ancient long before there was a petroleum "resource," let alone an OPEC or oil patch. It is a marble island just as Cuba and Hispaniola were sugar islands—and

like them, a sort of plantation; *carrarini* themselves sometimes complain that their own attitudes reflect a postslavery mentality, a heedless disdain for civic responsibility. "One thing I love about Carrara is that the dogs run free," says one. Yes, and the sidewalks show it—a fecal minefield worse than Paris or Florence. At excruciatingly tidy Sarzana, the police write tickets for parking too close to the curb; in downtown Carrara, cars park illegally everywhere on the sidewalks and piazzas.

The flip side of such recklessness is impulsive generosity, even among those of little means. Woe to whoever insists on paying for his own drink after a *carrarino* offers to buy a round, as one inevitably will. A gold-rush psychology still prevails; the marble hunters may work like bees, but they spend like grasshoppers. Fortunes are made and lost fast in the quarries; in a world of booms and busts, why sweat the small stuff?

The marble men could be devilishly sharp traders, swapping blocks like horses and turning them over to hide the flaws. In everyday dealings, however, the *carrarini* display an old-fashioned small-town rectitude. In Rome (and often even elsewhere in Tuscany) you take your wallet in your hands if you order without checking the menu, leaving the proprietors to charge what they think they can get away with. In Carrara, I was never overcharged. In the tourist meccas—even just forty minutes away in Pisa—insistent American-style tip jars are starting to appear. Leave an extra coin on a bar in Carrara and the *barrista* will call out that you forgot your change, as though you'd offended her pride.

LOCAL PRIDE AND hard cash were both on the line in what was called, quite seriously, *la guerra del lardo*—the lard war. It might sound like a parody of gastronomic hype for a substance as humble as pig fat to be invested with as much mystique, nostalgia, and connoisseurship as salmon in Seattle, rice in Burma, or steaks in Argentina. But the true *lardo di Colonnata* has all that, plus a large measure of defiant exclusivity. It is after all, in spirit and tradition and now in law, the special domain not of a region or nation, but of a village of a few hundred souls. And though it was not the economic mainspring of its territory, it is the mirror image of the stone that was—marble made flesh, with

the use of marble. Its appeal is more than gustatory: white, pristine, and softly translucent, it looks like the finest *statuario*. Would the people up here eat the marble if they could? They very nearly do.

Colonnata is the highest and most remote of Carrara's villages, the only one whose *cavatori* walk *downhill* to work, and it feels like an outpost. Frontier ways persist here: The little roadside shrine below the town does not mark the place where some poor joker with a belly full of wine drove over the edge. It's where an angry husband waited for the wife who left him and the sweet-natured boyfriend who took her in, and shot them both. And it's a community that increasingly revolves around pig fat.

For centuries, cured fatback was the cheap high-energy staple of the men who climbed the mountains by foot and tore them apart by hand. But this being Italy, it became wrapped in gastronomic tradition, like wine or bread or prosciutto. Through centuries of trial and error, a culture of preparation evolved to assure the safety and enhance the flavor of what would elsewhere be a throwaway commodity. Proper *lardo* is layered with rock salt, herbs, and spices and aged like cheese in *conche,* covered marble tubs, for at least six months, as long as a year. Rosemary, black pepper, and garlic cloves are universal; oregano, cinnamon, coriander, nutmeg, star anise, fennel, celery, savory, rue, mint, lovage, pennyroyal, purple betony, argemone, dried carnations, and who knows what else may also be used, but each *lardo*-making family guards its recipe. This infusion forms a rough, dark crust over the white *lardo,* like the earthen crust that covers the marble and fills its gaps. Slicing a slab of *lardo* reenacts the cutting of the mountain.

The right seasonings also lend a haunting fragrance; on the tongue, the fat seems to melt into pure aroma. Not all *lardo* is equally flavorful, nor is it all pure white. The stuff that has absorbed a faint pinkish golden blush, like light *cremo* marble, seems most fragrant, but any baconlike stripes of meat in the fat absorb too much salt, which overwhelms the flavor. *Lardo* is still usually (and, aficionados insist, best) eaten raw, sliced paper-thin, with bread and tomato, but *lardo* pizza is also a local standard. A light crostini-style toasting, until the fat starts to melt, seems to release the most flavor.

I don't even bring meat into my house, and here I am waxing rhapsodic on the best way to eat pork fat? But it's hard to resist *lardo*

around here. Its mystique permeates even religion: Saint Bartholo-
mew, the patron saint of butchers, is also Colonnata's patron. The
trimming of the fatback to make *lardo* recalls the flaying of
Bartholomew's martyrdom. That martyrdom also inspired one of the
most startling passages in Michelangelo's art: he seems to have por-
trayed *himself* as Bartholomew's eerily hanging flayed skin in *The Last
Judgment*.

Each year Colonnata celebrates Saint Bartholomew's Day (which
falls conveniently in August, for maximum tourist impact) with a
three-day *lardo* festival. It also hangs images of Saint Anthony Abbot,
in his traditional guise as a swineherd. This fourth-century hermit is
credited with healing shingles, the "sacred fire"; until recently, *lardo*
was applied when the rash appeared.[21]

For the old *cavatori,* a chunk of *lardo* was the heart of the midday
meal, rounded out by bread, a tomato, and onion, and swigs from a
three-liter *fiasco* of wine. In war and lean times people might have
only bread, and long for wine and *lardo.* "You'd just have this much old
bread to eat," a newly retired *cavatore* named Agostino Salviati tells
me, marking a length on his arm, as we chat in Colonnata's piazza.
"You'd dip it in water to make it soft. The Americans would say, 'The
Italians are so clean, they wash their bread with water.'"

Times are fatter today. "I had *lardo* for breakfast this morning,"
Salviati says tipsily, grinning. "With wine." He and another *cavatore*
turned pensioner, Antonio Diamante, are still celebrating their free-
dom—or drowning their regrets, trying to get used to life without the
work that was its anchor and their pride. *Lardo* making takes up some
of the slack for quarry workers washed out of the quarries by age, in-
jury, automation, and other factors. One, Giovanni Guardagni, makes
what he calls "mortadella" (a chewy, *salame*-like sausage nothing like
the usual soft mortadella) as well as *lardo.* He's still hale and hearty,
and still misses working in the *cave.* "I had to stop because my mother
got old and ill," he explains, "and if she took badly, no one could reach
me in time up there." Anyway, he shrugs, the quarry work's not the
same now. "I was never much interested in the machines. There are
vagabondi who can operate the machines. The real work is done by
hand. I've squared the blocks by hand, done it all." He shows the chis-
els he's using to shape a new *conca* for aging *lardo,* the old-fashioned
way, out of a single marble block. Thus formed, the *conche* look eerily

like old Roman sarcophagi, putting a new twist on the ancient mystery of life contained within dead stone.

Only white marble from the Canalone ridge due north of Colonnata, the hardest marble in the Apuans, makes a good *conca;* other stones are too porous. A proper *conca* from a single block can preserve *lardo* for three years and last for two hundred. Some *lardo* makers now use tubs glued together with machine-sawed marble slabs, but these don't last as long; nor, it's said, does the *lardo* cured in them.

The curing process seems to have been perfected since medieval, perhaps even Roman, times. The Romans loved cured meat and fish, sometimes to death; *botuli* (sausages), one of their many specialties, lent its name to a deadly food toxin. Their essential flavorings were an herb mix resembling that used for *lardo* plus garum and allec, a sauce and paste made from salted, seasoned, fermented fish. Garum (from the Greek word *garon*) corresponds to Vietnamese *nuoc mam,* Thai *nam pla,* Cambodian *prahok,* and Italian anchovy paste, and its name appears to be a linguistic cousin of *garam,* "spice" or "condiment," in various Indian languages.[22] In a lavish new book on the favored fat, Orazio Olivieri concludes that *lardo di Colonnata* represents "the point of encounter" between Roman culture—spices and meat curing—and the Celtic traditions of the pork-loving Apuan Liguri. If the Greeks brought the technique of aging in brine from India, then *lardo* marks a point of encounter with Asia as well.[23]

The medieval *comune* of Carrara confirmed these traditions by banning swine from the lowlands, presumably to prevent their fouling town streets and raiding gardens and grain fields. Instead, the authorities commanded Colonnata and other mountain villages to raise pigs, which could feed on the abundant wild chestnuts. This division of agricultural labor is reflected in a nineteenth-century *carrarino* nursery rhyme:

Torta dris d Toran	Rice cake from Torano
Castagnaz d Bdizàn	Chestnut bread from Bedizzano
Rapin d Bèrzla	Turnip greens from Bergiola
Patate d Castelpòz	Potatoes from Castelpoggio
Lard d Colonnata	Lard from Colonnata
Èc fat	And you've made
Una bela magnata.	a fine meal.[24]

Perhaps the European fixation on local authenticity, which the French call *terroir*, originated with such medieval agricultural specialization. Here, places are not interchangeable, and their names are not generic labels to be appropriated or brand names to be bought and sold; champagne is wine from Champagne, and chianti comes from the Chianti. But *lardo di Colonnata* was too new to the wider market to have such recognition.

One Italian food writer discovered *lardo* in the 1950s, and others followed. In the 1990s *lardo di Colonnata* achieved cult status; devotees smuggled it through U.S. Customs to trendy New York and Los Angeles restaurants. Italy's and the European Union's own food cops meanwhile tried to make the *lardo* makers age their precious fat in plastic or steel vats rather than marble *conche,* and in modern, sterilized, white-tile plants rather than damp old stone rooms. Colonnata's *lardo* makers repelled these attacks by invoking ancient traditions and modern biology; the latter showed that nary a nasty contaminant penetrates the *conca,* salt, and antioxidant, antiseptic herbs.

But success had bred another problem. Much more *"lardo di Colonnata"* was hitting the market than Colonnata could cure—much of it from a big knockoff producer in Montignoso, just the other side of Massa. A Massese stealing Colonnata's *lardo*! The pig fat's defenders howled about "UFOs," Unidentified Fat Objects. Finally, last November, they won a decisive battle, the subject of banner headlines in the local papers: the European Union granted *lardo di Colonnata* PGI—Protected Geographical Indication—status, Brussels-speak for "You can't say *'di Colonnata'* if it's not from Colonnata."

So Colonatta won its war. Carrara itself has not been so lucky, or savvy. The city where the marble saga began watches as artistic energy, glamour, and wealth continue draining to the most envied rival of all, Pietrasanta, in a process of usurpation that began with Michel-angelo.

CHAPTER 10

THE AGONY OF
THE BRONZE

HIS NATURE IS SUCH THAT HE NEEDS TO BE DRAWN OUT
BY KINDNESS AND ENCOURAGED, BUT IF HE IS SHOWN
LOVE AND TREATED WELL, HE WILL MAKE SUCH THINGS
AS WILL BE THE WONDER OF THE WORLD.

LETTER RECOMMENDING MICHELANGELO FROM PIETRO SODERINI
TO HIS BROTHER, A CARDINAL IN POPE JULIUS II'S ENTOURAGE

MICHELANGELO DOUBTLESS enjoyed many a *lardo* lunch with Topolino and the *cavatori*, and it didn't seem to hurt his arteries. He worked at full throttle and by early November had excavated his first batch of stone and even roughed out his first figures. Now he needed boatmen to transport this weighty treasure. Naturally he looked to the north; seamen from the nearby Ligurian ports of Lavagna and Porto Venere commonly got the job of shipping Carrara's marble; the Carrarese were landlubbers, mountain people, and once they got the stone to the boat, it was out of their hands.[1]

On November 12, 1505, Michelangelo signed a contract, notarized in Carrara, with two Lavagnese boatmen, Domenico di Pargolo and Giovanni Antonio del Merlo, to transport two figures, weighing thirty-four "carats" (about thirty-two U.S. tons) together, from Avenza, then Carrara's port, to Rome. Each captain would take a single figure in his small boat.[2] This carat, the *carrata*—not to be con-

fused with the *carato,* used to measure gems—was for centuries the standard Italian measure for coal and stone, yielding to the metric system only in the twentieth century. It means "cartload" and describes the weight that a two-oxen team can haul on level ground. It also happens to be surprisingly close to our ton—about 850 kilograms.

Getting the stone on the boat was a feat in itself. Carrara had no harbor until the late nineteenth century, and sand washing down the Magra River created a long, shallow beach. Oxen would haul the marble as far as they could, and then human and ox muscle would drag the boats up the sand, over log rollers, until boat and stone sat side-to-side. The blocks would be positioned on earthen ramps, or lifted with winches erected tepee-style over the boats, and nudged onto the decks; then the boats would be dragged back down to meet the rising tide.

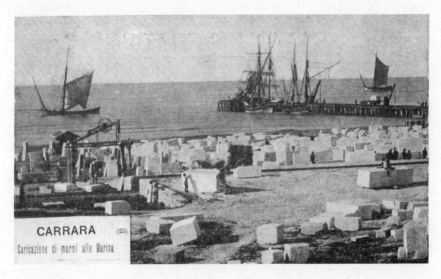

Blocks await shipping; until the dock was built and the harbor dredged, boats were dragged onto the sand for loading.

Small wonder that Pargolo and Merlo were promised sixty-two gold ducats—a craftsman's annual wages—to deliver the thirty-four *carrate* to the Ripa del Tevere, Rome's Tiber port, where it would be offloaded for hauling to the city. There the sculptor's duties, and worries, would begin anew; he had to provide the timbers along which the blocks would be slid off the boat, and the oxcarts they would be slid onto. The process was hazardous and uncertain at every stage; if

the river was too high or too low, or a load was not judiciously balanced, thirty tons of precious marble could wind up in the mud beneath the Tiber. And these were just the first of many boatloads that would be needed to build a tomb as grandiose as the pope who would eventually occupy it.

So far so good; Michelangelo had begun with high hopes, and made a good start. A month later, on December 10, just before leaving Carrara for Rome, he signed another contract with two quarrymen, Guido d'Antonio di Biaggio and Matteo di Cuccarello, for another seventy *carrate* of marble. This was to include four "big stones," two of eight *carrate,* costing four and a half ducats per carat, and two of five *carrate,* for four ducats per carat. The balance would be in pieces of up to two carats apiece, at two ducats the carat.[3] These prices reflected the fact that larger, uncracked blocks were scarcer and more difficult to extract and transport.

With this contract, Michelangelo had passed a milestone in the process of executing projects on the scale of Julius's tomb: he had established a system whereby the hard, slow slog of finding, quarrying, and roughing out stone to his specifications could continue even when he was not there. Henceforth payments could be made to Matteo di Cuccarello via the Balducci bank in Lucca, where Michelangelo promised to have fifty ducats available within two months; Carrara and Massa did not yet support their own bank branches.[4] But Michelangelo's demands for marble, which would eventually run to many hundreds of tons, boded to change that. Already five of Carrara's marble masters, including the Polvaccio proprietor Zampaolo il Mancino (Lefty), Pietro di Matteo di Casone, Jacopo di Antonino il Caldana (the Blush), Matteo di Cuccarello, and Antonio di Biaggio had formed a new corporation to meet that demand.

With things thus in hand, Michelangelo returned to Rome to await his marble and begin his carving. The forty-year saga of the tomb had begun.

"THE TRAGEDY OF THE TOMB" Condivi calls it, taking his master's cue. And his *Life of Michelangelo* is written to explain that tragedy, and excuse Michelangelo's failure to complete what was to be his masterwork and instead became his millstone and shame.

The trouble began soon after Michelangelo returned to Rome. On January 31, 1506, he wrote his father in a feverish tone about, first (as usual) Florentine real estate—the purchase of a farm, for which he'd sent money—and second, his own affairs in Rome.

> I would be doing well, if only my marbles would come, but on that point I seem to have terrible luck, because since I've been back there haven't been two days of good weather. A few days ago one boat got through but only by the greatest good luck escaped coming to grief, conditions were so bad; and then when I had unloaded the stones, suddenly the river rose and flooded them, so that I haven't been able to do anything; nevertheless, I give the pope promises and keep his hopes up so he does not get cross with me, hoping that the weather will clear so I can start work soon, God willing.[5]

To that end, Michelangelo instructed his father to send down the drawings he'd left in Florence, with nervous reminders to "make sure you wrap them well to protect them against water and insure that not the least little sheet gets harmed, and remind the carrier of all this, because there are some very important things there." He also implored his father to remind Michele—Michele di Piero Pippo, the "Little Clapper," who had joined him in Carrara eight years earlier to prepare the *Pietà* block—to hurry to Rome immediately, indicating the urgency he felt about pushing Julius's project forward.

Soon after, Michele joined him in Rome and more marble arrived from Carrara. The blocks were hauled to Saint Peter's Square and set out beside the church of Santa Catarina—about one hundred *carrate* (ninety tons). "The number of marbles was so great," writes Condivi, "that, spread out in that piazza, they roused admiration in everyone and delight in the pope." But any delight was short-lived. While the Romans marveled at the field of white stone Michelangelo had planted in the heart of their city, he worried about getting paid. Even before all the blocks arrived, he responded testily to a letter from his favorite brother, Buonarroto, asking him for money (in part to buy medicine for their father) and help finding a job in Rome. As for the job, Michelangelo replied, "I wouldn't know what to find or what to look for." And much as he regretted the family's privations, he couldn't send money just now because he had "four hundred broad

ducats' worth of marble here and I still owe 140 for it," with scarcely a *quattrino* to his name.

His situation grew more parlous as the rest of the marble arrived from Carrara but no further payment came from the pope. Finally it erupted in an incident that stands as the defining instance of both Michelangelo's and Julius's *terribilità,* and the art-history version of the Flight into Egypt. On May 2, Michelangelo was back in Florence, explaining in a letter to his friend and papal liaison Giuliano da Sangallo why he had fled the papal court: at the pope's table on Holy Saturday, he overheard Julius saying "he did not want to spend another *baiocho* on small stones or large ones; I, much amazed, asked him before I left for some of what he owed me so I could continue the work. His Holiness asked me to return on Monday; so I returned, Monday and Tuesday and Wednesday and Thursday, as he saw. Finally, on Friday morning, I was turned out, even chased away, and the man who sent me packing said that he knew who I was, but he had his orders."[6]

Thus rebuffed, Michelangelo, the master of the sudden departure, outdid himself. "Tell the pope if he wants me, he may seek me elsewhere," Vasari has him tell the groom, spinning on his heels. "Overcome with despair," Vasari continues, he returned to his rooms at Santa Catarina, packed his bags, directed his assistants to "go get a Jew and sell the contents of the house," saddled up, and lit out for Florence. Julius, immediately apprised, sent five courtiers to apprehend him. They caught up with him at Poggibonsi, inside Florentine territory. He spurned their entreaties and the pope's threats but agreed to send a reply (since lost), in which he begged Julius's pardon but vowed never to return after being "driven off like a criminal."

What made Julius, who had been so avid for the tomb design, bar his door and close his purse? And what prompted Michelangelo to flee so hastily? These questions form one of the great mysteries of Renaissance art; untold students of the era have gnashed over it, but overlooked one likely, obvious explanation.

In his letter to Giuliano da Sangallo, Michelangelo hints at dark threats: not only "despair" had driven him to flee, he writes, but "something else, which I don't want to write about; enough to say that it made me think that if I stayed in Rome, my tomb would be built before the Pope's. And that was the reason for my sudden departure." That "something" is generally taken to mean a conspiracy, or

Michelangelo's perception of one, with the papal architect Donato Bramante at its center. For years to come, he would see Bramante and his protégé Raphael lurking behind every misfortune, whether self-inflicted or not.

Bramante, who had established himself in Rome seven years earlier, was a gifted architect, an experienced fresco painter, and a seasoned player in the greasy-pole politics of the papal court. Already he had displaced Michelangelo's friend Giuliano da Sangallo in the biggest architectural job of the age, rebuilding the crumbling, twelve-hundred-year-old Church of Saint Peter—a project occasioned by Michelangelo's oversized design for the tomb, which revealed the inadequacy of the old basilica. Just as Sangallo had brought fellow Florentines, including Michelangelo, onto the papal payroll, Bramante, a native of Urbino, endeavored to replace the Florentines with his *paesani*—most notably Raphael, who would arrive in Rome two years later and fill Leonardo's old role as Michelangelo's designated rival. And so the canny Bramante would want to consolidate his position by displacing or discrediting any remaining members of Sangallo's Tuscan gang—beginning with Michelangelo.

As Michelangelo tells it via Condivi and Vasari, Bramante and his allies worked on the pope while Michelangelo was away, planting the idea of having him paint the ceiling of the chapel Julius's uncle Sixtus IV had built—the Sistine Chapel.[7] Their diabolical motive was supposedly to divert Michelangelo from his forte, marble sculpture, into an unaccustomed labor he would surely fail at—not just painting but fresco, the most difficult painting medium. And not just any fresco site but a curved, vaulted ceiling sixty-six feet above the ground.

This account is, however, belied by the primary documentary evidence, a letter that Michelangelo's friend Piero Rosselli, a minor Florentine architect working for Giuliano da Sangallo in Rome, sent him on May 10, 1506, about two weeks after he lit out for Florence. Rosselli recounted a meeting he'd had the night before with the pope, to which Bramante was also summoned. The talk turned inevitably to the fugitive Buonarroti. "Sangallo will go to Florence tomorrow morning and bring him back," the pope said. "Holy Father," replied Bramante, "nothing will come of it, because I've had a lot to do with Michelangelo and he's told me again and again he doesn't want anything to do with the chapel, even though you wanted to give him that

commission. For such a long time Michelangelo hasn't been interested in anything except the tomb, not painting." And, Bramante added, Michelangelo *shouldn't* undertake the ceiling. "I don't think he has the heart for it, because he hasn't worked much at figures, and especially because these figures must be high up and foreshortened, and that's a different matter than painting on the ground."

Rosselli recounts that he came to his friend's defense, speaking "very rudely" to Bramante. He told the pope that Bramante had "never spoken to Michelangelo, and if what he says is true, I want you to chop off my head." And, he added, Michelangelo would "return soon, whenever Your Holiness wishes."[8]

Perhaps Bramante was trying to derail Michelangelo so he could steer the Sistine commission to his own protégés. More likely he was trying to protect his patron from consigning an important project to an unqualified worker, and simply reporting the truth: that Michelangelo didn't feel up to painting the vault. Either of these motives or both together would be more plausible than Michelangelo's conspiratorial claim that Bramante was setting him up to fail. If he had failed after Bramante recommended him, both their reputations would have suffered.

But whether Bramante tried to talk the pope into or out of giving Michelangelo the Sistine commission, several things are clear from Rosselli's letter: Julius did not, as many biographies suggest, begin pressing Michelangelo to paint the ceiling in 1508; the subject was weighing on both their minds in spring 1506, and probably came up when Julius first summoned Michelangelo to Rome in 1505. Julius already wanted Michelangelo to do the job. And Michelangelo very much did not want to do it.

This suggests a likely scenario leading to the pope's refusal to receive Michelangelo and Michelangelo's sudden flight. Julius, whether out of superstition or shifting priorities, had cooled to the tomb project. So he ordered Michelangelo to desist from it and take up the ceiling frescoes. Michelangelo had good reasons to fear that job, as he himself would later declare and as his fumbling early efforts at it would confirm. So he refused, and insisted on continuing under the tomb contract, for which he'd procured a costly heap of marble. This provoked Julius's famous ire. Perhaps the pope said he would not pay

for the marble until Michelangelo agreed to paint the ceiling. Perhaps Julius blew up and told him that if he didn't paint the ceiling, he'd hang from it. Michelangelo, feeling insulted and alarmed, hit the road. Later, he concocted—or, in one of his feverish flights, imagined—the tale of Bramante's plot to trap him in the Sistine commission. It was a convenient excuse, and also a revealing projection of his own anxiety about the project.

THINKING HIMSELF safely ensconced in Florence, Michelangelo picked up as though he'd never left. He resumed work on the *Saint Matthew* for the duomo and perhaps on two other projects left dangling when Julius summoned him to Rome: the *Battle of Cascina* cartoon and the bronze *David* for France.

But Soderini had another patriotic statue in mind—a natural outgrowth of Michelangelo's first civic project, the marble *David*, and the answer to a question that had festered ever since this colossus was placed on one side of the entrance to the Palazzo Vecchio: what should go on the other side? The asymmetry was glaring, and the answer was evident: a second colossus. The biblical giant slayer David was one of two ancient heroes that republican Florence embraced as champions of liberty and symbolic defenders of its peace and security. The other was Hercules, the slayer of monsters and the personification of strength and steadfastness. Hercules may even have been more deeply enshrined in Florence's collective heart and ceremonial pantheon than David. The city's thirteenth-century seal shows his image, with an inscription on the other side that would prove ironically prescient of the approaching Medici tyranny: "The club of Hercules subdues the depravity of Florence."

Who better to sculpt such a pendant than Michelangelo, the creator of the first colossus? He himself had been drawn to the Hercules myth from an early age. In 1493, when he was casting about for commissions after the death of Lorenzo de' Medici, he acquired an eight-foot marble block and carved a figure of Hercules, ostensibly for his own pleasure. It was an audacious undertaking for an eighteen-year-old artist without a patron to back him or a master to guide him; many established sculptors would not have dared an oversized heroic

figure, something scarcely seen since the fall of Rome. But Michelangelo evidently pulled it off, and the Strozzi, one of Florence's leading families and fiercest opponents of Medici rule, bought the *Hercules*. (Filippo Strozzi sold it under duress thirty-seven years later, when the anti-Medici rebellion he'd led provoked a punishing seige by imperial troops. The purchaser, Giovanni Battista della Palla, sent it as a gift to Florence's hoped-for protector, King Francis I of France. It stood awhile at Fontainebleau, then disappeared.)

Now another *Hercules* loomed on Michelangelo's horizon. In August 1506, Soderini wrote to Marchese Alberico Malaspina in Carrara. The unpublished letter, in the state archive at Massa, has apparently been overlooked because of contradictory dating in its heading and signature:

> *To his Magnificent Lordship Alberico, Malaspina Marquis of Massa, like a dear brother*
>
> *Your Magnificent Lordship: We have had our superintendents of Santa Maria del Fiore look to your marble, and we have done this gladly. And we will always act so as to praise, honor, and accommodate you. Nevertheless we should tell you that the aforementioned marble masters have broken a very large piece of marble, which loss we hope Your Lordship will overlook, for which we will make agreeable satisfaction. And out of this will come something most welcome and pleasing, because we propose to make from it a statue as great as any that exists.*
>
> *Best wishes to your Lordship.*
>
> *From the Florentine Palace, August 7, 1506.*
> *Pietro Soderini, Standard-bearer for life of the Florentine People*[9]

The great statue Soderini proposed was certainly the *Hercules,* and though the letter does not mention him, Michelangelo was certainly the artist pegged to do it. Three months after he'd fled back home, his fellow Florentines were already seeking the marble with which he could carve a civic statue to equal or surpass his *David.*

But then, once again, Julius *il terribile* upset his plans.

★　★　★

WHEN MICHELANGELO wrote to Giuliano da Sangallo in May, he offered the pope an olive branch: "You write to me on behalf of the Pope, so read this to the Pope: his Holiness should understand that I am more ready than ever to continue the work, and if he wants to execute the tomb in whatever fashion, he need not bother himself over where I will do it, as long as at the end of five years as we have agreed it will be up in St. Peter's, wherever he pleases, and as beautiful as I have promised; for I am certain, if it is done, that it will have no equal in all the world." All his Holiness needed to do was deposit the agreed-upon sums in Florence, and Michelangelo would have the "many marbles" he had already ordered in Carrara sent there instead of Rome, and do the work in his hometown. He would send the sculptures down as he finished them, and would "work better and with more love, because I would not have to think about so many things."

These were extraordinary words from a sculptor in the cinquecento, when even the most sought-after artists traveled the rutted roads like tinkerers, filling their patrons' whims. They were even more extraordinary for being addressed to a pope—and astonishing when that pope was one of the most feared in church history, and one of the most feared princes in Europe. We can understand why Michelangelo so wanted to have the ten thousand ducats safely deposited in a Florentine bank and to insulate himself from the pope's meddling and the papal court's intrigues. It's just as understandable that these terms would be utterly unacceptable to Julius, even if he did not know how readily Michelangelo would succumb to the distraction of other commissions in Florence, and how readily they would be thrown at him.

Three times, Condivi writes, papal briefs "full of threats" landed before the Florentine Signoria demanding Michelangelo's return, by force if necessary. Soderini shrugged the first one off, hoping that the papal temper would cool. But after the second and third, he gave Michelangelo notice: "You have tried the pope as not even a king of France would, and he will not beg anymore. We do not want to go to war with him over you and put our state at risk, so prepare yourself to return." Michelangelo meanwhile warmed to the idea of accepting offers the

Ottoman sultan had tendered, via "certain Franciscans," to come to Constantinople and, among other projects, build a bridge across the Bosporus.[10] Soderini talked him out of it, saying he'd be better off dead in Rome than fed in Constantinopole, and offering him, as protection against the pope's wrath, a Florentine diplomatic passport and a guarantee of safety from the influential cardinal of Pavia.

Julius was now nearby, in Bologna, which he had just reconquered. When Michelangelo arrived there in late November, Julius raged briefly, then exacted penance: he made Michelangelo execute a colossal bronze statue of himself to commemorate the reconquest. It was a wearisome job and a wretched time, for many reasons. Bologna was no place to be in 1507: the heat was punishing, plague had struck, and prices had soared as merchants and landlords cashed in on the papal visit, forcing Michelangelo to share one bed with three assistants; worse yet for a Tuscan, the wine was expensive and "bad as it can be."[11] The town was "smothered in armor" and filled with fear as its former rulers angled to retake power and the papal legate cracked down. Michelangelo, who scorned portraiture, would have especially resented having to portray his tormentor —three times life size, no less. And he could hardly dispense with Julius's likeness as he later would with those of the two Medici "dukes" in their tomb at San Lorenzo, substituting the sort of ideal, expressive figures he always favored.

Worst of all, Michelangelo had to glorify Julius in the inimical medium of bronze, which he had studiously avoided pursuing even at Lorenzo de' Medici's garden, whose resident sculptor, Giovanni di Bertoldo, was a master bronze caster. So antipathic was bronze to him that he even resisted completing the much smaller, less fraught David, leaving it for an assistant to finish in 1508. "It is not my profession," he said simply, but today's marble sculptors, many of whom feel the same way about bronze casting, can fill in the reasons. In contrast to the organic, meditative process of "taking away," bronze casting entails successive stages of modeling, casting, correcting, removing, casting again, correcting again, and finishing. The casting itself transpires invisibly within the mold—a magical process to those who love it, mechanical and indirect to those who don't. And it changes the size and subtle proportions of the final piece, which in the lost-wax process emerges larger, by the thickness of the bronze itself, than the

artist's original model. "It doesn't really feel like your work," complains one modern marble carver.

Everything seemed to go wrong in Bologna. Michelangelo had brought in two Florentine sculptors, Lapo d'Antonio di Lapo and Lodovico di Guglielmo Lotti, to assist him, but they proved more trouble than help. Lapo was insolent and surly and, when Michelangelo sent him to buy wax for the casting, tried to cheat him by inflating the price and pocketing the difference. When Michelangelo fired him, he also had to fire Lodovico, who took Lapo's side; they then returned to Florence and blackened his name all over town. Perhaps they simply could not adjust to working for a prodigy who, at thirty-one, was much younger than they: "What really got them worked up," Michelangelo wrote, was that they, "and especially Lapo, never understood that they were not the masters, rather than I."[12]

Amidst all this, a Florentine pest named Pietro Aldobrandini imposed on Michelangelo, via his brother Buonarroto, to have a custom dagger made in Bologna, then as now a metalworking center. When the Bolognese knife maker dawdled, Aldobrandini haunted both Buonarroti brothers mercilessly, provoking an exhausting round of letters between them, and when the knife was finally done, he refused to pay for it. Such was the artist's life; even sculpting the *David* and the pope's triumphal statue did not win Michelangelo exemption from bullying deadbeats. To make matters worse, the most troublesome of his younger brothers, the sometime arsonist and chronic ne'er-do-well Giovansimone, craved to come visit him in Bologna. With neither space, funds, nor time to accommodate a guest, he held Giovansimone off with dire (and not unfounded) warnings of plague and political unrest there.

Finally, in late June, Michelangelo cast his giant *Julius*—and met one more grinding disappointment, another reason to loath bronze and miss marble. The sheer size of the piece seems to have confounded the experienced bronze caster he had hired, who heated the metal insufficiently and poured only enough to form the statue's lower half. A *Julius* cut off at the knees might be just what the defiant Bolognese wanted to see, but clearly it would not do. Michelangelo and his helpers had to tear down the furnace, extract the unpoured metal, rebuild the furnace, remelt the metal, and finish the casting. At last, in February 1508, the bronze pope was finished and installed. The tri-

umph was short-lived; three years later, when the Bentivogli retook Bologna, a mob tore down the giant *Julius* and smashed it like a Soviet Lenin statue. The pieces went to Alfonso d'Este, the duke of Ferrara and the pope's sworn enemy, who used them to cast cannon that were used to dislodge the dug-in papal garrison—perhaps with marble cannonballs.

Michelangelo emerged from the agony of the bronze with just four and a half ducats in his purse, by his own account (though his accounts were sometimes suspect). He was finally free to return to Florence. Evidently he expected to stay there; he bought a house in the old family neighborhood of Santa Croce.

Soderini and the Signoria still cherished the idea of having him carve a second giant sentinel for the Palazzo Vecchio, and the Carrarese had found a block of suitably enormous size and surpassing quality. In August 1507, Soderini wrote Marchese Alberico that "Michelangelo, sculptor, who has been in Bologna some months to cast the bronze of the pope, and who is by now at the end of his work, should be here soon. As soon as he is here we will send him there straightaway to see the marble you mention."[13]

But Michelangelo never got to occupy his new house. Again Pope Julius summoned him to Rome, a few weeks after he arrived in Florence, leaving the Florentines to pray for his return and to make their excuses to Carrara. Nearly a year and a half later, in December 1508, Soderini wrote to Alberico again. This letter begins with some curious private business, concerning a batch of jewels for which Soderini owed Alberico money; he announced that he was putting off paying him for now but promised to "make great diligence in it." And it closes by asking the marchese to "salute Madonna Lucretia [the marchesa] on our part, and that of our consort." If these seem unusually intimate flourishes for correspondence between two chiefs of state, that's because Soderini and the Malaspina, and Florence and Carrara, were bound by family ties as well as the stone trade; Soderini's wife, Argentina, was the sister of Lorenzo Malaspina, the marchese of nearby Fosdinovo.

Soderini's letter begs Alberico to save the languishing marble block and await the wayward maestro: "He has not come to rough out the marble because his Holiness has not permitted Master Michelangelo, our citizen, leave to come here for longer than twenty-five days. And

there being no other man in Italy capable of executing a work of this quality, it is necessary that he alone, and no other, come there to see and direct it, because any other, not knowing what he imagines, might ruin the block. And so as long as he does not come, we can only hope that he will soon, but cannot offer satisfaction to ourselves or to Your Lordship."

In another, fragmentary letter surviving from this period, Soderini tries further to console Alberico: "And since you've had so much patience, be assured that we will have this master Michelangelo make a statue that will stand without shame beside the ancients, and the marble will be well compensated."[14]

One can only imagine what a glorious *gigante* Michelangelo might have created on his home turf, in the lingering flush of patriotic spirit, with all the lessons he'd learned from the *David*. This time, he would not have had to accommodate a flattened, marred, *cotto,* and compromised block; he would have the best fresh marble Carrara could offer, shaped from the start according to his will.

But Julius, his patron and nemesis, had another project in mind.

CHAPTER 11

PAINTING IN STONE, SCULPTING WITH PAINT

HE LOVED THE VERY QUARRIES OF CARRARA, THOSE STRANGE
GREY PEAKS WHICH EVEN AT MID-DAY CONVEY . . .
SOMETHING OF THE SOLEMNITY AND STILLNESS OF EVENING,
SOMETIMES WANDERING AMONG THEM MONTH AFTER
MONTH, UNTIL AT LAST THEIR PALE ASHEN COLOURS
SEEM TO HAVE PASSED INTO HIS PAINTING.

WALTER PATER, "THE POETRY OF MICHELANGELO"

WHEN HE RETURNED TO ROME in spring 1508, Michelangelo still hoped against hope to recommence on the star-crossed tomb. The quarrying had resumed in Carrara; on June 24, Matteo di Cuccarello wrote that twenty-one more *carrate* (nineteen tons) were on their way down in Menino de Lavagna's boat, including four pieces that stood out for their *"beleza e bontade,"* beauty and goodness. Among these was the block planned for the figure of the Holy Father himself. A bigger block awaited shipping on the beach at Avenza.[1]

As usual, the shipping did not go without a hitch. What with all the difficulties of dragging the boat up the beach and easing the marble on it, Menino had been stuck at Avenza for "fifteen days or more" waiting to shove off. Matteo advised Michelangelo to slip the captain a couple of extra ducats for his trouble and keep him happy, since "you

won't find anyone else who wants to go down there," and to help the
boatmen escape the duty for importing marble to Rome, "because
they are poor men, and this will get you in their good graces." It
seemed that he who had the boat called the tune—as Michelangelo
would discover to his great regret nine years later, when Matteo's
warnings proved prophetic.

Michelangelo now had his marble, but he could do nothing with it;
two weeks earlier he had recorded receiving a five-hundred-ducat ad-
vance "for the painting of the vault of the Chapel of Pope Sixtus, at
which I will begin working today."[2] Again Julius insisted, and this time
Michelangelo did not flee or fight. Perhaps he had resigned himself to
wearisome tasks; after the bronze-casting ordeal in Bologna, a fres-
coed vault might not seem so grim. And part of him leaped to the
challenge; his sculptural vision, battered by the frustrations of the in-
terrupted tomb and unwanted bronze, seemed to redirect itself to a
medium that before seemed antithetical. The day after receiving his
advance, he advanced the master plasterer Jacopo Rosselli ten ducats
to scrape off the ceiling and apply a plaster scratch coat.[3]

The painting of the Sistine ceiling reprised the eternal debate over
painting and sculpture, with several twists and many ironies. In the
celluloid *Agony and the Ecstasy,* Charlton Heston as Michelangelo
echoes the part that made his career, Moses in *The Ten Commandments.*
He flees the overbearing pope, Rex Harrison, not to Florence but to
Carrara, where he's happily hacking out stone with his *cavatori* bud-
dies when the papal posse approaches. One tosses him a goatskin of
wine and he flees up into the Alpi Apuane like Moses climbing Mount
Sinai. As he reaches the highest peak, the sun sets out over the Li-
gurian Sea (a splendid sight, I can attest) and the luminous clouds
gather into a vision: the central image of the Sistine ceiling, God
handing Adam the spark of life. Heston/Michelangelo sees his
painterly calling, climbs down from the mountain, and returns to
Rome to paint the ceiling.

It is a cheesy, overblown scene and a brazen inversion of an actual
event, Michelangelo's vision of a giant monument on an Apuan
mountaintop. And it might seem a cruel trick to play on the reputa-
tion of a sculptor who so resisted being recast as a painter—that his
sculptural quest should culminate, there in the marble motherlode, in
an idea for a painting. But there is a broader truth to this Moses mo-

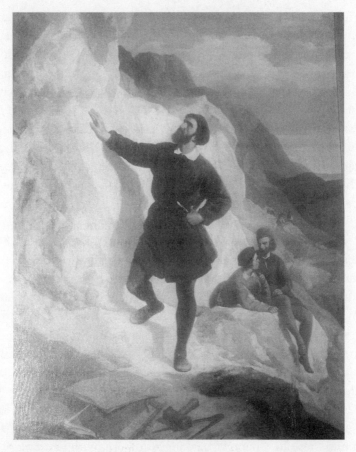

Michelangelo, not Charlton Heston, climbs the mountain, by the
nineteenth-century Florentine painter Antonio Puccinelli.

ment: the Sistine frescoes *do* mark the fulfillment of Michelangelo's
monumental sculptural ambitions, ambitions too vast to be realized
in the recalcitrant medium of stone. His ideas for the tomb flooded
onto the ceiling.

With the *David,* Michelangelo had worked such a wonder in a sin-
gle statue that, in Vasari's words, "anyone who sees this need not
bother seeing any other work of sculpture made by any other hand."
And so he sought a greater challenge: to integrate sculpture and archi-
tecture on an epic scale and capture an entire cosmology in marble—
to do in stone something like what Dante had done in verse. But all
three of his attempts would end in partial or total frustration. The San

Lorenzo façade would yield nothing but a heap of surplus marble for lesser talents to steal. Julius II's tomb would be "finished" in a sadly diminished and compromised form four decades later. And the most successful, the New Sacristy at San Lorenzo, would be an excruciatingly ambivalent unfinished masterpiece, embodying all the contradictions that its creation forced on Michelangelo.

The grand vision came together in fresco, not stone. Michelangelo the übersculptor undertook this heroic painting project under protest and duress—and produced what is arguably the world's greatest fresco cycle, certainly its best known, and the most popular of his works.

Except at tourist peaks, you can still visit Michelangelo's sculptural masterpieces in relative tranquillity, navigating easily around the little clusters pausing to view the *David* at the Accademia and the Medici Chapel at San Lorenzo, in Florence, or the Vatican *Pietà* and *Moses,* at San Pietro in Vincoli, in Rome. If you're lucky, you may find yourself communing alone with the other heart-stopping late *Pietà* in the Museo del Duomo. No such chance in the Sistine Chapel; visiting it is always an ordeal of waiting (outside the Vatican Museums and again outside the chapel), shuffling, and jostling with the eight thousand other visitors who stress its climate control systems each day, while guards with operatic projection bark out orders to keep standing and take no pictures. That last rule, not applied elsewhere in the Vatican Museums, comes courtesy of Nippon Television, which obtained reproduction rights when it put up nearly $4 million to clean the Sistine frescoes in the 1980s and 1990s.

THE WIDER APPEAL of the Sistine frescoes reflects a general difference between painting and sculpture. Despite, or perhaps because, of its three-dimensionality, sculpture is at once a more reserved and more intimate medium, one that demands engagement and attention. You must approach a statue, move around it, follow its forms, literally share the space it occupies, to the extent its placement allows. (Good luck if heedless museum designers have set it in a crude geometric recess, embalmed it behind glass, and drenched it in flat industrial light, as Britain's Royal Academy has the *Taddei Tondo*.) A painting does more of the work; it spreads before you, seduces the eye with color,

draws you into *its* space. Cinema and television, with their prescribed pacing and simulated dream states, do even more, and leave even less to the viewer: they stand to painting as painting does to sculpture.

With Michelangelo, however, the picture is at once simpler and more complicated. His painting has nothing to do with the poetic naturalism of his Venetian contemporaries Bellini, Giorgione, and Titian, who used the new oil paints developed by the Flemish to evoke landscape, light, and the air itself. His bare settings and sharply delineated figures seem harsh and abrupt by comparison. He is a throwback as well as an innovator; his biblical dramas unfold in the sharp morning air of the trecento rather than the denser atmosphere of his own time.

For all his virtuosic draftsmanship and feats of foreshortening in individual figures, Michelangelo gives little thought—and then, usually, unpersuasively—to illusionistic space. His figures and groups sit and stand in their private spaces like statues in niches. Perspective collapses and evaporates, as on a baseball infield viewed through a long lens. In the Sistine ceiling's *Flood* tableau, the middle-ground figures cling to rocks that seem to float on rather than rise from the water; they are as tall as the much nearer figures climbing onto land in the foreground; the groups are scattered like the studies on one of Michelangelo's sketchbook pages, as though he had not yet learned the century-old lessons of Masaccio and, earlier yet, Giotto. Even Adam and Eve in the Garden of Eden do not occupy the same picture space. Michelangelo most successfully integrates this space in the four pendentives, depicting bloody events that saved the Hebrew people, at the ceiling's corners, but even here, Holofernes would loom as large beside Judith, if he shared the same plane and regained the head she has severed, as Goliath does beside David in the next pendentive.

The scale gets even more jumbled across the various categories of figures. The prophets and Sibyls are giants, and they grow even larger as the ceiling progresses, from the austere, diffident Zechariah to the extravagant Jonah. The *ignudi* are smaller, though they too grow as the work progresses. And the biblical panels are entirely mixed in scale, according to dramatic requirements. But these disparities do not disturb the eye or derail the ceiling's dynamic harmony, whose conception is fundamentally sculptural rather than pictorial. The prophets, Sibyls, *ignudi,* and putti/caryatids are all securely contained within their niches and supported by their socles; the *faux-marbre* ar-

chitectural scheme joins them and in the process harmonizes the biblical and classical worlds from which they spring. On the Sistine ceiling, Michelangelo achieved in paint the grand integration of sculpture and architecture that he envisioned but was never able to complete in the tomb. The *ignudi* substitute for the tomb design's *Captives*, alternating as the *Captives* do in two modes, frenzied agitation and dreamy repose. The prophets and Sibyls correspond to the four great corner figures of the original tomb design; the brooding, bearded prophet Jeremiah, widely viewed as a self-portrait, is also a hunched-over version of the *Moses*, the only one of those four figures Michelangelo ever executed.

"Laying on," as he called painting, had its consolations—in particular, speed. In four years he painted 343 figures on the teeming ceiling, more than eight times the number planned for the tomb and more than he could have carved in five lifetimes. Such a range gave full scope to his knack for the grotesque as well as the exalted, a knack he only rarely indulged in his sculpture (*Bacchus*'s mischievous faun, the unfinished ape behind the *Dying Captive*, *Night*'s mask and owl in the Medici Chapel, and the lost faun's head in Lorenzo de' Medici's garden). The ceiling is, among many other things, an encyclopedia of impossible contortions, capricious caricatures, and extreme physiognomies. The star of this show is the Cumean Sibyl, with her enormous shoulders, gorilla arm, tiny head, and what the prudish John Ruskin called "the monstrous license of showing the nipples of the breast as though the dress were molded over them like raw plaster." The ancestors of Christ on the lunettes are a gallery of extras fit for a Fellini movie.

The Sistine ceiling is the tomb project's fulfillment but also its inversion. Where the tomb looks toward life's end, the ceiling celebrates its beginnings, and the bloody beginnings of the Hebrew nation. Nevertheless, it and his other Vatican frescoes are the only large, complex projects Michelangelo ever finished, aside from final retouches Condivi and Vasari report he was not able to add. We have no explicit evidence that he delighted in the ceiling's outcome, or in any of his works after the *Battle of the Centaurs*. His letters of the period focus, even more fixedly than usual, on money, real estate, and difficulties with his wayward brothers. He specifically mentions his great fresco project only at its start, when he laments that it is not going well "be-

cause of the difficulty of the work, and also it is not my profession,"[4] and at the end, when he complains of being "wearied by stupendous labors and beset by a thousand anxieties" for "fifteen years now and never an hour's happiness."[5] But still, he adds in the next letter, "the Pope is well satisfied."[6] That is as close as the great complainer comes to expressing his own satisfaction.

THE SISTINE CEILING'S story did not end when Michelangelo's scaffold came down. Like the *David*, it is an artwork with an afterlife—and, in recent years, its share of turmoil and controversy. The contest between painting and sculpture has continued to play out in that afterlife—especially in the unprecedented cleaning it underwent in the 1980s, the most celebrated and costliest restoration of a single work of art ever undertaken.

For all camps in the eternal art-restoration wars, the cleaned ceiling's brilliant hues and jarring contrasts—orange and green, blue and chartreuse, scarlet and violet mingling in the same irridescent garments—were a shock: of horror for some and delight for others. For centuries, artists and critics alike had celebrated the ceiling as a sort of proto-hologram, a sculptural vision miraculously transposed into two dimensions, and dismissed such painterly qualities as color as incidental to it. Condivi and Vasari lavishly praised the virtuosity of its draftsmanship, chiaroscuro, and, especially, foreshortening—and said not a word about its colors. Those contemporaries who did were unimpressed. In his 1548 *Dialogo della pittura*, Paolo Pinto, a fan of the Venetian colorists, dismissed Michelangelo's color with a barbed compliment: if Buonarroti's drawing could combine with Titian's color, you would have "the god of painting."[7] The Venetian Lodovico Dolce was blunter: "I will say nothing more of Michelangelo's coloring, because everyone knows that he took little care in this regard."[8] Michelangelo himself made no claims for his coloring, or for the role of color generally; *deseigno* was the essence of art, whatever the medium. When he saw Titian's work, he huffed that it was too bad the Venetians didn't study *deseigno* more thoroughly.

Nineteenth-century critics echoed this view, and infused it with a Romantic enthusiasm for his expressive *terribilità*. Walter Pater saw the "pale ashen colours" of Carrara transposed to fresco.[9] Romain

Rolland celebrated the ceiling's "twenty savage *Ignudi*, living statues" and "human frames like temples of flesh and blood, torsos like trunks of trees, arms like columns."[10] A century later the scholar Sydney Freedberg elaborated this view: "Even the coloring that Michelangelo employs grows out of his initial sculptural conception. The dominant tone is that of the fictive framework of architecture and of the nude figures that inhabit it, whose flesh is muted towards ancient marble." The clothed figures, especially the prophets, reminded Freedberg of another sculptural material, "the patinas of old bronze: their draperies evoke the memory of metal."[11]

Those draperies evoke a different metal now—shimmering foil. The cleaning seemed to reveal a whole new Michelangelo: a closet colorist, the first Fauve. The ensuing five centuries of Western art history would have to be rewritten, the project's chief restorer, Gianluigi Colalucci, proclaimed: his applications of ammonia bicarbonate, fungicide, and carboxymethylcellulose gel had freed the true Michelangelo from centuries of smoke, grime, and misunderstanding. It was time, the art-journal editor David Ekserdjian proclaimed, to throw out the twin delusions, "the Darkness Fallacy and the Sculptural Fallacy," that had clouded our appreciation of Michelangelo the Painter for centuries.[12] According to Colalucci, it was even time to throw out Michelangelo's *terribilità*, the brooding, solitary genius that Raphael portrayed in *The School of Athens:* "Michelangelo's paintings, with the deceptive joyfulness of their colors, and the disconcerting discontinuity in the proportions of the figures, are works that shrink from emotiveness and passion. They are transcendental paintings." The now-banished "dark and irregular veil of discoloration . . . extinguished the colors and occluded the forms as it dampened their impact. It revealed only monumentality, and that false, dark melancholy that had a facile hold on the human heart."[13]

And so we get Michelangelo on Prozac: instead of the Beethoven we always mistook him for, he was Bach with a brush, an Olympian fount of cheer and hope. And now he was a Michelangelo for our times. In the five centuries since he painted the ceiling, the relative importance accorded color and the other elements of painting has shifted again and again, just like (and sometimes in step with) the taste for white and colored marbles. In the nineteenth century, synthetic pigments offered painters a palette of unbridled range and intensity.

The Impressionists embraced them and swept away other considerations—fine line and perspective, modeling and chiaroscuro, psychological nuance and narrative detail, delicate glazes and varnished luminosity—in a blast of undiluted color. Since then we've reveled in the further flattening of the pictorial surface and the exploration of pure, saturated hues by painters as diverse as Matisse, Bonnard, Kandinsky, Mondrian, Rothko, and Hockney. Students discover the old masters through slides projected on bright screens in darkened classrooms; afterward, the actual masterpieces seem dim and grim. We swim in a sea of color, splashing across television and billboards, magazines and supermarket packages, animated films from Disney to manga. This makes a TV network's sponsorship of the Sistine restoration all the more apt.

Those who howled at this change and held out for the old, sculptural Michelangelo were easily dismissed as aesthetic Luddites or, worse yet, disgruntled artists. The art historian Kathleen Weil-Garris Brandt called them victims of "culture shock" and damned them with sympathy: "For artists today, who still keep [the academic tradition] alive while the mainstream of contemporary art rejects or ignores them, the cleaning of the Sistine Chapel is a painful personal loss."[14] But those holdouts, artists and a minority of scholars alike, made more substantial claims. They insisted that Michelangelo had muted and modulated his colors, adding shading and highlights, reinforcing volume, and integrating the *deseigno,* with retouches painted *a secco* ("on the dry") after the wet plaster binding the original *buon fresco* had dried and cured. They noted that the cleaners' ammonium bicarbonate wet packs would dissolve the glue and egg tempera used to bind *a secco* paint as easily as they did yellowed glue coats and organic contaminants. And, as they also noted, the lampblack and vine black used for shadows and outlines chemically matched the soot being removed, and so would be overlooked in tests.

But why would Michelangelo paint *a secco* when *buon fresco* is so much more durable? Because fresco imposes a brutal deadline: each section of wet plaster must be finished in a day, before setting up, and so is called a *giornata.* Any additions, corrections, and second thoughts—to which Michelangelo was famously prone—must be added *a secco,* or the section must be ripped out and started fresh. Michelangelo had plenty of time to retouch *a secco.* He spent four

years, minus perhaps three months sick or away, on the ceiling. The cleaning revealed just 449 *giornate* of *buon fresco* work.

To rebut this commonsense view, restoration advocates lean on that shiftiest of authorities, Giorgio Vasari. He extolled fresco as "the most manly" of methods and urged practitioners to "work boldly" and "not retouch in the dry, because, besides being a very poor thing in itself, this renders the life of the pictures short."[15] Vasari also revered Michelangelo and praised the Sistine ceiling as the light of the artistic firmament. Surely, then, its creator painted only in *buon fresco*?

In fact, few if any artists did—save perhaps Vasari, whose technique was superb though his art was turgid. Vasari's dismissal of *a secco* was wishful rather than descriptive; when another minor painter used pure *buon fresco,* he lauded it as a great achievement, and he conceded that "many artists" retouched *a secco.* Sometimes that cut close to home: Vasari began the decoration of Brunelleschi's great dome at Santa Maria del Fiore in *buon fresco,* which has held up well. But the less manly Federico Zuccari finished it in pure *secco,* and like Leonardo's *a secco* masterpieces, it has bubbled and pulled from the wall.

Certainly the somber haze that lay like smog over the "old" Sistine ceiling was an artifact—the residue of centuries of smoke from papal censers and the ritual fires of Vatican conclaves, of glue coats brushed on to brighten and protect the ceiling that eventually yellowed and dulled it, and of ordinary air pollution. And the newly revealed colors were exhilarating, especially in the lower lunettes, which had taken on the most dirt over the years and which, thanks to the speedy fashion in which they were painted, had the least to lose to cleaning. But the whole of the ceiling is now less than its parts; the individual swatches, so limpid and electric in themselves, clash like brilliant, jumbled beads, crying for integration—for *deseigno.* Flesh tones are wildly inconsistent; the prophet Jonah, the ceiling's magnificent last act, is an incongruous lurid red. Before, he shrank back in awe; now he grimaces with sunburn. Either the light of God shone bright indeed in the fish's belly or poor Jonah spent an awfully long time outside Nineveh's walls without even a fig for shade.

Likewise the other figures, who before seemed to thrust from the vault's surface and now spread against it in crisp outline. Along with the "emotiveness and passion" Colaluccio was so glad to be rid of, depth and volume, *life* as opposed to liveliness, have drained from

them. In the end, the eye must judge—something harder and harder to do these days, amidst all the hoopla over the scientific marvels and astonishing "discoveries" of art restoration. Compare photos taken before and after the restoration—and hold on to any "before" books on the frescoes, which are now valuable, vanishing documents. Having none with me on one visit, I wandered the Vatican Museums' bookstalls until I found one volume—the German edition of a cheap souvenir book—that had a few prerestoration photos. The clerk saw what I was looking at and said, "I liked it better before too."

You may view the outcome as a trade-off. The brilliant palette of Michelangelo's fresco base painting has been brought back to view, and his narratives read more clearly. But the subtler refinements of his overpainting are lost forever. The issue is not color itself; the hoopla over his electric hues is really a big red, and orange and blue and magenta and chartreuse, herring. Michelangelo's vision was both profoundly painterly *and* profoundly sculptural. On the Sistine ceiling, he proved that painting and sculpture could cohabit, but painting won out in the end.

CHAPTER 12

THE PROMISED LAND

IT WILL TAKE MANY MONTHS OF PATIENCE,
UNTIL THE MOUNTAINS ARE TAMED.

MICHELANGELO TO BERTO DA FILICAIA, SEPTEMBER 1518

LATER CENTURIES COULD DEBATE how he intended to finish the Sistine ceiling; Michelangelo did not look back. Change was coming fast and furious, in Florence and Rome. In August and September 1512, two months before the entire ceiling was unveiled, the wolves circling the fragile Florentine republic finally pounced. The *gonfaloniere* Pietro Soderini, Michelangelo's friend and patron, had rashly disregarded his counsellor Machiavelli's realpolitik advice on one vital point. Instead of keeping a selfish distance from the foreign powers clashing over Italy, and waiting till a winner emerged, he looked to Florence's traditional protector, France, and refused to join Julius II's Holy League against the French. France's King Francis I did not reciprocate; he withdrew his army. The league's Spanish troops massacred the residents of Florence's satellite Prato and closed on the city. The league convened at Bologna and decided to consign Florence to the pope's personal emissary—Cardinal Giovanni de' Medici, Lorenzo the Magnificent's second son. Soderini went into exile and Cardinal de' Medici rode into Florence in triumph, accompanied by his cousin and confidant Giulio, the illegitimate son of Lorenzo's assassinated brother, Giuliano di Piero de' Medici.

Michelangelo had known both Medici during his youthful years in

the Medici household, but still he feared he would be suspect and his family vulnerable under the new regime. "Stay peaceful, and don't get friendly or intimate with anyone except God," he advised his brother Buonarroto, "and don't speak well or ill of anyone, because no one knows how things will turn out."[1] When rumors rose that he himself had badmouthed the Medici, he begged his father to scotch them, feebly insisting that he'd merely repeated what "everybody" said about Prato and other atrocities: "If it's true that [the Medici] did those things, then they did wrong—not that I believed it." And he asked that Buonarroto check discreetly as to who had repeated what he said, so he could be on his guard.[2] His prudence was hardly heroic, but it was timely; the newly revived power of the Medici would soon reach Rome as well.

WHILE THE MEDICI'S strength waxed, Pope Julius's waned. The warrior pope had little time to enjoy his conquests, or the "wonder of the world" that Michelangelo had painted for him. On February 21, 1513, sixty-nine years old and worn out with several lifetimes' worth of trouble, toil, pleasure, and disease, he passed into illustrious, if not sanctified, memory. At the end he remembered the tomb and left his heirs ten thousand ducats and instructions for its completion. On May 6, Michelangelo signed a revised contract for a design that would require less floor space, with three sides projecting from the wall of whatever church might accommodate it rather than the four-sided mausoleum of 1505; Bramante's latest plan for Saint Peter's did not allow for the tomb, so the reduced footprint improved its chances of eventually finding a berth somewhere in the church. But this was not, as Vasari and others have written, a "smaller" project; it would soar half again as high as the first design, with angels now lifting up the recumbent figure of the pope, saints flanking him, and a colossal Virgin and child floating triumphantly above. It would be a mountain of stone; squint at the best surviving drawing of this design (a contemporary copy of Michelangelo's now nearly ruined original) and it's easy to imagine the marble stacks of Carrara. Michelangelo was to finish it in seven years, for a price now raised from 10,000 to 16,500 ducats, and not to undertake any other commissions that might interfere with it.

On March 11, Cardinal Giovanni de' Medici, who had assumed his

father's old role of untitled capo of Florence, became Pope Leo X. Later he would give a cardinal's cap to his gracious cousin Giulio and put him in charge of Florence. The halcyon days of Medici rule—refined, stable, and largely benign—seemed to have returned.

"God has given us the papacy," Giovanni/Leo is said to have declared. "Let us enjoy it." He was a pope for good times, a portly, self-indulgent humanist and epicure who enjoyed poetry, banquets, sparkling company, and a pet elephant sent him by the king of Portugal. He also loved art, but enjoyed Raphael's graceful tableaux more than Michelangelo's knotted muscles and psychospiritual agons. For the moment he was on good terms with Pope Julius's heirs, in particular Julius's nephew Francesco Maria della Rovere, the duke of Urbino, and did not want to tear Michelangelo away from completing the tomb. And so he had no work for his childhood companion.

Taking that cue, Rome's civic officials the next year selected a minor figure, Domenico Bolognese, rather than Michelangelo, to carve a statue honoring Leo.[3] Michelangelo could give thanks that he would not have to execute another pope's effigy. Though his habitual jealousy may have been piqued at seeing commissions pass him by, it seemed he would actually be able to finish Julius's tomb this time.

But the good times would not last, for Michelangelo, Pope Leo, or Italy.

MICHELANGELO RESUMED QUARRYING in Carrara, but not all was well there. Matteo di Cuccarello and the four other *scarpellini* who had formed a partnership to supply him with marble in 1506 had been busy in court rather than the quarries; they had fallen out over the large commission reserved for one of them, Guido di Antonio, and he sued the others to collect it.[4] Even with that issued settled, the quarrying and shipping went slowly. Michelangelo returned to Carrara after finishing the ceiling, perhaps in the spring of 1513, to order more blocks.[5] At the end of the summer he wrote heatedly to Baldassare di Cagione, the son of Zampaulo il Mancino, one of the five partners: "Baldassare, I'm amazed at you, because, having written me so long ago that you had so many marbles ready, and having had so many months of wonderful good weather for shipping, and having one hundred gold ducats from me, lacking nothing—I don't know why you

don't come through for me." Ship the marbles "as soon as possible," Michelangelo urged. "I'm only reminding you that you do wrong to break faith and jerk around[6] someone who is of service to you."

This was the first of many signs of friction in what had been warm dealings with the Carrarese *fornitori* (suppliers). The reasons can't be discerned with certainty, but may lie in the five-year delay that the Sistine commission interposed in the tomb project.[7] At that time Michelangelo, tugged off the job by Pope Julius, refused to disperse "one *quattrino*" more on marble, even as Matteo di Cuccarello was shipping blocks to him and urging him to help out the "poor men" who brought them. It would certainly have been in Michelangelo's penny-pinching nature to pass the difficulties he had getting paid by Julius down the food chain to the Carrarese *scarpellini;* his financial history is a long tale of poor-mouthing and miserliness until his old age, when, with a large fortune in land and gold, he atoned with charity.[8] If he had indeed stiff-armed the Carrarese in 1508, it would be only natural for them to scorn him as a deadbeat in 1513. Or the bad blood may have arisen because the blocks they supplied did not match his specifications, or because they, like Baldassare, did not deliver on schedule.[9] This would match his style; he was a demanding client, both knowledgeable and perfectionist.

Michelangelo meanwhile sought more agreeable help. In July 1513 he sent to Florence for Michele di Piero Pippo, the "Little Clapper," who had helped him quarry and rough out the block for the Vatican *Pietà* fifteen years earlier. Michelangelo sent Michele ahead to Carrara while he set to work with the stone he'd already received in Rome. He began three statues: the stalwart *Defiant Captive* and the dreamy *Dying Captive,* now in the Louvre, and the imposing *Moses.* The *Defiant Captive* proved one of the worst-flawed blocks of his stone-crossed career, with a long crack arcing from shoulder to shoulder, right through its face as though a scimitar had cleaved it; it is remarkable, given his horror of flawed stone, that he continued working at it anyway.

Moses was to be just one of four corner statues on the second level of the original design; now it carries most of the weight of the truncated tomb that was finally erected in San Pietro in Vincoli, the Roman church where Cardinal Giuliano della Rovere presided before becoming Pope Julius II. The setting inflicts two injustices on the *Moses.* First, viewed at ground level, the exaggeration in its elongated torso and up-

per arms are all too apparent; it would appear more natural viewed, foreshortened, from below, as it was meant to be seen. And second, Moses as seated turns to the left at an approximately sixty-degree angle, showing his dignified but unexpressive profile to the viewer standing in front—but his true view is face-on, where you are seized by his probing, anxious gaze. You still get that view if you approach the tomb from the side rather than the center of the church. This aspect reduces the glaring inconsistency in the quality of its figures, from the magnificent *Moses* and two less prepossessing later figures by Michelangelo, to a capably executed reclining figure of Pope Julius by Tommaso Boscoli, to the vacuous, crudely carved *Sibyl* and *Prophet*, which were contracted to the veteran sculptor Raffaello da Montelupo but executed by feckless assistants when Raffaello became ill. The side view also softens the discordance between the elaborate grotesqueries of its lower tier and stark upper level.

For all the tomb's faults and disapointments, the *Moses* remains as potent a presence as Michelangelo or anyone else ever shaped from stone. It combines elements of many of his other signature works: the magmic cascade of draperies of the Vatican *Pietà*; the brawny, hooked left arm of the *Cumean Sibyl*; the fierce, furrowed mien of God creating the sun and moon on the Sistine ceiling; the sharp profile and rippling white beard of both the prophet Ezekiel and God in the *Creation of Adam*; and *David*'s nervous, wide-eyed stare. But this "cataclysm made man," as one critic has called *Moses*, has a *terribilità* all his own, mitigated by sorrow and even doubt, or self-doubt—qualities that save him from becoming a cardboard hero like Cecil B. DeMille's Moses.

The stern lawgiver with his flowing beard is an obvious representation of the bearded warrior pontiff whose monument he guards, but does he represent the sculptor as well? "Every painter does a good self-portrait," Michelangelo once quipped when asked why a certain hack had rendered an ox more convincingly than anything else in his picture.[10] *Moses* is realized with the conviction of an idealized self-portrait—fearless and majestic where Michelangelo was sometimes timorous, but with eyes that give him away. He embodies the modern notion of the artist as not just craftsman but visionary and seer, a view that Michelangelo in large measure inaugurated. Just as Moses led his people to the promised land but could not cross over himself, the artist may point out the spiritual path though he himself falls from it.

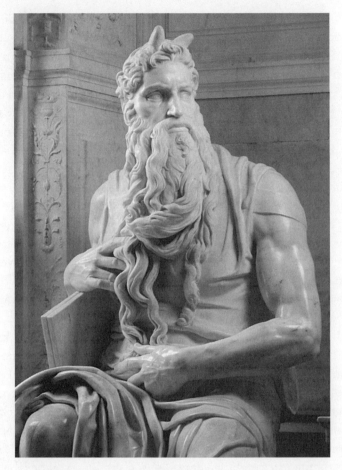

Moses, the apotheosis of *terribilità* (marble, 1513–16).

His statue has shaped later generations' views of the biblical Moses even more thoroughly than the *David* has defined David. It's said that for years after *Moses* was unveiled, Rome's Jews would flock to San Pietro in Vincoli on Saturdays to venerate it, defying the second commandment inscribed on the tablet under its left arm—on the sabbath in a Christian church, no less! Three centuries later a more skeptical Jew, Sigmund Freud, found himself awed and abashed by this "inscrutable and wonderful" figure: "Sometimes I have crept cautiously out of the half-gloom of the [church's] interior as though I myself belonged to the mob on whom his eye is turned—the mob which can hold fast no conviction, which has neither faith nor patience, and

which rejoices when it has regained its illusory idols."[11] Cecil B. DeMille himself chose the former model and football player Charlton Heston for *The Ten Commandments* after drawing a white beard on Heston's publicity photo and noting an uncanny resemblance to Michelangelo's *Moses*. No wonder Heston, in later interviews, confused this role with the Michelangelo he played in *The Agony and the Ecstasy*.

AS PART OF the new tomb arrangement, Michelangelo was provided a large house on the Macello dei Corvi (a street name meaning "Slaughter of Crows") in central Rome; it included ample work space and grounds that stretched from Trajan's Forum to the Piazza San Marco. There he stayed, working on *Moses* and the *Captives*, from 1513 until early 1516. Unlike his old cramped quarters behind the Church of Santa Caterina, this workshop had space for the marble blocks still sitting in the Piazza San Pietro and at the Tiber dock— a welcome if overdue amenity, since, as he claimed much later, nearly all the blocks left beside Saint Peter's had been filched, "especially the small ones."[12]

Perhaps that was why he used what proved an unsatisfactory stone for his next statue, a bit of moonlighting undertaken in defiance of the exclusive contract he had signed with Julius's heirs, perhaps to placate politically powerful patrons. In 1514 three Roman grandees, one of whom was the canon of Saint Peter's, induced or inveigled him into carving, for the unspectacular sum of two hundred ducats, a life-sized nude figure of the risen Christ holding the tokens of the passion, to go in the ancient church of Santa Maria sopra Minerva.

The result is one of Michelangelo's least popular works—partly because of its full frontal (though theologically correct) nudity, and partly because of its inconsistencies of form and execution: a powerful and expressive conception marred by protuberant buttocks, incongruously thin legs under a massive, powerfully modeled abdomen with a classical, overhanging carapace of oblique muscles, and stereotypically sweet, handsome features. These faults reflect the fact that Michelangelo left his second version of the *Risen Christ* to be finished by assistants when he returned to Carrara in 1519. He was obliged to carve it again, from a fresh block, because of yet another bout of mar-

ble trouble: a black vein that appeared on Christ's face, like the stain on *Bacchus*'s cheek, in the first attempt. He abandoned that effort and made a gift of it to Metello Vari Porcari, one of the three patrons. Porcari still insisted on a completed statue, and Michelangelo felt obliged to comply, perhaps for political reasons.

Clearly he needed a surer supply of marble; even his old stalwart Michele was not coming through in Carrara. And then a new prospect beckoned, just down the Apuan range, at a town enticingly named Pietrasanta.

THE TOWNS OF Pietrasanta and Seravezza lie just twelve miles south of Carrara, but historically and culturally they are in another world. Carrara, the inland "island," and its quarry villages were built by the descendants of slaves on the ruins of Roman Luni; from their beginnings they have depended on their marble *cave* and jealously protected these from foreign interlopers. Pietrasanta, by contrast, is a younger— that is, a medieval—town, Tuscan in speech and custom, which grew as a satellite in the orbits of Lucca and Florence.

The town's name sends travel writers waxing poetic: *pietra santa* means "holy stone," which most take to refer to the local marble; one account credits it to a ceremonial stone on which robbers were beheaded. But the name's origin actually has nothing to do with stone. In 1215 the republic of Lucca deputed a Milanese nobleman, Guiscardo Pietrasanta, to consolidate its control over this strategic choke point between the mountains and sea; he founded the town that bears his name on the site of an old Longobard fortress. In the ensuing centuries Pietrasanta and nearby Seravezza passed through the usual bloody round robin of overlords: Lucca, Pisa, the local counts of Corvaia and Vallecchia, Genoa, Florence. When the Florentine *commissario* Astorre Gianni seized Seravezza in 1429, he took a page from the Roman campaigns against the Liguri: he herded the leading families into the church, had all the men slaughtered, and sent the women back to their ravaged homes with only their torn shirts on their backs.[13]

The Seravezzese may have breathed easier when French invaders let Lucca retake control in 1494. But Florence still contested the loss, and when Giovanni de' Medici became Pope Leo X, he settled the issue with typical papal impartiality: he awarded Pietrasanta and its environs

to his native Florence. This transfer included a special prize: several promising but undeveloped marble deposits near Seravezza. The marble-fixated Florentines finally had their own marble mountain.

Seravezza sits at the bottom of an Apuan foothill corridor even narrower than Carrara's, where two mountain streams, the Serra and the Vezza, meet in a near-perfect right angle. Though only three miles separate them, Seravezza seems a world away from the prosperous, sunny flatlands of Pietrasanta. It feels like a mountain town, cool and drizzly, hemmed in by green walls so steep they seem ready to fall on it. Marble yards, truck yards, and *segherie* (stone-sawing mills) dot the approaches along the streams that originally powered the sawmills. These streams shine white with marble rubble tossed from the mills and washed down from the slopes.

The town core straddles the Serra along a zigzag stitch of bridges. Its most impressive buildings are a fortresslike palace where Florence's Medici dukes sometimes stayed in summer, which now holds a library and a fine little art and ethnological museum, and, beside it, a cavernous defunct *segheria*. There, sculptors from far away—France, Germany, China—hammer at their workbenches and strive to develop an ambitious cooperative sculpture center. Their presence here today, along with the *segherie* and the white rubble in the streambeds, can be indirectly credited to Michelangelo Buonarroti.

The Serra gorge climbs due north from Seravezza for about three miles, then slams into the postcard-perfect peak called Monte Altissimo. It is a wild, unsettling stretch, the sort of place where anything might happen; large hawks, rarely seen above the Carrara quarries, circle above, and one swooped in front of my car as it climbed the switchbacks. I stepped out at the road's end and began climbing the old quarry trail up Monte Altissimo, only to find it mined: it was chestnut season, and the spiny nuts snapped lightly as they popped from the trees arching overhead. One hit home, jabbing my head. Shadows rustled in the brush above, chamois or wild boar, or perhaps just feral goats.

A road runs atop the east side of the gorge, passing here and there a wary, closed-shuttered village and one outsized, solitary stone church: the thirteenth-century Pieve della Cappella. It has two notable features: a fine little *rosone* (rosette window) and a scattering of Ionic columns, some toppled and some standing forlornly. These last are the remains

of a marble portico, built between 1518 and 1536 and wrecked in World War II, that, locals say, Michelangelo himself designed. Legend also credits him with carving the *rosone,* called "L'Occhio di Michelangelo." It looks out, appropriately, over the now-abandoned five-hundred-year-old marble quarry of La Cappella, whose ledges and slopes are still dotted with hand-chiseled blocks of *bardiglio* and other preindustrial relics. That's unimaginable, but he might have sketched out a design on a lark or as a favor to a local host; if Michelangelo were to design a *rosone,* it would be robust and laced with dynamically opposing arcs as this one is.

The Apuan region is dotted with artifacts that local legend credits to Michelangelo; "Michelangelo carved here" is as much a byword in these parts as "George Washington slept here" is in the eastern United States. There's the carving over the portal of the church in the hilltop village of Ortonovo, just north of Carrara; a crucifix in the church in the nearby village of Castelpoggio; and another in the Church of Santi Rocco e Giacomo Apostoli in Massa, whose hip-looking young priest told me the parish had no idea what a treasure it held until an expert from Florence came bearing news. All these claims seem improbable, though scarcely more so than a small wooden crucifix in Florence that another expert attributed to Michelangelo in spring 2004, eliciting a splash in the papers and a special museum show.

But Michelangelo is also credited with a much grander *opera* in Seravezza territory: opening up the marble riches of Monte Altissimo itself. The name is somewhat misleading: "Mount Highest" stands just 1,589 meters (5,213 feet) high, lower than a dozen other Apuan peaks. But few mountains present such a stark, unobstructed aspect, and few provide such pure white marble, including *statuario* that competes with Polvaccio's. The sad truth is that Michelangelo didn't get any stone from Monte Altissimo, though he tried. But he did scale its slopes when they were truly wild, staking out its marble beds and perhaps dodging its flying chestnuts. And he whetted the appetites of those who would follow in his steps.

A third of the way up the Serra gorge to Monte Altissimo, just below the chapel that holds l'Occhio di Michelangelo, the La Cappella quarry has been dug into the ridge, and yet another, Trambiserra, lies across the river. There Michelangelo would find his marble, and nearly die for it.

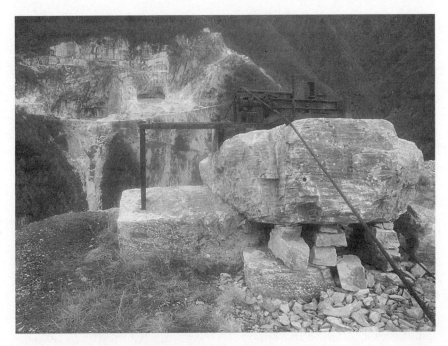

Traces of past quarrying at La Cappella, with Trambiserra across the gorge.

* * *

THE ETRUSCANS settled along the Serra River below Seravezza and apparently quarried the nearest marble beds; the stone in many funeral *cippi* (pillars) found nearby matches that of the Ceragiola quarry, a kilometer south of Seravezza.[14] The Romans who supplanted the Etruscans ranged widely through the Apuan Alps, and may have found the higher-level marble beds north of town, in the ravines above the Serra and even on Monte Altissimo. But there's no proof they ever exploited these, despite Vasari's claim that "all the ancients worked there, those masters who were so excellent, and used no other marbles than these to make their statues." Vasari apparently confused Pietrasanta with Carrara, since on the preceding page he lauds the Polvaccio quarry, by Carrara, as the source of the purest *statuario*. He may also have heard chauvinistic local claims of ancient quarrying in Pietrasanta. Or he may have deliberately hyped the antiquity of the Seravezza / Pietrasanta quarries, which his patron, Duke Cosimo I, was then striving to develop.[15]

By the late fourteenth century, some white marble went from La Cappella to Florence; in 1374 it was used to decorate the new Cathedral of Santa Maria del Fiore.[16] But quarry development here lagged far behind that at Carrara. After establishing Florentine control over the territory, Pope Leo and Cardinal Giulio de' Medici set out to change that—and precipated one of the most mysterious and torturous intrigues in Michelangelo's stormy life.

The marble that Michelangelo so desperately needed lay at the center of this intrigue. In March 1514, soon after Leo awarded Pietrasanta and Seravezza to Florence, a supervisor from Saint Peter's arrived to undertake improvements in the rough road that led up the Serra River to the La Cappella and Trambiserra marble beds. On May 18, 1515, the good people of Seravezza made an offer they could not refuse to make: under gentle persuasion from the pope and his fellow Florentines, they formally deeded those underdeveloped quarries to the Florentine republic.[17] The leaders of nearby Pietrasanta cheered the move, hoping that Florentine capital would develop those resources and bring a boom to the region. Carrara's marble masters, who had enjoyed a lucrative near-monopoly in the marble trade, grimaced at the prospect of competition.

Two weeks later, Michelangelo asked his brother Buonarroto to forward a letter "that goes to Carrara," and do so "secretly, so that neither Michele [di Piero, his stonecutter on the scene] nor the Duomo Operai nor anyone else knows about it."[18] The addressee is unknown, but Michelangelo also asked Buonarroto to see if a certain Luigi Gerardini could forward the letter directly to that mysterious party.

This tantalizing communication suggests two possible, and very different, interpretations. Gerardini was a family name at Seravezza, and Michelangelo may have been making discreet inquiries about the marble there.[19] If so, he would not want it known around Carrara, where it would arouse local jealousy and further inflame his relations with the *fornitori*. But he was more likely writing to someone at Carrara, perhaps to reassure the Carrarese that he still wanted to buy their marble, perhaps to use the new threat of competition from Seravezza as leverage in their dealings. And he did not want the Duomo Operai, who favored the development of the Seravezza quarries, or their agent Michele, who would soon relocate to Pietrasanta, to

know. Already, he seemed to foresee bitter competition between the two marble districts and fear he'd get caught in the middle.

He also realized that, with the acquisition of the Seravezza quarries, Pope Leo might soon grow more interested in marble projects and put him to work. This imposed new pressure to finish Pope Julius's tomb while he could. Michelangelo wrote again to Buonarroto, asking to have fourteen hundred ducats transferred to him for materials and other expenses, "because I must make a great effort this summer to finish this job as soon as possible, because I expect I'll then have to be in the pope's service."

AT SERAVEZZA, the quarry preparations seemed to be proceeding. The Arte della Lana, which funded Santa Maria del Fiore, agreed to build the quarry road, in order to get the marble to finish the great cathedral. Two months after the quarries were formally ceded to Florence, and five weeks after Michelangelo sent his brother the mysterious Carrara-bound letter, he heard from Domenico Buoninsegni, Cardinal Giulio Medici's treasurer and liaison on the project, that the road was "nearly done." He asked his brother Buonarroto to try to get a response from Michele as to how things stood there, "so I can make a decision. Much as I know not to count on anything from Michele, I thought he'd at least know the answer to this one thing I asked him, whether I'll be able to get marbles from Pietrasanta this summer."[20]

Three weeks later, in late July 1515, Michelangelo was still clamoring for stone. He sent Buonarroto another letter to forward to the wayward Michele—"not because I don't know he's crazy, but because I need a certain quantity of marble and I don't know what to do. I don't want to go to Carrara myself, because I can't, and I can't send anyone, though I should, because whoever's not a cheat is a lunatic or scoundrel."[21] A week later—too soon to have received a reply to his last plea, since it took five days for a letter to get from Rome to Florence—he wrote again, asking Buonarroto to find out "whether Michele or anyone else was building that marble road" at Seravezza and get back to him right away.[22] Since he'd returned to Rome, he lamented soon afterward, he had done "no work at all, just tried to make models and get things in order, so I'll be able to make one grand

effort and finish it in two or three years, with a whole workforce to do it."[23] But two things held him up: getting the funds for the tomb released from deposit in Florence, a problem soon resolved, and getting the marble to build it, a problem that would drag on for years.

Buonarroto offered some sort of help in obtaining marble, but we can only guess what it might have been; though many of his correspondents saved the letters he sent, Michelangelo had not yet begun saving those he received, so the record is frustratingly one-sided. "There's nothing you can do," he replied to Buonarroto. "I'll take care of it, one way or another."[24] He appealed to one more potential marble source, the sculptor Domenico "Zara" di Alessandro di Bartolo Fancelli, a scion of a leading Settignano stone-working clan who had thrived in Carrara producing imposing tombs for Spanish princes and nobles.[25] Michelangelo sent along a letter for Zara and directed Buonarroto to make several copies and send them as well, in hopes one would reach him; though Carrara was only about eighty miles from Florence, communications were tricky and uncertain, one more frustration for Michelangelo.

Three weeks later, the supreme stone carver was still stuck without stone to carve. A Tuscan sculptor had inquired about coming down to Rome to work for him; Michelangelo replied that he would gladly accept the help, but "I have no marble to work." In desperation, he sent a plea to Marchese Alberico's chancellor, Antonio da Massa, hoping to break the logjam in marble shipments.[26]

Chancellor Antonio apparently did not reply, which suggests Michelangelo's stock was still low in Carrara. But he finally heard in early October from Zara Fancelli, who said he'd been too ill to write before. Zara reported that he'd now found *"certi begli marmi di tuta beleza."* He didn't know if these beautiful marbles' dimensions suited Michelangelo's needs, but urged him to send someone he trusted to direct the quarrying and offered whatever help he could provide.[27] Michelangelo's Carrara connection seemed to be working again.

Down in Rome, however, big changes were afoot. Duke Francesco della Rovere, the nephew of the late Pope Julius, refused to support Pope Leo in a war against the French in Lombardy. Leo responded by excommunicating Francesco, taking the duchy of Urbino away from the della Rovere, and installing his own nephew Lorenzo de' Medici, the grandson of Lorenzo the Magnificent, in Francesco's place.

This reversal of fortune would drastically affect Michelangelo and his tomb project. The della Rovere heirs, now on the outs, could no longer defend their claim to his time and talents. Not only was Pope Leo disinclined to spare him to complete Julius's tomb, he now had an incentive to derail that project, which would only glorify his della Rovere enemies and the predecessor who overshadowed him. And Leo had another, even bigger, project in mind, one for which Michelangelo seemed ideally suited.

CHAPTER 13

"THE MIRROR OF ALL ITALY"

NOTHING TROUBLED MEDIEVAL AND RENAISSANCE
ARCHITECTS AS MUCH AS FAÇADES.

JAMES S. ACKERMAN, *The Architecture of Michelangelo*

THE COLLEGIATE CHURCH OF San Lorenzo, two blocks east of the Cathedral of Santa Maria del Fiore in Florence, had been uniquely important to the Medici for nearly a century, almost since the family first rose to wealth and prominence. In the 1420s, Giovanni di Bicci, the first great Medici patriarch, commissioned Filippo Brunelleschi, then occupied with the dome for Santa Maria del Fiore, to build a sacristy at San Lorenzo. The cathedral dome gets more attention today, thanks to its sheer scale and engineering audacity, but it was at San Lorenzo that Brunelleschi first and most fully achieved the neoclassical order and harmony that defined Renaissance architecture. The Renaissance began at San Lorenzo, and there it waited achingly to be completed.

Brunelleschi finished the Old Sacristy (as it's now called, to distinguish it from Michelangelo's New Sacristy) in 1428. Its dome is a graceful counterpoint to his larger cathedral dome—Mama Bear to the duomo's Papa Bear. Together, they define the city's skyline, just as the two churches define their eras: the cathedral represents late medieval Florence, and San Lorenzo the Renaissance city. Giovanni di Bicci's son Cosimo the Elder installed his parents' tombs in the Old Sacristy, effectively making San Lorenzo the Medici family chapel, and

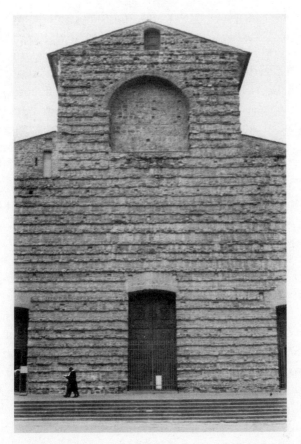

The still-unfinished façade of the Church of San Lorenzo.

directed Brunelleschi to rebuild the entire church along the new principles. The church's interior, not finished until after Brunelleschi's death, was one of the quattrocento's crowning architectural achievements.

But the most visible jewel in this crown was missing: the church's façade. It loomed blankly across the Piazza di San Lorenzo, a jagged wall of rough-cut brown *macigno* mocking Florence's pretensions to order and stability. For the Medici pope, bringing the Medici church to a glorious finish would be a special triumph, the hometown equivalent of rebuilding Saint Peter's. When Leo put out the word, the leading architects of Florence and Rome submitted designs—Baccio d'Agnolo, Giuliano and Antonio da Sangallo, Andrea and Jacopo

Sansovino, even Raphael of Urbino, upholding the legacy of his recently deceased mentor Bramante. Michelangelo intended to, but refused to accept anyone else's help in making a model and never got one done. Nevertheless, by summer 1516 he had fallen into a collaboration with Baccio d'Agnolo and somehow (the circumstances are murky) snared a joint commission: Baccio would build the façade and Michelangelo would make the sculptures for it. This seemed a sensible arrangement, teaming a seasoned, capable architect and the foremost living sculptor. But Michelangelo was not one to collaborate, as Baccio would learn.

With the San Lorenzo project beckoning, Michelangelo sought to open some space in his commitment to Pope Julius's heirs. In their weakened position, they could not hold out for terms, and in July 1516 signed the third iteration of their contract for the tomb. The scale of the project would be reduced by about a third, to something midway between the full-fledged mausoleum of the 1505 and 1513 versions and the sort of wall tomb other popes already had in Saint Peter's. The width of the two side walls would be reduced by about half, with a corresponding reduction in the number of statues, from forty to twenty-two; the first level of each side wall would now have just one niche holding a Victory and surrounded by two Captives. Michelangelo would have until 1522 instead of 1520 to finish. The della Rovere would provide him the big house on the Macello dei Corvi rent-free for the project's duration (he wound up staying until the end of his life), but he was permitted to work on the tomb statues at Florence, Carrara, or wherever he chose.

Now he had more time, but he also had two enormous projects to complete, and he needed marble for both of them.

IN APRIL 1516, Michelangelo rode to Florence, examined the San Lorenzo site, and consulted with Baccio d'Agnolo, his prospective partner. In late summer, he dispatched to Carrara the only quarry master he knew he could trust: himself. This time he sought help in smoothing the way from the ex-*gonfaloniere* of Florence, Pietro Soderini, now exiled in Rome, and his wife, Argentina Malaspina Soderini, a cousin of Carrara's Marchese Alberico Malaspina. Fortunately Soderini's reply survives, because in early 1516 Michelangelo

began saving much of the correspondence he received (along with the notes he recorded), making the documentary trail a busier two-way street. It now becomes possible to eavesdrop on his extensive long-distance exchanges with everyone from *scarpellini* to Medici prelates. The result is an unusually intimate look into the relations between artist, patrons, colleagues, and workmen in the High Renaissance, and into the workings of Michelangelo's mind and character. It's the epistolary chronicle of one of the most arduous and tumultuous periods in his long life, but because it did not finish triumphantly as his years on the *David* and Sistine ceiling did, it's all too often overlooked today.

Donna Argentina sent Michelangelo a letter of introduction to present to her brother Lorenzo, the marchese of Fosdinovo. In it, she asks Lorenzo to show the sculptor every courtesy and hospitality, especially if he should take ill. Such solicitude would be well repaid, she explains, since this Buonarroti is "expert in architecture and craftsmanship and in designing fortifications" and "much beloved of *il magnifico* my consort, and a person of such fine qualities, so cultured and gracious, that we do not believe there is today another man like him in all Europe."[1]

Her letter closes with familial cordialities: "My consort is well and his head is mending, and he sends a thousand greetings to Milady the Magnificent Bianca, to your wife, and to Milady Theodosia. Caterina salutes you and Milady Theodosia a thousand times, and so do I." Such warmth offers a cozy, oddly contemporary contrast to the endless haggling over ducats, marbles, and deadlines of most of Michelangelo's correspondence. It also points up the special connection between the Malaspina rulers around Carrara and Soderini's late republican government in Florence, which the Medici and their supporters had overthrown. This suggests a political subtext to the troubles that would soon ensue, when Michelangelo would find himself caught between the clashing interests of the Medici and Carrarese.

Argentina Soderini's letter may have engendered some trickle-down goodwill in marble country. In late August 1516 Michelangelo, now in Florence, received a letter from "Blush" Caldana, one of the five Carrarese marble masters who had formed a partnership to supply his stone ten years earlier and then fallen out with him over not getting paid. Now the hard feelings were set aside. "Command me,"

Caldana wrote to *"lo excellentissimo maestro Michelangelo."* He declared that he had lately quarried "beautiful stones, measuring up to fifteen *braccie,"* more than twenty-seven feet, and many more waited at Polvaccio. "Come here and you will be satisfied."[2]

Michelangelo arrived a few days later. He put down twenty ducats to rent a house on Carrara's Piazza del Duomo from Michele di Piero Pippo's brother-in-law Francesco di Pelliccia, a *fornitore* who had provided some of the 1508 marble for Julius's tomb.[3] Today this four-story building, covered in dark pink stucco and trimmed with traditional black shutters and a bit of rusticated marble, houses apartments and a corner *tabaccaio* shop. Only a small marble plaque reveals its distinction: "Many times within these walls did Michel Angelo Buonarroti stay when, to make eternal the images in his creative mind, he came to our mountains for marble." In 1516 it afforded Michelangelo space to build models and even carve stone; in the centuries before air-powered chisels and screeching circular saws, sculptors could still work in city centers. It was just a short walk to the ancient Via Carriona, down which the marble blocks were hauled in creaking wooden-wheeled oxcarts, and a few paces to Carrara's duomo, where Michelangelo may have drawn a key inspiration for the San Lorenzo project.

The day after taking the house Michelangelo met two members of his old quarrying team, Matteo di Cuccarello and "Lefty" Mancino, together with Mancino's pal Betto di Nardo, at the door of the duomo. With Matteo as witness, he hired Mancino and Betto to resume quarrying for him.[4] At the end of September he wrote his father that he had started quarrying in many places and hoped, if the weather stayed fair for two months, to have all the blocks he needed in order to finish the project. "Then I will decide whether to work on them here or in Pisa, or I might go to Rome. I'd be glad to work here, but there's been some unpleasantness and I feel uneasy here."[5]

What had gone amiss so soon? Michelangelo may have alluded to lingering ill will from a decade earlier, when he left Matteo, Caldana, and their partners hanging after he was forced to suspend the tomb project and start on the Sistine ceiling.[6] Matteo had not forgotten; he had lately been heard complaining about Michelangelo's behavior.[7] But this old rancor hardly seems enough to scare off even someone as nervous as Michelangelo. More likely, he feared the anger of the Car-

rarese should he be obliged to procure marble from their new rivals down the road at Seravezza.

That prospect now seemed more promising. At the end of September Michelangelo finally heard from the wayward Michele, the "Little Clapper," whom he had tried so frantically to contact from Rome. Michele had gone to Seravezza seeking marble for an apostle for the Florence duomo, but wanted to "be sure" of what he'd found before writing. Now he could attest that he had "fallen onto something good, thanks to the richness of the marble here. I've started making two cuts in a block twenty *braccie* long"—an astonishing length, more than twice the height of the *David*, such as had not been quarried since ancient times. The seam ran so deep, Michele added, "I can't see to the end of it. And this looks like a trifle compared to the big pieces to come, as big as they are beautiful. If I know you, you'll be able to meet your marble needs quickly here, just in the mass where I'm quarrying this Apostle."[8]

Two weeks later, the Clapper rang again, with the enthusiasm of a tourist-board brochure: "The men of this village want to get things going and promise to give great support to grading the road, partly with money and partly with their own effort." To reinforce this message, Michele sent along the head of the village, "who will regale you about everything. Speak with him in any case, and I assure you you'll come; with a good rope, you'll be able to realize your every design."[9] Verily, this was the land of marble and honey; in his next letter, Michele rhapsodized over "flawless" blocks, wonderfully firm, that would "detach themselves with just a little force on the wedge," so clear they "shone as the moon shines in a well."[10]

Michelangelo knew better than to take what "crazy" Michele said at face value. But he couldn't help being intrigued by these reports, even as he kept quarrying in Carrara. In November, another glowing report on Seravezza's stone arrived from the architect-sculptor Baccio Bigio, who worked for the Duomo Operai with Michelangelo's designated partner, Baccio d'Agnolo. At the pope's request, Bigio had checked out the Seravezza deposits and reportedly found "beautiful quantities, of a fine type and great firmness, and enough to last for eternity."[11]

* * *

IN MID-OCTOBER, Baccio d'Agnolo forwarded good news from Cardinal Giulio's liaison Buoninsegni: after talking to his cousin Leo, the cardinal concurred in having Baccio and Michelangelo produce the façade; all that remained was for them to meet with the pope and conclude terms. But they should come soon to catch him in Florence, before he returned to Rome, so that "the friend you know, or other friends of yours, will not have a chance to interfere."[12] Who might those meddlesome "friends" have been? One prospect is Giuliano da Sangallo, Michelangelo's old mentor, who had sought the San Lorenzo commission himself and may have also encouraged Michelangelo to put in for it; perhaps he hoped to displace Baccio d'Agnolo as Michelangelo's partner. Another is, of course, Raphael, who had also failed to win the commission but stood high in Leo's favor. But the likeliest suspect is the Florentine sculptor Jacopo Sansovino, another San Lorenzo hopeful, whose continuing interest in the project would indeed put him on a collision course with his old friend Michelangelo.

Bramante and Julius II were dead, but competition and intrigue had not gone from the papal court. Neither, it seemed, had artistic largess. "You should know," Buoninsegni assured the two San Lorenzo collaborators, "that [money] won't be lacking, because a good sum has already been set aside." These were words to set Michelangelo's imagination soaring; he might have a budget to match his ambitions.

At some point, Michelangelo must have passed along Michele's ecstatic report on Seravezza's marble. Soon after writing to Baccio, Buoninsegni wrote directly to Michelangelo, saying that the pope didn't need to wait for this "tall tale" to pan out; he was already determined to quarry at Seravezza. And so he would put up a thousand ducats to build the quarry road, which sum the Opera del Duomo would match. Buoninsegni advised Michelangelo to be prepared: "You can amuse yourself quarrying marble [at Carrara] until the road is finished, but then you'll get whatever you need from there."[13]

Furthermore, Michelangelo could limit his role in the façade, leaving the overall design and construction to Baccio. "For the Pope," Buoninsegni declared, "it will be enough if you carve the main figures and delegate the others to whoever you think is satisfactory." But that was not how Michelangelo worked. Soon after, his dealings with Baccio grew rocky and their collaboration unraveled—or rather, Michelangelo yanked the thread. This was probably inevitable; ever

since he was an upstart apprentice in Ghirlandaio's workshop, he had proven constitutionally incapable of yielding to the egos or ideas of other artists. From a practical view, the collaboration may have been the only way he could have hoped to finish the façade and the tomb. But he was inflamed with his own conception of the façade—not just as a frame to support sculptures, as his designs for Julius's tomb were, but as his first true architectural effort, a vast sculptural work in itself.

Pope Leo insisted that Michelangelo and Baccio come to Rome to confirm the façade commission and settle on a design. But Michelangelo was an old hand at resisting papal summonses, and he had less fear of Leo than he'd had of Julius. Now that he'd finally gotten to Carrara, he had work to do—a last desperate effort to push Julius's tomb forward before he got immersed in the façade project. On November 1, 1516, he contracted to buy nineteen roughed-out figures approximately eight feet tall—enough to finish the tomb sculptures—from the quarry of his landlord, Francesco Pelliccia. This time he tried to eliminate the risk of flawed stone: Pelliccia agreed to provide "the most beautiful, whitest marble in his *cava,* which will be *vivo bianco* and free of veins and cracks and without any marks, like the sample he provided the aforementioned M. Michelangelo."[14] Soon afterward Michelangelo bought three blocks of Polvaccio stone, likewise "clean and white," from Lefty Mancino, and advanced him twenty ducats for more stone to be quarried at Polvaccio within a month.[15]

Throughout November, Domenico Buoninsegni and Bernardo Niccolini, the treasurer for the archbishop of Florence, wrote repeatedly urging Michelangelo to hasten to Rome. Buoninsegni tried to play on his Florentine pride and anxiety about competitors, in particular Raphael of Urbino: "When you complain that the prestigious, desirable commissions are consigned to foreigners from outside, I say that you yourself are the cause, with your vain and abstract fantasies."[16] Baccio d'Agnolo added his voice to the chorus: "This seems extremely important to me, and I don't think I can go without you, because the Pope doesn't think things will ever be right if he doesn't speak directly to you, and Domenico hasn't written that the Pope has settled on the design."[17] But Michelangelo stayed on in Carrara, like Achilles sulking in his tent, replying first that he would, then that he would not go, and then not replying at all.

Baccio's tone turned frantic. He forwarded an anxious letter from Buoninsegni and added, "You can see how angry he is at me and you, complaining that you wrote him you would go and then that you can't. He seems to be getting in a great fury over this, because he believes his honor rests on your going. He's written me many times that I should go myself, if you can't, but I've written him that I don't want to go without you on any account, because the design still isn't resolved and I don't believe it will be without you. . . . Now I beg you to give me word. I'm amazed you have not written me."[18]

But Michelangelo saw a serpent in the garden. Baccio Bigio, who had gone to examine the Seravezza marble deposits in November, thought he had a stake in the San Lorenzo commission as well, and was putting out word that he and Baccio d'Agnolo would handle the design and Michelangelo would work under them to supply figures. Michelangelo wrote heatedly to Buoninsegni charging that the two Baccios were trying to cheat him out of the commission. Buoninsegni replied that he didn't "know what to say about such matters" and reassured Michelangelo that he and Baccio d'Agnolo had the commission to themselves, if they would only move on it:

The Cardinal insists that I write and make you understand how the Pope is determined to assign the façade to you and Baccio d'Agnolo, in case you want a part in it; and that I must advise you that you would do yourself good to make up your mind right away, if you want to take part in this enterprise, because they want to get started. And as far as I know, the Pope and Monsignor de' Medici very much want to work with you; but I tell you truly, do not dawdle further in making up your mind, and decide yes or no; notwithstanding the fact, though you don't realize it, that these are men who would do well by you, they are disposed to begin this project, and [if you don't act] they will find someone else and do the best they can.[19]

By the time Buoninsegni wrote this, Michelangelo was on his way to Rome alone; he was doing just what he had accused Baccio of doing, cutting his partner out of the loop. There, in early December, he worked up a drawing of the façade plan and obtained Leo's eager as-

sent to it. He next headed up to Florence to give Baccio the design, so his "collaborator" could execute a wooden model.

It is testimony to Michelangelo's stature among his contemporaries that the mightiest prelates in Christendom would put up with such prima donna behavior and still clamor for his services. In the end, however, his disregard and procrastination seem to have had a desired effect, whether or not he intended it: the episode showed how much Baccio depended on him to execute the façade, and relegated the experienced architect to a secondary, almost assistant status. Soon, Michelangelo would shed his collaborator entirely and secure the entire façade commission for himself. In the end, however, he would come to wish Leo *had* given up on him and found someone else.

MICHELANGELO RETURNED to Carrara in early January 1517 and, flush with a thousand ducats newly sent by the pope, set out after marble. He entered into one contract after another with various *cavatori*, none of whom could begin to supply all the marble he would need. Even Matteo di Cuccarello set his old rancor far enough aside to sign on.

But still the course of commerce did not run smoothly. In February Michelangelo filed a *libello* (lawsuit) to break a contract for four blocks that he had signed the month before with two *fornitori*.[20] In April he and Francesco Pellicia dissolved their ambitious contract for nineteen figures of perfect *statuario;* Pellicia too could not deliver the quality Michelangelo demanded.[21]

Michelangelo had already entered into an outright partnership with a certain Lionardo, also called Cagione, to develop an ancient quarry that Lionardo owned at Sponda.[22] If it succeeded, it might supply marble for the entire project. Michelangelo was starting to go native, turning into a *fornitore* himself. The next month, however, he terminated this partnership too, for what he would only say was "a very good reason," and instead contracted to buy one hundred *carrate* (more than ninety tons) outright from Lionardo over the next year.

Size mattered; the prices agreed reflected the difficulty of finding and safely transporting larger blocks. Pieces of up to two *carrate* were worth two scudi (a unit of currency equal to or slightly larger than the

ducat) per *carrata*. Three-to-four-*carrata* blocks brought two and a half scudi per *carrata*. And so on up to a ten-*carrata* block, worth four and a half scudi per *carrata*. (Later Michelangelo would be obliged to pay a whopping seven scudi per *carrata* for large blocks.) Columns were to cost a flat forty scudi each, without their bases and capitals; failing to get them at this rate, he later agreed to pay ninety for them with bases. So difficult were columns to extract intact that Michelangelo probably placed duplicate orders with various suppliers, in hopes one would come through.

Michelangelo went on to contract two columns from Matteo di Cuccarello, three figures from Mancino's quarry at Polvaccio, and another twenty-four pieces that Mancino and Matteo would quarry. The solitary sculptor had become a major wheeler-dealer, signing contracts and flinging scudi right and left. The leading maestri now largely worked to supply him; Carrara had, for the season, become a company town, and he was the company.

The bibles of this commerce, in that pre-blueprint, pre-CAD age, were his *quaderni* or *memoriali,* sketchbooks, two of which survive yellowed but intact at Casa Buonarroti in Florence. One contains drawings, outlined in fine ink, of twenty-two different architectural shapes, packed onto four of its twelve pages; many are indicated in multiples, for a total of 196 pieces. The other lists nearly three hundred blocks in forty-two shapes across eighteen pages. Their contents partly overlap, indicating that one was made for use in the quarries, the other as a record for Michelangelo to keep; some of his contracts specify that blocks be cut "as they appear in the book of the aforementioned master Michelangelo," and his foreman Topolino more than once wrote that he needed the master's *memoriali* to start cutting.[23]

On each sketch Michelangelo marked the dimensions (*lungo, alto,* and *grosso*) and where his brands—three Venn-like overlapping rings with an M in one, and a downward-arcing crescent with a projecting *T,* like a schematized caravelle—were to be incised, as on cattle. He often sacrificed perspective to clarity, bending the rules to show three, even four, sides at once. Some of his blocks are simple rectangles, others highly evocative sacklike shapes, in which one can see the figure, as in his famous sonnet, yearning to emerge. Weight was money, and the more surplus stone could be removed at the quarry, the less the cost of transport.

Michelangelo's contracts had also been streamlined. For his earlier commissions, and even when he first arrived in Carrara, they were written in Latin, the standard language for legal documents. Sometimes he obtained Italian translations, but his clients and notaries continued to use Latin. In Carrara, however, he had enough clout to demand a change. His Carrarese notary, Garlando Parlanciotto, began writing Michelangelo's contracts in Italian, though he continued using Latin with other clients. Parlanciotto stipulated the reason in a margin note: "I have written this contract in the vulgar tongue because *il excelente homo m. Buonarroti* cannot stand the fact that we in Italy do not write as we speak when we treat of public matters."[24] Perhaps Michelangelo, loyal son of Tuscany and devotee of Dante Alighieri, felt he was striking a blow for the revolution that Dante launched when he wrote his verse in Tuscan dialect (what henceforth became Italian) rather than Latin. When the members of the Florentine Academy petitioned Leo X to move Dante's bones from Ravenna to Florence, he alone signed in the vulgar tongue.[25]

BY AUGUST 1517, enough blocks were ready at the quarries to proceed to the next stage. Michelangelo contracted Matteo di Cuccarello and several other *scarpellini* to haul three roughed-out figures, eight blocks, and six cartloads of smaller pieces from Mancino's and Leone Puglia's *cave* at Polvaccio to the beach at Avenza. The price of this three-mile transport, forty-seven ducats, probably exceeded the cost of the quarried stone.

Much of the expense would have gone to sustain or replace the oxen that dragged the heavy-timbered carts with their iron-rimmed wooden wheels, with stone piled up like hay. Four centuries later, Dickens marveled to see these "clumsy carts of five hundred years ago, being used to this hour," and deplored the ordeals of the oxen "worn to death . . . in twelve months, by the suffering and agony of this cruel work!" And, he reported, "they die frequently on the spot; and not they alone, for their passionate drivers, sometimes tumbling down in their energy, are crushed to death beneath the wheels."[26]

Dickens exaggerated; a turn-of-the-century observer found that Carrara's overworked bullocks did last three years, versus ten at ordinary toil.[27] Those in photos of that time look miserably gaunt. "I'll bet

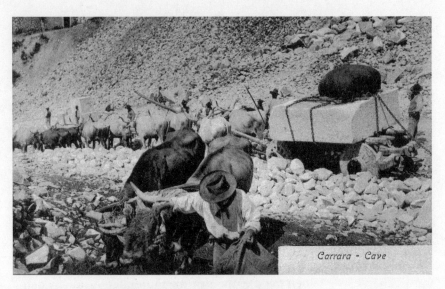

Carrara - Cave

The short, brutish life of a bullock in the *cave*.

the *cave* killed as many bulls as Argentina has," says Umberto Morescalchi, an ex-*cavatore* and collector of local lore. It's said that the stockmen who supplied the quarries would cry, as though begging forgiveness, "*O, mi' povero bue,* my poor bull, I'm sending you to Carrara to die!"

Today moving marble down the slopes is faster, more humane, and usually safe if hair-raising. After blocks are extracted from the rock faces and beds, powerful cranes and shovels swing them into position on the *piazzale,* a leveled staging area. There the crew—a couple of men with big machines, doing the work that scores did a few decades ago—will cut away dross and square off the blocks so they can be moved and milled. In place of a platoon of *riquadratori* swinging their hammers, a modern *cavatore* will set up the *filo diamante,* a motorized half-centimeter-thick steel cable strung with diamond-studded cylinders between steel-coil spacers. So hard are the tiny *diamante* grains that they outlast the cable around which they are wrapped; when it wears out, they are removed and strung onto new cable.

An armada of heavy trucks starts huffing up to the *cave* at dawn, bringing down up to nine hundred truckloads each day. But fewer than a third carry actual stone blocks; the rest are dump trucks, hauling *rifiuti*—dirt and other waste—and *sassi,* marble scrap that is nearly

pure calcium carbonate but too small or misshapen to be sawed. For centuries, the quarry operators dumped both where they dug them, creating the rubble glaciers that cover whole mountainsides in the old photos. But after catastrophic floods, blamed in part on stream-clogging erosion, overran the *cave* and city on September 23, 2003, the *comune* of Carrara began making the marble companies haul out their *rifiuti*. They'd already been hauling out their *sassi* for decades, and even mining the vast rivers left from past centuries. Ground into *carbonato* powder, this rubble is an essential industrial material, used to make paper, glass, paint, cement, asphalt, steel, rubber, plastics, adhesives, pollution scrubbers, even toothpaste, calcium supplements, and antacid tablets. Odds are there's a little bit of Carrara in all of us.

Carbonato is now a bigger business than marble blocks, and operates very differently. Two multinationals, Omya and Imerys, dominate it, in Carrara and worldwide; Omya has more than fifty plants in nearly thirty countries. The *cave* in the Carrara basin, by contrast, are divided among ninety-odd independent, often fractious operators, and concessions pass down from father to son. The drivers who haul the marble blocks are likewise a special breed. Truckers may come from anywhere to haul rubble, but those who transport the blocks are a specialized local elite, almost a hereditary guild, with roots in the old drayage craft. Sixty-five years ago, Carlo Orlandi brought down blocks by oxcart, and he can point out old cart paths that have reverted to woodland since the railway and trucking roads rendered them obsolete. Today he sends his sons and grandsons out in twelve-wheel tractor trailers to haul the blocks, a speedier but scarier passage.

The first critical step comes on the *piazzale,* the terrace where blocks are separated from the *sassi* and squared off for cutting. The driver guides the front-loader operator in precisely positioning the blocks—as precisely as one can slam twenty-ton boulders around—onto two heavy wooden beams set onto the truck's bouncing bed. The blocks must be balanced if they're not to pull the whole rig over one of the sheer drops on the descent. As insurance, they're only lightly strapped down, to steady them in city traffic but let them tear free in a fall. Drivers don't wear seat belts, and stop you if you try to buckle yours.

That calamities do not happen regularly seems nothing less than miraculous. The switchbacks on some unpaved quarry roads are far too tight for turning, so a driver will descend straight-on for one leg, to

the very edge of the precipice, then ease the truck's tail around and back down for the next, until his rear wheels are hanging over the edge.

I got my first cab's-eye view on a run to one of Barattini's quarries above Polvaccio with Claudio Vallerini, who was forty-nine and had driven marble down from the *cave* each day since he was twenty-two. "I have twin sons, twenty years old," he says, "but they won't do what I do. They're afraid to come up to the *cave*." He seems calm as a pond on a windless day, until he starts barking furiously into his cell phone, some business concerning another truck he owns. Then the pond smooths over again. I ask how he stays so equable, driving on the razor's edge. "I've done yoga for ten years," he replies. "I have classes twice a week, Monday and Wednesday. And I'm a second-level practitioner of Reiki"—a Japanese discipline whose name translates as "universal life-force energy." Vallerini reaches into his satchel and hands me a book on Reiki. "It's all about breathing from down here." He pats his belly. "Releasing the chakra. With yoga, Reiki helps you stay balanced. Lots of drivers here practice it."

MICHELANGELO could have used a little yoga. Trouble was gathering to a head. As he labored to get his marble down from the Carrara quarries, his Florentine patrons prodded him to break from there and hie to Seravezza. But now that he had finally mended relations with Marchese Alberico and the Carrarese, established himself in a work space, dispatched an army of *cavatori* to seek the best and brightest blocks, and ordered a small fortune's worth of stone, he had no desire to go prospecting in uncertain new territory. And so his opinion may not have been impartial when he visited the Seravezza beds and reported that their marble was "unworkable" and ill-suited to his purposes and "would be difficult and very expensive to transport to the marina."[28]

In January 1517, Cardinal Giulio sent a high-level delegation, including the sculptor Jacopo Sansovino, the Medici banker Jacopo Salviati, and "many other knowledgeable masters," to inspect Seravezza's marble. The fact that a man of Salviati's quality—Pope Leo's brother-in-law, the Vatican's financier, and one of the richest men in Europe—would undertake such a mission illustrates both the importance of the San Lorenzo project and Salviati's high regard for

Michelangelo. They came back praising the "quality, beauty, and infinite quantity" of Seravezza's stone.[29] Salviati concluded that quarrying there would cost less than buying Carrara marble.

And even if it cost more, Cardinal Giulio told Michelangelo, Pope Leo would still want to use Seravezza stone, not only for the San Lorenzo projects but for Saint Peter's in Rome and the duomo in Florence, "to advance and elevate commerce in Pietrasanta, for the city's public benefit." He scolded Michelangelo in the tones of an angry parent: "Considering your actions, which all work to favor Carrara, you have given no little amazement to His Holiness and to ourself, because what you say does not correspond to what we hear from Jacopo Salviati." And he even accused Michelangelo of hidden motives—perhaps a kickback deal with the Carrarese? "All this raises the suspicion that you, out of some accommodation of your own, want to favor the marble of Carrara and disparage that of Pietrasanta. And this you must not do, considering the trust we have always placed in you. . . . So see that you do all that we have ordered without fail, because when you do otherwise, it is against the will of His Holiness and ourselves, and we will have great cause against you."[30]

Eleven years after storming out on Julius II, Michelangelo had now managed to offend yet another papal client, this time one not so easily provoked. He had run afoul of a classic trade-protection scheme; the Medici cousins might be supreme prelates of the Catholic Church, but they were still Lorenzo de' Medici's heirs, hometown politicians first and foremost. The San Lorenzo façade might be art to Michelangelo, but to Pope Leo and Cardinal Giulio it was also pork; by developing the Seravezza quarries, they hoped not only to stop the flight of ducats to Carrara but to consolidate Florence's hold on a strategic, potentially wealthy territory. And Michelangelo was a key piece in their game.

Their aide Buoninsegni as usual played the good cop. He wrote Michelangelo the same day Giulio did, in sympathetic rather than chiding tones, reaffirming that the Medici really did want Pietrasanta/Seravezza stone, "even if it costs twice as much," for all their projects. "Not only that," Buoninsegni continued, "they don't even want you to take [marble from Carrara] for the sepulchre of Pope Julius"—which was *not* their project. But he offered Michelangelo an ironic consolation: the cardinal would let Michelangelo choose the garments for the

various saints in the façade's niches, because he "did not wish to take up the trade of tailor."[31]

Following this eruption, both sides backed off, in what was becoming a familiar artist-patron minuet. Michelangelo stopped openly protesting. Buoninsegni encouraged him to continue negotiating for marble with the Carrarese and promised to discreetly solicit the cardinal's approval for future purchases. But he specified the maximum prices Michelangelo should pay—about half a scudo less than what he'd already agreed to.[32]

The critical issue seemed to be product disparagement; Michelangelo might be able to get away with quietly using some Carrara stone, but when he openly scorned Florence's new marble beds, he crossed a line. To have the most celebrated sculptor in Christendom badmouthing the Medici's prize threatened not just their account books but their authority.

All these machinations were over a pig in a poke: the design of the façade was still a matter of conjecture. The pope and cardinal had applauded the preliminary drawing Michelangelo brought to Rome in December, but drawings were not enough; they demanded a model, which Baccio d'Agnolo was making in Florence. Michelangelo traveled there repeatedly during the winter of 1517 to view Baccio's progress, and always found it unsatisfactory. Finally, in March, he wrote Buoninsegni that the model was "still the same, *cosa di fanciugli*," kids' stuff; Baccio's efforts were hopeless. Michelangelo apologized heartily to the pope and cardinal for this bad news, but it wasn't bad to him; he was glad to shunt Baccio aside, and had already arranged to have a *scarpellino* from Settignano make another model of clay.[33]

It seems unlikely that this stone worker could make a better model than the experienced cathedral architect Baccio, and indeed he never did produce it. But Michelangelo had three possible ulterior motives for scrapping Baccio's model: The two may have differed on the design. Michelangelo may have seized the pretext to jettison an unwanted collaborator. Or as the scholar James S. Ackerman argues, having conceived a whole new approach to the façade, he wanted to bury the earlier concept that Baccio's model embodied. Or all of the above.

Whatever the motive, the pope and cardinal concurred. "They've notified me that if Baccio doesn't perform for you, you may take on

whomever you wish," Buoninsegni wrote.³⁴ Michelangelo was thus free of the partnership—and Baccio, remarkably, held no hard feelings, and remained willing to assist him. But he was not yet free of all collaboration: Leo had promised some of the façade statues to Jacopo Sansovino, who offered to come join Michelangelo in Carrara for a month and assist the quarrying.³⁵ Given the scale of the project (not to mention the still-looming tomb of Julius II), this might have been just the help Michelangelo needed. But, unable to brook any collaboration, he squeezed Sansovino out too, and then blamed his patrons. Sansovino responded with one of the great "screw you" letters in the annals of art: "And I tell you that the Pope, the Cardinal, and Iachopo Salviati are such men that when they say something, a card is as good as a contract—that is, they are manly and not as you say they are. But you measure them by your stick, you who value neither contracts nor fidelity, and who every hour say no and yes as it serves you.³⁶

This rupture marked a pattern that would recur often in Michelangelo's relationships with other artists. With assistants, *scarpellini*, scholars, pious widows, handsome courtiers—almost any sort of person who was his social inferior or superior—he could maintain warm, generous, long-term relationships. But with his peers—brothers in art and potential rivals—this second in a brood of five brothers often reached bitter ruptures, at least until he reached a mellower old age and no longer publicly practiced painting or sculpture. Sometimes these breaks lasted forever, but often they were mended. Sansovino terminated their friendship with bitter brevity: *"E basta"*—"Enough." But years later they were friendly again.

EVEN AS BUONINSEGNI gave Michelangelo leave to dismiss Baccio d'Agnolo, he urged him to hurry and finish the model for the pope and cardinal. "It seems to me unwise to delay setting your hand to it," he warned. "You don't want this to seem like a wild-bird chase to them."³⁷ But Michelangelo did delay; six weeks later he wrote that, for reasons it would take too long to recount, he had no proper model to send. He'd made a small one from clay but it "rolled up like a pancake"; he offered to send it anyway to prove he wasn't blowing smoke.³⁸

Michelangelo actually did have something in the works—a new scheme for San Lorenzo so radical and ambitious he did not want to

disclose it yet. Instead, he readied the way with an uncharacteristic burst of drum beating. Ordinarily he was diffident, even elaborately self-effacing, in describing his own work, prefering to let his hammer and chisel do the talking. Now he told his papal patrons to pay attention, because he had "something important" to say: "I have enough spirit to execute this work, the façade of San Lorenzo, so that it will be, in architecture and in sculpture, the mirror of all Italy." But, he added, it's going to cost you. A portion of the mass of marble he'd already acquired had proven unusable, he explained, "because it's deceptive, especially with these big blocks that I need, as beautiful as I want them to be. In one block that I'd already had cut, some faults showed on the other side that could not have been divined." A defective block here, a few blocks there, and pretty soon the loss ran to "hundreds of ducats." He wouldn't mind, he declared, if he only had a contract and knew what the price would be; then he could transport the marble to Florence and get to work on the façade. Otherwise he'd have to take the stone to Rome, where others wanted his services, and resume doing his "own work." Either way, he was determined to leave Carrara, for reasons he would not name.[39]

The implication was clear: the pope and cardinal had better sign on the line and stop telling him how much to pay for marble, or he'd take the blocks he'd already quarried and resume making Pope Julius's tomb. Pope Leo would then lose the preeminent artist of the age to a dead rival. To forestall this he'd better be ready to spend a fortune on the façade: thirty-five thousand ducats—several million of today's dollars, nearly one hundred times the price of the *David* and more than triple the original contract for Julius's tomb.

If Michelangelo could do the façade for less, he would let them know. "But the way I intend to build it," he stipulated, "it's more likely that this price will not be enough."[40]

It was a bold gambit, establishing his terms even before he showed his design. And it worked. Buoninsegni replied that Cardinal Giulio was "delighted" with the news and encouraged him to keep on quarrying at Carrara until the Seravezza quarries were opened, so as not to waste time. "The Pope only needs to see the model, but since this is not possible, they will be patient."

A month later, however, Buoninsegni resumed pressing Michelan-

gelo to get the model done, in proper wood rather than clay. He also warned that if the pope, after seeing the model, decided on another design, the marble already cut would be for naught. This was a prudent question to raise with Michelangelo—who would, for example, begin at least seven statues for Julius's tomb that would not fit in the final design.

Nothing came of these warnings. Michelangelo didn't provide the model, Pope Leo didn't provide the contract, the building of the road and opening of the Seravezza quarries didn't progress, and the quarrying continued at Carrara. It is remarkable that Michelangelo would remain in a conceptual limbo for so long, cutting an epic quantity of marble even as he continued to work out his ideas. And those ideas kept growing, to an almost megalomanic level, encouraged by the sheer scale of the marble mountainscape that surrounded him. It was a reprise of the heady months he'd spent in the Apuans ten years earlier, quarrying marble for Pope Julius's tomb, when he dreamed of carving the mountain itself into his own megalithic memorial.

That time, inspiration went before a fall; if the marble mountains seduced him, then they also betrayed him. The long months Michelangelo spent seeking the perfect stone gave Julius time to get dissuaded or distracted from the project and precipitated the "tragedy of the tomb." Inspiration would lead to even greater disappointment at San Lorenzo.

WITH THE SAN LORENZO FAÇADE, Michelangelo the rookie architect faced the most vexing design problem of the Renaissance, a fundamental disjuncture between the medieval tradition its architects inherited and the classical aesthetic they strove to revive.[41] Renaissance churches preserved the stairstep outline of the Gothic church façade: a high central nave, with lower aisles alongside it, and, pulling everything together, the rose window high in the center. Brunelleschi's San Lorenzo design accentuated the stairstep effect with an additional, lower level of aisles. But the classical temples upon which Renaissance façades were modeled were rectangles topped by full-width tympani. The various orders (levels) in classical and Renaissance façades—columns, pilasters, entablatures, friezes, architraves—were arranged in

fixed proportions, expressive of an essential, ineluctable order. And the Gothic stairstep silhouette blew this rational system all to pieces.

In one drawing after another, often a feverish doodle, Michelangelo struggled to reconcile these opposites. He tried the same obvious solution Giuliano da Sangallo had: breaking the surface into three levels, corresponding to Brunelleschi's aisles and nave. But the proportions were all wrong. He tried breaking up the levels, adding a second order of tall columns in front of the central nave with a lower pediment, which could hold relief friezes, on each side—schemes that were two and three stories tall at once. This worked somewhat better, but was still an obvious accommodation.

And then he took a characteristically radical notion: to dispense with the Gothic silhouette entirely, covering it with an enormous rectangular façade, a Wild West–style false front, while preserving the tympanum crown of the nave roof. The result, imperfectly expressed in the wooden model he finally finished in late 1518, is a surprisingly harmonious arrangement, vaguely recalling the faux-architectural frame of the Sistine ceiling frescoes. He had at first envisioned the façade as a sort of gallery wall, broken into niches for statues and panels for reliefs, with little overall coherence—a frame for sculpture, like Julius's tomb. The final design still had niches and panels, but these were subsumed in a form that was a sculpture in itself. And it was a sculpture in the round: rather than a flat façade, Michelangelo decided to build a narthex—a projecting portico. This provided niches for two more larger-than-life statues on each side, bringing the total number of marble statues to twelve, plus six bronze statues and nearly thirty relief panels—an enormous assemblage, more than matching his design for Julius's tomb.

The narthex made possible Michelangelo's most audacious, even reckless innovation. The Greeks had built their temples of solid marble blocks, even if their homes were wood shanties. They could do this because they had marble beds close by; even then it cost seven times as much to haul Corinthian limestone eleven miles uphill to the Delphic Temple of Apollo as it did to quarry it, and ten times as much to cart the Parthenon marbles nine miles as to quarry them at Mount Pentelikon.[42] Roman, medieval, and Renaissance architects almost invariably built with stone that was near at hand, plus brick, concrete, and rubble. Then, if they could afford to, they clad these humbler ma-

terials in marble veneer. It was common sense: marble was costly, transport was risky and even more costly, and Carrara was far away.

But if Michelangelo could not carve a mountain, then he would build one. With the wealth of the church behind him, he would slough off petty practicalities, sweep aside the millennia, and build as the Greeks had: an enormous structure of solid blocks, far from the marble beds. This three-dimensional façade would itself be a sculpture, the largest ever created.

Where did he get this notion? The art historian William Wallace, in a detailed study of Michelangelo's various San Lorenzo projects, suggests one inspiration: the Septizodium, the imposing ruin of the palace of Septimus Severus that stood at the foot of the Palatine Hill, one of the few Roman buildings built entirely of marble.[43] Michelangelo would have seen this ruin, but another candidate stood much closer at hand: a building he passed every day over the course of many months, where he would have gone to pray and savored the austere dignity of the solid marble blocks that form it: Carrara's Chiesa (now Duomo) di Sant'Andrea, kitty-corner to the house he rented from Francesco Pellicia.

To build with solid marble might make sense in Carrara, two miles below the quarries. To do so a hundred miles away by land, sea, and unreliable river in Florence was soaring hubris—and fatal for a project that might otherwise stand beside Brunelleschi's dome as the wonder of Florence.

CHAPTER 14

TAMING THE MOUNTAIN

IF YE HAVE FAITH . . . YE SHALL SAY UNTO THIS MOUNTAIN,
REMOVE HENCE TO YONDER PLACE, AND IT SHALL REMOVE;
AND NOTHING SHALL BE IMPOSSIBLE UNTO YOU.

MATTHEW 17:20

FA 'L MODR. (Be careful)

CARRARINO GREETING

BACK IN FLORENCE, A NEW problem had surfaced; the foundation that had supported the old portico of the San Lorenzo basilica was too weak for the monumental façade Michelangelo had designed, and a honeycomb of old walls had to be dug out so a solid base could be laid. In July 1517, Michelangelo received word that this work was finally proceeding, *"pocho a pocho."*[1] With it came some outwardly positive, but for him unsettling, news: the two Baccios, d'Agnolo and Bigio, who had tried to join as his collaborators in the façade project, had been dispatched to Seravezza to revive the stalled road construction. Michelangelo would have worried once again about their horning in on the project. And once the road was finished, he would no longer be able to avoid moving on to Seravezza and upsetting the ties he had so assiduously built in Carrara.

This seemed to spur him to tie up the design and commission for the façade. On August 20 he left for Florence, where he spent most of the rest of the year completing a large wooden model (with wax figures of the statues) with the help of his assistant Pietro Urbano. Meanwhile the

sledges and oxcarts continued creaking down the tracks from the Polvaccio, Sponda, and Rozeto quarries, and Michelangelo's marble piled up in Carrara's sprawling Piazza dei Porci ("Plaza of the Pigs"). Later this expanse would be laid with marble, ringed with palaces and porticos, and renamed the Piazza Alberica, but for now it served as a staging area for marble passing to the beach at Avenza.

The Florentine advances in Seravezza and Michelangelo's absence in Florence reawakened the old suspicions and resentments toward him among Carrara's *fornitori* and *scarpellini*. Biographers generally describe the Carrara marble masters' campaign against him as he did—as simple protectionism, an attempt to block him from using any marble but theirs. But this was only one of their concerns; more than getting shunted aside, they feared getting burned again, should he depart and leave them holding the unpaid blocks as he did a decade earlier.

In September one *fornitore*, Lionardo Cagione, wrote to dispel rumors that he and Matteo Cuccarello had called Michelangelo a "swindler,"[2] and to reassure him that they still wanted to work for him. But whatever they may have said, someone was spreading the bad word about Michelangelo. Even Marchese Alberico had lost confidence in him. In October the Carrarese notary Leonardo Lombardello, who was well disposed to Michelangelo, wrote to warn him, "I cannot entirely attest to the Marchese's goodwill toward you."[3] Alberico had directed Lombardello to inventory all the blocks and figures Michelangelo had accumulated at the *cave* and Avenza, evidently to guard against their being removed without his paying the duty owed on them.

Michelangelo returned briefly to Carrara that fall to check on the quarrying and transport. In December 1517 he sent the finished model down to Rome; the pope and the cardinal were well pleased. Buoninsegni wrote that he'd heard just one "calumny" regarding the design: "that with these augmentations you will never finish it in your lifetime."[4] This warning would prove prophetic.

In January Michelangelo rode to Rome himself and finally signed a contract for the façade. It granted him eight years to finish, a higher price (now forty thousand ducats), and a key dispensation: he could take marble from Carrara or Pietrasanta, as needed. This provision undercuts the appealingly romantic view, propounded by Michelangelo and both contemporary and modern biographers, that he was forced entirely against his will to seek marble at Seravezza. It reflected the re-

alities of the situation: the pope relented on his ban on Carrara marble because, until the ever-pending road to the Seravezza quarries could be completed, that was the only good stone available. At the same time Michelangelo softened in his resistance to using other marble, because he had begun to fear he would not get all he needed from Carrara.

In February 1518, he returned to Carrara after stopping in Florence for more funds. There, as he recounted, he found the earlier contracts and orders still not fulfilled and "the Carrarese trying to besiege me."[5] He did not elaborate on the circumstances of the "siege," but the tale has come down that he was "in grave danger," pinned down in his house, until he agreed to change the "oppressive terms" of his contracts with the marble masters.[6] It's likely that his demands—for larger, more perfect blocks and columns than any client had sought before—had proved harder to meet than the *fornitori* had expected. So they sought changes in the terms, just as he had in his contract with Julius's heirs.

Michelangelo completed one more marble purchase in Carrara— four pieces from Lefty Mancino—in early February,[7] and in March moved on to Pietrasanta. His attitude seems to have completely reversed itself; where before he had dug in his heels against going to Pietrasanta, he now considered buying a house there. Buoninsegni, eager to sever Michelangelo's bothersome ties to Carrara, encouraged the idea and offered real estate tips: "If you can get that place of Vernacci's for 1,300 ducats, don't let it go!"[8] Michelangelo did not take his advice, else Pietrasanta, which knows better how to promote such things than Carrara, would have made a shrine of the house. Even a house on Pietrasanta's Piazza del Duomo where he sat down to sign some contracts bears a marble plaque, and the bar that occupies it— the spiffiest in town—is, of course, the Bar Michelangelo.

From Seravezza, Michelangelo wrote to the Medici that both the marble and the workforce looked promising. Cardinal Giulio replied ecstatically: "We take great pleasure in learning that you have found in the mountains of Pietrasanta marble according to your needs and that there are workmen to undertake the enterprise . . . and since no other difficulty remains save the road, proper instructions have been sent to M. Jacopo Salviati, so that nothing will in any way be lacking to level it."[9]

Fine hopes, but things looked very different on the ground. The Arte della Lana still had not provided money for the road, and despite

the two Baccios' sojourn at Seravezza the preceding summer, no one had taken charge of the project. Michelangelo, assuming ever more responsibilities, asked the pope and the cardinal to grant him authority, "because I know where the best marbles are and what sort of road is needed to carry them, and I think I can make it much better for whoever pays the bill." He requested, via Salviati and his own brother Buonarroto, that the Arte della Lana grant him a concession for the road, and if they wouldn't to let him know "so that I may get out of here, because I've set myself on the road to ruin and nothing is going as I anticipated."[10]

In fact, things had gone as Michelangelo anticipated, and that was the problem. Sure enough, his sudden transfer to Seravezza infuriated the Carrarese *fornitori*. He still had a large store of marble waiting to be shipped, but could not find any boatmen willing to take it; the aggrieved Carrarese organized a strike against him up and down the coast, and Michelangelo ventured all the way to Genoa to get beyond their reach. From there, he wrote, "I brought four boats down to the beach to load up, but the Carrarese have corrupted the masters of these boats and are determined to block me, so that I couldn't get anything done. I think today I'll go to Pisa to find other boats." And he begged Jacopo Salviati to have his agents in Pisa help find boatmen willing to break the strike.[11]

The shippers' strike was a disaster for Michelangelo, but it foreshadowed one of the most important threads in Carrara's history: its role in the vanguard of Italian trade unionism and (not coincidentally) the international anarchist movement. Quarries and mines have since ancient times been seedbeds of labor organizing and radical resistance. Slaves in Athens's mines staged one of history's few large-scale slave uprisings in 134 B.C.E. Free stonecutters and carvers meanwhile organized in guildlike Greek *hetairiai* and Roman *artes* and *corpora*, ancestors to Carrara's Ars Marmoris; even the Luni slaves formed associations of specialized workers. These associations collapsed with the empire but had reformed by 634 C.E., when the master stonecutters of northern Lombardy organized themselves as the Como Masters.[12]

Today the Journeyman Stonecutters Association is the oldest (though also perhaps the smallest) labor union still active in North America. The Washington Stonecutters reportedly marched together at the laying of the U.S. Capitol in 1792, and many more locals were

born in the 1820s and 1830s.[13] American coal miners fought long and bloody battles for better conditions and the right to organize, and Britain's mining unions were a mighty force until Prime Minister Margaret Thatcher broke them.

Vermont's famous leftist, nonconformist streak was born not in granola cafés and elite colleges but in its rough-and-tumble quarries and stone mills. At the end of the nineteenth century the state was solidly WASP and Republican save for the town of Barre, the designated "Granite Capital of the World." With sixty-three active quarries, Barre was a magnet for Italian immigrants, who made up a third to half its population, and a cauldron of labor and political agitation.[14] Many of the immigrants were Varese, Milanese, and Carrarese stone workers who had first landed at the marble center of Proctor to the south but, disappointed at low wages and rigid anti-unionism, moved north to the granite sheds. Barre's politics somewhat resembled Carrara's today: socialists and anarchists sometimes cooperated in fighting for workers' rights and at other times clashed violently. They shared a spacious volunteer-built Labor Hall where Samuel Gompers, Eugene Debs, Mother Jones, Norman Thomas, Big Bill Hayward, and virtually every other important movement figure spoke; Emma Goldman came and decried the corruption of the local authorities, who promptly ran her out of town. When the textile workers of Lawrence, Massachusetts, met violence in their 1912 "Bread and Roses" strike, they sent thirty-five of their hungry children to be sheltered in Barre.

The granite workers struck a dozen times for better wages, shorter hours, and, especially, safer conditions. The shed owners' obduracy on the last score was appalling: they knew by the turn of the century that granite dust caused fatal silicosis, but refused to install protective suction equipment until forced to in the late 1930s. More than one Barre street was called *la strada delle vedove*: the street of widows.

The leading anarchist intellectual of the day, Luigi Galleani, landed in Barre after getting expelled from a union he had organized in Argentina, and published a newspaper, *La Cronaca Sovversiva,* that was smuggled to Italian communities throughout America. The government eventually deported Galleani, and his *Cronaca* is only a historical footnote now. The cause was sustained for a few years by *Umanità Nova,* an anarchist daily out of Milan, until the Fascists shut it down in 1920. But a weekly *Umanità Nova* still goes out to keepers of the flame

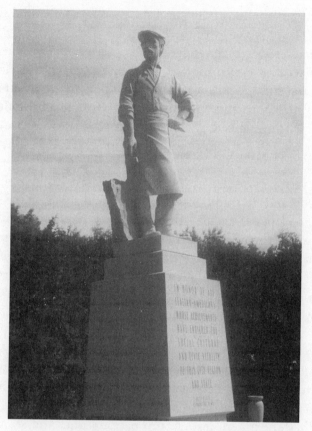

Giuliano Cecchinelli's monument to the immigrant
stone carvers of Vermont's Little Carrara.

worldwide—though only about a tenth as many as the 1920 reader-
ship—from the movement's bastion, Carrara.

During the Italian political upheavals of the mid-1800s, many mar-
ble workers found work in Britain, France, and the United States. They
returned home with the latest political ideas and social ideals, which
sent down deeper roots in Carrara than anywhere else. In the eco-
nomic crisis of 1894, the city and *cave* erupted in open rebellion; one
carabiniere was killed and another injured; troops and police rushed in,
a massacre ensued, and 464 rioters were convicted on flimsy charges.
Nearly all their sentences were eventually suspended, but by then
many had gone to prison or exile, only to return even more radicalized.

By 1912, Carrara, with about one-thousandth of Italy's population,

held a tenth of the Italian Syndicalist Union's one hundred thousand members. They joined with the local Labor Council, led by a shock-haired anarchist organizer and journalist named Alberto Meschi, and managed to shut down the *cave* in a protacted, bitterly contested strike. In the end the *cavatori* won unheard-of reforms: better wages and safety standards and, unique in Italy, a six-and-a-half-hour work-day, commencing when they arrived at the *poggio* (lower base), so they would not have to make the entire hours-long trek to the *cave* on their own time.

Why were the *cavatori* so bold and steadfast in their resistance? Some credit ancient traditions—the Liguri and slaves who defied Ro-man oppression, the medieval *vicinanze* that jealously guarded their autonomy and their precious marble birthright. The dangerous, gru-eling character of quarry work, requiring exquisite cooperation and mutual trust, certainly taught them solidarity and lent urgency to their demands. After facing death on the slopes, they weren't the sort to be cowed by any bosses—not even popes or divine artists.

IN SUMMER 1518, Jacopo Salviati's Pisan bank manager arranged for boats to transport Michelangelo's stranded marble from the beach, but again nothing came of the effort. Perhaps the Carrarese bullied or cajoled these boatmen as well into backing out. And so Michelan-gelo's marble sat on the beach at Avenza for six more months, and did not reach Florence until early 1519.

Meanwhile, things went no better at Seravezza. At Carrara, Michelangelo had benefited from a quarrying and transport system developed over centuries, with everything from ancient Roman roads to a deep pool of quarrying and stone-working expertise. At Sera-vezza he found none of this, not even skilled *scarpellini*. And so he turned to his hometown connections.[15] In March 1518 he brought seven master stone workers from Settignano, his childhood *vicinanza*, to oversee the inexperienced local laborers; he also hired his excitable old pal Michele di Piero, who was already on site, and one supervisor from Azzano, the last village in the Serra gorge on the route to Monte Altissimo. They signed the contract in the home of Donato Benti, a Florentine sculptor living and working in Riomagno, just up the river from Seravezza.

With high hopes, and to make sure he too would benefit from the opening of the quarries, Michelangelo asked the ever-helpful Salviati to get the Arte della Lana to grant him a concession for a perpetual supply of marble for his own use and that of his heirs. But his hopes were dashed when his Settignano ringers arrived in marble country. Harvesting *macigno* in the rolling hills back home proved to be poor preparation for quarrying marble on the steep Apuan slopes. On April 18, a month after calling in the home team, Michelangelo wrote Buonarroto:

These scarpellini *that I brought from there know nothing in the world about quarries or marble. They have cost me more than 130 ducats and have not yet gotten a chip of marble that's any good. They go around hoodwinking everyone into believing they've found great things, and try to do work for the Duomo Operai and others with the money they've gotten from me. I don't know what encouragment they're getting, but the Pope will hear all about it. Since I've landed here, I've wasted about three hundred ducats and haven't yet gotten anything I can use. I have tried to raise the dead, by seeking to tame these mountains and bring art to this territory.*[16]

It's not surprising the Florentine stone workers' skills seemed feeble beside their Carrara counterparts'. Carrara's marble masters, bred to the work from an early age, then served unusually long apprenticeships, five to six years. They learned not only how to extract, transport, trim, and square the stone but often how to shape, decorate, and sculpt it. When he finished, an apprentice *scarpellino* graduated to marble master with suitable pomp, receiving a ceremonial costume that included a red beret, a vest and leggings of colored cloth, and a "mantle of fustian or cape of Neapolitan cloth."[17] That, though few now realize, is exactly the garb decking a seated marble figure outside the Accademia di Belle Arti, carved by the nineteenth-century master Carlo Fontana. Lean and goateed, it looks like a nineteenth-century bohemian but actually represents Pietro Tacca, the son of a cinquecento marble *fornitore*, Giambologna's assistant and successor, and the foremost sculptor ever to emerge from Carrara.

Today a public *scuola di marmo* named after Tacca has succeeded the old apprenticeship system, but I still saw one graduating student wearing a red beret and a long robe. And something of the old rigor

survives. Tristan Cassamajor, a Haitian-born sculptor from New York, was drawn to Carrara by the stone after reaching artistic maturity—or so he thought. Instead, in his forties, he found himself a novice once again: "I wanted to master the material, to become not just an artist but an artisan. I became a versatile sculptor in the U.S., which means I could use many media but I didn't really understand any of them. There you go to school for four years and bam, you're a sculptor. Here, it takes six years just to learn to work marble."

WITH HIS SETTIGNANO stone mates failing him, the blocks he'd already quarried still stranded, and the wool guild stiffing him, Michelangelo's exasperation overflowed. If the Arte della Lana did not come through with the marble concession, he fumed to Buonarroto in April 1518, "I will immediately mount up and ride off to find Cardinal de' Medici and the Pope and tell them what my situation is, and I will quit this business here and return to Carrara, where they implore me as they implore Christ."[18] After signing off, he scribbled an anguished postscript: "The boats I hired at Pisa never arrived. I think I've been snared, and that's how everything goes for me. Oh cursed a thousand times be the day and hour when I left Carrara! This is the cause of my undoing, but I will return there soon."

So he may have hoped, but he still had to play the card he had drawn and make the Seravezza gambit work. And for this he needed the road, which everybody involved seemed to expect someone else to build. In early May, Michelangelo sent Buoninsegni a letter that tells a very different, much rosier story. "The marble here has proven beautiful for me," he announced, and the marble that Pope Leo needed for Saint Peter's—construction rather than statuary grade—could be easily gotten at the established quarries of Corvaia, a village downhill from Seravezza; all that was needed to transport it was a short causeway over a marsh by the shore.

But reaching the *statuario* beds above Seravezza was another story. It meant widening two miles of existing roadway and creating up to a mile of new road—"that is, cutting it out of the mountain with pickaxes." If the pope wouldn't pay for that, Michelangelo declared, he would pick up his marbles and go home. "To Carrara I would not go, because I would not get the marble I need there in twenty years. For

I've earned great enmity there, because of this business, and [for lack of marble] I would be forced to work in bronze." A dire thought.[19]

Which account was the truth? Surely Michelangelo was being more forthright with his brother and more politic with Buoninsegni. The Carrarese might not have welcomed him like Jesus, but he did not believe they would thwart him for "twenty years" if he tried to buy marble. He may have raised that alarm to play on Leo's and Cardinal Giulio's consciences and prod them into coming through with the long-promised road.

A month later Michelangelo, frustrated by the still-undone road, tried to rebuild his old ties in Carrara. Apprehensive about going there himself, he hired the genial notary Leonardo Lombardello to approach his old *fornitori* and see if they would quarry for him yet again, and on what terms. Michelangelo's old landlord, Francesco Pellicia, replied sarcastically that he would sell blocks for the square in ducats of their weight in *carrate*. That meant one ducat for a one-*carrata* piece (a bargain), four ducats for two *carrate* (a bit pricey), and twenty-five ducats for five *carrate* (outrageous). But Mancino and several others were more accommodating. Pellicia's own son advised Michel–angelo not to listen to his father; they could work something out. Matteo di Cuccarello wrote secretly to say he'd not only sell Michelangelo marble at a very reasonable price but arrange to ship it to Pisa for another half ducat, if Michelangelo would supply the skids and ropes for loading it.[20]

But shipping was easier said than done. Michelangelo and the Salviati bank in Pisa approached one boatman after another, in Pisa, Livorno, and Portovenere. Even Cardinal della Rovere, Pope Julius's heir, got into the act and tried to obtain ships from distant Savona so that Michelangelo could proceed with the tomb statues. But what boats were available—small coastal craft called *liuti*, "lutes," with an eight-*carrata* capacity—could not carry Michelangelo-sized blocks.[21]

Two *liuti* finally arrived from Portovenere and bore what they could to Pisa. There another mishap struck: an iron strap on the new "horsehead" crane at the Pisa dock snapped when it lifted the first block; the boat had to be hauled up onto the shore, at great labor and risk, to unload the other two. Donato Benti, Michelangelo's on-site manager, recommended he build a derrick to hoist blocks off the boats. Francesco Peri, the Salviati bank's Pisa manager, suggested he

buy a bigger ship at Genoa, capable of hauling ten *carrate,* for trans-
porting larger marbles.[22] Mission creep seemed to be inexorably over-
taking Michelangelo; he'd started this project a sculptor, usurped the
role of architect, assumed the responsibility for procuring marble, and
found the jobs of road builder and quarry blazer thrust on him. Next
stop, shipping magnate. He declined to buy the ship.

Michelangelo and his backers continued to blame Marchese Al-
berico (at least partly unfairly) for the shipping troubles, and in October
the Holy See itself stepped in. At Cardinal Giulio's request, Leo issued
a papal brief directing Alberico to stop obstructing the removal of the
marble—"an extraordinary document," Michelangelo's Roman friend
Leonardo Sellaio reported, which would surely cow the marchese.[23]

Sure enough, Alberico apologized to both the pope and the cardi-
nal. He offered "grand excuses," Leonardo told Michelangelo. "He
said how always, for love of the Pope, he had honored you and done
what he could for you, but that you did not reciprocate because of
your wretchedness, and that you always wanted to fight with others
and act strangely, and that you were the cause of everything."[24]

The marchese wasn't the only one alarmed at Michelangelo's be-
havior. Cardinal Aginensis was said to be "furious" at his lack of prog-
ress on Pope Julius's tomb.[25] Jacopo Sansovino, the former friend
whom Michelangelo had spurned, had stirred up Cardinal Giulio's
suspicions by spreading rumors that, as late as January 1519, the mar-
ble for the façade still hadn't been moved from Avenza. Leonardo tried
to reassure the cardinal, showing him Michelangelo's reports from the
quarries and promising (wishfully) that he would have the first façade
figure done that spring.[26]

Back in Seravezza, Michelangelo strove desperately to get the mar-
ble moved. He had returned from Florence in August 1518 to find en-
tropy setting in again: a crew he'd hired from Pietrasanta gave up
quarrying but refused to repay the one hundred ducats he'd advanced.
(He sued and eventually recovered ninety.) All but two of the *scarpellini*
he'd brought from Florence had likewise vanished. But the road was
nearly finished, he reported, save for a couple of outcrops to be hacked
away and a few patches to be leveled. "And all these tasks, because
they're brief, could be done in fifteen days, if there were *scarpellini*
worth anything here." As for the obstructing marsh down below, when
last he'd checked "they were filling it as badly as they could."[27]

Despite his sour mood, Michelangelo managed to assemble a new, inexperienced crew and head up to the undeveloped quarries. There they faced their make-or-break challenge: the twelve enormous columns that were to uphold the façade, both visually and literally. Columns were the essential, distinguishing feature of neoclassical edifices, and Michelangelo had, typically, upped the ante. Greek and medieval builders assembled their columns of stacked sections called "drums." But just as he would not patch pieces of marble into a sculpture, Michelangelo would not assemble them into a column; a column was both the limb of a building and a surrogate for the human body, and must be straight and unbroken. Nor would he pillage columns from Roman ruins as countless other builders had done, and as the chaplain of Santa Maria del Fiore would suggest he do for a later project at San Lorenzo.[28] He would quarry them himself, from the best white stone to be found.

This was audacity multiplied. The columns vastly increased the cost, difficulty, and danger of completing the façade. Brunelleschi had used monolithic columns in the portico of the Ospedale degli Innocenti, one of the seminal buildings of the Renaissance. But they were smaller and thinner and, most important, were carved of local *pietra serena* sandstone rather than Apuan marble. Michelangelo had set himself a challenge of another magnitude, comparable to the massive granite columns the Romans transported from Egypt to uphold the portico of the Pantheon, their temple to all the gods.[29] He was matching himself against the greatest quarriers and builders of all, attempting to reinvent their lost mastery while surpassing the purity of the marble they used.

Through the winter of 1518–19, Michele and Donato reported happily on the marble they were finding and sending down. "We haven't yet started on a column because we haven't found the length," Michele wrote, ever optimistic. "But we hope to soon."[30] A week later they'd found two column-length veins of clear marble and begun chipping them out, a process that could take months.

It also took months to assemble the equipment to secure the column's descent; in that pre-hardware-store age, what could not be begged or borrowed had to be fabricated from scratch. In August 1519 Michelangelo bought the lumber from a walnut tree and hired two master woodworkers to make two windlasses from it.[31] He bought a leather cord from a Seravezza cobbler to bind the windlasses, and a

cherry tree from which to cut skids to slide the column on.[32] The
Opera del Duomo in Florence lent him the most complex parts: two
heavy tackles, each weighing eighty-plus pounds and containing dou-
ble bronze pulleys in an iron casing.[33] But the hardest equipment to
secure was the most basic: rope. After strenuous searching by Michel-
angelo, his brother, Michele di Piero, the Duomo Operai, and various
Pisan contacts, a 370-foot, 510-pound rope was finally located at Pisa.

As it turned out, Michelangelo might have done better to skip the
tackle and locate two more ropes and local stone skidders who knew
how to use them. In early September he and his green crew managed
to lower one column to the valley, almost to the road. It was an ex-
traordinary feat—the largest block taken from the Apuans since an-
cient times. But, as he recorded, "Rigging it was harder than I
expected. Someone made a mistake with the rigging and one man got
his neck snapped and died instantly, and I nearly lost my life."[34]

He wrote matter-of-factly, but he was clearly shaken and fatigued,
and soon fell ill. Jacopo Salviati wrote from Florence to cheer him up:
"I'm told this bothers you, as if you did not realize that in an enterprise
of this nature you would have much greater upsets than this. Be of good
spirit and pursue your goal gallantly, for there lies your honor once you
start at it."[35] Buonarroto sent just the opposite advice and offered to
come to Seravezza to look after him, in a letter full of brotherly solici-
tude: "As I see it, you must value your person more than a column, more
than the whole quarry and than the Pope and the whole world. . . . And
if the Pope or anyone else wants to have quarrying done, leave them out
of your thoughts, because when you are dead they won't count for any-
thing. . . . I encourage you, if you feel like coming [to Florence], to come
regardless, and let everything else go to hell."[36]

But Michelangelo was determined to push on. He reported that he
had almost finished blocking out the other column but had come
upon a hairline crack, forcing him to, in effect, cut out a new column
from the vein behind. Otherwise, he concluded, he had nothing good
to say: "This place is very rough to quarry, and the men very ignorant
about this activity; and it will take great patience for months to come,
until the mountains are tamed and the men trained. Then things will
go faster. It's enough that, as I have promised, I will do whatever it
takes and produce the most beautiful work that has ever been made in
Italy, if God will help me."[37]

* * *

THE DIFFICULTIES OF LOWERING the massive column may have been compounded by an excess of technology; Michelangelo used what was then state-of-the-art block and tackle to control the perilous descent, whereas the *cavatori* of later centuries would rely on much simpler equipment, dating from ancient Egypt: a few ropes and strips of wood. Right up through the 1960s, when trucks and roads finally reached Carrara's *cave*, millions of tons of marble were eased down the steep slopes to ledges where they could be loaded onto oxcarts or railcars through an ingenious system, at once stone-age and sophisticated, called *la lizzatura*. In it, a marble block, sometimes with smaller blocks stacked on top, was levered or jacked onto a pair of skids roughly hewn out of beech or holm-oak trunks. This formed an improvised, very heavy, and rather precarious sledge, called *la lizza*.[38] This term might also apply to the tracks, from wide ramps to cliffside paths, that were hacked into the slopes and piled up with marble rubble. The sleds were skidded down these tracks over wooden crosspieces called *parati*, greased or soaped to reduce friction and laid like railroad cross ties.

It would have taken a whole grove to supply the *parati* for a long descent, and a battalion of *lizzatori* to haul and set them. So the crews would use, and reuse, just a small stock, running alongside, scooping up the ties already crossed, and dashing ahead to lay them under the skidding twenty-ton blocks—a fast-stepping combination of relay race, game of chicken, and obstacle course.[39] For this they wore specially made boots with rounded soles (to guard against catching on stone edges and crevices) and a special pattern of studs for maximum grip. Timing and teamwork were critical, and the *lizzatori* faced the same trade-off as ski racers: the faster they brought the blocks down, the more runs they made, the more they got paid, and the more risk they took of getting squashed. Such choices lay with the *capolizza*, who watched each lurch of the block and shouted out each move like a coxswain.

Boys helped out on the *lizza* as soon as they were quick and steady enough. Walter Danesi started when he was twelve. He grew up in the middle of the *cave*, where firewood was scarce and mothers would send their children out to scour the rubble for worn-out *parati* and *piri*

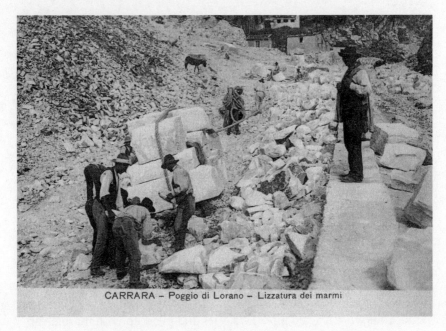

CARRARA – Poggio di Lorano – Lizzatura dei marmi

Old-time *lizzatori* take it easy on a relatively level patch.

to fire the stove. "*A capolizza* would say, *'O bimbo, passami la corda,'*" Danesi recalls. "'Hey, kid, hand me the rope, and I'll give you a scrap of wood.'" Soon he was running alongside the blocks, fetching the *parati,* rubbing them with soap, and passing them to the experienced hands.

The *lizzatori* were not entirely at gravity's mercy; they controlled the block's descent with three heavy hemp ropes called *canapi* (as in "cannabis"), replaced with steel cables in the 1920s. The ropes' other ends were wound around wooden pylons called *piri*—resilient chestnut posts shielded by strips of hard beech—jammed into anchor holes chiseled out of the solid rock at strategic points along the way. Just as the *lizzatori* continually reset the crosspieces along the path, the *mollatori,* the rope men, would lift their lines one at a time and carry them down to the next *piri.* By selectively playing out the ropes, again with superb coordination, they could keep the blocks from falling and even guide them around curves.

Massese *lizzatori* used three lines, but the Carrarese were bolder: they used only two, unless the load weighed more than twenty-seven

tons. "It was the most grueling and difficult job of all," says the preservationist Mario Venutelli. "Three hours of *lizzatura* was worth eight hours of *cavatore* work." His wife, Joanna, chimes in: "I had a relative who was a *lizza* captain. He got cut in half by the cable."

Today the *lizzatura* is performed only in nostalgic enactments each August: one, sustained by the heroic efforts of the Carrarino-language poet Antonio Doretti, at the Ponti di Vara crossing in the Carrara quarries, and the other at the remote village of Resceto above Massa. But it continued well into the atomic age, outlasting all the great innovations—explosive mines, heliocoidal wire, the Marmifera railroad—that brought the industrial age to the *cave*. Even now ex-*lizzatori* recall their exploits with the pride of ex-Olympians; the fact that they're alive to tell their tales is an accomplishment. Between tumbling *lizze* and snapping cables, mistimed mines, and falling overhangs, rockslides and all the other things that go wrong when men try to move mountains by hand, thousands died in the *cave*—one or two a month during the nineteenth and much of the twentieth century. Each time, the *tromba di morte,* a long, unstopped cone that sounds like a French horn from beyond the grave, would blow and work would cease while the fallen *cavatore*'s comrades bore him down the mountain.

Sirens later replaced *la tromba,* and modern safety practices reduced *cave* mortality to that of an ordinary dangerous occupation—just one or two deaths most years. But today's retired *cavatori* can still remember the bad old days, painfully. "I saw so many men wounded, so many men killed," says Mario Corsi, a soft-spoken octogenarian with cheeks scarred by sunburn from years amid the marble glare, looking up from the street where we're chatting to the marble-capped peaks above. "My son wanted to become a *cavatore*. I told my wife, if he goes to the *cave*, I'll cut his throat. I didn't want to wait for it to happen to him. He became a mechanic instead."

EVEN AS THE quarrying progressed above Seravezza, Michelangelo reported to Cardinal Giulio that the Carrarese seemed to become "more humble"—though we can't know whether that was because the papal brief changed their attitude or because he finally settled some overdue accounts. He ordered a *"gran quantità"* of new marble from them,[40] once again pushing the limits of Medici tolerance;

Salviati reminded him that the pope was "delighted to have you take two or three columns from Carrara, if this helps speed things up, but if it is just more expedient for you, His Holiness is not pleased, because he still wants to advance the quarries of Pietrasanta."[41]

In December 1518, boats became available and began moving the accumulated blocks from the Avenza and Motrone beaches to Pisa. Then nature threw in another hitch, though only a temporary one: unseasonable drought had choked off the Arno and the marble-laden barges could not be towed up to Signa, for transfer to carts, until March—a year after the blocks started piling up at Avenza.

As it turned out, the marbles that had been scooped up and hauled to Pisa belonged to Mancino, whose nephews had ordered they not be removed until Michelangelo fulfilled the contract he'd signed. The other *procuratori*, though willing to work for him, also wanted to have their old contracts fulfilled and get paid. Poor Donato Benti, Michelangelo's right hand, had literally moved mountains to finish the road and advance the quarrying and shipping, at Carrara as well as Seravezza. But his blithe employers at the Opera del Duomo (who, Michelangelo elsewhere complained, merrily skimmed their share off projects) didn't bother paying him. Donato implored him: "I've gone three months here without money; now I have no more to buy grain if you don't help me, in particular with his Magnificence Iachopo Salviatti, whom I trust more than the others. Recommend me to him, and tell him how I have five children and nothing to rely on but my own arm. . . . I beg you, Michelangelo, that you will endure this chore for the love of God and of these children."[42]

Michelangelo did provide some cash and, when Donato needed a new doublet, a bolt of cloth, and surely interceded on his behalf. But Donato was not the only one imploring him. If Donato was his right hand, the excitable Michele, who had helped him since the *Pietà*, was his left. Michele sent a desperate note from Seravezza: he had found one block from which he had roughed out a festoon at La Cappella, but nothing else that came "up to your measure," and he could do nothing more without instructions and the "help" (funds) that Michelangelo had promised. "I am here for your sake," Michele implored. "Do not abandon me."[43]

Michelangelo was beset from all sides, the middleman in a sclerotic system that his best efforts only seemed to make worse. Domenico

Buoninsegni advised him to get out of the quarries and back to his studio: "I tell you, in the position you are in, you should delegate this business of quarrying and transporting the marble to someone else, because it seems to me something that is always afflicting you and takes all your time and puts you under a cloud. Even though you understand all this better than I do, I say it for the affection I have for you."[44]

Michelangelo understood the problem differently. "I have already tried three times to commission others [to procure the San Lorenzo marble]," he replied from Florence,

and all three times I wound up cheated. This was because the *scarpellini* from here didn't understand marble, and when they saw they weren't getting anywhere, they went their way [went with God]. And so it is that I've thrown away hundreds of ducats there, and that's why I've had to spend such time there myself, to get them working and show them the nature of the marble and the things that do it damage, and which stone is bad, and even how to quarry, because I am expert in such things. And in the end I had to stay there.[45]

On its face, this seems a rationalization for Michelangelo's compulsive micromanagement. After all, "crazy" Michele di Piero and the calmer Donato Benti both had more experience in the *cave* than he, as had a score or more of Carrara's marble *maestri*. But delegating did not come naturally to Michelangelo; however much he planned, he still improvised as he went along, refining his ideas in the ongoing "dialogue with the stone." The quarrying itself was part of that dialogue, and much as he complained about its hardships and perils, he seems to have gotten hooked on it, just as soldiers and journalists get hooked on combat.

His attraction to the *cave* was so compulsive, and his insistence on finding flawless stone so absolute, as to suggest deeper currents stirring in him. Some commentators see it as a religious yearning, and the *cave* as a spiritual retreat, the desert where he went to wrestle with his demons. "His love of marble was almost like a saint's love for some manifestation of God," writes one.[46] The psychoanalyst Robert Liebert sees the maternally deprived Michelangelo struggling to re-

cover the only "maternal and nurturing origins" he'd ever known—the stonecutter's wife in Settignano, with whose milk he had imbibed "the hammer and chisels" of his art. "At the deepest level of unconscious thought, the marble mountain presented the maternal breasts."[47] And if he could only find the perfect block of marble, he would complete the circle, recover the infantile bliss that had eluded him through all the wracked and driven years since. Michelangelo himself seems to voice some such yearning when he writes of trying "to raise the dead" in these marble cliffs. But Pygmalion's miracle is only a myth, the stone remains cold and unyielding, and instead of succor he finds toil and pain. And so he writes, in a later madrigal to a nameless "woman" who seems to represent art itself, that

> the stone in which I form her
> is so sharp and hard that it
> is just like her.[48]

Amidst such torments, practical concerns still pressed: given the project's complexities, the challenges he had set, and the need to be artist, architect, engineer, business executive, and diplomat all at once, was there anyone to whom he could entrust the hunt for marble? On a Saturday morning in April 1519, he seemed to get his answer. Gravity and bad tackle struck again, this time without fatal consequence. Michelangelo and his crew had lowered a column ninety feet down the steep Trambiserra ridge when one of the iron rings securing the rope around it snapped. The column narrowly missed the men guiding it and, Michelangelo recounted, "fell into the river in a thousand pieces." Donato Benti had had the ring made by a blacksmith friend, and Michelangelo was furious: "After it broke, we saw what a rotten business it was: it was not solid at all inside, and the iron was no thicker than the spine of a knife." The tackle blocks that Donato had also ordered had "likewise all cracked at the rings and were likewise ready to break." Donato was now disgraced, and Michelangelo was confirmed in his belief that only he could lead the quarrying.

CHAPTER 15

THE WALLS COME TUMBLING DOWN

AND THOSE WHO HAVE ROBBED ME OF MY YOUTH,
MY HONOR, AND MY WEALTH CALL ME A THIEF!

MICHELANGELO TO A PAPAL OFFICIAL, 1542

My poor Carrara, now you've gone to your end.

ANTONIO DORRETTI

MICHELANGELO HAD HAD enough of clueless helpers, rotten rings, tumbling columns, and the other rigors of quarry blazing in the wilderness. Three weeks after the second rigging mishap, in May 1519, he turned his sights back toward Carrara, again pushing the limits of the exception the pope had granted him to take some marble from there. He directed Urbano to head to Carrara, dust off his pending contracts with the *fornitori,* and drive them to get the blocks quarried.[1] This time the quarrying went faster; by August he was negotiating once again with a Porto Venere boatman to transport blocks from Avenza to Pisa.[2] Urbano wrote that at one quarry, Maestro Santino had excavated a huge block, large enough to yield three or four columns, but the stone seemed a bit too dark; he sent a sample so Michelangelo could judge for himself.[3]

And then, just as Michelangelo at long last seemed to have cleared

the obstacles and gotten quarry and transport operations up to speed, his Medici patrons slammed on the brakes. Without a word of explanation, as far as the record shows, they took control of the Seravezza quarries away from Michelangelo and bestowed it on the Duomo Operai. In early September 1519, Michelangelo advised Urbano, who was at Seravezza, that "certain *scarpellini* will come there and spend a day looking at the *cave.*"[4] He did not explain that these were the Opera del Duomo's delegates, coming to take charge. But though his authority over the operation had ended, his work had not; it was, as William Wallace writes, "like a giant flywheel . . . difficult to set in motion, but once turning it continued long after the power was shut off."[5] Michelangelo's assistants continued extracting and shipping blocks, and he continued receiving a stipend from the Opera, until spring 1521. In January 1520, according to the Salviati account books, the first shipments of Seravezza marble were finally launched from a dock newly constructed for the purpose on the beach near Fort Motrone, Pietrasanta's port.[6] The resort town of Forte dei Marmi, with its blaring discos, has since sprouted around this nucleus, giving it a special claim to Michelangelo's legacy.

Inevitably, the transition turned messy. As in Rome, where the marbles Michelangelo quarried in 1505 disappeared under the shadow of Saint Peter's, vultures were waiting to pick off unguarded stones. In February 1520, Cagione's son-in-law Francesco warned Michelangelo that three of his more colorfully named *scarpellini*, Bello, Leone, and Quindiche ("Handsome," "Lion," and "Fifteen"), were stealing his marble from Polvaccio and selling it to Jacopo Sansovino—the same resentful sculptor Michelangelo had shut out of the San Lorenzo commission. "They would sell their daughters to whoever has money," Francesco huffed.[7]

The next March Michelangelo gave Domenico Buoninsegni a bitter accounting: the Duomo Operai had been "sent to take possession of the holdings and relieve me of the marble I had quarried for the façade of San Lorenzo, in order to use it to pave Santa Maria del Fiore." The culprit behind this presumptuous act, he charged, was Cardinal Giulio de' Medici; Pope Leo "still wanted to pursue the façade." Michelangelo insisted that if Leo had decided to drop it, the two of them would have reached a settlement and the quarry holdings, marble, and equipment would have belonged to one or the

other. But Cardinal Giulio and the Opera del Duomo did not offer any such terms; they barged in, took possession, and "allocated the marble to others," without reaching any settlement. As a result, Michelangelo claimed, after all he'd paid for marble and transport, he was left with only five hundred of the twenty-three hundred ducats he'd received for the façade—against the three years he'd wasted, the model he'd made at his own expense, the "more than five hundred ducats' worth of marble, furniture, and artwork" lost in the house he'd abandoned in Rome, "the fact that I have been ruined by this effort," and "the great insult of bringing me here to perform this job and then pulling me away from it."[8]

This accounting, like so many of Michelangelo's financial claims, was partly self-serving, but his sudden ejection from the quarry operation had indeed left him feeling betrayed and bewildered. Years later, still thrashing it over in his mind, he imagined various motives for Cardinal Giulio's and Pope Leo's actions. In a 1542 letter to an unnamed Vatican *monsignore*, Michelangelo claims that Leo had merely "pretended" to want him to execute the façade in the first place, in order to divert him from Pope Julius's tomb. But this would have been an insanely expensive diversion; if Leo wanted to keep Michelangelo busy, why not have him paint another chapel?[9] Several years later, Vasari published an equally improbable claim, in the first edition of his *Lives*: that Domenico Buoninsegni, the project's go-between, had tried to draw him into a scheme to overcharge Leo for the marble and pocket the difference, and when the upright sculptor refused, Buoninsegni conceived a vendetta against him and sabotaged the project.[10] No evidence of such a scheme survives; if Michelangelo planted the charge with Vasari, it seems a shabby way to treat someone who'd given him prudent advice and encouragement.

In his later edition Vasari offers a more plausible reason for abandoning the façade: the project had "gone on so long that the money the pope had consigned to it was consumed in the war in Lombardy." Indeed. The papal court was hemorrhaging ducats, and not just in Lombardy against the French. Leo's Medicean generosity to poets, painters, and sycophants, his defensive alliances, and his bribes to pacify restless nobles had stretched the Vatican budget thin as parchment. To cover these expenses he was forced to ramp up the sale of indulgences, get-out-of-purgatory-free cards. This accelerating cycle of extravagance

and corruption had epochal consequences; in 1517, while Michelangelo was scrambling to get his blocks shipped from Carrara, a disillusioned monk named Martin Luther nailed ninety-five theses on a church door in Wittenberg and turned Christendom on its head.

Leo knew that he would not live to see the façade finished, if it ever could be; though he was the same age as Michelangelo, his health had never been robust, and he died, just forty-six years old, the year after terminating the contract. Nor was his idea of using the project to develop the Tuscan quarries working out as planned; it seemed Michelangelo would never be able to abandon Carrara for Seravezza's marble. Michelangelo had followed the same self-defeating course with the façade as with his first design for Julius's tomb: he had gotten drunk on stone, thought too big, stayed in the *cave* too long, and given another pope time to come to his senses. After nearly four years of trouble over the quarries, staking a megalomanic genius forty thousand ducats (and probably much more) to build a neoclassical marble temple in Florence seemed a less alluring proposition.

Still, Leo was not the type to lower the boom; he was sentimental, and he had been heard to cry and declare that he loved his childhood companion Michelangelo "like a brother." That task fell to his harder-headed cousin, Cardinal Giulio. Later writers have condemned the two Medici prelates for peremptorily killing the façade project, but their greater fault may have been to let it get so far out of hand, leaving Michelangelo to sink under an impossible load of stone.[11]

Were these three, or nearly four, years on an aborted project an entire waste? For all the toil and woe that the Serra quarries had cost Michelangelo (not to mention nearly costing him his life), they contributed precious little to his art, even in the way of stone. The hundreds of tons of marble he had so strenuously searched, cut, and hauled out wound up abandoned or appropriated by others, scattered like a trail of crumbs from La Cappella and Trambiserra to Motrone, Pisa, Florence, and parts unknown. Much of the stone was incorporated into the duomo paving and other local projects; to paraphrase Mark Twain, the Creator finished Florence, and Rome as well, with marble quarried by Michelangelo. Condivi records that four of the splendid columns he had extracted with so much blood and sweat were left languishing on the beach; as many again were probably broken in quarrying. Only one actually made it to the Piazza San

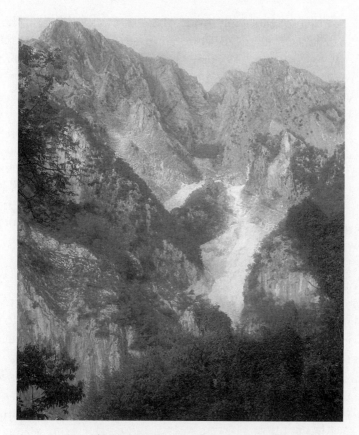

Monte Altissimo, where Michelangelo prospected
but did not take stone.

Lorenzo, where it seems to have sat until the early seventeenth century, when it was buried in a ditch along with other detritus from the unfinished façade.[12]

In marble country the various quarries have their loyalists, who are just as ardent as sports fans and political partisans. And Pietrasanta's partisans cherish the notion that their marble played an essential role in Michelangelo's art. One gracious young representative of Henraux SpA, the two-century-old marble firm that works Monte Altissimo today, told me emphatically that Michelangelo took the marble for his Vatican *Pietà* from that very mountain. It seemed cruel to tell him the truth: there is abundant evidence that Michelangelo took that block, and many more, from Carrara's Cava Polvaccio. At that time, Michelangelo had never set foot on the wild, abandoned Monte Al-

tissimo, though he did scout it out when he was working on the San Lorenzo façade. And much as he admired Altissimo's *statuario,* he never managed to take any of it; to do so would have entailed much more road building than he could manage.

So which masterpieces did Michelangelo carve from Seravezza's marble, and which from Carrara's? I put this question, along with many others, to Danilo Orlandi, Pietrasanta's all-but-official historian, the walking archive that librarians and everyone else will send you to with questions about the city's past. Orlandi was unequivocal: "There is not a single work by Michelangelo carved in *marmo versiliese*"—from Versilia, the region surrounding Seravezza and Pietrasanta. All his masterpieces seem to be in *marmo carrarese.*[13]

The fact that people still fret and fume over such questions five centuries later testifies to the persistence of two phenomena: the world's enduring fascination with Michelangelo Buonarroti and Carrara's enduring rivalry with Pietrasanta. The first led to the second: the rivalry can be dated precisely to Michelangelo's arrival in Versilia. It then grew in fits and starts, whenever the development of the quarries above Seravezza accelerated.

After the façade and Leo expired and Michelangelo returned to Carrara, the quarries he'd opened languished for decades. Then a new Medici potentate rose to power, with ambition, ability, and ruthlessness far surpassing that of his predecessors. The main Medici line faded away, but Cosimo di Giovanni, the youthful scion of a rump branch, scrambled to the top and established himself as Cosimo I, first grand duke of Tuscany. Like all upwardly mobile despots, Duke Cosimo turned his thoughts to marble. In 1555, he consolidated his authority over Seravezza by dispatching the prominent Florentine sculptor-architect Bartolomeo Ammannati there.

Ammannati is best known for the muscle-bound *Neptune* that presides over the fountain in the Piazza della Signoria just north of the *David*'s original site—a cartoonish stab at imitating Michelangelo that almost makes Baccio Bandinelli's notorious nearby *Hercules* look graceful by comparison. Florentines call it *il Biancone*—"Whitey." When *il Biancone* was installed, it inspired an imperishable satiric couplet: *"Ammannato, Ammannato, che bel marmo hai rovinato"*—what fine marble you've ruined!

In Seravezza, Ammannati spared the *statuario* and built the quirky

fortress/palace that stands just up the Serra. One charming tale has it that Maria Cristina of Lorraine, whose husband (and Cosimo's nephew), Duke Ferdinand I, packed her off to this outpost in 1600, delighted in watching the enormous trout that splashed in the river below. One day a particularly large one was presented to her; she ordered its image carved from marble and placed at the spot. Later the marble trout was removed from the riverbed and installed atop the fountain in Seravezza's City Hall courtyard.

The usurpation of Carrara's commercial and artistic supremacy in marble, which began when the Medici forced Michelangelo to shift to Pietrasanta, did not end with the collapse of his grandiose projects. Indeed, he unwillingly set in motion a chain of growth, decay, competition, and emulation that is still playing out to this day. Even now, Pietrasanta and Carrara battle over his legacy at the broadest and most literal levels. Each claims to be the place where the master found this block of marble or that inspiration, and each asserts itself as the keeper of a legacy that is both artistic and commercial. The nuances are different—Carrara is the "City of Marble" and Pietrasanta *"la Città d'Arte,"* but the turf is the same, and the rivalry endures.

That rivalry reflects a broader, age-old clash of culture and geography: Carrara, the "island," was an outpost of the northern Longobards and heir to the Roman slave legacy. Pietrasanta and Seravezza, by contrast, were outposts of the original Tuscany—the central Italian region that Carrarese still refer to as though it were a foreign country, even though they are now nominally part of it. Carrara evolved from the local *vicinanze,* and upholds their "Don't Tread on Me" tradition in its attachment to anarchist ideology and governance that often verges on the anarchic. Pietrasanta by contrast was a child of powerful patronage from the first.

Cosimo also set out to complete the work Michelangelo had begun: extending the road up the Serra River all the way to Monte Altissimo itself and cutting another road eastward up the Vezza to Stazzema. Vincenzio Danti, the Perugia-born sculptor Cosimo assigned to the job, consciously followed in Michelangelo's traces. "I went to two more sites [on the Altissimo slopes]," Danti wrote Cosimo at one point, "to see better what Michelangelo Buonarroti wanted to do with that section of road that climbs up to the new road."[14] He confirmed that, preoccupied though Buonarroti was with

other cares when he labored there, he had indeed "planned to con-
tinue the road to this mountain, because we have found many spots
where the blocks show marks from iron tools."[15]

Top sculptors and architects, including Ammannati, Giambologna,
and Vasari himself, flocked to the new quarries at Altissimo. Just as
Michelangelo expected, they found large blocks of clear stone; even
today, when the pure white stone has been tapped out at many of
Carrara's quarries, Monte Altissimo delivers marble of a brilliant
whiteness, though with a coarser, more "saccharoidal" (sugary) grain
than Polvaccio's *statuario*. At Stazzema they found very different
stone, lavishly patterned and colored *brescia* that was useless for
sculpture but splendid for decoration. Such stone suited the new taste
that we now call Baroque, and Stazzema thrived; Seravezza, with its
austere *bianco* and *bardiglio*, did not. With the early death of Duke
Cosimo's successor, Francesco I, in 1587, the Medici dropped out of
the marble business, leaving it to the Duomo Operai, but their marble
needs also eased. At the same time, the river Versilia silted up, forming
a malarial hot zone; when Montaigne passed through in 1581, he
found Pietrasanta nearly emptied by the "bad air."

Carrara's much ampler quarries, meanwhile, outlasted the shifts in
taste and regained their near monopoly over the marble market.
Monte Altissimo languished through the seventeenth century, until
Napoleon swept across northern Italy, crowned his sister Elisa princess
of Massa-Carrara, and ramped up marble production to supply his
campaigns of national and self-glorification. One of Napoleon's cavalry
officers, Jean-Baptiste-Alexander Henraux, became France's marble-
buying agent and, in time-honored fashion, exploited this position to
build his own private marble empire. He backed a local attorney and
sometime Seravezza mayor, Marco Borini, who dreamed of reviving
the Altissimo quarries. With that accomplished, Henraux's heirs even-
tually bought (or squeezed) Borini out and established a dominance
over the Versiliese marble industry that endures to this day.

This orderly hegemony is conspicuously different from Carrara's
much larger but more fragmented quarry business. And it's sympto-
matic of a general difference in attitude between ducal Pietrasanta,
and scruffy, independent Carrara. Pietrasanta, unlike Carrara, could
not look to its quarries as a perpetual meal ticket: "In the mountains
of Carrara, the marble is everywhere," says Danilo Orlandi. "But here

we have to look for it." And so Pietrasanta prospered by also producing olive oil and silk and by mining the nearby iron deposits that make its creeks run red with rust.

And so while the Carrarese assumed their quarries would support them forever, resourceful Pietrasanta kept its eye cocked for the next chance. That came by mischance around 1840, when a Pietrasanta sculptor named Vincenzo Santini lost his leg in an accident. Unable to carve marble monuments, Santini turned to teaching, at which he proved gifted. The city fathers, seeing an opportunity, established a School of Marble, with Santini as director, which became the seedbed of an artisanal renaissance that is still growing today. Pietrasanta's carvers left the industrial production to Carrara and studiously pursued high-end work, altars and monuments and, especially, commissions for international, often big-name artists. In the late 1800s the first of Pietrasanta's eight bronze foundries opened, rooted in the local iron-forging tradition; mosaic studios followed. In the 1950s Henry Moore came and pronounced Pietrasanta's *artigiani* the best anywhere at realizing his ideas, and other celebrated artists followed. Pietrasanta was no longer the number two quarrying town; it was the premier City of Sculpture, a one-stop shopping center for artists seeking able hands to execute their designs—and for sculptural sojourners seeking to find themselves in a brief studio carving class. Its ascension was highlighted, and Carrara's anxieties piqued, in 2003, when a professor at Carrara's Accademia di Belle Arti suggested that the Accademia, Carrara's cultural linchpin, be moved to Pietrasanta. The idea was hooted down, but a quiet accommodation is being enacted: painting and some other classes can move to Pietrasanta, but sculpture stays in Carrara.

Foreign artists also flock to Carrara, some rookies and students and others famous in their home countries, to execute their designs themselves. Their styles and intentions fly in every direction, but one thing binds them: a fixation—sometimes almost sexual, sometimes a romantic infatuation, sometimes a vendetta—on marble. Manuel Neri, one of America's leading sculptors, has kept an apartment and studio here since the 1970s, and still waxes rhapsodic about the stone that drew him to Carrara in the first place. Marco Pinio, a star in his native Berlin, has decamped to Carrara to pursue his epic Projetto Stella Maria, an obsessive series of sculpted portraits of himself and his estranged fam-

ily. Another Berliner, Susanne Paucker, reproduced the *David*'s head as a three-dimensional jigsaw puzzle in Carrara *statuario*—both a pithy comment on *il gigante*'s kitsch exploitation and a homage to its enduring mystique. A Swiss video artist named Patrick Castellani piled a floor in the Chamber of Commerce's Marble Museum with marble scrap, dangled transfusion bottles filled with blood and milk above it, and showed a video of himself dancing dreamily around a quarry to the lowing of the *tromba di morte*, with a suckling pig cradled *Pietà*-style in his arms.

Marble, with all its cultural and historical freight, dares artists to defy, traduce, and transpose it, to shape it in ways it was never meant to be shaped. The French sculptor Roland Baladi has gone the pop route, carving impeccable, actual-size vintage toasters, radios, and Coke machines, a 1953 Fiat (in an auto executive's collection), and a sixteen-ton Cadillac (available, at the SGF sculpture studio in Torano). Others, taunted by the stone's literal and figurative weightiness, seek to make it *float*. Michelangelo tried with his gravity-defying *David*, and then embraced gravity in his Prisoners, late *Pietàs*, and, especially, Medici tomb figures, who struggle against all the weight of the world. In 2002, the Torino sculptor Fabio Viale shaped a dinghy out of black marble, attached a Johnson outboard, and puttered around Carrara's marina. Earlier, an MIT-trained engineer turned sculptor named Ken Davis, who had left DuPont Chemical for Carrara, made hollow, floating marble spheres, held together by pumping the air out from inside them. Then Davis figured out how to work a miracle—to float solid marble spheres: he shaped and ground them and the basins containing them so precisely that they spin on thin membranes of water pumped at ordinary household pressure. One of his first *Floating Balls* still spins defiantly in Carrara's Piazza d'Armi, with the white-rubbled mountains for a backdrop. Designers worldwide have copied it, but the locals take it for granted and let their dogs clamber around it.[16]

Davis, who died in 1986, was an artist-scientist in the Leonardo mold. Kazuto Kuetani, a Japanese sculptor who's lived in Italy for thirty-five years, is Michelangelo's successor, at least in monumental ambition. Kuetani is scarcely five feet tall and over sixty years old, but like Michelangelo, he can work marble faster than men twice his size and half his age. And he thinks big. His life's project is a marble mountain dwarfing Michelangelo's fondest designs for Julius's tomb and the

San Lorenzo façade: a twelve-thousand-square-foot, eighty-two-foot-high *Hill of Hope* that is at once sculpture, architecture, earthwork, and Buddhist temple, carved and assembled from seven thousand tons of Carrara marble on a hilltop near Hiroshima. (Kuetani enjoys two advantages Michelangelo lacked: power tools and a reliable patron, a Japanese tycoon.) Why use Carrara marble for such a distant opus? "It will last two, three thousand years without war, without earthquake," he explains. "We have granite in Japan, but granite gets a little darker in the sun, which I don't like. Marble will stay white. White marble and green inside, or blue—it looks like a flower, like the cosmos. It's like nature. Marble is nature."

Michelangelo never waxed so, but he might share Kuetani's sentiments. Others lured by the stone certainly do. One expat American sculptor, Bo Allison, left Carrara two decades ago but finally moved back. "This is the center of the universe," he exclaims. "*Semplice.* It's like a painter's palette. You can have all the colors of the universe here, if you're talking stone."

But you can't eat stone, and Carrara's sculptors almost to a man and woman find it harder and harder to get attention and sell their work from their isolated "island." One veteran, Pazzi de Peuter, prospered before and struggles now, but she shrugs at the thought of decamping to the greener fields of Pietrasanta: "Carrara is more raw, but it's more real." Carrara's homegrown carvers still scorn their Pietrasanta counterparts as pretenders and arrivistes. "We have the blood of our culture in us," says Manuele Costa, one of the sons in Paolo Costa and Sons, a Carrara marble *laboratorio* that, outlasting many others, merges classic skills and the latest computerized technology.[17] "They have arrived at what they do. They can do more or less the same work, because they learned it from us. But if it takes us a week to make a piece, it takes at least two in Pietrasanta. They have to send out for designs, models to make statues. We can carve one straight from a photograph—no model!"

Whatever they think of their neighbors' carving skills, however, the Carrarese don't hide their envy of Pietrasanta's success, nor their scorn for their own city's failure to follow the same path. "The *carrarini* thought only about extracting stone, about the market," laments Silvio Santini, the son of a *spartano* stone scrounger and cofounder of SGF, Carrara's most innovative sculpture studio. "Not about art, about

valorizzando the marble." Vittorio Bizzarri, a veteran carver at Paolo Costa, wishes that he could share his knowledge with younger *artigiani* just as his master shared with him. "But I can't—it's a business now, and you always have to produce, produce, produce. I'm sorry—it shouldn't be like this. There's a mystery, a passion to share."

Pietrasanta was smart, the Carrarese say; it wooed name artists, promoted itself, and nailed the high value-added segment of the marble economy. Carrara went for volume, perfecting the industrial slicing, dicing, and polishing of marble and granite. It became the world's stone factory, cutting and reexporting more stone from Africa, Brazil, and other far-off places than it did marble from the Apuans. In the process, it automated away three quarters of its labor force, left itself achingly vulnerable to international competition, and became a living fable of the pitfalls of globalization.

In 1990 an Indian mining official visited Carrara and reported enthusiastically that while "most of [India's many] mines and quarries are being mined manually," Italy used advanced machines and techniques, and produced five times as much stone. He concluded, with prophetic understatement, that it "can be beneficial to Indian marble and quarry operators to know the Italian practices in this field."[18] Not just to Indian operators. Carrara's *cavatori* were already crisscrossing the globe, making very good money as they scouted out stone deposits from the Sahara to the Arctic and taught the locals how to exploit them. Raise a glass with one and he'll tell of big strikes and narrow escapes in Yemen, Pakistan, Nigeria, or Siberia; Alfredo Mazzucchelli spent so much time opening quarries in Brazil he learned enough Portuguese to pass for Brazilian, and the explosives expert Uriano "Bombetta" Rossi dealt in Saudi Arabia with Osama Bin Laden's construction-magnate father.

Now other countries—Spain, Brazil, Turkey, India, and, especially, China—are rapidly overtaking Italy's lead. China's productivity and quality still lag, but with wages one-twentieth of Italy's, it can sell marble for a half or third as much. Shipping stone around the globe costs much less today than it did to ship it to Rome or Florence in Michelangelo's day. For those with the time to wait, it costs less to quarry a block of *bianco Carrara*, ship it to China, have it carved into a funeral monument, ship it back, and plant it on *la nonna*'s grave than to work it at home. And less yet to use Chinese marble.

"We sell them the technology, and they use it against us" is a favorite local refrain. In 2003, Italy's exports of stone-processing machinery grew 12 percent, while marble exports fell 20 percent. Even the machine-making advantage may not last; Italy's customers/competitors are busily copying the technology they buy. I buttonhole K. Vikram, the editor of the Jaipur-based trade magazine *Stone Panorama*, at Carrara's annual Marble and Machinery Fair and get a succinct prognosis: in the stone business, "Italy is finished."

Locals read this prognosis in another set of numbers. Massa-Carrara has the economic indices of Italy's perennially depressed south: the lowest per capita income and highest unemployment in Tuscany, perhaps in northern Italy. *"Carrara sta morendo,"* "Carrara is dying," I hear again and again, though I also hear it denied just as vehemently.

Pietrasanta meanwhile treads its chosen path, little fearing that the next generation's Henry Moores will decamp to Guanzhong. It has superseded Carrara as the local cultural mecca in spite, not because, of their relative legacies. Architecturally, Carrara is older, richer, and more interesting. Its marble-paved Piazza Alberica, ringed by palaces and porticos and overlooked by a white-capped marble peak, would be a scenic magnet, if anyone could see it. But with parking chronically short, it's usually full of cars. Pietrasanta's Piazza del Duomo is an arid asphalt expanse, but it's car free, wide open to strolling tourists and gamboling children, as is a long, boutique-lined concourse. Graffiti is everywhere in Carrara, but so rare in Pietrasanta that one small tag at a bus stop is a glaring sore thumb. Carrara has its street figures—amiable vagabonds with their change cups, rucksacks, and dogs, Senegalese and Moroccan peddlers toting armloads of umbrellas in stormy weather and sacks of baby clothes in fair. They're accepted as local fixtures; the Senegalese, who refuse handouts, are especially esteemed for their honesty and good humor. But I never saw peddlers or panhandlers in Pietrasanta—nor the authorities who, presumably, keep them away.

All this makes Pietrasanta cozy and comfortable to a fault—a Stepford town, too tidy and nice to be true. Something was unnerving about the place, and trying to put my finger on it led me to the artist who is its standard-bearer, the *gonfaloniere* of this *città d'arte*. He is Fernando Botero, the Colombian-born painter known and loved world-

wide as "the one who paints the fat people." And he is, or was until recently, the anti-Michelangelo.[19]

Michelangelo's marble figures are all heroic, tense with inner or outward struggle; even his baby Jesuses have knotted muscles and *contrapposto* twists. But Botero's signature figures, especially the nominally heroic ones, are neutered and infantilized. Men, women, and children, peasants and kings, horses and birds appear as the same figure, fat and stupefied, a benign, overstuffed sausage. Even his skeletons have chubby bones.

In this sculptural mecca, where he lives during the warm months and exploits the famous foundries, Botero the painter has become a sculptor and an institution. His figures fill the streets in special exhibitions; their plaster models dominate Pietrasanta's *gipsoteca*, and the most consummately insipid of them all, an enormous bronze *Warrior* even more rotund than the rest, stands like a sentry at the gateway to Pietrasanta. His name now appears above Moore's among the illustrious talents who have found inspiration and skilled execution in Holy Stone City. Perhaps he is the perfect *gonfaloniere* for this happy, self-satisfied town. *Bologna il grasso*—"Bologna the fat," Italy's gourmand capital—will have to share the sobriquet with Botero's Pietrasanta.

Or Pietrasanta may choke on its own success. Its artists are being forced out by high rents and strict noise regulations that bar them from working in town. They can always return to lean, hungry Carrara, chewing on its memories of Michelangelo.

THE LOST YEARS in the quarries did afford Michelangelo a valuable education. For all his weariness and frustration, he emerged from the debacle seasoned and strengthened. He had performed well, given the circumstances (and the hubris of the whole endeavor), in his first trial at managing a large, complex, widely dispersed operation. It would serve him well in his crowning architectural effort, when he would design and supervise the reconstruction of the greatest church in Christendom and bring order out of the chaos left by the leading architects of the age. It would serve him nine years later when he built the fortifications to protect his beloved Florence in its last defiant stand against the combined powers of the empire, papacy, and Medici. But first it would serve him yet again at Carrara and San Lorenzo,

in two new architectural projects for those same Medici patrons.

Even as Michelangelo struggled to quarry stone for the San Lorenzo façade, Cardinal Giulio conceived a different project for him, at the opposite end of the same church. The idea, like the façade, had been gestating for years, and it was even more central to the goal of perpetuating Medici glory and legitimizing the clan's rule over Florence: a funeral chapel that would link the revered patriarchs of the quattrocento with their undistinguished cinquecento heirs.

The first two Medici patriarchs, Giovanni di Bicci and Cosimo the Elder, were suitably interred in San Lorenzo's Old Sacristy and the main church respectively. But his grandsons Lorenzo the Magnificent and Giuliano (Cardinal Giulio de' Medici's father, assassinated in the Pazzi conspiracy of 1478) still awaited proper entombment. So did the clan's last direct, legitimate male heirs, who were supposed to carry on the lineage but inconveniently died first: Lorenzo il Magnifico's youngest son, also named Giuliano, and his grandson Lorenzo di Piero. This Giuliano was thoughtful, courtly, pious, and popular, but weak in health and at statecraft. His brother Giovanni (Pope Leo X) had nevertheless managed to marry him to a French princess, securing a claim to the title "Duke of Nemours," and made him captain of the papal forces. All this came to naught in 1516, when Giuliano died of tuberculosis.

Leo was still determined to establish a Medici dynasty to rule over Florence. His hopes now fixed on his nephew Lorenzo, the hotheaded son of the same Piero de' Medici who once made young Michelangelo carve a snow sculpture and whose overbearing ways provoked the revolution of first Medici expulsion in 1494. Leo installed young Lorenzo as governor of Florence, where he promptly lived down to his father's legacy and alienated almost everyone with his own erratic, overbearing ways. Lorenzo was nevertheless immortalized by not one but two geniuses: Michelangelo and Machiavelli, who dedicated his cynical manual of statecraft, *The Prince*, to him in hopes that, faute de mieux, he would be the champion who'd free Italy from foreign occupiers. Or that he'd at least give Machiavelli a job.

Uncle Leo wanted also to give young Lorenzo a title, but knew that creating a duke of Florence, especially a Duke Lorenzo, would stir public resentment. So in 1516 he bestowed the dukedom of Urbino, which he had lately appropriated from Francesco della Rovere, on his nephew.

There was just one hitch: Francesco, who was also Pope Julius II's heir, refused to back down, obliging Lorenzo to lead a papal army against him. The campaign in the bitter Apennine winter wrecked Lorenzo's health, and he died in 1519. His uncle, Cardinal Giulio de' Medici, resumed ruling Florence.

Thus the Medici lost their two best hopes for dynastic succession. But if Pope Leo and Cardinal Giulio could not enthrone Giuliano or Lorenzo in life, they determined to enshrine them in death, loading them with unearned prestige that would carry over to the next generation. And that was where Michelangelo came in. His chapel would commemorate and, by implication, equate two Lorenzo-Giuliano pairings: the *magnifici* brothers of the previous generation and their doomed, disappointing heirs.

The foundation for the chapel, called the New Sacristy, had already been laid beside Brunelleschi's Old Sacristy, whose exterior design Michelangelo modestly echoed. The interior would be something else entirely.

This time, Cardinal Giulio kept a closer eye on the project, ensuring that Michelangelo did not succumb to marble mania as he had in his façade design. He required full-size models of the figures, a task Michelangelo had never had to perform before but which, to judge by the one such model that survives (a River God, in Casa Buonarroti) and the final result, served him well. Michelangelo set aside grandiose structural notions and used the marble in conventional, feasible fashion: as veneer—in marble bays and cornices punctuated by tall, squared columns of *pietra serena,* the hard, dark local sandstone, on the lower level—and a rhythmic play of *pietra serena* ribs, columns, and window arches on the upper levels. The expressive effect would, however, be anything but conventional.

The New Sacristy afforded Michelangelo a novel challenge and opportunity: to work from *inside* a space rather than around a form—to define that space, to carve out of air as well as stone. It was a new level of three-dimensionality for him—and even four-dimensionality, since he made time itself an element of the design. Embittered though he was by the veiled termination of the façade, he threw himself into this project, and by spring 1521 had completed its design and returned to Carrara to seek marble for it. And then mortality, the project's theme, threw up an obstacle: in December, Pope Leo died.

Leo left a church and a continent in crisis. To the north, Luther and Zwingli had lit their fires; the Protestant Reformation was blazing across middle Europe. The church was discredited and nearly bankrupt. Its cardinals had had enough of Leo's luxurious Medici ways, his profligate spending, diplomatic finagling, futile wars, and nepotism. They chose a successor untainted by Renaissance enlightenment and corruption: a pious, ascetic Dutchman, once tutor to the future Emperor Charles V, who took the name Adrian VI. Adrian cast a chill on the arts as he set out to cure Rome's worldly ways; he even determined to knock down Michelangelo's Sistine ceiling. Worse yet, with the Medici out of power, Michelangelo had lost his buffer against the demands of Julius's heirs, who resumed pressing him to finish the tomb according to their 1516 contract. Adrian agreed with them and issued a *motu proprio,* a personal decree, ordering him to fulfill the contract or return the advances he'd already spent on stone.

At the same time, Leo's uneasy reign had left the Medici as well as the papal coffers drained, and Michelangelo was told to hold off on the sacristy statues. Once again, a major commission had been delayed just as he got up steam. Michelangelo was now approaching his fiftieth year with little to show for the past decade and no end of uncertainty in the coming one. He fell into a deep depression but set to work in his Florence studio, beginning the four tomb *Captives* that now stand in the Accademia and continuing to prepare drawings and models for the New Sacristy. These *Captives'* wracked postures—beaten down by weight or sucked into the stone as though into quicksand—seem to express his own feelings about an on-again, off-again project that had weighed on him for nearly two decades and would dog him for three more. The earlier *Dying* and *Defiant Captives,* which he began before the San Lorenzo ordeal, seem by comparison the brash expressions of a vanished youth.

Michelangelo's mood permeates his writing as well as his sculpture from this period. "Out of something rare and lovely, from a fountain of mercy my misery is born," he inscribed on the back of one sheet of Medici tomb sketches.[20] "At the twenty-third hour, and each one seems a year to me," he signed one letter, indicating perhaps his anxiety at the upcoming papal election, or his general mood.[21] Meanwhile, his octogenarian father was becoming increasingly contentious and delusional, and their relations were more trying than ever. "Lodovico,

I'm not responding to your last letter, save for those points that seem necessary to me," he wrote, with an exasperation unusual even for him. "The rest is enough to make me laugh. . . . Say what you want about me, but don't write me any more, because you don't let me get to my work, which I must do if I'm to recover all that you have gotten from me over the past twenty-five years." It is his last extant letter to his father.[22]

In early 1524, provoked by a dispute with an aggrieved former assistant, Michelangelo vented a more general complaint: "Because of some strangeness or madness they say I show, which does not hurt anyone except myself, they find occasion to speak ill and slander me, which is the reward of all decent men."[23] The next year his dark clouds seemed to clear at last, and he wrote, as though it were a miracle, of taking "the greatest pleasure" in going to dinner with friends, "because I emerged a little from my melancholy, or should I say my madness?"[24]

His spirits finally lifted, thanks in part to a regime change in late 1522. The shock of the killjoy Pope Adrian and his proto-Counter-Reformation proved too much for Rome; twenty-one months after he was elected, Adrian died, apparently of poisoning. The pendulum swung back; the Vatican conclave elevated a second Medici, Cardinal Giulio, to the papacy, and he chose a papal name that promised mildness, mercy, and reconciliation: Clement VII. The times over which he presided would prove to be anything but mild and merciful.

Michelangelo cheered the ascension of yet another of his Medici household companions, and an urbane man of taste to boot. "You will have heard how Medici has been made pope," he wrote his foreman Topolino, "for which I expect the whole world will rejoice. I believe that as far as art is concerned, many things will come from this."[25] Sure enough, Pope Clement put off Julius's heirs yet again and granted Michelangelo a handsome salary, fifty ducats a month, and he tore into the marble for the Medici tomb figures. At the same time, in 1524, he took on another commission at San Lorenzo: the creation of a library to contain the foremost collection of rare books and manuscripts in Europe, assembled by Lorenzo the Magnificent and his kinsmen.

Michelangelo approached the library commission in familiar fashion: he was supposed to merely furnish designs, but wound up taking over the entire project, which had been assigned to a lesser talent.

Once again, he had overextended himself between two projects, the sacristy and the library; once again, a cascade of circumstances conspired to prevent his finishing either. Nevertheless, the two together would mark an architectural milestone, the transition from the Renaissance to the style that would come to be known as Mannerism; they at once fulfill and overturn the classical precepts enshrined by Brunelleschi and Bramante.

Michelangelo was as much an original in architecture as in sculpture and painting, nowhere more so than in the library's famous vestibule. It is a strange and unsettling space, but like the New Sacristy strangely exhilarating. Both are unusually high and narrow, like towers or mine shafts, boldly patterned in light plaster and dark *pietra serena,* at once airy and ponderous, soaring and claustrophobic. In the vestibule, heavy, brazenly nonstructural columns of *pietra serena* float midwall, touching neither ground nor ceiling. Michelangelo does not mask his structural armature with smooth, frescoed walls, the usual Renaissance approach, nor minimize it to induce an impression of weightless soaring as Gothic builders did. He flaunts it, even exaggerates it with false structural members, anticipating twentieth-century postmodernism. The same effect shows later in his great dome for Saint Peter's Basilica, with its heavy, rhythmic exterior ribs and buttresses and powerful-looking but purely ornamental columns.[26] This is entirely different from Brunelleschi's Florentine domes, which conceal their structural tensions in modest skins of tile. But it's very much like Michelangelo's muscular sculpted and painted figures, forever twisting and straining; his buildings flex their muscles in plain sight.

Below the library's flamboyant columns, and taking up half its floor area, is what may be the most influential staircase ever built, and also the oddest. Its lower section is actually three grandly redundant stairways, two with conventional rectangular steps dropping off perilously to the sides and, in the middle, like a torrent descending between two banks, a stairway of concentric ovals. I met it under optimal circumstances: the library itself was closed, but the San Lorenzo caretakers, gracious as only Italian museum attendants can be, opened the vestibule for me, and I sat alone in the silence. The door atop the stairs was closed, reinforcing the sense of being at the bottom of some vast but crushingly confined space, like a crevasse or . . . a quarry. I felt I'd

been in this space before; the soaring walls, patterned with dark matrix, recall Cava Calagio below Colonnata, where Dante's words hang above the yawning pit. Consciously or not, Michelangelo transposed the marble mountain to this quiet cloister in the middle of downtown Florence.

Michelangelo conceived an elaborate iconographic scheme for the tombs that were to fill the New Sacristy. The north side would be the simplest, with a small recessed apse containing the altar. The opposite side would hold a monumental shrine, with the Virgin and child in a central niche and the Medici patron saints, Cosimo and Damiano, adoring them in side niches. Below, in two sarcophagi set end to end, would rest the remains of Lorenzo the Magnificent and his brother Giuliano.

The east and west walls were each consigned to the tomb of one of the recently deceased Medici captains. In front of each stands an oversized sarcophagus, capped by a swooping oval lid (a shape that was becoming a Michelangelo trademark) ending in inward-curving spiral volutes fitting crisply around the sarcophagus's sharp edge. Atop each lid, two oversized allegorical nudes representing the times of day—*Night* and *Day* on one, *Dawn* and *Twilight* on another—recline precariously; two more symbolic giants, dubbed River Gods, were to loll at each sarcophagus's base but were never completed. A central niche above contains a statue representing the deceased, with his trophies—empty armor, gnawed by enormous worms, representing the soul's departure from earthly confinement—carved above the niche. In niches on either side would stand other allegorical figures, mourning, with smaller mourners hunched, in relief, above.

These last mourning figures, never executed, reprise the monochrome, often overlooked genii that fill the shadowed cavities above the triangular pendentives on the Sistine ceiling. In fact, the triangular design of the tomb groups, bisected by the arc of the sarcophagus lid, echoes the Sistine pendentives and the arched lunettes below them, with the lid-top allegories of the tombs filling the place of the ancestors of Christ painted in the Sistine lunettes. Nothing is wasted in Michelangelo's designs; ideas are transposed and transformed from one medium to another.

But none of his elaborate sculptural designs was ever finished. Michelangelo eventually executed, to various degrees of completion,

just seven of the seventeen major figures he originally envisioned for the New Sacristy, and none of the relief. Other hands would execute Saints Cosimo and Damiano according to his designs and assemble the tombs as he intended—or perhaps as he did not.

This time he followed the advice Buoninsegni had given him years earlier, and delegated the quarrying; indeed, he appears to have gone to Carrara just twice during the fourteen-year tomb project, after seventeen trips to the quarries from 1516 to 1519.[27] His agents and suppliers still implored him to come check out the marble they'd uncovered; once he replied curtly, "For myself, I don't have mules to ride off on or money to spend."[28] Delegating was easier this time, for two reasons: Clement did not insist on developing the Seravezza quarries as Leo had earlier, and Michelangelo had on site his trustiest foreman yet, the irrepressible Topolino, who touted each shipment he sent as "beautiful marble such as has never been quarried."[29] But the quarrying and transport remained vexing and mishap-prone. The sarcophagi and lids for the two ducal tombs were the largest and most difficult blocks to secure; it took nearly two years to quarry them and get them to Florence. Even then, some of the stone that reached Florence proved substandard, and Michelangelo sent two more agents to Carrara to straighten things out.[30]

Topolino was forever running out of money and pleading the case of the *fornitori* who clamored to get paid. The Arno ran low and blocks were stranded at Pisa for months; one, six feet long, cracked when the attendants at the papal office in Pisa lit a large fire right next to it.[31] Still the valiant Little Mouse stuck at his mission, even on Christmas Day 1524, when he wrote dolorously to report that he could not secure any blocks until a large mass of rubble could be cleared from Leone's quarry, but that it might be possible to excavate one or two at Mancino's "when it becomes possible to go up there." And, oh yes, it being Christmas, Topolino asked Michelangelo, "if you want to," to pass on word to his wife that he was in good health.[32]

Soon after receiving Topolino's Christmas letter, Michelangelo made so bold as to write Pope Clement directly, "because intermediaries are often the cause of great scandals," to exculpate himself for the delays. The "advantage" of abstaining from quarrying himself had proven illusory, he declared. "I am certain, mad and worthless as I am, that if I'd been left to continue as I began [supervising the quarrying

myself], all the marble for this project would be here, at much less expense than has already been incurred, and roughed out to order, and would be something to admire, like the other marble I brought here. Now, from the quantity I see here, I do not know how it's proceeding, or what they're doing there at the quarries, and I see that it will take a very long time." Michelangelo then insisted that "not having authority there, it does not seem to me I should have the blame."[33] This plea seems puzzling in light of Topolino's steadfastness and Michelangelo's clear authority over him—unless it was actually a delayed riposte to Clement, who as Cardinal Giulio had torn him away from the Seravezza quarries four years earlier and granted them to the Duomo Operai.

If so, Clement did not react hotly, as Pope Julius would have; he knew Michelangelo and his moods too well to be provoked. Eventually the marble arrived, at no small cost; by April 1526, the marble bill for the chapel, including transport, came to more than thirteen hundred ducats.[34] But Clement did not complain; he could see a masterpiece taking shape.

For all the trouble in procuring the marble, working it proceeded smoothly, if not rapidly, at Michelangelo's Via Mossa studio and in the sacristy itself. His years of solitary creation were behind him; he was now an impresario, overseeing a roster that, between the sacristy and library, included by Wallace's count 168 *scarpellini* and specialized carvers, as well as four stone sawyers and three blacksmiths.[35] They executed Michelangelo's elaborate, inventive detailing to superb effect. Conducting this orchestra did not sap his solo work; at the same time he began carving the most expressive, original figures of his career. After the ordeals of Julius's tomb and the façade, a project was progressing well, with his papal patron's wholehearted support.

But Michelangelo's luck would not let him off so easily—even if it took a war and revolution to throw him off track.

CHAPTER 16

THE KISS OF THE MEDICI

THE ONLY FEELING THAT THE DIVINE CAN INSPIRE IN FEEBLE
MAN IS DREAD, AND MICHELANGELO SEEMS TO HAVE BEEN
BORN ONLY TO STRIKE TERROR IN THE SOUL.

STENDAHL, *Roman Walks*

POPE CLEMENT'S REIGN, WHICH began so hopefully, soured quickly. The reasons lay both in his character—he was a classic number two, an able administrator but indecisive executive—and in a perfect storm of calamities. The church was caught like a kernel between two mill wheels, France and the Holy Roman Empire, just as Florence had been. The pope squeezed his hometown dry to raise money to buy favor with the first one, then the other invading power; as a minor consequence, Michelangelo's funding for the New Sacristy dried up. Clement threw in first with the mightier empire, then switched to France, Florence's traditional protector. That choice proved as disastrous for Clement in 1526 as it had for Soderini's republic in 1512. The next year Emperor Charles V's Spanish troops and German mercenaries sacked, raped, looted, and pillaged Rome and besieged Clement in the Castel Sant'Angelo, the papal panic room. The Florentines saw their chance and rose up one last time, expelling the Medici and reestablishing a republic in fact as well as name.

Michelangelo was torn between two loyalties, to Clement, his Medici patron and childhood friend, and to his city and republic. He chose the latter and became both a member of the militia's Council of

Nine and captain of the fortifications being thrown up to resist the approaching imperial assault. His patriotic reputation was sullied when, supposedly alarmed at warnings that the city would be undone by treachery and unable to get an ear for his fears, he panicked and fled to Venice. But implored and threatened with dispossession, he returned to Florence and stood fast, even when the cause proved hopeless.

This brief republican spring brought Michelangelo one boon: a second chance at the project he had craved since 1505, when Soderini engaged him to carve another colossus, a *Hercules,* to stand beside his *David* at the entrance to the Palazzo della Signoria. Pope Julius had spoiled that chance by summoning him to work in Rome, but the idea continued percolating in his mind and among his fellow Florentines. For them, Hercules remained a potent republican symbol, and Michelangelo was just the artist for it.

A second chance arose around 1520 when, during the quarrying of the San Lorenzo marble, a suitably immense block of fine *statuario* was discovered near Carrara. The nominal leaders of the puppet Florentine republic of that day invited Michelangelo to undertake the long-delayed colossus, showing Hercules vanquishing the ravenous ogre Cacus. Michelangelo discarded that theme and instead sketched the hero defeating another brute, Antaeus, by holding him in the air and preventing him from drawing strength from the earth. It was a bold and original notion, though balancing the weight of both figures on Hercules' legs alone would have been even more challenging than making the *David* stand. It was never put to the test: Pope Clement vetoed the assignment, for reasons that have inspired much speculation. Vasari, always quick to see conspiracies against *il divino* Michelangelo, alleges that the Vatican treasurer Domenico Buoninsegni steered the project away from Michelangelo, just as he supposedly queered the façade project, after Michelangelo refused to help him cheat the pope on the San Lorenzo marble.[1] There's a simpler explanation: Clement did not want to overburden Michelangelo and distract him from finishing at San Lorenzo. And there's a political subtext to the decision: the new colossus represented, in one modern biographer's words, "the last chapter of a struggle lasting almost a quarter of a century between two historical-political powers, the city of Florence and the Medici popes." A *Hercules* by the republican stalwart Michelangelo would "become a declaration in stone of the Florentine urge for inde-

pendence," just as the Medici were strangling that independence.[2] Better to keep him occupied at San Lorenzo and have a safer artist execute a neutralized *Hercules*.

And so Clement deflated the symbolism by awarding the commission to an artist with impeccable pro-Medici credentials, who was so widely disliked he could tarnish even Hercules' reputation: Baccio Bandinelli, the second most prominent Florentine sculptor of the day. Where Michelangelo "sucked up hammer and chisel with his nursemaid's milk," Baccio was practically born into the Medici service. His father

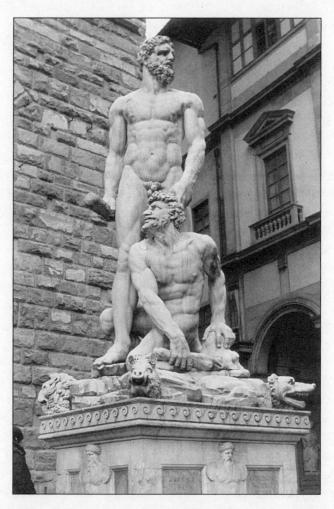

Baccio Bandinelli's *Hercules and Cacus*, subduing the depravity of Florence.

(named Michelangelo) was a master goldsmith and favorite of Lorenzo the Magnificent and his sons; when the Medici were driven from the city in 1494, he hid their gold and silver plates till they returned.

Baccio di Michelangelo followed his father in choosing an artistic vocation and in serving the Medici. At the same time he mimicked the other Michelangelo's grandiose aspirations and career path; Baccio was not Buonarroti's match, but he was in many ways his shadow. He too was a scion of a once-distinguished family that had sunk into the petty bourgeoisie. He too schemed and labored tirelessly to restore his family's fortunes. And Baccio di Michelangelo claimed noble ancestry just as Michelangelo Buonarroti had, though with even less basis: he merely appropriated the Bandinelli name from an aristocratic Sienese clan.

In youth, Baccio, like Michelangelo, won acclaim for a precocious snow sculpture. In maturity, he aspired to become a universal master on the order of Michelangelo, though he failed dismally at painting and architecture, and even dared to challenge the master directly at the site of his hometown triumph, the *David*. Given this trajectory, and given how essential marble was to their work and how rare large, pristine blocks were, it seems inevitable that Baccio and Michelangelo would collide over a colossal block of Carrara *statuario*. This collision colors Florence's and Carrara's cityscapes to this day.

Baccio pursued self-portraiture more avidly than Michelangelo or any other artist of their time. In some self-depictions he looks enough like Michelangelo, with the same scraggly forked beard, flattened nose, and somber expression, to be his twin. In temperament, he displayed the same faults—pettiness, miserliness, ill temper, a consuming sense of grievance and persecution—swelled to grotesque proportions. And for all his powers of persuasion and persistence in winning clients, he had an uncanny gift for alienating people of every station. One *scarpellino* working for Bandinelli in Carrara, angry at not getting paid, leaped at the chance to work for Michelangelo instead.[3] Benvenuto Cellini, Bandinelli's bitter rival for commissions and court favor, called him "the foulest villain who ever breathed" and barely resisted killing him in one chance encounter.[4] Driven by an ambition that was consuming even by Renaissance standards, Bandinelli stood as a sort of evil twin to Michelangelo; who else could make *il terribile* seem modest and sanguine by comparison?

And there lies Bandinelli's role in the Renaissance story line, particularly in Vasari's *Lives*. For Vasari, the all-too-human Baccio was an indispensable foil to the divine Michelangelo, the tragic figure against whose failure Michelangelo's triumphs shine. He was Salieri to Michelangelo's Mozart, the plodding, envious hack haunting the genius's traces. He was also the Eddie Haskell in the Mayfield of cinquecento Florence, the spirit of discord who pops up in one Vasari *Life* after another—Tribolo's, Andrea del Sarto's, Giulio di Baccio d'Agnolo's, and of course Michelangelo's—to sow mischief, horn in on commissions, and steal craft secrets.[5] If Bandinelli had not lived, Vasari would have had to invent him.

Indeed, Vasari did invent him in part, just as he invented Michelangelo the artistic messiah. Vasari's animus toward Bandinelli may reflect a student's grudge against an unloved teacher; though he does not disclose it, Vasari studied in the innovative art academy that Bandinelli founded, and recounts that Baccio "took no pains and showed no interest" in another talented student, Leonardo's kinsman Pierino da Vinci.[6] He lays a litany of unconfirmed and dubious charges against Bandinelli, the shakiest of which are alleged crimes against Michelangelo. In one such tale, Bandinelli steals a commission for a royal tomb from the sculptor Tribolo by telling Duke Cosimo de' Medici that the marble to execute it is ready and waiting in Florence. He then persuades Cosimo to requisition a large stock of marble blocks and roughed-out figures, including "one statue well advanced," that Michelangelo, then in Rome, had left behind and "cut and smashed them all to pieces, apparently to take vengeance and to make Michelangelo unhappy."[7]

The losses from the Via Mozza studio were indeed tragic, but no evidence suggests Bandinelli was to blame. And Vasari's most grievous brief against him is certainly a bad rap. In his biography of Bandinelli, Vasari claims he destroyed Michelangelo's celebrated cartoon for the *Battle of Cascina*, either to deny other artists the chance to learn and copy from it as he had, to protect the reputation of his friend and mentor Leonardo, or out of sheer malice and jealousy.[8] In fact, as Vasari himself concedes in his Michelangelo biography, many artists carried off pieces of the cartoon. And however he envied Michelangelo, Bandinelli's own words evince no malice toward him; in his memoir he salutes "the good Buonarroti, the judge whom I es-

teemed above all others, as much because he was intelligent as because he was not moved by a malignant spirit."[9] When Michelangelo deprecates his work, Bandinelli concedes the criticism, and when he praises it, he gloats like a pupil who's received his first gold star.[10]

Even Vasari conceded Bandinelli's mastery in drawing, relief carving, and, when he took the time and care, carving in the round. But for his fellow sculptors, Bandinelli's worst failing may have been not the way he treated colleagues but the way he treated the stone that was the stuff of their art. To most of them, and especially to Michelangelo, the integrity of the block was sacrosanct. It might be charming for a naïf like Topolino to fill out a statue's dwarfish legs, but to correct a flaw or mistake by patching in different stones, like a dentist filling teeth, was grievously unprofessional—"the trade of botchers," wrote Cellini, "who do it in all conscience grievously ill."[11] In this scruple Renaissance sculptors far surpassed the ancients they revered, who routinely assembled sculptures from different stones. The heads of Roman portrait statues were commonly carved separately and attached with lead bolts, so that if a likeness didn't please the client it could be replaced without jettisoning the entire figure; if one client reneged, a new head could be bolted on and the result sold to another. Even the magnificent *Laocoön*—hailed as a revelation and an inspiration for Michelangelo, who witnessed its unearthing in Rome in 1506—was, necessarily, assembled from at least three pieces.

That fact contradicts Pliny's description of the original *Laocoön* as being carved from a single block by Athanadoros, Agesandros, and Polydoros of Rhodes. And this in turn is one of the many inconsistencies that led an American art historian, Lynn Catterson, to announce a startling contention in April 2005: that the *Laocoön* exhibited at the Vatican since 1506 is not a first- or second-century-B.C.E. Hellenistic sculpture, as commonly supposed, or a Roman copy, but a fake done by the known forger Michelangelo Buonarroti six to eight years earlier, while he was working on the Vatican *Pietà*.[12] That novel claim aside, Michelangelo never combined stones or patched flaws; when they appeared, he either scrapped the work (the first version of his *Risen Christ* and a later *Pietà*) or gritted his teeth and finished but bemoaned the result. To fill in would have violated the principle of "taking away." Bandinelli had no such qualms. He customarily added "pieces small and large," writes Vasari, including one of Cerberus's

heads in his impressive *Orpheus* group, a section of drapery in his *Saint Peter* at Santa Maria del Fiore, and "two pieces, a shoulder and leg," added to the colossal *Hercules* he eventually executed for the Piazza della Signoria. Worse yet, he made light of these practices that "damn a sculptor completely."[13]

In fact, Bandinelli used a total of *eighteen* pieces of marble in the colossus, including its base. The prospect of such abuses, some marble-venerating Florentines opined, was enough to drive a self-respecting block of *statuario* to suicide. In 1525, when Clement awarded the *Hercules* commission to Bandinelli, the Duomo Operai finally shipped the fabled block down the coast from Carrara and up the Arno to Florence. When it was unloaded at Signa, it slipped and fell deep into the riverbed muck. This, recounts Vasari, inspired many verses "ingeniously ridiculing Baccio." One wag wrote that "after being promised to the genius of Michelangelo, when the marble learned it would be mangled at the hands of Baccio, it threw itself in the river."[14] These were not the last such verses Bandinelli's colossus would elicit.

Then the tale of the second *gigante* took another turn. When the Florentines drove out the Medici in 1527, Bandinelli had already started roughing out the fabled block (which had been recovered from the river). He fled to Lucca, and the reborn republic commandeered the block and once again awarded it to Michelangelo. As with the *David*, Michelangelo had to work within the limitations of another sculptor's rough-out. He dropped the idea of *Hercules and Antaeus* and produced a small, rough clay model, stunning in its twisting, intertwined action, of two struggling figures, one atop the other. Critics still debate whether it shows Hercules and Cacus or Samson pummeling a Philistine; Vasari writes mysteriously that Michelangelo meant to show Samson and two Philistines. Regardless, to compare this model with what was finally erected on the piazza is to mourn, as so often in contemplating Michelangelo's career, for what might have been.

The model was as far as Michelangelo got at this long-awaited project; he was too busy designing fortifications to defend Florence against the approaching imperial forces. These designs were in their way as innovative as his more glamorous efforts in sculpture, painting, and architecture. He devised a new form called the angle bastion, a starlike footprint whose projections enabled shooters to rake attackers from multiple directions; this design's principles were employed

up to the American Civil War and in the French Maginot Line.[15] But another, more homespun bit of ingenuity may have proven more effective: as Vasari tells it, Michelangelo saved the strategic campanile at the hilltop stronghold of San Miniato, which the enemy gunners had targeted, by hanging mattresses and wool bales from its projecting cornice to absorb the cannonballs' force.

Even as the noose closed on rebel Florence, the pope's aides continued to send Michelangelo encouragement and directions for the tombs. Vasari recounts that he continued working "with intense passion and care" on the Medici statues, while fighting to stop the Medici from retaking the city. Unlikely as this sounds, it suggests the depth of the ambivalence that gripped him when he fled Florence and then returned—and the ambivalence that suffuses the figures he created for the tombs.

Hanging mattresses could not stop the imperial army, and Florence finally yielded to the emperor in August 1530. Pope Clement, who had already made his peace with Charles V, regained control of the city and cast clemency aside; his emissaries hunted down and tortured, executed, or exiled scores of rebel leaders. Michelangelo hid for several days in the bell tower of the Church of San Niccolò in Oltrarno, covering its walls with drawings. But word soon came that Clement had forgiven him, reinstated his salary, and directed him to keep working on the tombs. Art outlived politics.

While Buonarroti was building rebel fortifications, Baccio Bandinelli intercepted Clement at Bologna, kissed his feet, gave him several carvings (the sort of flattery Michelangelo never stooped to), and begged to regain the *Hercules* commission and the marble dedicated to it. Sweetening the plea, he even named his son Clement, after the pope. The colossus was his once again.

Bandinelli boasted that he would surpass Michelangelo in this milestone project. The *David* had been the first colossal statue since antiquity; *Hercules and Cacus* would be the first colossal figure group. Bandinelli's original wax model captured Hercules' slaying of the castle-rustling Cacus in thrilling action: the hero, all brawny arms and oversized hands, raises his club high while his victim seems to melt into the fractured rocks. But this extravagant pose exceeded even the enormous block at hand. It would have been perilously fragile, and its violence might have been too much even for a public accustomed to

the severed heads decorating statues of Florence's other civic heroes, David and Judith. So Bandinelli made other models; the one Clement picked was more static, closed, and subdued, but also more massive. Where Michelangelo's *David* steps lightly in classic *contrapposto*, Baccio's *Hercules* stands stiffly on both massive legs, clutching his heavy club in his right hand and the cringing Cacus's hair in his left. The half-human Cacus actually seems more human than the brutish Hercules; he grimaces pathetically, as though pleading for mercy, his body as contorted as Hercules' is rigid.

Hercules and Cacus was installed on May 1, 1534, thirty years to the month after *David* was set on the other side of the City Hall steps. It seemed flatter in the light of day than it had in Bandinelli's studio; his work often tended toward smooth, elegant, antiseptic surfaces.[16] But so determined was he to make an effect that he screened off the installed statue and worked it further, leaning on the *arco* drill and exaggerating Hercules' twisting curls, cavernous eye sockets, and bulging muscles, which Cellini later likened to a "sack full of melons."[17]

Bandinelli had, in one sense, surpassed the great Buonarroti; next to *Hercules and Cacus*, Michelangelo's most contorted figures seem models of grace and restraint, and his muscular *David* seems downright undernourished. The contrast between the paired titans goes deeper: Michelangelo's *David* is liberty's champion, the embodiment of civic courage, a citizen warrior anxiously but unflinchingly facing down despotic power. Bandinelli's *Hercules* is the enforcer of that power, an implacable executioner whose furrowed brow and eyes may suggest anguish, but whose cruel bearing promises stony retribution. One critic has called him a figure of clemency, because he holds Cacus cowering but alive, but he seems merely to have paused before delivering the death blow. He stares out over the piazza like a gladiator awaiting the thumbs-down, and warns the passing Florentines: See the fate of this lawbreaker. Which of you is next?

This message is reinforced by the mythic roles of the two heroes. David repels external invaders while Hercules exterminates "monsters," internal enemies, and "subdues the depravity of Florence." The Florentines, who knew these tales, could not mistake the message, which was reinforced by what they also knew of the sycophantic Bandinelli. While carving the *Hercules*, he resided in the Medici palace and, as Vasari (the servant of a later Medici despot) puts it, wrote Pope

Clement "almost every week" with "an odious officiousness" to report
not only on the statue's progress, but on the doings of other citizens
and officials.[18] In other words, while carving the signature sculpture of
the newly reinstalled Medici dictatorship, he spied on his fellow Floren-
tines for the Medici pope in Rome. This made him even more unpopu-
lar, and prompted some citizens to complain to Duke Alessandro de'
Medici, whom the emperor and pope had installed as outright ruler to
insure the Florentines suffered no more delusions of liberty. Bandinelli
responded to these denunciations by appealing to the pope, in an eerie
reprise of Michelangelo's famous Bologna pilgrimage to placate Pope
Julius; he intercepted Clement at Bologna, kissed his feet, gave him
more gifts, and begged him to punish the detractors.

Baccio's *Hercules* inevitably offered a fat target to the many Floren-
tines who resented the new ducal dictatorship. They flocked to see it
unveiled, then papered its base with satiric verses such as this one by
Alfonso de' Pazzi:

> *The mallet that's been here, and the scarpello,*
> *show who is buried here—Bandinello,*
> *who expected to gain great fame.*
> *If he'd died first, he'd leave a happier name.*[19]

That other Medici lackey, Giorgio Vasari, both chuckled and shud-
dered at the spectacle, relieved perhaps not to receive such treatment
himself: "It was pleasing to see the wit, the ingenious conceits, and the
sharp sayings of the writers," he writes, "but they overstepped all de-
cent limits."[20] Duke Alessandro, ever vigilant for "indecency" and any
hint of sedition, clapped the boldest versifiers in prison.

Even today, Baccio Bandinelli remains the sculptor Florentines love
to hate. His *Hercules* still glares balefully at them in the heart of their
city, while the copy of Michelangelo's beloved *David* glances uneasily
at the looming giant, wondering whether to come to his people's de-
fense.

THERE IS ONE OTHER PLACE where Bandinelli, bound forever in
envy and emulation, faces off against Michelangelo through a marble
proxy: Carrara's Piazza del Duomo. At the piazza's center, between the

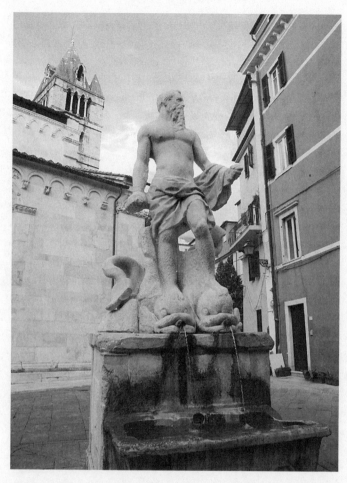

Bandinelli's orphan *gigante*, with Carrara's duomo on the left
and Michelangelo's house on the right.

Duomo di Sant'Andrea and the Pelliccia house where Michelangelo
lived, stands a utilitarian fountain. Two unadorned spouts spit into a
stained marble basin resembling the *conche* used to age *lardo*. The Car-
rarese, who don't trust all their fountains, say this one carries good
marble-filtered water from the mountains above Torano. Atop it a
muscular figure, nearly thirteen feet tall and heavily bearded, stands
proudly atop two dolphins. Most locals call this simply *"il gigante,"* the
nickname the Florentines gave Michelangelo's *David*. This giant's legs
and much of his right arm are only roughed in, in a *gradina*-chiseled

pattern resembling fish scales. That suits what is clearly a figure of Neptune, the king of the sea, standing incongruously before a white-capped mountain backdrop

The statue represents Prince Andrea Doria, the Genovese admiral who brought his city under the imperial wing, defeated the previously invincible Turkish corsairs in several battles, and, four centuries later, gave his name to a famously doomed ocean liner. And it is Baccio Bandinelli's most star-crossed work.

In 1523, the republic of Genoa asked Michelangelo to execute a colossal statue of Admiral Doria, but he was occupied with the San Lorenzo sacristry. When Bandinelli fled revolutionary Florence in 1527, he washed up in Genoa and received the commission, with an advance of four hundred florins (by his account—five hundred according to Vasari) against a rather generous total of one thousand florins. He headed straight to Polvaccio, the quarry where Michelangelo had found his most prized marbles, found a stone, and blocked it out.

But when the Medici regained power, Bandinelli returned to Florence and, echoing Michelangelo once again, left the colossus unfinished in Carrara. It's said there that he blew his advance on wine and women (to whom he was more partial than Michelangelo was) and skipped town before his wastrel ways caught up with him. More likely he hurried back to recover the *Hercules* commission. As Vasari tells it, Cardinal Doria, Andrea's kinsman, intercepted Bandinelli at Bologna, castigated him for leaving the statue unfinished, and warned that if the admiral caught him, he would send him to the galleys.[21] Baccio vowed to return to Carrara and, because his first effort had gotten lost or spoiled, to start fresh with another block he had waiting there. But instead he returned to Florence and resumed working on *Hercules and Cacus*.

Admiral Doria himself asked Duke Alessandro to make Bandinelli fulfill his earlier contract, and threatened vengeance if he didn't. After receiving assurances of safety, Baccio finally returned to Carrara in April 1537 and hired two *scarpellini* to rough out a new block; he subsequently recorded that he had "brought the likeness of the Prince to life."[22] But Doria's agents in Carrara, who checked daily on the project's progress, reported that it wasn't up to the "excellence promised,"[23] and Bandinelli's enemies spread the ill word around Genoa.[24] According to one account, the Genovese balked at seeing their admiral as a pagan god, in classical undress rather than modern finery,[25] but

this seems doubtful; Agnolo Bronzino, court painter to Florence's Duke Cosimo I and an artist exquisitely attuned to patrons' tastes, portrayed Doria as an even nakeder Neptune. Perhaps the Genovese fretted about the bearded face atop the statue, which resembles the inveterate self-portraitist Baccio Bandinelli. For whichever reason, or for all of them, Bandinelli fled back to Florence in "great fear of the galley," leaving the unfinished statue to gather more dust.

One account has it that Bandinelli returned to Carrara in 1559, shortly before he died, alone and embittered, at the age of seventy-two. Did he suffer a tardy pang of conscience or burst of inspiration and set out to finish his *gigante*? Or did he merely seek marble for his own tomb? Whatever he intended, the *gigante* remained unfinished. But the Carrarese weren't the sort to let a perfectly good *bozzato* go to waste; they ran water pipes through the mouths of the dolphins upon which Doria/Neptune rides and set him in the piazza. And there stands Baccio Bandinelli's most heroic and least auspicious self-portrait, quenching the thirst of puppies and children and staring forever at the house of Michelangelo, the hero he could not match and the nemesis he could never overcome.

BACCIO BANDINELLI inherited one other project from the unbeatable Buonarroti. When Cardinal Giulio de' Medici first undertook to have Michelangelo design the family funeral chapel, he envisioned a tomb for himself there as well. But when he became pope, tradition required that he be buried in Rome, along with his cousin and predecessor Leo X. Bandinelli was called to Rome to carve both their sepulchres.

Perhaps Giulio/Pope Clement was relieved at not having Michelangelo execute his tomb, given their fraught history and considering how Michelangelo had memorialized his cousins Lorenzo and Giuliano. The Medici tombs are conventionally described as being what Clement intended—glorifications of the two dead "dukes" and, by extension, of the Medici line and Medici rule. But scholars have read untold other meanings in them, interpreting them variously as allegory, political propaganda, and elaborate Neoplatonist cosmology. One proposes that the exalted statues of the two pseudo-dukes "also functioned as representatives of the two magnificents," Lorenzo and his brother Giuliano, whose bones are deposited, without sarcophagus or

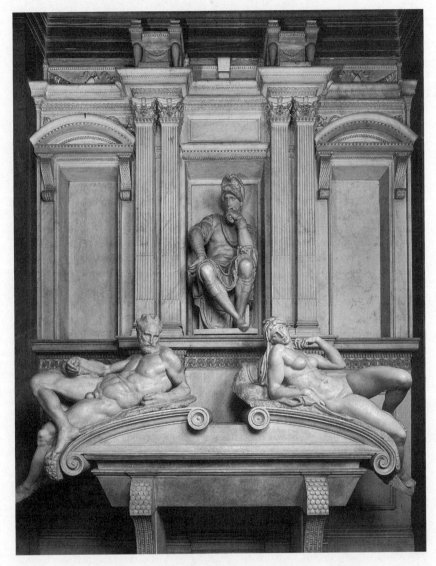

The tomb of Lorenzo de' Medici (marble, c. 1520–34).

effigy, under the statues of the Virgin and two saints.[26] Others see the
key to the tombs' meaning in the cult of the Magi, the three kings of
the nativity, which was extravagantly celebrated in quattrocento Flo-
rence and with which the Medici patriarchs Cosimo and Lorenzo
closely identified themselves.[27]

Vasari began the apotheosis of the ducal tombs' occupants when he declared that Michelangelo framed them with the four celestial allegories because "he thought that earth alone would not be enough to honor their greatness, and wished to have all the world take part." For even the fawning Vasari to expend such hyperbole on these failed standard-bearers of a withering line is so ludicrous as to sound sarcastic. Far from being an unmitigated celebration of Medici despotism, the tombs are an ambiguous, almost subversive, masterpiece—Michelangelo's most mysterious and haunting creations.

The mystery begins with the memorial statues: whom do they represent? Likenesses do not help; told that the statues did not resemble their subjects, Michelangelo replied, "No one will remember what they looked like in a thousand years." The clue seems to lie in their placement. Seated above the allegorical figures *Day* and *Night* is a powerfully built man in ancient Roman armor, hunched and brooding—*il pensieroso,* "the thinker," as he's come to be called. His chin rests on his hand and his arm on a strongbox with a grotesque animal's head—linx? fox?—carved on its front. Opposite him and above the figures of *Dawn* and *Twilight* sits a youthful, muscular figure with fine features and thick curls, a dandyish aspect that his improbable giraffelike neck both reinforces and mocks. His pectoral and weirdly asymmetric abdominal muscles bulge through his cuirass with impossibly sharp definition, a fantastic touch much imitated by subsequent Mannerist and Baroque artists and, unknowingly, in twentieth-century superhero comics. In his lap he cradles the *bastone,* a baton signifying military command (and predecessor to the swagger stick), and so he's called *il bastoniere.*

Almost everyone believes *il bastoniere* is Lorenzo the Magnificent's son Giuliano, the papal captain and so-called duke of Nemours, and that *il pensieroso* is *il Magnifico*'s grandson Lorenzo, whom his uncle Leo X designated duke of Urbino and placed in charge of Florence. Confirmation seems to lie in this note that Michelangelo scribbled on a tomb sketch:

Heaven and Earth
 Day and Night speak, and say: "We with our speed have led Duke Giuliano to his death, and it is only fair that he should take revenge on us as he does. And his vengeance is this: we having killed him, he being

dead has taken the light from us, and with his eyes closed has shut our
own, which shine no more upon the earth. What would he then have
made of us, had he lived?"

Michelangelo originally planned doleful figures representing
Heaven and Earth for the niches on each side of Lorenzo. Though the
conceit is a conventional one—the death of a great man shuts out the
light of the world—there is something ominous, given the tyranny's
tightening noose around Florence, about that last line, "What would
he have made of us?"

But is *il pensieroso* really Lorenzo? From what we know of the two
deceased captains, the statues and their supposed subjects seem ab-
surdly mismatched. Lorenzo the soldier was young, brash, impetu-
ous—everything that *il pensieroso* is not and the other figure, the curly-
haired *bastoniere*, is. By the same token, Lorenzo's reflective, sickly
Uncle Giuliano, the supposed *bastoniere*, was much more the *pensieroso*
type, right down to his posture: he tended to stick his head forward,
just as the tomb's purported "Lorenzo" does.

Pondering such inconsistencies, one German scholar argued as early
as 1860 that the identities of the two "dukes" had been switched.[28]
Most subsequent biographers and art historians have stuck by the offi-
cial identification, and some have proposed ingenious justifications: *il
pensieroso*'s brooding posture and bizarre headgear (apparently a lion's
snout) refer to the fact that Lorenzo "died insane." And the coins that *il
bastionere* holds in his left hand signify Giuliano's renowned generosity,
which Baldassare Castiglione salutes in *The Courtier*, his manual of aris-
tocratic etiquette.[29]

These justifications pale against the case for a switch propounded
by the American historian Richard C. Trexler, based on the comman-
der's baton that he holds lightly in his lap.[30] First, this truncheon-like
bastione is the Florentine form as opposed to the flagstaff-like Roman
style, indicating that this figure is the Florentine captain Lorenzo,
rather than the papal captain Giuliano. More important, the *bastione*
was a potent symbol of sovereignty, "the baton of dominion," and for
a Roman captain to openly bear his in Florence, whether in life or in
posthumous effigy, was the sort of provocation the Medici avoided;
when Giuliano's funeral procession shuffled through Florence, his Ro-
man *bastione* was "covered with black taffetta" and borne by flag bear-

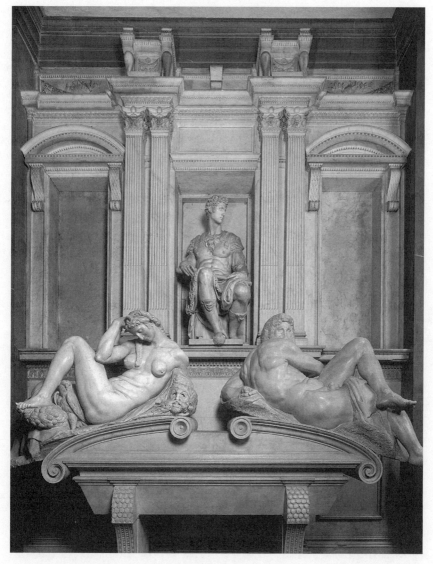

The tomb of Giuliano de' Medici (marble, c.1520–34).

ers rather than placed on his body, to ensure that even his corpse did not offend Florentine pride.[31]

But how could not just the identities but the *placement* of the two statues have been so egregiously confused? Once again, blame Vasari, who got so many things wrong. Not only did he propound the dubi-

ous official identifications, he assembled the tombs, which Michelangelo had left in pieces, when he and Bartolomeo Ammannati finished the New Sacristy, on Duke Cosimo I's orders, in 1555.

Ambivalence and contradiction energize nearly every figure Michelangelo carved, from the adolescent *Madonna of the Stairs* onward: *Bacchus* steps forward and lurches back at once, while *David* stands defiantly and twists uneasily. But the four allegories atop the sarcophagi raise them to a symphonic crescendo. Each is a battleground of conflicting emotions and motives, in which will and paralysis battle for supremacy. They are massive and powerful, and at the same time the most fluid forms Michelangelo ever carved; they float ambiguously over the arcing volutes, defying gravity even as they struggle to lift their heavy heads against it. And they are his consummate "dialogue with the stone," composed in a vocabulary of finish and *non finito* effects so rich and expressive they seem deliberately calibrated.

Dawn is the only body that is entirely formed and consistently finished. This seems too fitting to be accidental; she is the youngest of the four, the most voluptuous and feminine figure Michelangelo ever carved—though her nippleless, conical breasts jut improbably, she actually has a woman's waist and hips. She is also the most alert; she awakens with dread from a nightmare, or perhaps with horror into one. Her counterpart, *Twilight,* an aging but still-muscular man, slumps heavily and hangs his head, whose features have been only roughed in. Its plowed surface, with chisel strokes etched like wrinkles around his brow and eyes, contrasts eloquently with the smooth polish of his body, and expresses all the wear and regret of a long life entering the late stretch. The face resembles some portraits of Michelangelo, just as *Twilight*'s posture expresses the weariness of age that he so often lamented in these middle years.

Day, the most massive and powerful of the titans, rears back in shock at what he sees, or would see if he had eyes: though his limbs and torso are fully shaped and partly polished, his head is a roughed-in mass, with eye sockets, nose ridge, and hairline crudely shaped and the rest just raw stone. He is a beautiful Frankenstein's monster, a mighty, mindless body as unformed as the new day itself. Artists of every sort, from Byzantine icon painters to modern portraitists, have rendered the human figure selectively, detailing the most individual and expressive elements, the face and hands, and summarily sketching

or outlining the rest. But Michelangelo follows the opposite course: he leaves the face for last and carves the frame, in particular the midriff muscles, to rippling completion.

Michelangelo took great inspiration from the *Belvedere Torso*, the armless, headless remains of a first-century B.C.E. figure, perhaps of Hercules, commonly credited to Apollonius of Athens, which had recently been discovered and installed in the papal palace's Belvedere Court. He called it his "teacher" and studied it so ardently that some wags called it "Michelangelo's torso." The lesson he took from this splendid fragment was that not only gesture and facial expression could reveal drama, pathos, and struggle: these also played out in the torsion and tension of the muscles at the body's center. When Michelangelo touches marble, every back and belly is as expressive and distinctive as the face—more so in the tomb figures; it is no accident that he left the pupils of their eyes, and of his subsequent *Rachel* and *Leah*, blank.

Mary McCarthy, in *The Stones of Florence*, writes that "painting, with its trickery, could master a class of subject that was forbidden ground to the sculptor: that is to say, dreams and visions—reality in its hallucinatory and hypnotic aspects."[32] In the Medici tombs, Michelangelo conclusively refutes her. And of all the dreams and visions captured in their too, too solid stone, the figure of *Night* is the most haunting and paradoxical. Her lean, lithe, and washboard-muscled body seems distinctly male, save for the unusual length of her torso, the fullness of her hip, and the breasts that hang like sacs from her board-flat sternum. Their distended nipples have been sucked so deeply that they have begun to deflate, as has her will; her features droop in lidded slumber that seems serene from the side view and wracked and sorrowful from the front. She alone among the four figures is surrounded by emblems: a staring owl, a heap of soporific poppies, and a beguilingly hideous mask with eyes sunk deep within their sockets like the world-within-a-world of a Chinese devil's work ball— a portal to the world of nightmares. (Condivi recounts that Michelangelo also meant to carve a mouse, signifying time that gnaws all things, beside *Day*, but was somehow "prevented from doing so.")

Two areas of *Night* remain incongruously uncarved: the long braids hanging down her back and chest and her coiled left arm and hand, whose useless unformed fingers suggest paralysis and helpless-

ness. Elsewhere, however, she has been ground and rubbed to a polish unmatched in any of Michelangelo's other works save the Vatican *Pietà*. In the diffuse light of his artfully placed windows, and against the warm, smoky tones of the other figures, *Night* gleams cold and bright as moonlight on winter waters.

The contrast between *Night*'s polish and the rougher finishes of the other figures (and of parts of *Night* herself) seems not so much a difference in stone texture as in tone, light, shadow, even color—in short, a painterly rather than sculptural distinction. Just as the forms of the four Medici Tomb allegories have a fluidity and vitality only rarely found even in the greatest masters' drawings, their execution, the variation in their finishes, has the nuance of oil glazes in a master's hand. Nobody, including Michelangelo, ever painted with marble as he did in the New Sacristy.

But just because he poured the utmost measure of his imagination and craft into these figures does not mean he threw himself into the familial and political agenda that prompted the tomb project. He revealed his intentions in 1546, when the Medici loyalist Giovan Battista Strozzi penned these lines, punning on Michelangelo's name:

> *Night, who seems to sleep so sweetly in your view,*
> *was sculpted by an Angel's hand and knife*
> *out of this stone, and though she sleeps, has life.*
> *Rouse her if you doubt it, and she will speak to you.*[33]

Michelangelo replied with his own haunting quatrain in Night's voice, which leaves no doubt where his sympathies, and his disillusionment, lay:

> *Sweet to me is sleep, and sweeter yet to be of stone*
> *so long as the shame and injury endure.*
> *To neither see nor hear is a blessed cure,*
> *so wake me not—speak soft, leave me alone.*[34]

That he wrote these lines just as the most absolute tyrant Florence had known, Grand Duke Cosimo I de' Medici, was ruthlessly quashing the city's last traces of republican liberty makes them seem all the more bitter.

* * *

ONE CAN READ the turmoil and disappointment of the times in one minor sculpture that bridges the eras: an enigmatic, unfinished marble figure variously decribed as an *Apollo* or a *David*. It may be both. Its style suggests Michelangelo carved it earlier, but it surfaced around 1530 as a commission for Baccio Valori, the temporary governor installed after the pope and emperor retook Florence. The assignment, undertaken under duress, cannot have been a welcome one: Valori had directed the postsurrender bloodbath, and even targeted Michelangelo for execution before Clement ordered him spared. By one account,[35] Michelangelo had begun the figure as a *David* in the mid-1520s and then, when he had to come up with something for Valori and did not want to flaunt giant-killing republican heroes, recast it as *Apollo*. The slight, youthful figure looks more like a shepherd boy than an adult god, and the large, rough sphere at his feet could well be Goliath's unfinished head. His left arm reaches over his shoulder, holding a likewise unfinished lump of marble that might, depending on identification, be a sling or quiver; the lack of a strap in front suggests it was originally a sling.

What's striking and revelatory about this figure is its introspective, melancholy lassitude, far removed from the tautness of Michelangelo's earlier, larger *David*. Far from killing giants, this David/Apollo has barely strength to lift his arm, and casts his hooded eyes back over his shoulder as though avoiding the view ahead. He is *Night's* child, David defeated, shuffling into the darkness of the new, despotic age.

This time, Michelangelo did not resume allegiance to the Medici regime. After the revolutionary republic fell in August 1530, he traveled back and forth between Florence and Rome, staying just a few months—in one case a few days in each. In Florence he worked on the San Lorenzo sacristy and library, and in Rome resumed work on the tomb of Julius II; Francesco della Rovere, who had regained his title as duke of Urbino, had resumed pressing him for the overdue project, and in 1532 they agreed to a drastically reduced version. Michelangelo was still obliged to carve six statues for it, but he retained dispensation to alternate working on it and on the Medici tombs in Florence.

That same year, however, Michelangelo gained a new incentive not to tarry in Florence: the vicious, half-mad Alessandro de' Medici, os-

tensibly the illegitimate son of the late "Duke" Lorenzo and actually the fruit of Pope Clement's preclerical days, was proclaimed the first duke of Florence. Alessandro despised Michelangelo as a rebel traitor and, but for Clement's protection, would likely have dealt with him as he did with other rivals and recalcitrants (including his own cousin Cardinal Ippolito de' Medici, whom he had poisoned). And that protection would not last forever; as Clement himself said, "You know that popes do not live long."

Perhaps it was that realization that stirred Clement to launch Michelangelo on yet another vast project, despite the unfinished San Lorenzo projects and Julius's ever-pending tomb: to paint a *Last Judgment* on the Sistine Chapel's back wall and a *Fall of Satan and the Rebel Angels* on its entrance wall. All roads seemed to lead to Rome for Michelangelo. In October 1533 he wrote Clement's representative that he urgently needed some of the salary he'd been deferring to "expedite my business in Rome," and that he was heading there straightaway but leaving behind two small models, the *Heaven* and *Earth* for Giuliano's tomb, for other hands to execute.[36]

He returned to Florence the next spring, but it was not the same city. Bandinelli's *Hercules and Cacus* had been erected outside the old meeting place of the defunct Great Council, and Duke Alessandro had begun building the Citadel, an imposing fortress designed to protect Florence's rulers from their own citizens. Michelangelo had refused to assist in designing the Citadel, further alienating Alessandro. With the end of the San Lorenzo work, the last link tying him to Florence was now broken; his favorite brother, Buonarotto, had died (of the plague) in 1528, and his father in 1531. "I leave tomorrow morning for Pescia," Michelangelo wrote from Florence on September 22, 1534, to a young friend in Rome.[37] From there he would proceed to Pisa and down to Rome. As for Florence, he declared, "I will not come here again."

He left just in time to avoid falling into Alessandro's bloody hands. Two days later Clement VII, his forgiving protector and last Medici patron, died, and work ceased on both the New Sacristy and the Laurentian Library. Two decades later Alessandro's successor, Grand Duke Cosimo I, using Vasari and Cellini as emissaries, would try to lure Michelangelo back to Florence, where he would be honored as a living treasure. He promised to go, but held Cosimo off with unctu-

ous flattery and protestations about his obligations at Saint Peter's. Some biographers take this flattery as evidence that he had become reconciled to the Medici tyranny, but it seems merely to reflect the need to protect his family in Florence from Cosimo's vengeance. Michelangelo revealed his true feelings in a message conveyed via friends to France's King Francis I, declaring that if Francis "would restore Florence to liberty, he would make a bronze statue of him on horseback and set it in the Piazza della Signoria at his own expense."[38] Francis never took him up on the offer, and Michelangelo never returned to Florence or Carrara.

THE LAST BLOWS OF
THE CHISEL

I AM AT THE TWENTY-FOURTH HOUR, AND NOT A THOUGHT
IS BORN WITHIN ME THAT DOES NOT HAVE DEATH
CARVED WITHIN IT.

MICHELANGELO TO GIORGIO VASARI, JUNE 22, 1555

A POEM IS NEVER FINISHED, ONLY ABANDONED.

—PAUL VALÉRY

POPE PAUL III, CLEMENT'S successor, bridged two ages, just as Michelangelo did. He emerged from the freewheeling ferment of the Renaissance—when, as Cardinal Alessandro Farnese, he fathered four natural children—but oversaw the stern reforms of the Counter-Reformation, the founding of the militant Jesuit order, and the opening of the Council of Trent. Paul shed his old ways but not his love of art, and he esteemed Michelangelo at least as highly as his predecessors had. He demanded the full benefit of Michelangelo's talents, granted him an extraordinary appointment as the Vatican's "chief architect, sculptor, and painter," and with a papal bull, put off Julius's put-upon heirs yet again.

The idea of a second Sistine fresco showing Satan's fall soon fell by the wayside, but *The Last Judgment* occupied most of the next six years

of Michelangelo's life, through 1541. Two more large frescoes, executed under the usual duress for Pope Paul's private chapel, filled most of the following eight years—an arduous task for an artist entering his eighth decade, leaving little time for sculpture. At the same time, Michelangelo had every reason to be weary of marble projects, which had brought him such frustration. The decades since the *David* had brought a string of unfinished and overconceived projects, from the dreamed-of mountaintop monument above Carrara to the unconsummated *Hercules* colossus and San Lorenzo façade, to the start-and-stop ordeals of the Julius and Medici tombs.

And so he found other outlets. He operated as something between a conceptual artist and a ghostwriter, designing paintings for his friends, especially the Venetian Sebastiano del Piombo; this arrangement worked to their glory and let him see ideas realized that he would never have time for, in a new medium, oils, that he had not learned. His poetry meanwhile earned him renown and even scholarly exegeses. And he devised a style of presentation drawing very different from both his preparatory figure studies from life and the impulsive ink sketches with which he jotted down ideas, often on the backs and in the margins of letters. This style reached its fullest, if not fairest, fruition in four large drawings executed in the early 1530s for Tommaso de' Cavalieri, a young nobleman and talented draughtsman with whom Michelangelo had lately become deeply (though apparently chastely) infatuated, and with whom he maintained a lifelong friendship. These compositions, based on Ovid's *Metamorphoses,* explore the eternal dialogue between order and passion and pure love and carnal desire in mythological subjects with obvious Neoplatonic connotations: Zeus as an eagle bearing away a swooning, ecstatic Ganymede; the vulture tearing out the liver—the seat of passion—of the condemned giant Tityus; the presumptuous Phaëton falling from his celestial joyride; a bacchanal of cavorting toddlers. Together they offer a metamorphical map of Michelangelo's feelings for Cavalieri and qualms about his own passions.

These drawings are finished works in themselves, carefully composed on their pages and shaded with almost mechanical precision in a fine stippling of black or red chalk. They contravene the usual rule of diminishing vitality in works of art. Ordinarily, drawings have a spontaneous energy that grows attenuated in their makers' finished

paintings and sculpture; they are less self-conscious and closer to the original subject. But Michelangelo's frescoes and, especially, sculpture are miraculously vivacious: he seems to draw freely across great swaths of wall or right through layers of marble, as though his hammer and chisel were a stick of charcoal. But the drawings for Cavalieri, based in imagination rather than on models, are among his most fussy, labored, and mannered works. They seem to try too hard to impress—which is just what they were meant to do.

ARCHITECTURAL PROJECTS—the great Campidoglio piazza atop the Capitoline Hill, the Farnese Palace, the epic construction of Saint Peter's—meanwhile absorbed more and and more of Michelangelo's time. The former *"Michelagniolo scultore"* now signed his letters simply *"Vostro Michelagniolo Buonarroti."* In the course of a decade, he initiated just one new sculpture—a throwback to the republican and sculptural fervor of the old days. It is a modest piece but a remarkable one—a portrait bust, the only one he ever executed despite many requests from the great and mighty, of a subject who had been dead for nearly sixteen hundred years.

The circumstances were exceptional. A simmering community of exiles from Medici-ruled Florence, called *fuoriusciti,* had gathered in Rome. There, in the way of exiles in Paris, Miami, and other refuges, they railed at the regime they'd fled and plotted to overthrow it. Many were old friends and acquaintances of Michelangelo, and he shared their resentment of the hardening Medici grip. He may even have been in on their plots, though he was never identified as a conspirator. But those plots came to nothing; the real danger for Duke Alessandro proved to be much closer at hand: yet another Lorenzo de' Medici, the impoverished scion of a forgotten cadet branch of the family, called Lorenzino because of his small stature.

Lorenzino, who was two years younger than Alessandro, became an accomplice in his cousin's seamy adventures. At the same time, he burned with envy, ambition, and disgust at Alessandro's excesses and, like many humanists of the day, became enthralled with the figure of Marcus Brutus, Julius Caesar's assassin and the poster boy for stoic virtue and righteous tyrannicide. One of Alessandro's escapades gave Lorenzino his chance: in 1536 he lured Alessandro to a supposed assig-

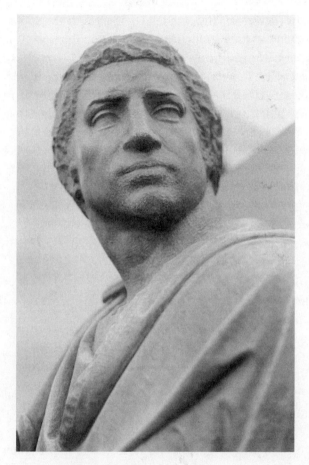

Michelangelo's *Brutus* (marble, c. 1542).

nation with another man's young wife and, with a hired assassin's help, stabbed him to death.

Lorenzino fled to Venice, penned a passionate *Apologia,* and had a medal stamped showing himself as Brutus. Though his motives were mixed, his words and deed inspired the *fuoriusciti,* who sought to add their endorsement. Once again, marble was the medium of legitimacy. One whom Lorenzino particularly inspired was the historian and former republican official Donato Giannotti, who advocated tyrannicide in his 1538 book *On the Florentine Republic* and planned to write a play about Brutus. Giannotti asked Michelangelo to execute a bust of Brutus in honor of Lorenzino for Cardinal Niccolò Ridolfi, a

leader of the *fuoriusciti,* and Michelangelo took to the subject eagerly.

His *Brutus* is a study in fortitude and determination. With its bull-dog neck, small pursed lips, and clenched jaw, it reprises an earlier statue, the *Defiant Captive.* Michelangelo modeled the head with crisp, vivid strokes of the *gradina,* save a section of the right temple where the original block still shows. But he then abandoned the bust and gave it to his protégé Tiberio Calcagno, who finished its toga'd shoulders in smooth, conventional fashion with the flat chisel but fortunately spared the head; the contrast between the two textures reinforces the portrait's rough-hewn energy.

Why didn't Michelangelo finish *Brutus* and present it to Ridolfi? Discretion may have dampened his initial enthusiasm. The revolutionary wave had ebbed; the *fuoriusciti* assembled an army but were routed by Florentine and Spanish troops, and many were captured. *Brutus,* prominently displayed, would be a pointed provocation, and Michelangelo feared endangering his family and property in Florence. In one of the great ironies of art collecting, the bust wound up several decades later in the collection of Grand Duke Francesco de' Medici—whose father, Cosimo I, had the "modern Brutus" Lorenzino murdered in Venice.

Duke Francesco had an inscription carved on *Brutus's* base, declaring that Michelangelo chose to leave it unfinished rather than commemorate a murder. That's generally taken as a self-serving gloss, but there's some truth to it; much as he abhorred Florence's new tyranny, Michelangelo had deep doubts about assassination as a remedy. In this he echoed his idol Dante, who consigned Brutus and his fellow assassin Cassius to the lowest place in Hell, inside Satan's grinding jaws. The evidence comes from the *Brutus's* instigator, Giannotti, in the second of two dialogues he wrote on Dante, with Michelangelo appearing as wise foil to his own hotheadness.[1] In the dialogue, Giannotti asks a question that has troubled many a reader: "Doesn't it seem to you that Dante erred in putting Brutus and Cassius in Lucifer's mouth?" Didn't the poet understand that the whole world "celebrates, honors, and exalts" anyone who kills a tyrant and frees his homeland? Of course, replies Giannotti's Michelangelo, and yes, Brutus and Cassius acted justly. But, he adds, it is a "great presumption" to kill a prince, because you can't know what good or ill will result. Many of the emperors who followed Caesar's death were far worse than he

would have been—and who knows but what he might have given Rome back its liberty after setting it in order, if he hadn't been murdered?

THAT'S A PRUDENT, conservative argument, but it would earn Michelangelo hisses in today's Carrara, a city that celebrates tyrannicide just as he did—in marble. Gaetano Bresci, modern Italy's answer to Brutus and Lorenzino, came from Prato (and from Paterson, New Jersey, where he had emigrated and worked as a weaver) rather than Carrara. And he won his notoriety at Monza, where, in 1900, he shot King Umberto I, avowedly because Umberto had decorated a general who had ordered hundreds of demonstrators gunned down in Milan. But it's Carrara that has adopted Bresci as its special hero, and defied bigger powers on his account.

Beside the town's grandest junction, where its main drag meets the old Via Aurelia, lies a small graveyard known as the Anarchists' Cemetery. This holds the remains of such movement heroes as Goliardo Fiaschi, a Carrarese who got caught on a quixotic mission to assassinate Spain's General Franco in 1957. Its centerpiece is a large slab of marble standing upright in front, visible from the road, and crudely carved with a simple epitaph: "A Gaetano Bresci—Gli Anarchici."

This monument came to be at a particularly inauspicious time, the mid-1980s. Italy was rocked by Red Brigade violence, and at the same time it was considering readmitting King Umberto's Savoyard heirs, who had been exiled since 1946. Carrara's anarchists decided to state their view in marble. Ugo Mazzucchelli, the ex–partisan commander who organized the feeding and rebuilding of Carrara after the war, lobbied the city council for a monument to Bresci.[2] The council's Communist majority resisted, but the more conservative members— Republicans, Christian Democrats, Socialists—and a few breakaway Communists agreed. The monument then became a national cause célèbre. The Italian Monarchist Association sued to block it, arguing it would encourage terrorism; the anarchists insisted that "libertarian" acts like Bresci's were different from violence directed at terrifying the general population. The president of Italy weighed in against the monument, and a magistrate began proceedings against all the council members who voted for it.

As the legal process ground on, Sergio Signori, the sculptor execut-
ing the monument, died, leaving it crude and unfinished.[3] Finally, late
one night, Mazzucchelli and friends brought a crane and installed
the slab. The provincial government prosecuted him, but he was ac-
quitted.

In 2002, Italy readmitted the exiled Savoyards, and the anarchists
rallied at the Bresci monument to protest. Carrara, less afflicted with
qualms than Michelangelo, cheered their defiance. Politics are differ-
ent in this town where Communists dominate the government and
anarchists define the culture, though they cede the electoral field.
(*"Noi non votiamo,"* their bumper stickers proclaim: "We don't
vote.") But the generation gap is universal. When a vivacious Accad-
emia student named Laura Mannucci learns I'm from Seattle, where
anarchists and other rioters besieged the World Trade Organization
in 1999, she says, with a smile big enough to light a billboard, "That
was good, but you didn't go far enough." She and her friends scorn
the fuddy-duddies of the Anarchist Federation: "They're the *demo-
cratic* anarchists. They're too moderate. We're the *real* anarchists." Is
her father an anarchist too? "Oh no. He's a Stalinist. He's for order,
absolute, total order." His parents, anarchists, were sent to Buchen-
wald, she explains, and he's remained devoted to the side that
destroyed the Nazis. All his children seem to have rebelled against
this legacy: "My sister's an anarchist too, just like me. But my
brother's with Berlusconi"—Italy's right-leaning, billionaire prime
minister. And her mother? "She's a saint."

IN GIANNOTTI'S DIALOGUE, Michelangelo offers one more argu-
ment against Brutus and Cassius: "According to Christian opinion," he
declares, God consigned the rule over the world to Rome, whose em-
pire was the antecedent to the one true church. And so "whoever tra-
duces the authority of the Roman Empire must be punished in the
same place and with the same agonies as he who traduces divine au-
thority." Dante "had to make an example of someone who had be-
trayed the Empire," and however nobly Brutus and Cassius acted in
killing Caesar, the first emperor, they were the "most famous" exam-
ples he could find.

Contorted and bloody-minded though this logic may seem, it com-

ports with a general shift in Michelangelo's focus, away from politics and toward a more quiescent Christian piety. He had proven a reluctant partisan before, when he took pains to avoid speaking against the Medici and when he fled the siege of Florence. And he had always been a devoted Christian. Now, with mortality's time clock ticking ever louder, his thoughts turned even more toward God and the cross.

The change shows starkly in the pared-down "tomb" of Julius II that he finally completed, in the Church of San Pietro in Vincoli in 1545. Though the label has stuck, it is actually not a tomb at all but a wall monument; Julius is interred in Saint Peter's, where the tomb was originally to go. In their final contract, signed three years earlier, Julius's heirs had insisted that Michelangelo supply three statues by his own hand and allowed him to farm out the three others that remained to be carved. The already finished *Moses* and nearly finished *Dying* and *Defiant Captives* would have filled this bill. But as Michelangelo himself noted, the *Captives,* carved when the tomb was to be much grander, were too large for the current design, "nor in any case would they be appropriate there."[4]

Indeed not. Though no one blinked when they were conceived in 1505, no one would imagine setting a nude such as the sensuous *Dying Captive* on a pope's tomb in 1545. Epochs had changed in the interim: *The Last Judgment* marked the last flourish of the High Renaissance and the dawn of the Counter-Reformation. In that fresco, Michelangelo barely got away with showing nearly every angel, demon, saint, and soul nude, save the covered Christ and heavily robed Virgin Mary. It was one thing to have the spluttering papal chamberlain Nanni di Biggio decry the fresco's saintly expanses of uncovered flesh, but Michelangelo also received a venomous denunciation from a more dangerous party: the Venetian poet, courtier, pornographer, and journalist Pietro Aretino, a shaper and bellwether of taste whom the poet Ariosto immortalized as "the Scourge of Princes."

"In a sordid bathhouse, not in an exalted chapel, is where your work belongs!" Aretino roared, in a letter that is a masterpiece of leering hypocrisy and threatening insinuation. "Your vice would be less if you yourself were an unbeliever, than that you should so determinedly undermine the faith of others."[5]

Michelangelo refused to kiss Aretino's ample backside, but he could not continue to defy the new puritanism. At the same time, his

own sentiments and sensibility had also shifted, away from the classical heritage and neopagan syncretism he imbided in Lorenzo the Magnificent's household over fifty years earlier. In the 1540s he undertook a new series of presentation drawings for Vittoria Colonna, the pious widow and poet who became a spiritual muse to his later years, expressing his deepening devotional sentiment.[6] These shed the mythological subjects of his drawings for Cavalieri and fix on two events: the *Crucifixion* and *Pietà,* depicted with a pathos verging on bathos. And his Pauline Chapel frescoes, showing Saint Paul's conversion and Saint Peter's crucifixion, are likewise works of unalloyed religious emotion.

The shift is most evident in the figures Michelangelo carved for Julius's monument in place of the two *Captives.* He called them *"una Vita activa et una Vita contemplativa,"* an *Active Life* and a *Contemplative Life,* an obvious parallel to the *pensieroso* and *bastoniere* captains of the Medici tombs. These are the roles in which Dante casts Leah and Rachel, the two daughters of Laban and wives of the patriarch Jacob, in the *Purgatorio.* And thus Vasari, and everyone since, has labeled the two statues.[7]

Rachel, standing to *Moses'* right and wrapped like a nun in a cascade of cowl and robe, is the more expressive. Her frame coils in a spring-like S-curve, culminating in hands folded in prayer. She smiles sweetly; her head arches back to heaven and her eyes roll upward. She is as lost in her rapture as the *Dying Captive* she replaced is lost in his; in her case, however, there is no mystery as to its source. *Leah* by contrast is resolutely of this world. Her legs, flexing powerfully through her robe, are firmly planted on the ground. A curious gather of her tunic at her groin evokes the fertility of the biblical Leah, who bore Jacob six sons.[8] Her face, stronger-featured than her counterpart's, seems at once to gaze benignly down at the viewer and abstractly into the small mirror upheld by her muscular arm.[9]

One must look closely to appreciate *Leah* and *Rachel.* They are overwhelmed by the architectural and sculptural mishmash of the tomb at San Pietro in Vincoli, assembled from four decades' ideas and artifacts, and by *Moses'* colossal size and presence, nearly twice their scale. And they are finished to an even blandness, like the work of ordinary, competent marble sculptors, as though Michelangelo had lost interest in the sensuous possiblities of the stone; they show none of the ex-

pressive extremes of his other pieces, neither the gleaming polish of *Night* and the Vatican *Pietà* nor the unpolished *non finito* of so many other works. Their features, especially *Rachel's*, are broadly worked and stereotypic, almost archaic—a striking contrast to the particularity of *Brutus*, Michelangelo's previous marble piece. They are his most modest and reserved works since the *Madonna of the Stairs* more than fifty years earlier.

And yet their crisp, sure forms still hold their own against the titanic *Moses*. Quiet though they are, Rachel's spiritual passion and Leah's physical vitality threaten to burst through their robes. Even when he swaths the human body in long robes, Michelangelo cannot avoid showing its play of masses and forces, the pull and counterpull of muscle and sinew; he articulates these as surely as if these biblical matrons stood naked as the *David*. Approaching seventy, he was still at the top of his sculptural game.

But he set that game aside. *Rachel* and *Leah*, executed under compulsion to satisfy the tomb contract, were his last public sculptures. At the same time, he left behind the sculptural concerns—mass, relief, anatomy—of his earlier paintings and drawings, and pursued very different ends in his two-dimensional works of the 1540s and 1550s. In the Pauline Chapel frescoes, he dealt for the first time since the Sistine ceiling's awkward *Deluge* with large figure groups integrated into three-dimensional settings, complete with receding hills and a distant city. But he cast aside the specificity, gestural grace, and anatomic precision of his Sistine figures. The Pauline figures are stylized and lumpy, almost primitive, clearly drawn from memory and imagination rather than life. They are throwbacks to the early quattrocento, closer in form and feeling to Masaccio's, Mantegna's, and Paolo Uccello's breakthrough experiments, even to Giotto's in the 1300s, than to the post-Raphaelite era in which they were painted.

This reversion shows most starkly in the contrast between the *Conversion*'s Christ, blasting the heathen persecutor Saul with a bolt of light, and *The Last Judgment*'s Christ as celestial judge, painted just a decade earlier. Superficially their actions are similar; each Christ on high extends his right arm in a terrible gesture of divine power. But they could hardly be more different. In the *Judgment* Michelangelo overleaped a thousand years of religious convention to show Jesus in boldly classical terms: a sculptural titan, clean-shaven and muscular,

planted on his cloud throne as firmly as on a pedestal, his enormous torso twisting in dramatic *contrapposto*. The Pauline Christ, robed and bearded according to the conventional formula, flies into the frame like a bullet, starkly foreshortened and uncomplicated as an early comic-book superhero.

Age and loss of facility cannot explain this retrenchment; when he chooses to in the Pauline frescoes, as in the *Leah* and the *Rachel*, Michelangelo still commands his craft superbly. But he suppresses his own virtuosity, the *deseigno* (drawing) that he upheld as the essence of all the arts, sacrificing form for expression. The awkwardness and strange, frozen gestures of many of the fresco figures reinforce the terror and, in the *Crucifixion*'s case, the tragedy of the events they depict. For all their solemnity, however, they have a melancholy delicacy, a chromatic harmony much subtler than the stark outlines of *The Last Judgment* and the acid hues of the Sistine ceiling. They are not only less sculptural than his earlier masterpieces, but more painterly.[10]

Michelangelo's painting career ended in 1546 with the completion of the *Crucifixion of Saint Peter*, but the same evolution continues in his religious drawings. He moved further and further from his earlier sculptural conception, away from the crisp definition of solid forms to luminous, spectral figures in fugitive strokes that seem to quiver on the page, as though beginning to take shape. Soft chalk had long since replaced precise ink as his chosen medium. Leonardo da Vinci might gloat at the outcome; the "anatomical painter" he once derided had developed an even hazier, more *sfumato* touch than his own.

This quivering style suits the tragedy of Michelangelo's persistent subject, the Crucifixion and its aftermath, and these simple depictions have a veracity and quiet grandeur lacking in the fastidious designs for Cavalieri. Four centuries later another former prodigy, Pablo Picasso, would say, "It took me four years to paint like Raphael, but a lifetime to paint like a child." Michelangelo learned to draw like Michelangelo while he was still a child; now, as an old man, he was unlearning.

IN 1546, "Michelangelo *scultore*" was declared a citizen of Rome, but the professional designation already seemed an artifact. As far as the wider world knew in his last two decades, the greatest sculptor had become an architect and left sculpture behind. He designed and

supervised an impressive range of buildings: the Farnese Palace, the Church of San Giovanni dei Fiorentini for Rome's Florentine expat community (unbuilt), the Porta Pia gateway, the transformation of Diocletian's Baths into the Church of Santa Maria degli Angeli, and his main task, Saint Peter's. In none of these did he try to reinstate his aborted vision for the San Lorenzo façade: a total integration of architecture and sculpture, entirely in marble—a massive structure that would be both a sculpture in itself and a frame for sculpture on a scale unseen since ancient times. Perhaps he bore too many inner scars from the ordeals of the façade and Pope Julius's tomb: all the

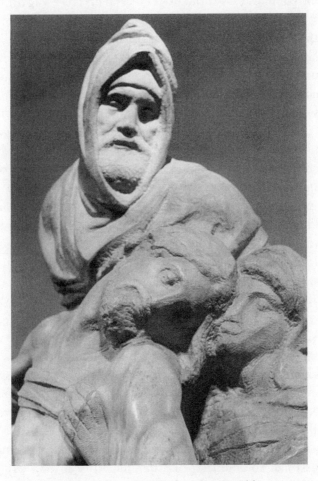

The *Florence Pietà*, rejected by its maker (marble, ?–1555).

frustration, all those years in the quarries, the lingering taste of guilt and betrayal. He abandoned the crisp edges and gleaming surfaces of pristine Carrara *bianco* that had so enchanted him, just as he eschewed sculptural precision in his drawings and used the more malleable materials that were readily available: *pietra serena* in Florence, travertine in Rome, brick and stucco everywhere.[11] He seemed to have finally freed himself from the tyranny of marble.

But back on the Via Mozza, locked within his studio, something else was taking shape. He might renounce the art he'd sucked in with his "nursemaid's milk," but he could not leave it forever. Quietly, without commission or obligation, he picked up his chisels again.

Vasari, who was now close to Michelangelo and could write from observation rather than reconstruction and supposition, records that after he finished the *Crucifixion of Saint Peter,* Michelangelo undertook a sculpture strictly "for his own amusement and to pass the time and, as he said, because working with the hammer kept him healthy"— probably from a block left over from Julius's tomb. Vasari later discloses a more serious motive: "He had the idea of placing it on his own tomb." It was thus a uniquely personal undertaking, and a somewhat secretive one. One evening in the early 1550s, Vasari stopped by Michelangelo's house on an errand for the pope. As they chatted, Vasari's eyes fell on the statue, particularly on a leg that Michelangelo was altering. "To stop Vasari from seeing, Michelangelo let his lamp fall, leaving them in darkness." After his servant brought another light, Michelangelo intoned, "I am so old that death tugs often at my cloak. . . . One day my body will fall just like that lamp."

This apprehension of mortality, which was always with Michelangelo through his long and vigorous old age, seems reflected in the statue's subject: the dead Jesus being borne down from the cross by his mother, Mary Magdalen, and a hooded, bearded man. It was a daring undertaking. To carve even two interlinked, oversized figures from a single block of stone, as Bandinelli did in *Hercules and Cacus,* was bold. A group of four such as Michelangelo now undertook was an extraordinary challenge. In his late seventies, he had lost none of his audacity, nor his passion for carving, nor, for all his complaining and bouts of serious illness, his stamina. After a long day herding snakes at Saint Peter's, he would work on this valedictory sculpture late into the night, wearing a cap folded of heavy paper with a candle

mounted atop it. (Carrara's *artigiani* still fold caps of newspaper to keep the marble dust off their hair.) And he worked at it with the "impetuosity and fury" that so astounded the visiting Vigenère, hammering "more chips out of very hard marble in a quarter hour than three young stone carvers could in three or four."

At last, it seemed, Michelangelo had found the perfect balance of the intimate and monumental in his creative life. Before, in "the tragedy of the tomb" and the fiasco of the façade, he tried to combine the two and hit a wall: he conceived enormous projects revolving around marble sculpture, but could not delegate the execution to anybody else, and finally collapsed under the impossible burden. Now he directed a project, Saint Peter's, that was even larger and more complex, but blessedly free (at the structural stage) of marble and statues. And so he could stand back coldly and critically and save his "impetuousity and fury" for the block cached at home.

Even then, the fickle stone, or his own steadfast perfectionism, betrayed him. In the winter of 1555–56, at the age of eighty, he smashed the *Deposition* that was to be his funeral memorial and final sculptural testament. Some chroniclers chalk this up as yet another first for Michelangelo: the first recorded case of an artist vandalizing his own work, aside from deliberate sacrifices such as Botticelli's contribution to the Bonfire of the Vanities. Vasari offers various possible reasons for this outburst: "Because this stone was full of emery and hard, and often shot sparks under the chisel; or perhaps it was only that his standards were so high he was never content with anything he did." He quotes Michelangelo himself as saying he smashed the block because of "the importunity of his servant Urbino, who every day urged him to finish it, and because among other things a piece of the Madonna's arm lifted off, making him hate it.[12]

Tiberio Calcagno, his untalented protégé, persuaded Michelangelo to give him the fractured *Deposition*. Tiberio then patched it together and finished one figure, Mary Magdalen, with a clumsiness that should serve as a warning to art restorers everywhere. Fortunately, he spared the other three figures, and the marred miracle now called the *Florence Pietà* survives today.

It is a uniquely personal and deeply moving testimonial. Like the Vatican *Pietà* fifty-five years earlier, it rises in a pyramid—a sharper, leaner one—but there the resemblance ends. Next to the *Florence*

Pietà, the more famous youthful work seems the bravura perform-
ance of a cocky twenty-four-year-old, a lush orchestration of mawk-
ish looks, well-turned limbs, and cascading drapery, whose dandyish
Jesus seems to stir from a cozy nap. In the later *Pietà,* Michelangelo
dispenses with drapery and flashy effects. It is a rhythmic series of
downward diagonals—the two Marys' arms, Jesus' akimbo thigh and
slumping head, the signature strap around his chest—struggling to
contain the tragic thrust of his falling, twisting arm. This is the rare
deposed Christ who actually seems *dead* and subject to the law of
gravity; he falls toward the tomb with all the weight of the world and
its sorrows. And yet his wracked body is infused with energy, a life be-
yond life. It is one of the most succinct, compelling visual distillations
of the gospel story ever formed by human hands.

Holding the body from above and looking down sadly is an old
man; his hood forms a perfect apex to the overall pyramid. With his
forked beard, flattened nose, heavy brow, and deep-set eyes, he is a
ringer for his maker, the surest self-portrait Michelangelo ever made.
He represents one of the two men who take down Jesus and bury him
in John 19: most authorities read him as the sympathetic Pharisee
Nicodemus, some as the secret disciple Joseph of Arimathea. Either
seems a stunningly apt choice for Michelangelo's sepulchral stand-in.
Joseph gave up *his* tomb for Jesus, and Nicodemus, to whom Jesus
said, "Unless a man be born again, he cannot see the kingdom of
God," was according to medieval tradition a sculptor. As such,
Nicodemus was especially revered in the Apuan region; local legends
have it that he, assisted by angels, carved a revered wooden crucifix,
the *Volto Santo* ("Holy Face"), in Lucca cathedral, and another at the
Convent of Monte Marcello at Punta Bianca.

Given all that, why would Michelangelo shatter this powerful testa-
ment and consign it to the likes of Tiberio Calcagno? Vasari was
plainly grasping for reasons with his "shooting sparks." And if
Michelangelo did blame Urbino, he only made him a scapegoat for
other frustrations. That the Virgin's arm, or rather hand, vexed him is
doubtless true: too little stone remains to fully model that hand. But
he also faced a much larger lack: Jesus' left leg. The fact that most
viewers don't notice that this leg is missing testifies to the work's eye-
filling power, but its absence is all too obvious from the side.

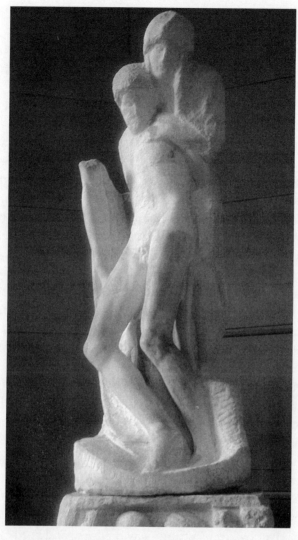

The *Rondanini Pietà*, the final taking away (marble, ?–1564).

Some scholars argue that the incestuous "implications of a leg slung over Mary's thigh" obliged him to remove it.[13] This is a stretch; in the 1499 *Pietà* and untold others, Mary cradles Jesus more intimately, with both his legs across her thigh. And where the leg was cut off, a chiseled-out hole waits to take the pin that will bind a new one. Far from eliminating the splayed-over leg, Michelangelo had prepared

to replace it, after a flaw or carving mishap ruined it. Perhaps after all these years of respecting the integrity of the block, he could not bring himself to commit the sin of "adding on," so he smashed what was to be his last masterpiece. So near his end, the stone had foiled him yet again.

Still, he did not give up. Sometime in the mid-1550s, after discarding the *Florence Pietà*, Michelangelo embarked on another postcrucifixion group, one with elements of a *Pietà, Deposition,* and *Entombment* but not exactly like any of them—indeed, like nothing anyone had made before. In the so-called *Rondanini Pietà,* he stripped the gospel tragedy down to its barest essentials: two figures, the mother standing behind the dead, slumping son, miraculously holding him upright. It is an impossible pose, harkening back not to *Pietàs* but to medieval depictions of the Trinity with the Father holding up the dead Son.[14] But this impossibility is part of its transcendent logic.

A sheet of tiny sketches[15] shows that Michelangelo first envisioned muscular figures in his usual style, more robust than the *Florence Pietà's* Jesus. And what remains of the Christ he originally carved—two legs and a single disembodied right arm—is indeed well-turned, and polished to a surprising sheen.

His contemporaries could not understand what he did next; Vasari shrugged as though it were busy work for his dotage, an excuse for him to "continue using his chisel each day." How could they understand? In his last, boldest artistic gesture, Michelangelo anticipated not just the next decade's or generation's sculptors, but the revolution that would overtake sculpture three and a half centuries later.

He attacked this partly finished *Pietà* in a fashion even more extraordinary than his assault on the previous one. He did not destroy it; he undid it, layer by layer, cutting away the torso and head of the powerful Christ to reveal a wraithlike figure, half formed from stone left from both his original body and his mother's. The two figures seem to fuse together, like roots at a trunk or smoke from two coals, growing upward instead of falling down. Viewed from the left side, vertical and stark like columns, they evoke Giacometti's gnarled stick figures. Viewed from the right, they curve up in a single ecstatic arc, like a wing or a flame, anticipating Brancusi's abstracted *Birds.*

Standing before this joint apotheosis of mother and son, one can't help recalling Michelangelo's earlier icy mothers, from the *Madonna of*

the Stair to the Medici tomb's nursing Mary, looking abstractedly past or away from their children, and recalling his own childhood abandonment, relieved by the stone carver's wife who nursed him. Now, in his last work, he returned to his earliest preoccupations—the *madre macchia,* as they say in marble-haunted Carrara, the "mother stain" that purges the stone of impurities. But rather than rake old anxieties, he aims at a reconciliation. In one of his last drawings, done while he worked on this final *Pietà,* he shows a very different Madonna and child: both naked, voluptuous, and adoring as a late-Renoir maternity pair. She squeezes her baby to her chest. He clutches her neck and nuzzles her cheek. She smiles, eyes closed in bliss. The merging of the adult mother and son in the *Rondanini Pietà* completes the reunion, in the only medium that would serve, using the mallet and chisel that he "absorbed with my nursemaid's milk."

The result is a marvel of scriptural compression: in this so-called *Pietà,* Michelangelo has inserted the Resurrection as well. He has passed through the tragedy he captured so fully in the *Florence Pietà* to a sort of redemption, or at least release. And he has crossed over by discarding his craft and virtuosity, the art that had brought him this far.

And that, I suspect, explains the oddest puzzle of this wonderfully mysterious work: the vestigial arm of the old Christ figure, cut off midbicep but still attached to the stone below. Authorities view it as an artifact, which he neglected in his hurry. But that makes little sense; like the matrix he left enclosing the *Bearded Captive,* the arm would only be in the way—far easier to lop it off. Instead he left this right arm—the mallet hand—as a talisman, a memento of the facility he had lost or renounced, of the art he had given up to God.

At last, Michelangelo was ready to give up. He had resisted death in every way he could, lamented and decried it in his poems for half a century, survived one illness after another, watched a parade of those he loved, along with colleagues, patrons, rivals, and adversaries, pass on. Now one more bit of taking away remained. On February 12, 1564, when he was one month short of eighty-nine years old, his friend Daniele da Volterra stopped by and found him still chipping away at this strange pair of figures. Two days later he took to his bed. Four days after that he died, tranquil and lucid, with his friends gathered around him.

ANOTHER WAR

MICHELANGELO LIVED IN A period of nearly unprecedented turmoil, violence, and outright horror in central Italy. Two incidents in particular impressed themselves on the contemporary imagination with almost apocalyptic intensity: the massacre at Prato in 1512 and the Sack of Rome in 1527, both perpetrated by imperial Spanish and German troops. After the controlled, chivalrous warfare of medieval times and mercenary campaigns composed as much of feint as of combat, these atrocities gave the Italian peninsula a foretaste of the total war to come.

That war arrived in 1944, when American, British, Polish, Canadian, and Brazilian troops fought their way up from the peninsula's southern tip and crashed against a wall of German resistance in the Apuan and Apennine mountains. And it descended more heavily on the region around Carrara then almost anywhere else in Italy; the memory still colors Carrara's culture and politics, and the outlook of anyone old enough to hold even a faint memory of it.

Tuscany, ever a land of political extremes, was a seedbed of Fascism, which was born in nearby Emilia Romana, and of resistance to it. "Here we are extremists, basically," says Roberto Figaia, head of Carrara's oldest family marble business, with records going back four hundred years. "A lot of the leftist extremists were Fascists before the war." In Carrara, some quarry owners cheered the efforts of Renato Ricci, the local Fascist Party chief, to organize the freewheeling quarries in a controlled consortium, breaking the power of the biggest marble families. Even now, Figaia sighs and reminds me that Ricci,

who went on to become a minister in Mussolini's government, "did a lot for this area" and that "politics aside, Fascism developed some beautiful works of art."

Most Carrarese were less forgiving. They were roused against the Fascists as early as 1921, when the Blackshirts gunned down Renato and Gisella Lazzeri on the Via Carriona. Just down the street, where a hole-in-the-wall bar now stands, a secret court of the Comitate di Liberazione Nazionale, the partisan command, convened two decades later. Fascist operatives would be kidnapped, tried, and, if condemned, smuggled down the river or up into the hills and shot. The anarchist journalist Alfonso Nicolazzi's house still bears mementoes of those days: a rooftop door, whence those inside could flee across neighboring roofs in the event of a raid, and a trapdoor in a false floor, opening onto a crawl space where fighters and weapons could be hidden.

Open defiance was suicidal, but Albe Vanelli, a child at the time, recalls how his great-uncle Gregorio, in a consummate gesture of Carrarino hardheadedness, staged a personal protest that stopped just short of the line: "He would drive a wagon carrying a bundle of sticks in front of the Fascist headquarters and call out, '*Il fascio si sfacia*'"— "The bundle is coming undone"—referring to the old Roman *fasces,* a bundle of sticks around an ax that represented authority and gave Fascism its name. "They'd beat the shit out of him, and he'd come back and do it again."

The mountain villages were special partisan strongholds, and the quarries and caves that surrounded them became refuges for partisan squads and civilians fleeing the carnage below. Anarchist, socialist, republican, and Christian partisans fought together. "There was no disagreement among us then," thunders Angelo "Taro," an elder statesman among Carrara's anarchists, who joined the *partigiani* at fifteen and is still known by his nom de guerre. "After the war there was *divergenza,* but we were all *d'amore,* all dedicated to driving the Germans and Fascists out of Italy." Other veterans and historians echo the same theme: for once, the fractious local factions managed to join together.

The worst sufferings came as the occupation unraveled, when Carrara again became a no-man's-land suspended between clashing powers. After being driven from their southern bulwark at Cassino, the Germans reestablished their defensive perimeter along the natural barrier that stretched from the mouth of the Rubicon (the river Cae-

sar crossed) on the Adriatic, along the diagonal spine of the Apennines and the Apuan Alps, and finally reached the Ligurian Sea a few miles south of Carrara. Fifteen centuries earlier the Byzantine Empire used this same natural barrier to block the Goths sweeping down from the north; Hitler adopted the Byzantines' name for this perimeter intended to keep Germans out: the Gothic Line. The line's natural defenses were formidable, and the Germans made them far more so, planting nearly twenty-four hundred machine-gun nests, hundreds of thousands of land mines, and heavily fortified artillery along the two-hundred-mile perimeter. They set their biggest firepower across the Magra River from Carrara, on the promontory called Punta Bianca: ten 152-millimeter big guns that could rake the shore to the south, the natural choke point for the Allied advance. Allied bombs leveled swaths of Massa; German guns and dynamite did a much more thorough job on Viareggio, Querceta, Ripa, and other towns in the advancing Allies' path. Carrara, on the German side of the Gothic Line, suffered less devastation, but dreary postwar boxes still mark the spots where bombs leveled graceful old buildings. Topography and bomber-deflecting sea winds meanwhile protected the guns of Punta Bianca; the Allies threw enough ordnance at them to level several cities and never took them all out. American accounts say the Germans finally scuttled the guns when they retreated; locals say it was the partisans who captured them.

As the Allies pushed into the Apuans, the Germans endeavored to evacuate the intervening villages, ostensibly for humanitarian reasons, actually to eliminate resistance and drain the sea in which the *partigiani* swam. Nearly fifty thousand people, as many as the Romans had exiled, fled from Massa to desperate conditions in the countryside. Residents of the mountain villages, where partisan loyalties ran highest, were assured they'd be taken to safe havens beyond the mountains, then shipped to concentration camps or herded into the hills and shot. Major Walter "Bubi" Reder, the one-armed SS commander on the Gothic Line, undertook some of the most sweeping, brutal reprisals and massacres in all Italy; his is still a name to curse with here. Among other glorious campaigns, Reder's raiders and their allies in the local Black Brigades shot, burned, and bayonetted some 560 residents of the Sant'Anna valley, 107 villagers at Valla, 154 at Vinca and Bardine di San Terenzo, and 159 prisoners held in Massa castle. They

carried out more massacres at Fontia and Castelpoggio and set La Vaccareccia, Viano, Vezzanello, Campiglione, Tenerano, and, just above Carrara, Bedizzano and Colonnata to the torch, shooting whoever got in the way. When parish priests at Fosdinovo, Molina di Stazzema, and other villages tried to intercede, the SS shot or hung them too.

Sixty years later, those times can still seem eerily present. At one gathering in Carrara, I happened to meet a cheerful older gent in a tweed jacket, with a healthy shock of white hair and a disarmingly clear, intent gaze. His name was Almo Baracchini, a friend explained, and he had written a book too; he stepped out to his car to get a copy.[1] The volume, newly republished, recounts the events of August 21, 1944—an experience that might leave another man a haunted basket case, but which seem to have left Baracchini at peace and made him an enduring local hero. On that day, the SS, under Reder's personal command, completed their customary ten-to-one reprisal for sixteen soldiers killed by the partisans. After shooting or bayonetting everyone they could find in Bardine di San Terenzo—107 people, mostly women and children—they trucked in fifty-three men seized elsewhere, hung them with barbed wire, and declared that anyone who touched them would be shot. Young Baracchini defied the threat and dragged nearly half the putrefying corpses to a grave site seven hundred feet away before others came to help. By rare fortune, he had a camera and recorded the atrocities—indelible documents of a horror that might otherwise be unimaginable. Poster-size prints of them hang in the expansive offices of Carrara's wartime partisans' association, whose members were occupied with the war in Iraq when I visited (rainbow-colored *Pace*—Peace—flags hang everywhere in Carrara). Some of the grisliest are reproduced in Almo Baracchini's book. He smiled and signed a copy for me.

But the recollections can switch quickly from horror to a *Life Is Beautiful*–style fable. My cousin Luigi's father was among a crowd of Carrarese men forcibly assembled in the piazza for shipment to labor camps in Germany. He escaped, says Luigi, by cocking his nose in the air, "looking like a German" (the family resemblance came in handy), and walking off. On another side of the family, however, the recollections are not so sunny, or innocent.

It was an atrocity that carries a special weight of memory around

Carrara. A *partigiano* acting on his own killed a German guard near La Foce, on the high road between Massa and Carrara—the rural district whence my great-grandmother had immigrated five decades earlier. A fireman from nearby Bergiola Foscalina came upon the body and fled, panicking so at the thought that he'd be blamed that he dropped his knapsack. On that evidence, Reder ordered reprisals against Bergiola. On September 16, 1944, the SS and Black Brigades swept in and slaughtered seventy-two people, mostly women, children, and old folks. Most of the victims died inside the Bergiola Foscalina schoolhouse, which was torched with flamethrowers.[2] Luigi tells me that some of my great-grandmother's relatives at nearby La Foce participated in that massacre. Today none of her family remains at Foce, and people just shrug when I tell them her family name.

"There were so many stupid acts by the partisans," laments Alfredo Mazzucchelli, a Carrara marble industrialist who was a child at the time. "The Germans killed thousands in reprisals." Mazzucchelli has special standing on this subject: his father, Ugo Mazzucchelli, was an anarchist partisan commander who chose to deal with the Nazis rather than lead Carrara to a similar fate. Mazzucchelli *padre* recognized that while the *partigiani* could harry and bedevil the Germans, they could never defeat them alone—and that endlessly attacking would cost endless civilian lives. Their role should rather be to spy, to guide the Allies through the mountains, and to "minimize harm to the people." That became especially clear in November 1944, following the summertime massacres, when the Allies announced they would not push forward into the Apuans until spring. And so the partisans struck up an extraordinary accord with the Nazis.

The Germans had earlier ordered an evacuation of Carrara, but the city's women faced them down. They poured into the Piazza delle Erbe, in the old city, and refused to move or let the troops get at their men. That time, in a crowded city rather than an isolated village, the Germans backed off. Now Mazzucchelli sent an emissary with an offer: if the Germans would spare Carrara from evacuations and massacres, the partisans would not attack them there. The partisans posed just enough threat to make the deal stick. Carrara became an open city between the German and Allied lines—and a very hungry one, cut off from supplies on both sides, its population doubled from the refugee influx. The Carrarese hunkered down and waited for the

Americans. And waited. Pinned down by the Punta Bianca guns, with their supply lines stretched, the Americans were in no hurry to liberate a city that had already been liberated.

Young and old scattered into the hills to forage: "As long as there were chestnuts, it went well," says Taro, an ex-partisan. "Afterward, the hunger was terrible. The bread ration was just fifteen grams a day. We ate leaves, or the pods of the chestnuts. Many older people died." Cesare Ropa, who was four or five years old at the time, remembers eating chestnuts "roasted, boiled, baked, crude, as polenta and as bread. It was prime food—it had everything you need. But I haven't been able to stand chestnuts since."

Once again, the local women rallied. With their men dead, deported, hiding from the Germans, or off with the partisans, it fell on them to obtain food. And so they loaded up handcarts and rucksacks with whatever they could find to barter—food coupons, salt from the coastal basins, embroidery, silver, and other household items—and headed across the Apuan and Apennine mountains to Parma in the fertile Po valley, sixty miles away. The trails were steep, icy in winter, and always perilous. Cesare Ropa accompanied his mother on one of her five or six treks to Parma. Once, coming back, she and her companions were stopped by a patrol of Germans and Black Brigadists on Monte Lugo above Massa, who demanded the food. "You do what you want," she said, "but either you kill me or you let me pass." Ropa says the Fascists were about to exercise the former option, but the Germans insisted on letting her go. On another trip, she trekked to Piacenza instead, and returning came upon a truck Allied bombers had struck, presumably in the belief it carried arms. Instead it was loaded with wine and cookies; Ropa still smiles dreamily at the memory.

And so Carrara endured, through the autumn, winter, and spring of 1944–45. "When the Americans finally arrived," says Nicolazzi, "people were glad to see them. But not as glad as they would have been six months earlier."

"The Americans were welcomed," says Taro defiantly. "But not as liberators. Carrara was already liberated, by the partisans!" Cesare Ropa remembers the anticipation of receiving his first piece of chocolate from an American soldier and having to wait and show it to his mother "because she'd told me never to eat anything if I didn't know

what it was." Ropa did not see his father, conscripted to work in Germany, for four more years; he was "liberated" by the Russians, who held him until 1949, and then walked home, through eight hundred miles of an Eastern European winter.

NOTES

I have omitted citations for Condivi's and Vasari's biographies of Michelangelo, unless particular citations call for additional explication. Both these *Lives* are so brief and familiar, so readily available in so many editions, and, with their straightforward narrations, so easily surveyed, that readers may find it more pleasant and convenient to locate passages of interest themselves.

Translations from Italian and French are by the author, unless only English-language sources are cited.

Introduction: Aristide's Trail

1. Cecchinelli is endeavoring to establish a marble arts school, the equivalent of Carrara's Scuola di Marmo, in Barre, and, together with local enthusiasts, is building a Barre Granite Museum in the town's historic Labor Hall.
2. David Shaw, "The Maestro and His Magic Knife," *Los Angeles Times,* 15 January 2002; Thomas Murray, "Purging Drugs from Sports Is Critical to Reward Natural Abilities," *Taipei Times,* 31 July 2004; Michael Ruse, "'HUMAN Nature': My World, and Welcome to It," *New York Times Book Review,* 4 July 2004; "Carve Release," *Evansville Courier & Press,* 24 October 2004.
3. "Righteous Rides," *Knoxville News Sentinel,* 14 July 2004.
4. Dan Steinberg, "At 76ers Brainstormer, It Was Raining Ideas," *Philadelphia Inquirer,* 24 July 2004, viewed at www.philly.com 25 July 2004.
5. Proust, *In Search of Lost Time,* 2:18.
6. De Tolnay, *Michelangelo,* 1:21 ("The Youth of Michelangelo").
7. Stone, *Agony,* 252–53, 480–81, 514. The supposition that Michelangelo contracted and recovered from syphilis rests on two letters from his friend Lionardo Sellaío di Compagno. On January 4, 1522, Lionardo cheered the news "that you are cured of a malady from which few recover." On January 22 he wrote again: "I am delighted you are free of a malady that harms the soul and the body." But there's no further evidence the *"malattia"* was syphilis, or if it was, that Michelangelo caught it from a female prostitute. An earlier letter from Lionardo urging Michelangelo to "abandon practices harmful to the body and the mind, that they may not hurt the soul," suggests the "malady" may have been sexual practice rather than venereal disease. See Ramsden, *Letters,* 1:xlviii; Poggi, *Carteggio* 2:339 and 2:341.
8. Ramsden, in his own tortuous attempt to disprove Michelangelo's homoerotic leanings, endorses Giovanni Papini's amazing contention that the *Leda* and the *Dawn* prove not only that he was "normal" but that he was not "impotent," since they "presuppose the direct experience of a heterosexual relationship." Ibid., 1:li.
9. "I do not ask for anything [from the pope] because my work [the Sistine ceiling]

does not seem to go ahead in a way to merit it. This is due to the difficulty of the work and also because it is not my profession." Michelangelo to Lodovico di Buonarrota Simoni, 27 January 1509; Poggi, 1:88; Ramsden, 1:48.

Chapter 1: *Pietra Viva*

1. Penny, *Materials of Sculpture,* 57–58.
2. The Yule Quarry reopened in 1990, went into bankruptcy in 1998, but emerged and is now operated by a Canadian conglomerate. The Arlington National Cemetery plans to replace the tomb in the same historic stone, if and when a suitable block can be quarried. A proposal to replace the tomb gratis, in return for permission to duplicate the tomb for a new museum in nearby Marble, Colorado, fizzled when Marble's residents rejected the proposed museum.
3. Gemignano, "La favola del marmo," *Carrara e le sue favole,* 18–20.
4. Sonnet, ca. 1538–44, no. 151 in Saslow, *The Poetry of Michelangelo,* 302:

 > *Non ha l'ottimo artista alcun concetto*
 > *c'un marmo solo in sé non circonscriva*
 > *col suo superchio, e solo a quello arriva*
 > *la man che ubbidisce all'intelletto.*

5. Plotinus, Ennead 1.6:9, in *Essential Plotinus,* 42. The early church fathers, including Gregory of Nazianzus in his *First Theological Oration* and Gregory of Nyssa (cited by Barolsky in *Michelangelo's Nose,* 33) echoed this theme, urging the believer to "polish his soul like a statue."
6. Gautieri, "Memoria sopra Grantola e Cenardo," in *Patrin, Diction d'Histoire nai. Art. Filons,* 28, cited by Repetti, *Sopra l'Alpe Apuana,* 38.
7. Repetti, *Sopra,* 36–37.
8. Ibid., 39.
9. Alison Leitch, an Australian anthropologist who has done extensive fieldwork in and around Carrara, in "Life of Marble," 238–39.
10. Walter Pater, "The Poetry of Michelangelo," in Seymour, *Michelangelo: The Sistine Chapel Ceiling,* 164.
11. 1 Peter 2:4–6.
12. Madrigal to Vittoria Colonna, ca. 1540–45, no. 240 in Saslow, *Poetry,* 406:

 > *Sol d'una pietra viva*
 > *L'arte vuol che qui viva*
 > *Al par degli anni il volto di costei.*

13. No. 54 in Saslow, *Poetry,* 140, begins:

 > *Io crederrei, se tu fussi di sasso,*
 > *amarti con tal fede, ch'i' potrei*
 > *farti meco venir più che di passo . . .*

14. Pliny, *Natural History* 36.7:22–23.
15. Durability, however, varies widely and sometimes unpredictably according to local conditions and the particular variety, even the individual block, of stone and how it has been treated. I've seen a granite monument in Barre, Vermont, "the Granite Capital of the World," badly eroded after less than a century, while statues in Carrara marble have survived two millennia in Rome's much dirtier (though more temperate) air.

Chapter 2: The Sculptor in the Garden

1. Liebert, *Michelangelo: A Psychoanalytic Study*, 22.
2. Festin, *1865–1910 Settignano*.
3. Most biographers merely recount that Michelangelo sent "to Florence" for workers, but William Wallace exhaustively documents the Settignano connection, correlating village records and Michelangelo's payment records, in *Michelangelo at San Lorenzo*.
4. Converting Renaissance sums to modern currencies is a chancy, partly arbitrary, business; relative costs were very different then. The rate I've adopted, $150 U.S. per Florentine florin, is a midrange guess that turns out to be the one propounded by the Society for Creative Anachronism. At that rate, labor cost about a third as much in 1500 as now; artisans earned fifty to one hundred florins, $7,500 to $15,000, a year. And gold cost nearly three times as much—eight florins, or $1,200, an ounce. Scudi and ducats, also common currencies, were more or less equal to florins.
5. Vasari, "Life of Domenico Ghirlandaio," *Vite*, 3:166.
6. Wind, in *The Religious Symbolism of Michelangelo*, 158, cites an October 14, 1494, letter from Ser Amadeo to his brother Adriano, a bronze caster working in Naples, noting that the "sculptor from the garden has taken off to Venice without a word to Piero"—Piero de' Medici, Lorenzo's son and heir and Michelangelo's personal patron.
7. Michelangelo's biographers tend to take Lorenzo's sculpture "school" at face value. But Condivi does not mention it, and Hale, in *Florence and the Medici*, 59, dismisses it as "an invention of [Vasari] designed to impress his own patron, Duke Cosimo I, with the glory that came from protecting and educating artists."
8. Ames-Lewis outlines these changes in *Tuscan Marble Carving*, 12–13.
9. Young Michelangelo probably did sit by Lorenzo sometimes, but the explanation is less exalted than Condivi's account suggests; seating at Lorenzo's table was on a first-come, first-in-place basis.
10. Pico della Mirandola, *On the Dignity of Man*, 5.
11. Vasari, "Torrigiano," *Lives of the Artists*, 2:484–85; Cellini, *Autobiography*, 14.
12. Plato, *Phaedrus* 252.
13. Both the extract from Piero di Marco Parenti's diary and the "scurrilous lampoons" are cited by Edgar Wind in *Religious Symbolism*, 167–68.
14. Karl Bluemel offers a provocative comparison of these techniques in *Greek Sculptors at Work*, 25 ff.
15. In Hibbard, *Michelangelo*, 252.
16. Bluemel, *Greek Sculptors*, 26–27.
17. Rockwell, "Some Reflections," 216. He discusses sculpture tools in more detail, with schematic illustrations, in *The Art of Stoneworking*, 31–68.
18. Rockwell, "Some Reflections," 221.
19. Giovannini, *The Non-Finished*, 105.

Chapter 3: Cities of Stone

1. Condivi, *Life*, 18.
2. Letter of July 11, 1496, to Lorenzo di Pier Francesco de' Medici; Poggi, 1:1–2; Ramsden, 1:3.

3. Ibid., 5.
4. Penny, *Materials of Sculpture*, 35–38.
5. After the last world war, Italy repaid Greece for the gift, twenty-two hundred years earlier, of the knowledge of working marble; according to Carlo Nicoli, Carrarese masters went to reopen Paros's quarries, which had shut down again.
6. Rockwell, in *The Art of Stoneworking*, 26–28, offers a succinct comparison of various carving stones informed by deep personal experience. Parian lignite, for example, is "a fine carving marble" that "takes detail well" but "shows a greater inclination to fracture than Carrara marble and has less tensile strength."
7. Dennis, *Cities and Cemeteries*, 67s.

Chapter 4: The Magra's Mouth

1. *CARRARA, morti son vescovi e conti*
 di Luni, e son dispersi i loro avelli;
 gli Spinola e Castruccio Antelminelli
 son morti, e gli Scagliere e i Visconti;

 ed Alberico che t'ornò di fonti,
 gli antichi tuoi signori ed i novelli.
 Ma su quante città regnano i belli
 eroi nati dal grembo de' tuoi monti!

 Quei che li armò di soffio più gagliardo,
 quei fa su te da vertice rimoto
 ombra più vasta che quella del Sagro.

 E non il santo martire Ceccardo
 t'è patrono, ma solo il Buonarroto
 pel martirio che qui lo fece magro.

2. Dennis, *Cities and Cemeteries*, chapter 35.
3. Mannoni, Luciana and Tiziano, *Marmo*, 202. This wide-ranging study of marble culture is nevertheless valuable, and it's virtually the only one translated from Italian into English (as *Marble: The History of a Culture*, published by Facts on File). Its Genovese viewpoint is also a refreshing change from the usual Florencentric focus.
4. Franzini, "Il marmo della Punta Bianca," 37.
5. Cantisani et al., "Sulla provenienza apuana."
6. Bruschi et al., "Stratigrafia delle dischariche," 28.
7. Martial and Pliny, cited by Dennis, *Cities and Cemeteries*, 18.
8. Franzini, "Il marmo della Punta Bianca," 38.
9. Ibid., 37.
10. Pliny, *Natural History* 36.7.48.
11. The historian Suetonius recounted that Augustus "so beautified [the city] that he could justly boast that he had found it built of brick and left it in marble." Suetonius, *Lives of the Caesars* 2.28.3.
12. McKendrick, *The Mute Stones Speak*, 145–46.
13. Strabo, *Geography* 5.2.5.
14. Carlo Lazzoni, *Carrara e le sue ville* (1880), 477, cited by Dolci, *Carrara cave antiche*, 160.

15. Another explanation, not widely accepted, credits the name Torano to the oxen, *tauri*, used to haul blocks down from the quarries. Monfroni, *Michelangelo a Carrara*, 43.

16. Pliny, *Natural History*, 36.1.1–2.

17. In 1976 Stroobant, a sculptor, photographer, filmmaker, and writer long resident in Carrara, showed a film shot entirely in Carrarino at the Venice Biennale. "The people of Venice had no problem understanding it," he recounts. "They did not even look at the subtitles."

18. "Languages of Italy," *Ethnologue: Languages of the World*, 14th ed., viewed at http://www.ethnologue.com/show_country.asp?name=Italy, 31 August 2004.

Chapter 5: The Cardinal's *Pietà*

1. Milanesi, *Lettere*, 613–14.

2. Ibid., 613. The inclusion of Cardinal Bilhères' two letters in Milanesi's standard 1875 collection makes their neglect by some subsequent biographers all the more surprising.

3. Topolino to Michelangelo, 13 August 1524; Poggi, 3:98–99.

4. Repetti, *Sopra l'alpe apuana*, 49–50.

5. Ibid., 51–52.

6. Cited by Hirst, "Michelangelo, Carrara, and the Marble for the Cardinal's Pietà," 156, the most comprehensive study of the procurement of the Vatican block, to which this account owes much.

7. Ibid., 70.

8. Wallace, *Michelangelo at San Lorenzo*, 19.

9. Vasari, "Of Architecture," in *Vasari on Technique*, 45.

10. The Accademia di Belle Arti in Carrara also displays samples of more than two hundred mostly Italian marble varieties, without the museum's international range. Those who can't get to Carrara can get a sense of the range of marble varieties from technical books such as Studio Marmo and Frederick Bradley's *Natural Stone: A Guide to Selection* (New York: W. W. Norton, 1998) and Studio Marmo and Marco Campagna's *Stone Sampler* (Norton, 2003).

11. Rockwell, *Art of Stoneworking*, 29n.

12. Renwick, *Marble and Marble Working*, 21. Recycling ancient monuments continued.

13. Penny, *Materials of Sculpture*, 31.

14. Rockwell, *Art of Stoneworking*, 18.

15. W. Brindley in *Transactions of the Royal Institute of British Architects*, new series 3:53, cited in Renwick, *Marble*, 19.

16. Regesto del Codice Pelavicino, doc. 224, May 19, 963, 202, cited by Bernieri, *Carrara*, 19. On Otto's proclamation, see also Luciani, *Vocabulario*, 9, and Repetti, *Sopra l'alpe apuana*, 81–82.

17. Repetti, *Sopra*, 81–83.

18. Luciani, *Vocabulario*, 13.

19. *Kar* is the ancestor of English "hard" and has its apparent descendants in English as well. From it come the Welsh *carreg* and Irish/Scottish Gaelic *carraig* for "stone" or "rock," which are related to *craig* and *creag*, whence comes our "crag."

20. Gemigniani, *Carrara e le sue favole*, 13.

21. Enrico Dolci, a professor at Carrara's Accademia di Belle Arti and a leading authority on the early history of the *cave,* describes the provenance of the duomo marbles in *Manutenzione e sostituzione nel restauro dei monumenti lapidei,* 56.

22. Giancarlo Paoletti (*Il Duomo,* p. 5) describes the *Annunciation* as French-influenced Pisan work; the Belgian native Dominique Stroobant contends it is from the Mosan.

23. Bernieri, *Carrara,* 50; Luciani, *Vocabulario,* 14–15.

24. In his *Novella CCXXIX,* Sacchetti tells of a priest who, as a practical joke, is sent to find a certain maiden: "Arriving in Carrara, he looked and looked, turning to each marble piece he saw thinking it was his woman, and finally, not seeing her, he began to ask. . . ." Quoted by Magenta, *L'industria dei marmi apuani,* 31.

25. Exactly how the system worked remains a mystery. Christiane Klapisch-Zuber, the scholar who has researched the medieval quarry system most deeply, could not find "any text [that] confirms the hypothesis of the *vicinanze*'s preeminence over the territory in which the quarries were situated." But she also could not find any record of a quarry being sold—which would confirm private ownership—until the 1530s. Perhaps the *vicinanze*'s authority was so deeply embedded that it did not need to be recorded. The situation seems to have resembled the American open range before barbed wire and railroad grants sectioned it off. Vague communal property rights would have favored independent marble masters—such as those working for Michelangelo—who wanted to open new quarries; no one would be blocking the way with a deed. Klapisch-Zuber, *Les maîtres du marbre,* 132–33.

26. Ibid., 142

27. Ibid., 52.

28. Mannoni, *Marble,* 220.

29. Dickens, *Pictures from Italy,* 356.

Chapter 6: *David* and the Orphan Stone

1. Contract between the Opera del Duomo and Michelangelo of August 16, 1501, in Milanesi, *Lettere,* 620–23, translated in Seymour, *Michelangelo's David,* 137.

2. In 1968 Joachim Poeschke contended that Donatello actually executed the *Isaiah* that was credited to Nanni in 1408 and produced this *David* in 1412. Most other scholars don't concur. Poeschke, *Donatello,* 371–72, 377.

3. Seymour, *Michelangelo's David,* 32.

4. Ibid., 36–37.

5. Poeschke, *Donatello,* 416.

6. I rely on oral descriptions of these documents by John Paoletti of Wesleyan University, in whose upcoming book they will be presented.

7. Vasari gives an entirely different account; he blames one Simone da Fiesole for leaving the block "completely botched and misshapen." Modern historians dismiss it, but if it were true, the Donatello connection might still hold; the sculptor Simone da Fiesole, a pupil of Brunelleschi, was thought to be Donatello's brother. Or perhaps Vasari meant Simone's son Francesco di Simone da Fiesole, whose active years, the latter part of the fifteenth century, correspond to the search for a sculptor to carve the block.

8. Seymour, *Michelangelo's David,* 37–38.

9. Contract of August 16, 1501, in Milanesi, *Lettere,* 620.

10. Vasari, "Of Sculpture," from the introduction to the *Vite*, in *Vasari on Technique*, 148–50; Cellini, "Treatise on Sculpture," in *Treatises*, 135–36. See also LeBrooy, *Michelangelo's Models*, 17–22.

11. Michelangelo wrote this in his 1547 letter to Benedetto Varchi and couched it as the view he formerly held. But as other parts of the letter reveal, he had not fundamentally changed his opinion. A contemporary, Giovan Battista Armenini, also recorded him as declaring "that the closer you see paintings approach good sculpture, the better they will be; and the more sculptures will approach paintings, the worse you will hold them to be."

12. Cellini, *Autobiography*, 231.

13. Cellini, "Treatise on Sculpture," in *Treatises*, 135–36.

14. In 1987, the University of Virginia art historian Frederick Hartt, a leading Michelangelo scholar, announced a once-in-a-lifetime discovery in his majestically misleading *David by the Hand of Michelangelo*: a small but exquisitely formed plaster model of the *David's* torso. The discovery was subsequently discredited when the model's shady provenance emerged, and Hartt's reputation suffered after it emerged that he had obtained a promise of a 5 percent commission on the eventual auction price of the model, which was expected to run as high as $80 million—a record for any artwork at the time. In retrospect, the attribution seems implausible to the point of absurdity; though its taut, sucked-in waist is very different from the final *David's*, the eight-inch torso's pubic hair is almost identical to the final version's, and just as finely detailed. No other Michelangelo model shows such fetishistic, wasteful attention to a superficial detail.

15. The sculptor Kenny Hunter in "Familiarity Breeds Boredom. And Yet . . . ," Scotland *Sunday Herald*, 29 February 2004. Viewed online at http://ww1 .sundayherald.com/40236, 26 December 2004.

16. Prisca Giovannini outlines this process in "The 'Non-Finished,'" 109, and also details the chisels Michelangelo used on the *David*, based on marks left in unpolished areas of the hair, sling strap, trunk, and rock: *subbia, subbia da taglio* (cutting point), *unghietto, dente di cane,* and, of course, his favored *gradina*. She found no marks from the flat chisels that less-adept sculptors used for finishing.

17. Seymour, *Michelangelo's David*, 7–17.

18. These incidents are recounted in many Italian texts and by Falletti, "Historical Research," 55–73.

19. Ibid., 61.

Chapter 7: The Painter and the Sculptor

1. Poeschke, *Donatello*, 77.

2. Hartt (*Michelangelo*, 302) writes these off as "probably carved by pupils" and omits them from his *Complete Sculpture*, but at least two evince Michelangelo's hand. His noncompliance, and threats of lawsuits, hung over his head for the next six decades, and after his death his nephew and heir Lionardo paid the Piccolomini heirs one hundred ducats. See also Wallace, *Michelangelo: The Complete Sculpture*, 56–57.

3. In Milanesi, *Lettere*, 79–80.

4. Letter to Giovan Francesco Fattuci, chaplain of Santa Maria del Fiore, late December 1523; Poggi, 3:7; Ramsden, 1:148.

5. The thoroughgoing Caterina Rapetti traces this trail, which other scholars overlook, in *Michelangelo,* 14.

6. Liebert, *Michelangelo: A Psychoanalytic Study,* 222–23.

7. Seymour, *Michelangelo's David,* 74.

8. Rockwell, *Art of Stoneworking,* 70, 72.

9. Ibid., 201.

10. Mercedes Carrara alerted me to this important factor, which most accounts overlook.

11. As a servant of Duke Cosimo de' Medici, who buried the Florentine republic, Vasari had a motive for making Soderini and the republic look ridiculous.

12. Again, consider the source, and his role in the aftermath. In 1565 Vasari, who wrote the history, painted over Leonardo's marred republican masterpiece with a fresco more congenial to Duke Cosimo I. As Jonathan Jones suggests in the *Guardian* (22 October 2002), surely the *Battle* merited preservation as much as that other victim of Leonardo's technical experiments, *The Last Supper.* It's a good thing Vasari wasn't court artist in Milan, where *The Last Supper* survives, sort of, despite repeated abuse, restoration, and abusive restoration, and is still revered.

13. Letter to "Monsignore . . ." (Cardinal Alessandro Farnese?), October 1542; Poggi, 155; Ramsden, 2:31. In fact, Raphael was a creative sponge, studiously absorbing and translating the advances of, among others, his teacher Perugino, Leonardo, the Flemish and Venetian masters of oil painting, and, of course, Michelangelo's Sistine ceiling. In the same letter, written to justify his behavior in the successive commissions for Julius's tomb and account for payments received, Michelangelo declares that "all the discords that arose between Pope Julius and me were owing to the envy of Bramante and Raphael."

14. Leonardo, *Paragone* 37, 95.

15. This tale, recorded by the "Anonimo Magliabechiano," is recalled by Goffen, *Renaissance Rivals,* 148.

16. Leonardo, *Paragone* 43.

17. Letter to Benedetto Varchi, spring 1547; Poggi, 4:265–66; Ramsden, 2:75. Another contemporary, Giovan Battista Armenini, recorded Michelangelo as declaring "that the closer you see paintings approach good sculpture, the better they will be; and the more sculptures will approach paintings, the worse you will hold them to be."

Chapter 8: The Tomb of Dreams

1. On Soderini's and the republic's downfall, see Brucker, *Renaissance Florence,* 272–74, and Hale, *Florence and the Medici,* 92–94.

2. Guicciardini, "Oratorio accusatoria," in *Scritti autobiografici,* 213; *Storie Fiorentine,* 299, also cited by Hirst, "Michelangelo in 1505," 765.

3. The British art historian Michael Hirst proposes this linkage in "Michelangelo in 1505," 762–66.

4. By the late Italian scholar Giovanni Poggi, first published by Hirst, ibid.

5. "Beard," in *The Catholic Encyclopedia,* vol. 2, online edition published by K. Knight, http://www.newadvent.org/cathen/02362a.htm, viewed 12 August 2004.

6. Vasari does not mention figures in the niches, but Condivi does, though he does not describe them. A badly damaged drawing of one side of the temple by

Michelangelo and a well-preserved copy by his follower Giacomo Roccheti show the figures thus.

7. Letter from Matteo di Michele, 24 June 1508; Poggi, *Carteggio*, 1:68.

8. Document 3:61, Archivio Malaspina di Fosdinovo marchesi di Massa, Archivio di Stato di Massa.

9. Vetruvius, *De architectura* 2.1–4. Michelangelo's peers noticed the parallel; two poems composed upon his death compared him to Dinocrates. See Bush, *Colossal Sculpture*, 20.

10. Letter to Giovan Francesco Fattuci, December 1525; Poggi 3:190–91; Ramsden, *Letters*, 1:164–65.

11. Michelangelo certainly visited Fantiscritti, and Repetti noted his initials carved on a Roman *edicola* there in 1820. Repetti, *Sopra*, 61.

12. *"Questa era, disse, una pazzia venutami per detta. Ma s'io fusse sicuro di vivere 4 volte quanto son vissuto, sare' vi io entrato."* The amanuensis who recorded this and Michelangelo's other *postille* was apparently his assistant Tiberio Calcagni. *Postilla* no. 10 in Condivi, *Vita*, xxi.

13. This version of Curzio's tale is collected by Gemignani as "Marco cavaliere" in *Carrara e le sue favole*, 22–25.

14. Gemignani, "Aronte e la Sirena," ibid., 16–17.

15. Lucan, *Pharsalia* 1:586. In the poem, Aronte or "Arruns" plays a Cassandra-like role. The Romans, alarmed at Julius's march on Rome, beg him to prophesy, but every entrail he reads is vile and ominous. Some of Lucan's translators place Aronte in "Lucca" (Jane Wilson Joyce) or "Luca" (P. F. Widdows in *Lucan's Civil War*). But common sense suggests, and Dennis argues in *Cities and Cemeteries* (pp. 64–65), that Aronte would have dwelt by Luna.

16. Montesquieu, *Voyages en Europe*, 245.

17. Martini, *Viaggio in Toscana*, 404–6.

18. Dickens, *Pictures*, 356.

Chapter 9: The Brotherhood of Stone

1. Dante, *Inferno* 20: 46–51:

> *Aronte è quei ch'al ventre li s'atterga*
> *che ne' monte di Luni, dove ronca*
> *lo Carrerese che di sotto alberga,*
> *Ebbe tra' bianchi marmi la spelonca,*
> *per sua dimora; onde a guardar le stelle*
> *e 'l mar non li era la veduta tronca.*

2. The following account of Dante's sojourns draws on Chubb, *Dante and His World*, 508–15, 544–47; Galanti, *Il secondo soggiorno*; Zananaini, *I Malaspina*, 36–41; and Scott, *Dante's Political Purgatory*, 40.

3. Article originally published in *La Nazione*, republished in Batini, *Album delle apuane*, 232.

4. Dante, *Purgatorio* 19:142–45:

> *Nepote ho io di là c' ha nome Alagia,*
> *buona da sè, pur che la nostra casa*
> *non faccia lei per essemplo malvagia;*
> *e questa sola là m'è rimasa.*

5. Chubb, *Dante*, 514; Bemrose, *A New Life of Dante.*

6. Boccaccio, *Life of Dante*, 63–64.

7. Cited by Galanti, *Il secondo soggiorno*, 17.

8. Dante, *Inferno* 24:146–52:

> Tragge Marte vapor di Val di Magra
> 　ch'è di torbidi nuvoli involuto;
> 　e con tempesta impetüosa e agra
> sovra Campo Picen fia combattuto;
> 　ond' ei repente spezzerà la nebbia,
> 　sì ch'ogni Bianco ne sarà feruto.
> E detto l' ho perchè doler ti debbia!

9. Chubb, *Dante*, 509–10.

10. Dante, *Purgatorio* 8:124–29:

> La fama che la vostra casa onora
> 　grida i segnori e gridi la contrada,
> 　sì che ne sa chi non vi fu ancora;
> e io vi giuro s' io di sopra vada,
> 　che vostra gente onrata non si sfregia
> 　del pregio della borsa e della spada.
> Uso e natura sì le privilegia
> 　che, perchè il capo reo il mondo torca,
> 　sola va dritta e 'l mal cammin dispregia.

11. *"Qui visse e morì l'uomo più duro del mondo!"* I heard this version of the tale passed down from a native Gragnagnese. Gemignani recounts it, minus the load of bricks, in "Michelangelo contro Dante," in *Carrara e le sue favole*, 44–45.

12. Ibid., 44. *Porcoboia* means literally "hangman pig." This yarn comports with Vasari's description of Michelangelo's "tenacious and profound memory," *Vite*, 7:236.

13. The long struggle between the Holy Roman Empire and the papacy, and between Ghibellines and Guelphs, began with Matilda's resistance to Emperor Henry IV. It was at her castle door that Henry stood for three wintry days begging absolution, when Pope Gregory VII was her guest.

14. *Purgatorio* 28:37–33:135, passim.

15. Michelangelo refers to his family's supposed descent from the counts of Canossa. Letter to Lionardo di Buonarroto Simoni from Rome, 4 December 1546; Ramsden, 2:64.

16. Letter to Lionardo Sellaio, 25 September 1540; Poggi 4:110; Ramsden 2:7.

17. Ibid., 2:64.

18. Circa 1509–10, no. 5 in Saslow, *Poetry*, 70:

> I' ho già fatto un gozzo in questo stento,
> 　come fa l'acqua a' gatti in Lombardia. . . .
> La barba al cielo, e la memoria sento
> 　in sullo scrigno, e 'l petto fo d'arpia. . . .
> E' lombi entrati mi son nella peccia,
> 　e fo del cul per contrapeso groppa. . . .

19. Circa 1546–50, no. 247 in Saslow, *Poetry,* 451:

> D'intorn'a l'uscio ho mete di giganti,
> ché chi mangi'uva o ha presa medicina
> non vanno altrove a cacar tutti quanti.
> I' ho 'mparato a conoscer l'orina
> e la cannell ond'esce, per quei fessi
> che 'nanzi dí mi chiamon la mattina.

20. I owe this explanation to Giuliana Morescalchi, a researcher cataloging the genealogy of Carrara's Fossola parish. She found a "Domenico, il Topo di Torano," who married into the parish a few decades after Michelangelo passed through. Michelangelo never resorted to such patching together in his *own* statues. But he oversaw, some say collaborated in, a little-noted patchwork on one of the most celebrated statues from antiquity: the *Farnese Hercules,* a marble copy of the famous bronze by the Hellenistic master Lysippos, discovered, minus its lower legs, in 1546. His follower Guglielmo della Porta—who completed his designs for the Farnese Palace, where the *Hercules* was installed—carved new legs. Then the originals turned up. Michelangelo reportedly convinced the Farnese that the new legs were as good or better, and *Hercules* stood on them for centuries. The National Archaeological Museum in Naples, which holds the statue, finally re-attached the original legs, but set out the della Porta/Michelangelo versions so visitors may judge for themselves. See http://www.metmuseum.org/toah/hd/engr/hod_17.37.59.htm, viewed 7 March 2005.
21. Olivieri, "Il *genius loci,*" 23.
22. Modern Indian *garam masala* is not fish sauce, but the transition to it over two millennia is less radical than the evolution over far fewer years of "ketchup" from the Amoy Chinese *ké-tsiap*—fermented fish sauce.
23. Olivieri, "Il *genius loci,*" 61.
24. Ibid., taken from R. Bavastro, *Del porcello e delle sue prelibatezze . . . il lardo,* (Massa, 1999), 34.

Chapter 10: The Agony of the Bronze

1. Rapetti, *Michelangelo, Carrara,* 18.
2. "Documento I" appended by Frediani, *Ragionamento storico,* 47.
3. Contract of 10 December 1505; Milanesi, *Lettere,* 631.
4. Rapetti, *Michelangelo, Carrara,* 19.
5. Letter of 31 January 1506; Poggi, 1:11; Ramsden, 1:11.
6. Letter to Giuliano da Sangallo, 2 May 1506; Poggi, 1:13; Ramsden, 1:13.
7. Vasari credits "Bramante and Raphael" with planting the suggestion, although Raphael did not arrive in Rome until 1508, when Michelangelo returned. And, striving as ever to paint a more colorful tale, he writes that Bramante and Raphael persuaded Julius that building his own tomb during his lifetime would only bring his death nearer.
8. Letter from Piero Rosselli, 10 May 1506; Poggi 1:16.
9. Letter of 7 August 1506, document 3:32 in the Archivio Malaspina di Fosdinovo marchesi di Massa, Archivio di Stato di Massa:

*M. D. Albericho, Marchione Malaspina Massa, tanquam frat. carissime
Magnifico Domino— Habbiamo operata che questi vostri de marmi hanno apunc-
tato nostri operai qui di Santa Maria del Fiore: et lo habbiamo facto volontieri: et
faremo sempre per quella e [] suo dono lauda honore [] comodo. Come per altro le
diremo [ci] pare che cotesti maestri di marmi habbino spezhato un pezo di marmo
molto grande: il quale desideriamo che la Signoria Vosta vi lo fama falsare: che lo
satisfaremo convenientemente: et vene fare cosa molto grata et accepta: che desider-
amo farné una statua che lo maggiore non existe. Benevaleat D. V.*

*Ex Palatio florentino, die 7 Augusti 1506
Petrus de Soderinibus, Vexillarius in perpetus
Populi Florentini*

10. This seems an unusual job to offer an inexperienced engineer, even in the age of
 universal genius, and it contradicts Michelangelo's stated determination to stay
 in Florence. Nevertheless, a margin note declares, "It was true, and I had al-
 ready made a model." Postilla 13, Condivi, *Vita*, xxii.
11. Letter to Buonarotto, 10 August 1507; Poggi, 1:51; Ramsden, 1:38.
12. Letter to his father, Lodovico, 8 February 1507; Poggi, 1:13; Ramsden, 1:24.
13. Letter of 21 August 1507, document 3:34(1) in the Archivio Malaspina di Fosdi-
 novo marchesi di Massa, Archivio di Stato di Massa. Published in Frediani, *Ra-
 gionamento storico*, 49.
14. Letter of 16 December 1508 and undated fragment; Archivio c. Minute di Pier
 Solderini filza 127, published in Gaye, *Carteggio inedito*, 107.

Chapter 11: Painting in Stone, Sculpting with Paint

1. Letter of 24 June 1508; Poggi,1:68–69.
2. *Ricordo* of 10 May 1508; Milanesi, *Lettere*, 564.
3. Receipt of 11 May 1508 from Jacopo Rosselli; Milanesi, *Lettere*, 564. Some ac-
 counts confuse Jacopo Rosselli with the architect Piero Rosselli.
4. Letter to his father, 27 January 1509; Poggi, 1:88; Ramsden, 1:48.
5. Letter to his father, October 1512; Ramsden, 1:74.
6. Letter to his father, October 1512; Poggi, 1:136; Ramsden, 1:75.
7. Cited by Francesco Buranelli in his foreword to *The Last Judgment: A Glorious
 Restoration*, 6. Pinto's remark is the mirror image of Michelangelo's, after seeing
 Titian's paintings, that the Venetians would be unbeatable if they only had a
 sound early foundation in drawing.
8. Cited by Eskerdjian in "The Sistine Ceiling and the Critics," 401.
9. Walter Pater, "The Poetry of Michelangelo" (1871), in *The Works of Walter Pater*,
 excerpted in Seymour, *Michelangelo*, 164.
10. Romain Rolland, *La vie de Michelange* (1905), excerpted in Seymour, *Michelan-
 gelo*, 171.
11. Freedberg, *Painting in Italy*, 37.
12. Eskerdjian, "The Sistine Ceiling and the Critics," 401.
13. Colalucci, "Technique, Restoration, and Reflections," 202–3.
14. Brandt, "Twenty-five Questions," 400.
15. Vasari, *Vasari on Technique*, 221–22.

Chapter 12: The Promised Land

1. Letter of 18 September 1512; Poggi, *Carteggio* 1:136; Ramsden, *Letters,* 1:74.
2. Letter of October 1512; Poggi, 1:139; Ramsden, 1:81.
3. Letter to Marchese Alberico Malaspina from the Conservatores Camere Alme Urbis di Roma, seeking marble for the statue of Leo, 14 April 1514, in the Archivio Malaspina di Fosdinovo marchesi di Massa, Archivio di Stato di Massa. Also published in Frediani, *Ragionamento,* 52–53.
4. Judgment of 23 January 1511; Milanesi, *Lettere,* 633–44.
5. Rapetti, 24, estimates the timing thus, though this might not have given Baldassare time to extract and ship the marble in any event. The contract itself has been lost.
6. "*Stratiare.*" Letter of August–September 1513; Poggi, 1:144; Ramsden, 1:81.
7. Rapetti, 24, considers these possible explanations.
8. He would lament in one letter that he was starving, and instruct his father or brother to bid on yet another farm property in the next. Simple greed was not the motive, despite the charges of avarice that dogged him even in his lifetime; he lived frugally, like any miser, and sincerely proclaimed that he worked like a quarry mule only for his family's sake. More than the well-being of individual family members, that meant the stature of the familial line, which he set out to restore by building a vast estate and claiming a noble legacy. But that line barely continued—via Buonarroto, the only one of Michelangelo's brothers to have children; Buonarroto's only son, Lionardo; and Lionardo's son (the second whom he named after his uncle) Michelangelo the Younger. The last direct heir, Cosimo Buonarroti, died childless in 1858.
9. Rapetti, *Michelangelo,* 24.
10. Vasari, *Vite,* 7:238.
11. Freud, "The Moses of Michelangelo," 213.
12. Unaddressed copy of a letter to Cardinal Alessandro Farnese, October–November 1542; Ramsden, 2:31. It may seem strange to imagine blocks of marble disappearing almost under the pope's nose, but Renaissance Rome was a notoriously lawless place. Then again, Michelangelo was recalling distant events to justify his claims of financial loss in the execution of the contract.
13. Henraux, "Cenno storico," in *Seravezza.*
14. Cantisani et al., "Sulla provenienza apuana."
15. Vasari, *Vite,* 1:106. See also Magenta, *L'industria,* 41–42.
16. *Libro delle deliberazioni e stanziamenti digli operai di Santa Reperata del 1 giugno 1397,* cited by Magenta, 42.
17. Proclamation of 18 May 1515, in the Archivio di Stato di Massa; Milanesi, 643; Frediani, 54.
18. Letter of 2 June 1515; Poggi, 1:165; Ramsden, 1:89.
19. Ramsden notes that a Marco Gerardini was one of the signatories to the deeding of Seravezza's marble beds to Florence. *Letters,* 1:90.
20. Letter of 7 July 1515; Poggi, 1:168; Ramsden, 1:92.
21. Letter of 28 July 1515; Poggi, 1:170; Ramsden, 1:93.
22. Letter of 4 August 1515; Poggi, 1:171; Ramsden, 1:93–94.
23. Letter of 11 August 1515; Poggi, 1:172; Ramsden 1:94–95.
24. Ibid.

25. Ibid., footnote; Wallace, *Michelangelo at San Lorenzo*, 32–33.
26. That sculptor was Benedetto di Bartolomeo da Rovezzano; Michelangelo gave his reply in a letter to Buonarroto 1 September 1515; Poggi, 1:176; Ramsden, 1:96.
27. Letter from Domenico di Sandro, 3 October 1515; Poggi, 1:180.

Chapter 13: "The Mirror of All Italy"

1. Letter from Argentina Malaspina Soderini, 15 July 1516; Poggi, 1:188–89.
2. Letter from Jacopo di Antonino di Maffiolo, 26 August 1516; Poggi, 1:195. See also Rapetti, 26.
3. *Ricordi* of 5, 7, and 14 September 1516; Milanesi, 566.
4. *Ricordo* of 15 September 1516; Milanesi, 566.
5. Letter to his father, Lodovico, end of September 1516; Poggi, 1:201; Ramsden, 1:103.
6. See Rapetti, 28.
7. The Florentine sculptor Baccio da Montelupo reported to Michelangelo that Matteo was badmouthing both of them, in a letter of 17 October 1516; Poggi, 1:206.
8. Letter of 28 September 1517; Poggi, 1:200.
9. Letter of 11 October, 1517; Poggi, 1:202.
10. Letter of 13–16 May 1518; Poggi, 2:6.
11. Domenico Buoninsegni to Michelangelo, 11 December 1516; Poggi, 1:232.
12. Letters from Baccio d'Agnolo, 13 October 1516, and from Domenico Buoninsegni to Baccio, 7 October 1516; Poggi, 1:204 and footnote.
13. Letter of 3 November 1516; Poggi, 1:207–8.
14. Contract of 1 November 1516, in the Archivio di Stato di Massa; Frediani, 56–58, cited by Rapetti, 29.
15. Contract of 18 November 1516; Milanesi, 654–55.
16. Letter of 21 November 1516; Poggi, 1:219–20.
17. Letter of 6 November 1516; Poggi, 1:211.
18. Letter of 26 November 1516; Poggi, 1:225.
19. Letter of 11 December 1516; Poggi, 1:230.
20. Contract of 3 January 1517 and *libello* of February 1517; Milanesi, 655–57.
21. Rapetti, 29–30.
22. Contract of 12 February 1517; Milanesi, 660.
23. Wallace, "Drawings," 118–21.
24. Frediani, 20. Also Rapetti, 30–31.
25. Michelangelo also offered his "services to the divine poet for the erection of a befitting sepulchre to him in some honourable place in this city," but nothing came of it. Symonds, *Life*, 1:335.
26. Dickens, *Pictures from Italy*, 355.
27. "The Marble Quarries of Carrara," *Scientific American* 80 (8 April 1899): 215.
28. Condivi, *Vita*, 37.
29. Letter from Domenico Buoninsegni, 2 February 1517; Poggi, 1:245–46.
30. Letter from Cardinal Giulio de' Medici, 2 February 1517; Poggi, 1:244.
31. Ibid.
32. Letter of 8 March 1517; Poggi, 1:261–62.

33. Letter of 20 March 1517; Poggi, 1:267; Ramsden 1:104.
34. Letter of 27 March 1517; Poggi, 1:268.
35. Letter of 20 April 1517; Poggi, 1:273.
36. Letter of 30 June 1517; Poggi, 1:291.
37. Letter of 27 March 1517; Poggi, 1:268.
38. Letter to Domenico Buoninsegni, 27 March 1517; Poggi, 1:277–78; Ramsden, 1:105–6.
39. Ibid.
40. Ibid.
41. For an extended discussion of this problem and Michelangelo's attempts to resolve it, which informs this account, see Ackerman, *The Architecture of Michelangelo*, 11–20.
42. Wallace, *Michelangelo at San Lorenzo*, 45; Ashmole, *Architect and Sculptor*, 17.
43. Wallace, *Michelangelo at San Lorenzo*, 13–14. The Septizodium was demolished soon after.

Chapter 14: Taming the Mountain

1. Letter from Andrea Ferrucci, 8 July 1517; Poggi, 1:292.
2. Letter of September (?) 1517; Poggi, 1:302.
3. Letter of Leonardo Lombardello, 30 October 1518; Poggi, 1:308.
4. Letter from Buoninsegni, 1 January 1518; Poggi, 1:315.
5. An unaddressed letter, possibly to Buoninsegni, of February or March 1520, expounding Michelangelo's side in the collapse of the San Lorenzo project; Poggi, 2:218–19; Ramsden, 1:129–31.
6. Magenta, *L'industria*, 33–34.
7. *Ricordo* of 2 February 1518; Milanesi, *Lettere*, 572.
8. Letter of 13 March 1518; Poggi, 2:324.
9. Letter of 23 March 1518; Poggi, 2:332.
10. Letter to Buonarroto, 2 April 1518; Poggi, 1:334; Ramsden 1:109–10.
11. Ibid.
12. Verbena Pastor, "Nameless Brothers," 1.
13. Walter S. Arnold, a Chicago stone carver, presents this and other union lore on his Web site, www.stonecarver.com/union. Viewed 24 August 2004.
14. Barre's quarries and labor history: Karen Lane, "Old Labor Hall—Barre, Vermont," *Labor's Heritage*, spring/summer 1999, 49–61; Richard Hathaway, "Men Against Stone: Work, Technology, and Health in the Granite Industry" in *Celebrating a Century of Granite Art* (exhibit catalog), Vermont College Arts Center and Barre Museum, 1989; Carol Maurer, "A More Perfect Union Hall," *Preservation*, September/October 2001, 52–55; Mari Tomasi, "The Italian Story in Vermont," *Vermont History* 28 (1960): 73–87.
15. Wallace details his dealings with his Settignano compatriots in *Michelangelo at San Lorenzo*, even charting the family relationships among them, and this account owes much to his; see especially 29–38.
16. Letter of 18 April 1518; Poggi, 1:346–47; Ramsden, 1:112
17. "Manteau de futaine our cap de drap de Napoli." Klapisch-Zuber, *Les Maîtres du Marbre*, 121.
18. The Arte della Lana granted the concession four days later, on April 22.

19. Letter of early May (mid-March, according to Ramsden) 1518; Poggi, 2:9; Ramsden 1:108–9.
20. Letters from Leonardo Lombardelli, 11 June 1518 (Poggi, 2:24–25), and Matteo di Cuccarello, 12 June 1518 (Poggi, 2:26). See also letters from Iacopo detto Pollina, Poggi, 2:66.
21. Letter from Lodovico Doffi, 1 August 1518; Poggi, 2:44. See also Wallace, *Michelangelo at San Lorenzo,* 51.
22. Letters from Donato Benti, 7–11 October 1518 (Poggi, 2:90-91) and Francesco Peri, 7 October and 15 October 1518 (Poggi, 2:89, 2:96). See also Rapetti, 64.
23. Letter of 23 October 1518; Poggi, 2:100.
24. Letter of 13 November 1518; Poggi, 2:106.
25. Michelangelo himself blew up when Bernardo Niccolini accosted him in a Florentine haberdasher's shop and read out Buoninsegni's letter "as though it were an indictment, so all would know I was being sent to my death." Letter to Buoninsegni, late December 1518; Poggi, 2:134; Ramsden, 1:122 and note.
26. Letters from Lionardo Sellaio, 28 November 1518 and 22 January 1519; Poggi, 2:106, 2:146.
27. Letter to Berto da Filicaia, 13–14 September 1518; Poggi, 2:82, Ramsden, 1:117.
28. Letter from Giovan Francesco Fattuci, 3 April 1526; Poggi 3:217. See Wallace, *Michelangelo at San Lorenzo,* 49–51, for an extensive discussion of the columns' importance.
29. Re the Ospedale and Pantheon columns, and Michelangelo's, see Wallace, "Michelangelo Engineer," 101–2.
30. Letters from Michele di Piero of 14 January and 1, 7 February 1519 (Poggi, 2:142); Donato Benti, 28, 29, and 31 January and 2, 3, 7 February 1519 (Poggi, 2:147–50, 153, 155, 158); and Andrea di Giovanni and Domenico di Matteo, 6 February 1519 (Poggi, 2:157).
31. *Ricordi* of 21 and 28 August 1518; Milanesi, 573.
32. *Ricordi* of 5 and 14 September 1518; Milanesi, 574.
33. Letter from Giovanni Cappelli, 12 August 1518; Poggi, 2:53.
34. Letter to Berto da Filicaia, 13–14 September 1518; Poggi, 2:82, Ramsden, 1:117.
35. Letter from Jacopo Salviati, 20 September 1518; Poggi, 2:84.
36. Literally "got to the bordello." Letter from Buonarroto, 20 (?) September 1518; Poggi, 2:85.
37. Letter to Berto da Filicaia, 13–14 September 1518; Poggi, 2:82; Ramsden, 1:117.
38. *Lizza* is another endemic local term that, in keeping with Carrara's crosscultural traditions, supposedly combines the southern Italian *l'ilza* and the Longobard *helcia.* (Lattanzi, *Lizzatura & Marmifera,* 20–21). It seems to correspond to the Italian *slitta,* "sledge."
39. *Parati* derives from *pararare,* dialect for the verb *prepare,* "prepare," befitting the function of laying the path. Ibid., 22.
40. Letter to Cardinal Giulio de' Medici, late November (?) 1518; Poggi, 2:109–10; Ramsden, 1:136–37.
41. Letter of 15 January 1519; Poggi, 2:143–44.
42. Letter from Donato Benti, 16 (?) October 1518; Poggi, 2:98. See also Wallace, *Michelangelo at San Lorenzo,* 30–31.
43. Letter of 6 November 1518; Poggi, 2:117.
44. Letter of 18 December 1518; Poggi, 2:125.

45. Letter to Domenico Buoninsegni, late December 1518; Poggi, 2:134; Ramsden, 1:123.
46. Liebert, *Michelangelo*, 219.
47. Ibid., 220.
48. Madrigal "for sculptors," ca. 1540–44, no. 242 in Saslow, *Poetry*, 409:

> *Ben la petra potrei,*
> *per l'aspra sua durezza,*
> *in ch'io l'esempro, dir c'a lei s'assembra.*

Chapter 15: The Walls Come Tumbling Down

1. Letter to Pietro Urbano, 11 May 1519; Poggi, 2:190–91; Ramsden, 1:125–26.
2. Letter to Girolamo del Bardella, 6 August 1519; Ramsden, 1:126–27.
3. Letter from Pietro Urbano, 19 August 1519; Poggi, 2:196–97.
4. Letter to Pietro Urbano, 5 September 1519; Poggi, 2:200–201; Ramsden, 1:127.
5. Wallace, *Michelangelo at San Lorenzo*, 70–71.
6. In the Salviati Archives, cited by Ciulich, "Michelangelo, Marble and Quarry Expert," 174.
7. Letter from Francesco di Giovan Michele, 29 February 1520; Poggi, 1:217.
8. Letter of late February/early March 1520; Poggi, 2:218–21; Ramsden, 1:128–31.
9. Letter to "Monsignore . . ." of October 1542; Poggi, 4:152; Ramsden, 2:28.
10. Ramsden credulously credits this theory in Appendix 14, *Letters*, 1: 271.
11. Re the patrons' neglect, see Elam, "Drawings as Documents," 111.
12. G. Cambi, *Storie fiorentine*, cited by Wallace in *Michelangelo at San Lorenzo*, 73.
13. That's not to say Michelangelo didn't use stone from the Seravezza quarries for architectural elements of his San Lorenzo projects and Julius's tomb. J.-B.-H. Henraux (*Seravezza*, "Cenno storico/Historical Outline") claimed he used marble from yet another quarry, Vincarella, for the latter.
14. Vincenzo Danti to Cosimo I, 27 June 1568; SpA Henraux Archives B/7, 5.
15. Ibid., 2 July 1568, p. 7.
16. See Stroobant, *Kenneth Davis*, for a fuller description.
17. For example, in 2004 the Costa brothers precisely duplicated weathered ornaments on Milan's Gothic cathedral by copying them with infrared scanners, then finishing them with hammer and chisel.
18. Indian Bureau of Mines, *Marble and Granite Mining*, 1.
19. In 2004, fired with outrage, Botero began painting Iraqi prisoners at Abu Ghraib Prison and their American tormentors. His figures, still chubby but now knotted with pain and fury, lent a special irony to his indictment.
20. Verse no. 16 in Saslow, *Poetry*, 86:

> *D'un oggietto leggiadro e pellegrino*
> *d'un fonte di pietà nasce 'lmie male.*

21. Letter of 1522–23 to Giovan Francesco Fattucci; Poggi, 2:344; Ramsden, 1:140–41.
22. Letter to Lodovico Buonarroti, June 1523; Poggi, 2:373; Ramsden, 1:144–45. Lodovico lived eight more years, and many more of his letters to his son survive.
23. Letter to Piero Gondi, 26 January 1524; Poggi, 3:27; Ramsden, 1:153.
24. Letter to Sebastiano del Piombo, May 1525; Poggi, 3:157; Ramsden, 1:160.
25. Letter to Topolino, 25 November 1523; Poggi, 3:1; Ramsden, 1:146.

26. Regarding Michelangelo's exposed and exaggerated structural forms, see Ackerman, *Architecture*, 131–32.
27. By Wallace's count; *Michelangelo at San Lorenzo*, 27.
28. Letter to Domenico Buoninsegni, September-October 1521; Poggi, 2:322; Ramsden, 1:135.
29. Letter from Topolino, 21 June 1524; Poggi, 3:81.
30. Wallace, *Michelangelo at San Lorenzo*, p.119.
31. Ibid., 119. See 113–20 for a fuller account of Topolino's troubles securing and shipping the Medici Chapel marble.
32. Letter from Topolino, 25 December 1524; Poggi, 3:123.
33. Letter to Pope Clement, late January/early February 1525; Poggi, 3:131; Ramsden, 1:151.
34. Wallace, *Michelangelo at San Lorenzo*, 118.
35. Ibid., 106.

Chapter 16: The Kiss of the Medici

1. Vasari, *Lives*, "Baccio Bandinelli," 7:66–67.
2. De Tolnay, *Michelangelo*, 3:98.
3. F. B. Andrews, *The Mediaeval Builder and His Methods*, quoted by Wallace, *Michelangelo at San Lorenzo*, 98.
4. Cellini, *Autobiography*, 231, 227. Such threats from Cellini were to be taken seriously; he did kill another rival. With both Cellini and Vasari lined up against him, Bandinelli didn't stand a chance with posterity.
5. Vasari, *Lives*, "Niccolò, called Tribolo," 7:27–28; "Andrea del Sarto," 5:96; "Giuliano di Baccio d'Agnolo," 6:70–71.
6. Ibid., "Pierino da Vinci," 7:42.
7. Ibid, 7:27–28.
8. Vasari, "Baccio Bandinelli," 6:17–18.
9. Colasanti, "Il memoriale di Baccio Bandinelli," 434. This *memoriale*, a series of autobiographical and admonitory dispatches Baccio left for his children, forms a revealing self-portrait, by turns preening and self-justifying, and heartfelt and anguished.
10. Ibid., 434, 425.
11. Cellini, *Autobiography*, 229.
12. The evidence Catterson initially presented was intriguing. Michelangelo had the means and motive; he had proven his knack for forgery and his willingness to undertake it, not only with the *Sleeping Cupid* but with the drawings Vasari reports he faked while still in Ghirlandaio's workshop. He needed the money, and supposedly received mysterious extra income and bought unaccounted-for blocks of marble during that period. He was one of the first to authenticate the *Laocoön;* Giuliano da Sangallo, who had been dispatched by Pope Julius II, brought him along to view the unearthing. Three months later, he suddenly fled Rome for Florence, citing as reasons the rebuff he'd received from Julius and "something else, which I don't want to write about," that put him in fear of his life; had Julius caught him out, or suspected the scam? And, most provocatively, the statue itself, with its hyper-naturalistic detail, explosive action, and extravagant emotion, has always been an anomaly in the classical catalogue,

described often (and anachronistically) as "baroque." Certainly it seems more Michelangesque than classical.

But many questions and considerations seemed to weigh against Catterson's claim: Who paid Michelangelo? How could even he carve two such works as the *Laocoön* and *Pietà* in less than two years? How could he execute and transport such a conspicuous work in secret, especially in as envious and gossip-crazed a milieu as Renaissance Rome? Why was it only uncovered six years later? And finally, for all their echoes in the Sistine Chapel frescoes, the *Laocoön's* frenzied movement and elaborate composition are unmatched in Michelangelo's other sculpture, just as they are in known classical works. Still, if it stands, Catterson's bombshell will be one of the greatest attribution breakthroughs of all time. See Kathryn Shattuck, "An Ancient Masterpiece or a Master Forgery?" *The New York Times*, 18 April 2005, p. E5.

13. Vasari, *Lives*, "Baccio Bandinelli," X:86–87.
14. Ibid., 68.
15. Wallace, *Michelangelo*, 235.
16. The prissy *Adam and Eve* Bandinelli carved for Florence's duomo look like over-sized porcelain dolls, and even his well-received copy of the *Laocoön* softens the original's straining muscles.
17. Cellini, *Autobiography*, 230.
18. Vasari, "Baccio Bandinelli," 72.
19. "Al Bandinello," in Colasanti, "Il memoriale," 429.
20. Vasari, "Baccio Bandinelli," 75.
21. Ibid., 73
22. Colasanti, "Il memoriale," 432.
23. Vasari, *Vite*, 6:48.
24. Campori, *Gli artisti italiani*, 30.
25. Borgioli and Gemignani, *Carrara e la sua gente*, 248.
26. Beck, "Michelangelo and the Medici Tombs," 26–27.
27. Trexler and Lewis, "Two Captains and Three Kings." Trexler emphatically re-states this thesis and its corollary, that posterity has switched the identities of the two captains, and decries the art-history establishment's rejection of this contention in "True Light Shining."
28. Grimm, *Life*, 506–10.
29. Hibbard, *Michelangelo*, 188.
30. Trexler and Lewis, "Two Captains," 93–116.
31. D. Moreni, *Pompe funebri . . .* , cited by Trexler and Lewis, 113–14.
32. McCarthy, *Stones*, 86.
33. La notte, che tu vedi in sì dolci atti
 dormir, fu da un Angelo scolpita
 in questo sasso, e perché dorme, ha vita,
 destala se non 'l credi, e parleratti.

34. Verse no. 247 in Saslow, *Poetry*, 419:
 Caro m'è 'l sonno, e più l'esser di sasso
 mentre che 'l danno e la vergogna dura;
 non veder, non sentir, m'è gran ventura;
 però non mi destar, deh, parla basso.

35. Hartt, *Michelangelo: The Complete Sculpture*, 242–44.
36. Tribolo was to carve them, but fell ill. Letter to Giovanbattista Figiovanni, 15 October 1533; Poggi, 4:55; Ramsden, 1:196.
37. Letter to Febo di Poggio, September 1534; Poggi, 4:66; Ramsden, 1:187.
38. Letter from Luigi Riccio to Roberto Strozzi; Poggi, 4:183–184, footnote. Cosimo was a tyrant to be feared; he had Strozzi's kinsman Filippo, a wealthy banker and anti-Medici leader who was married to Lorenzo il Magnifico's daughter, strangled in his dungeon; his own cousin Lorenzino murdered in Venice; and the former Medici enforcer Baccio Valori beheaded.

Chapter 17: The Last Blows of the Chisel

1. Giannotti, *Dialogi*, 88–97. Giannotti was just one of Michelangelo's contemporaries, and Francisco de Holanda another, to cast him as a pillar of wisdom in dialogues on philosophy, art, and poetry.
2. This account of the monument's creation derives in large part from the recollections of Alfredo Mazzucchelli.
3. That sculptor, Sergio Signori, also carved the large dove that stands in front of Carrara's city hall.
4. Petition to Pope Paul III, 20 July 1542; Poggi, 4:139; Ramsden, 2:19–21.
5. Letter from Pietro Aretino, November 1545; Poggi, 4:215–17; also in Symonds, *Life*, 2:51–55. Aretino, no pious exemplar himself, cites his own notorious dialogue *Nanna*, whose heroine teaches her daughter the prostitute's art, as a model of reserve because "in treating lascivious and indecent material, I use only decent, proper language." Michelangelo, by contrast, dares to show saints and angels "indecently." Aretino did not just complain privately; in a letter to Michelangelo's engraver, he menacingly mentions "the Duke of Tuscany" and warns Michelangelo, "I am one to whose letters even kings and emperors respond." At heart, however, he seems a deranged fan who felt snubbed by his idol. When Michelangelo started *The Last Judgment,* Aretino offered a grandiose program for its design and begged the gift of a drawing. Michelangelo replied with characteristic irony that it was too late to switch to Aretino's "perfect" vision of the Last Judgment, and never sent a drawing (Poggi, 4:82–83, 4:90–91; Symonds, 2:48–49). Aretino in turn whined that if Michelangelo had given him an artwork as he promised, he would have disproven the "invidious reports that you can only give things to Gherardi and Tomai"—an insinuating reference to Gherardo Perini and Tommaso de' Cavalieri, two young men Michelangelo had favored with drawings (Poggi, 4:216).
6. He also expressed this sentiment in sculptural terms in a madrigal (ca. 1538–44, no. 152 in Saslow, *Poetry*, 305) to Vittoria Colonna, harkening back to the Neoplatonic conceits he absorbed as a youth in Lorenzo de' Medici's circle:

Sì come per levar, donna, si pone	Just as, lady, to take away, one seeds
in pietra alpestra e dura	into hard alpine stone
una viva figura,	a living figure that
che là più crece u'più la pietra scema;	grows greater with the stone's decline,
tal alcun'opre buone,	just so are good deeds
per l'alma che pur trema,	for the trembling soul,

cela il superchio della propria carne	which the surfeit of its own flesh
co' l'inculta sua cruda e dura scorza . . .	disguises in a crude, hard rind . . .

7. Dante, *Purgatorio* XXVII:100–108, 354.
8. Wallace, *Michelangelo*, 99.
9. This is a curious inversion of the two sisters' identities: Dante's Leah stops to adorn herself "in the glass," but Rachel is the one who "never leaves her mirror and sits all day."
10. Such comparisons are only provisional, pending the completion of the restoration of the Pauline frescoes begun late 2004 and depending on what colors the restorers uncover—and what original touches they may remove.
11. See Ackerman, *Architecture*, 130–31.
12. Liebert, 404, speculates that Urbino—whom Michelangelo cherished after twenty-six years' service, and who was then fatally ill—urged him to "finish it before I die," and Michelangelo feared bringing on his death.
13. Hibbard, *Michelangelo*, 284. However, the Freudian Liebert (405–8) rejects this simple explanation, arguing that a *Pietà* carried "feelings of rage and aggression toward the mother who left him frightened and alone" when he was six, which Urbino's quasimaternal nagging and impending death exacerbated.
14. De Tolnay, *Life of Michelangelo*, 5:90.
15. In Oxford University's Ashmolean Museum; plate 35 in Perrig, *Michelangelo's Drawings;* and in other illustrated volumes.

Epilogue: Another War

1. Baracchini, *La Sepoltura*.
2. These incidents and many others are recounted by Casella, *Tuscany and the Gothic Line*, 333–34. See also Cerrito, *Gli Anarchici*, and, for an American soldier's view of the Apuan war, Baker's *Lasting Valor*.

BIBLIOGRAPHY

Ackerman, James S. *The Architecture of Michelangelo*. Studies in Architecture, vol. 4. London: A. Zwemmer, 1961.

Ames-Lewis, Francis. *Tuscan Marble Carving 1250–1350: Sculpture and Civic Pride*. Hants, England: Ashgate, 1997.

Ashmole, Bernard. *Architect and Sculptor in Classical Greece*. New York: New York University Press, 1972.

Baker, Vernon J., with Ken Olsen. *Lasting Valor*. New York: Bantam Books, 1999.

Balas, Edith. *Michelangelo's Medici Chapel: A New Interpretation*. Philadelphia: American Philosophical Society, 1995.

Baracchini, Almo. *La sepoltura delle vittime dell'eccedio di Bardine a San Terenzo*. Ed. Mario Venutelli. Carrara: Grafiche Catelani, 2004.

Batini, Giorgio, ed. *Album delle apuane: cronache d'altri tempi*. Florence: La Nazione, 1991.

Bavastro, Romano. *Gli Eroi del Marmo*. Pontedera: Bandecchi & Vivaldi, 2004.

Beck, James. "Michelangelo and the Medici Tombs." In *Michelangelo: The Medici Chapel*. New York: Thames and Hudson, 1994.

Bemrose, Stephen. *A New Life of Dante*. Exeter (U.K.): Univ. of Exeter Press, 2000.

Bernieri, Antonio. *Carrara*. Città della Toscana. Genoa: Sagep, 1985.

Bertozzi, Massimo, ed. *Tra Arte e Industria: La tradizione artigiana in provincia di Massa Carrara*. Società Editrice Apuana, 1997.

Bluemel, Carl. *Greek Sculptors at Work*. Trans. Lydia Holland. London: Phaidon, 1955.

Boccaccio, Giovanni. *Life of Dante*. Trans. J. G. Nichols. London: Hesperus, 2002.

Borgioli, Maurio, and Beniamino Gemigniani. *Carrara e la sua gente*. Carrara: Stamperia Editoria Apuana, 1977.

Brandt, Kathleen Weil-Garris. "Twenty-five Questions About Michelangelo's Sistine Ceiling." *Apollo*, December 1987.

Brucker, Gene A. *Renaissance Florence*. Berkeley: Univ. of California Press, 1983.

Bruschi, Giuseppe, Antonino Criscuolo, and Giovanni Zanchetta. "Stratigrafia delle discariche di detrito dei bacini marmiferi di Carrara." In *Ante et post Lunam: splendore e ricchezza dei marmi apuani*, vol. 1, *L'evo antico*. Ed. Antonio Bartelletti and Emanuela Paribeni. Marina di Carrara: Parco Regionale delle Alpi Apuane, 2003.

Buranelli, Francesco. Foreword to *Michelangelo/The Last Judgment: A Glorious Restoration*. New York: Abrams, 1997.

Bush, Virginia L. "Bandinelli's *Hercules and Cacus* and Florentine Traditions." In *Studies in Italian Art and Architecture 15th Through 18th Centuries*. Ed. Henry A. Milton. Memoirs of the American Academy in Rome 35. Cambridge: MIT Press, 1980.

———. *The Colossal Sculpture of the Cinquecento*. New York and London: Garland Publishing, 1976.

Buzzegoli, Ezio. "Michelangelo as a Colourist, Revealed in the Conservation of the Doni *Tondo*." *Apollo*, December 1987.

Campori, Giuseppe. *Gli artisti italiani e stranieri negli stati estensi.* Modena: Tipografia R. D. Camera, 1855 (reprinted by Forni Editore, Bologna).

Cantisani, Emma, and Fabio Fratini, Giancarlo Molli, and Lucca Pandolfi. "Sulla provenienza apuana del marmo di cippi ferari etruschi." In *Ante et post Lunam: splendore e ricchezza dei marmi apuani,* vol. 1, *L'evo antico.* Ed. Antonio Bartelletti and Emanuela Paribeni. Marina di Carrara: Parco Regionale delle Alpi Apuane, 2003.

Casella, Luciano. *Tuscany and the Gothic Line.* Trans. Jean M. Ellis D'Allesandro. Florence: La Nuova Europa, 1963.

Cellini, Benvenuto. *The Life of Benvenuto Cellini.* Trans. and ed. John Addington Symonds. Reprint. New York: Heritage Press, n.d.

———. *The Treatises of Benvenuto Cellini on Goldsmithing and Sculpture.* Trans. C.R. Ashbee. Reprint. New York: Dover, 1967.

Cerrito, Gino. *Gli anarchici nella resistenza apuana.* Lucca: Maria Pacini Fazzi, 1984.

Chubb, Thomas Caldecott. *Dante and His World.* Boston: Little, Brown, 1966.

Ciulich, Lucilla Bardeschi. "Michelangelo, Marble and Quarry Expert." In *The Genius of the Sculptor in Michelangelo's Work.* Montreal: Montreal Museum of Fine Arts, 1992.

Colalucci, Gianluigi. "Technique, Restoration, and Reflections." In *The Sistine Chapel: The Art, the History, and the Restoration.* New York: Harmony Books, 1986. (Also published as *The Sistine Chapel: Michelangelo Rediscovered.*)

Colasanti, Arduino. "Il memoriale di Baccio Bandinelli." *Repertorium für Kunstwissenschaft* 28 (1905): 405–43.

Condivi, Ascanio. *Vita di Michelangelo Buonarroti.* Ed. Giovanni Nencioni. Florence: Studio per Edizione Scelte, 1998.

Dante. *The Divine Comedy: Inferno, Purgatorio and Paradiso.* Translation and commentary by John D. Sinclair. New York: Oxford University Press, 1939.

Dennis, George. *The Cities and Cemeteries of Etruria.* London: John Murray, 1848.

Dickens, Charles. *Pictures from Italy.* In *American Notes and Pictures from Italy.* London: Oxford University Press, 1957.

De Tolnay, Charles. *Michelangelo.* 5 vols. Princeton: Princeton University Press, 1943–60.

Dolci, Enrico. *Carrara cave antiche: materiali archeologici.* Carrara: Commune di Carrara, 1980.

———, ed. *Manutenzione e sostituzione nel restauro dei monumenti lapidei.* Firenze: Edizioni Regione Toscana, 1995.

Elam, Carol. "Drawings as Documents: The Problem of the San Lorenzo Façade." In *Michelangelo Drawings.* Ed. Craig Hugh Smyth and Ann Gilkerson. Washington: National Gallery of Art, 1992.

Eskerdjian, David. "The Sistine Ceiling and the Critics." *Apollo,* December 1987.

Falletti, Franca. "Historical Research on the *David*'s State of Conservation." In *Exploring David: Diagnostic Tests and State of Conservation.* Ed. Susanna Bracci, Franca Falletti, Mauro Matteini, and Roberto Scopigno. Florence: Giunti/Firenze Musei, 2004.

Festin, Simonetta Angeli. *1865–1910 Settignano: colle armonioso.* Florence: SP 44 Editore.

Franzini, Marco. "Il marmo della Punta Bianca (La Spezia): l'estrazione di 'marmo lunense' in epoca romana ebbe inizio di questo giacimento." In *Ante et post Lunam: splendore e ricchezza dei marmi apuani,* vol. 1, *L'evo antico.* Ed. Antonio Bartelletti and Emanuela Paribeni. Marina di Carrara: Parco Regionale delle Alpi Apuane, 2003.

Frediani, Carlo. *Ragionamento storico su le diverse gite che fece a Carrara Michelangelo Buonarroti.* Massa-Carrara: Palazzo di S. Elisabetta, 1975.

Freedberg, Sydney J., ed. *Painting in Italy 1500–1600*. 3rd edition. New Haven: Yale University Press, 1993.

Freud, Sigmund. "The Moses of Michelangelo." In *The Standard Edition of the Complete Psychological Works of Sigmund Freud*. Ed. James Strachey. Vol. 13. London: Hogarth Press, 1955.

Gaye, Giovanni. *Carteggio inedito d'artisti dei seicoli XIV, XV, XVI*. Vol. 2, 1500–1557. Florence: Presso Giuseppe Molini, 1840; Turin: Bottega d'Erasmo, 1961.

Galanti, Livio. *Il secondo soggiorno di Dante in Lunigiana e la composizione del Purgatorio*. Lunigiana: Società Dante Alighieri et al., 1993.

Gemignani, Beniamino. *Carrara e le sue favole: i nostri antenati raccontano che . . .* Carrara: L'ecoapuano, 1994.

Giannotti, Donato. *Dialogi di Donato Giannotti, de' giorni che Dante consumó nel cercare l'Inferno e 'l Purgatorio*. Ed. Deoclecio Redig de Campos. Florence: G. C. Sansoni, 1939.

Giovannini, Prisca. "The 'Non-Finished' Surfaces on the *David*: Preliminary Observations on the Sculpting Marks." In *Exploring David: Diagnostic Tests and State of Conservation*. Ed. Susanna Bracci, Franca Falletti, Mauro Matteini, and Roberto Scopigno. Florence: Giunti / Firenze Musei, 2004.

Goffen, Rona. *Renaissance Rivals: Michelangelo, Leonardo, Raphael, Titian*. New Haven: Yale University Press, 2002.

Gombrich, E. H. *The Story of Art*. London: Phaidon, 1995.

Grimm, Herman. *Life of Michael Angelo*. Trans. Fanny Elizabeth Bunnètt. 2 vols. Boston: Little, Brown, 1877.

Guicciardini, Francesco. *Scritti autobiografici e rari*. In *Scrittori d'Italia*. Ed. Roberto Palmarocchi. Bari: Giuseppe Laterza & Figli, 1936.

———. *Storie fiorentine dal 1378 al 1509*. In *Classici della BUR*. Ed. Alessandro Montevecchi. Milan: Biblioteca Universale Rizzoli, 1998.

Hale, J. R. *Florence and the Medici: The Pattern of Control*. London: Thames and Hudson, 1977.

Hartt, Frederick. *David by the Hand of Michelangelo: The Original Model Discovered*. New York: Abbeville, 1987.

———. "The Meaning of Michelangelo's Medici Chapel." In *Essays in Honor of Georg Swarzenski*. Chicago: Henry Regnery; Berlin: Verlag Gebr. Mann, 1951.

——— *Michelangelo: The Complete Sculpture*. New York: Harry N. Abrams, 1968.

Hatfield, Rab. *The Wealth of Michelangelo*. Rome: Edizioni di Storia e Letteratura, 2002.

Henraux, J. Bernard Sancholle. *Seravezza: Da Forte dei Marmi all'Altissimo e alla Val d'Arni*. Paris: Société Henraux, 1908. Reprint, Pietrasanta: Edizioni Monte Altissimo, 2000.

Hibbard, Howard. *Michelangelo*. London: Allen Lane, 1975.

Hirst, Michael. "Michelangelo, Carrara, and the Marble for the Cardinal's Pietà." *Burlington Magazine* 127 (March 1985): 154–56.

———. "Michelangelo in 1505." *Burlington Magazine* 133 (November 1991): 760–66.

Indian Bureau of Mines. *Marble and Granite Mining in Italy—Scenario in India*. Nagpur: Indian Bureau of Mines, 1991.

Joannides, Paul. "'Primitivism' in the Late Drawings of Michelangelo: The Master's Construction of an Old-Age Style." In *Michelangelo Drawings*. Ed. Craig Hugh Smyth. Studies in the History of Art 33. Washington, D.C.: National Gallery of Art, 1992.

Klapisch-Zuber, Christiane. *Les mâitres du marbre, Carrare, 1300–1600*. Ports, Routes, Trafics, vol. 25. Paris: S.E.V.P.E.N., 1969.

Lattanzi, Christina Purger. *Lizzatura & Marmifera*. Carrara: Società Editrice Apuana, 1997.

Lavin, Irving. "The Sculptor's 'Last Will and Testament.'" *Allen Memorial Art Museum Bulletin 35*, nos. 1–2 (1977–78), 4–39.

LeBrooy, Paul James. *Michelangelo's Models (Formerly in the Paul von Praun Collection)*. Vancouver: Creelman & Drummond, 1972.

Leitch, Alison. "The Life of Marble: The Experience and Meaning of Work in the Marble Quarries of Carrara." *The Australian Journal of Anthropology* 7, no. 3 (1996): 235–57.

Leonardo da Vinci. *Paragone: A Comparison of the Arts*. Translation and introduction by Irma A. Richter. London: Oxford University Press, 1949.

Liebert, Robert S. *Michelangelo: A Psychoanalytic Study of His Life and Images*. New Haven: Yale University Press, 1983.

Lorenzini, Pietro. *Tyranny of Stone: Economic Modernization and Political Radicalization in the Marble Industry of Massa-Carrara (1859–1914)*. PhD dissertation, Loyola University, 1994.

Lucchesi, Rossella, ed. *Massa-Carrara and Surrounding Areas*. Pisa: Felici Editore, 2002.

Luciani, Luciano. *Vocabolario del dialetto carrarese*. Carrara: Aldus, 2003.

Magenta, Carlo. *L'industria dei marmi apuani*. Collana "Reprints." Firenze: G. Barbera, 1871; Carrara: Casa di Edizioni, 1992.

Mannoni, Luciana and Tiziano. *Marble: The History of a Culture*. Trans. Penelope J. Hammond-Smith. Genoa: Sagep, 1978; New York: Facts on File.

Martini, Georg Christoph. *Viaggio in Toscana (1725–1745)*. Modena: Deputazione di Storia Patria per le Antiche Provincie Modenesi, 1969.

McKendrick, Paul. *The Mute Stones Speak: The Story of Archaeology in Italy*. New York: St. Martin's Press, 1960.

Milanesi, Gaetano, ed. *Le lettere di Michelangelo Buonarroti, pubblicate con i ricordi ed i contratti artistici*. Florence: Le Monnier, 1875.

Monfroni, Luigi. *Michelangelo a Carrara e nelle cave*. Carrara: Glue & C., 1996.

Montesquieu, Charles de Secondat, Baron de. *Voyages en Europe*. In *Oeuvres Complètes*. Paris: MacMillan, 1964.

Olivieri, Orazio. "Il genius loci." In *Il lardo di Colonnata*. Ed. Orazio Olivieri, trans. Barbara Fisher. Milan: Federico Motta, 2003.

Osborne, Robin. *Classical Landscape with Figures: The Ancient Greek City and Its Countryside*. London: George Philip, 1987.

Paoletti, Giancarlo. *Il Duomo di Carrara: Breva guida a schede*. Massa: Glue & C., 1996.

Paolicchi, Costantino. "Non è davvero il Carchio il monte di Michelangelo!" *Versilia Oggi* 31, no. 335 (April 1996).

Pastor, Verbena. "Nameless Brothers: Art Guilds and the Anonymity of the Artist." In *Celebrating a Century of Granite Art*. Ed. Gene Sessions. Exhibition catalog. Barre and Montpelier: Vermont College Arts Center and Barre Museum, 1989.

Penny, Nicholas. *The Materials of Sculpture*. New Haven: Yale University Press, 1993.

Pensabene, P. "Some Problems Related to the Uses of Luna Marble in Rome and the Western Provinces During the First Century AD." In Yannis Maniatis, Norman Herz, and Yannis Basiakos eds., *The Study of Marble and Other Stones Used in Antiquity*. London: Archetype, 1995.

Perrig, Alexander. *Michelangelo's Drawings: The Science of Attribution.* Trans. Michael Joyce. New Haven: Yale University Press, 1991.

Pico della Mirandola, Giovanni. *On the Dignity of Man.* Trans. Charles Glenn Wallis. Indianapolis: The Library of Liberal Arts, 1965.

Pierotti, Piero, ed. *La Valle dei Marmi.* Pisa: Pacini, 1996.

Plotinus. *The Essential Plotinus: Representative Treatises from the Enneads.* Selected and translated by Elmer O'Brien. New York: New American Library, 1964.

Poeschke, Joachim. *Donatello and His World: Sculpture of the Italian Renaissance.* Trans. Russell Stockman. New York: Abrams, 1993.

———. *Michelangelo and His World: Sculpture of the Italian Renaissance.* Trans. Russell Stockman. New York: Abrams, 1996.

Pliny. *Natural History.* Trans. D. E. Eichholz. Vol. 10. Loeb Classical Library, 1962.

Poggi, Giovanni, compiler and transcriber. *Il carteggio di Michelangelo.* Ed. Paola Barocchi and Renzo Ristori. 5 vols. Florence: Sansoni, 1965.

Proust, Marcel. *In Search of Lost Time,* vol. 2, *Within a Budding Grove.* Trans. C. K. Scott Moncrieff and Terence Kilmartin. Revised by D. J. Enright. London: Chatto & Windus, 1992.

Ramsden, E. H., trans. and ed. *The Letters of Michelangelo.* 2 vols. Stanford: Stanford University Press, 1963.

Rapetti, Caterina. *Michelangelo, Carrara, e i maestri di cavar marmi.* Florence: All'Insegna del Giglio, 2001.

———. *Storie di marmo: sculture del Rinascimento fra Liguria e Toscana.* Milano: Electa/Università di Parma, 1998.

Renwick, W. G. *Marble and Marble Working: A Handbook for Architects, Sculptors, Marble Quarry Owners and Workers, and All Engaged in the Building and Decorative Industries.* London: Crosby Lockwood, 1909.

Repetti, Emanuele. *Sopra l'alpe apuana ed i marmi di Carrara.* Fiesole: Badia Fiesolana, 1820.

Rockwell, Peter. *The Art of Stoneworking: A Reference Guide.* Cambridge: University of Cambridge Press, 1993.

Saslow, James, trans. *The Poetry of Michelangelo.* New Haven: Yale University Press, 1991.

Schevill, Ferdinand. *The Medici.* New York: Harper & Row, 1949.

Scott, John A. *Dante's Political Purgatory.* Philadelphia: University of Pennsylvania Press, 1996.

Seymour, Charles, ed. *Michelangelo: The Sistine Chapel Ceiling: Illustrations, Introductory Essay, Backgrounds and Sources, Critical Essays.* New York: Norton, 1972.

———. *Michelangelo's David: A Search for Identity.* Pittsburgh: University of Pittsburgh Press, 1967.

Shulman, Ken. *Anatomy of a Restoration: The Brancacci Chapel.* New York: Walker, 1991.

Silvano, Giovanni. Introduction to *Repubblica Fiorentina* by Donato Giannotti. Geneva: Librairie Droz, 1990.

Strabo. *The Geography.* Trans. Horace Leonard Jones. Vol. 4. Loeb Classical Library, 1949.

Stroobant, Dominique. "Carrara, Island and Metaphor." In Luigi Biagini, *La Pelle del Monte.* Carrara: Aldus, 1999.

———. *Kenneth Davis: The Floating Stones / Le pietre galleggianti.* Torano: I Quaderni della Scuola di Torano, 2000.

Suetonius. *Lives of the Caesars*. Trans. J. C. Rolfe. Vol. 1. Loeb Classical Library, 1998.

Symonds, John Addington. *The Life of Michelangelo Buonarroti*. 2 vols. London: John C. Nimmo, 1893.

Trexler, Richard C. "True Light Shining vs. Obscurantism in the Study of Michelangelo's New Sacristy." *Artibus et Historiae* 42 (2000): 101–17.

Trexler, Richard C., and Mary Elizabeth Lewis. "Two Captains and Three Kings: New Light on the Medici Chapel." *Studies in Medieval and Renaissance History* 4 (1981): 93–177.

Valentiner, W. R. "Bandinelli, Rival of Michelangelo." *Art Quarterly* 18 (autumn 1955): 241–63.

Vasari, Giorgio. *Le vite de' piu eccellenti pittori, scultori e architettori*. 9 vols. Novara: Istituto Geografico De Agostini, 1967.

———. *Lives of the Most Eminent Painters, Sculptors and Architects*. Trans. Gaston du C. de Vere. 7 vols. London: Philip Lee Warner, 1912–14.

———. *Vasari on Technique: Being the Introduction to the Three Arts of Design, Architecture, Sculpture and Painting, Prefixed to the Lives of the Most Excellent Painters, Sculptors and Architects*. Trans. Louisa S. MacLehose. London: J. M. Dent, 1907; New York: Dover, 1960.

Vossila, Francesco. *Baccio Bandinelli's Colossus in the Piazza della Signoria*. Florence: Alinea Editrice, 1999.

Waelkens, M., and P. De Paepe and L. Moens. "The Quarrying Techniques of the Greek World." In *Marble: Art Historical and Scientific Perspectives*. Malibu: J. Paul Getty Museum, 1990.

Wallace, William. "Drawings from the Fabbrica of San Lorenzo During the Tenure of Michelangelo." In *Michelangelo Drawings*. Ed. Craig Hugh Smyth. Studies in the History of Art. Washington, D.C.: National Gallery of Art, 1992.

———. *Michelangelo: The Complete Sculpture, Painting, Architecture*. Beaux Arts Editions, 1998.

———. *Michelangelo at San Lorenzo: The Genius as Entrepreneur*. Cambridge, England: Cambridge University Press, 1994.

———. "Michelangelo Engineer." In *Architettura e tecnologia: Acque, tecniche e cantieri nell'architettura rinascimentale e barocca*. Ed. Claudio Conforti and Andrew Hopkins. Rome: Nuova Argos, 2002.

Ward Perkins, J. B. "Quarrying in Antiquity: Technology, Tradition and Social Change." *Proceedings of the British Academy* 57 (1971): 137–58.

Weil-Garris, Kathleen. "Bandinelli and Michelangelo: A Problem of Artistic Identity." In *Art, the Ape of Nature: Studies in Honor of H. W. Janson*. Edited by Moshe Barasch and Lucy Freeman. New York: Abrams, 1981.

———. "On Pedestals: Michelangelo's *David*, Bandinelli's *Hercules and Cacus* and the Sculpture of the Piazza della Signoria." *Römisches Jahrbuch für Kunstgeschichte* 20 (1983): 379–415.

Wilde, Johannes. *Michelangelo: Six Lectures by Johannes Wilde*. Oxford: Clarendon Press, 1978.

Wind, Edgar. *The Religious Symbolism of Michelangelo: The Sistine Ceiling*. Ed. Elizabeth Sears. Oxford: Oxford University Press, 2000.

Zananaini, Giuseppe. *I Malaspina di Lunigiana*. Lucca: Maria Pacini Fazzi, 1986.

ACKNOWLEDGMENTS

*S*ono duri e chiusi, i carrarini!"* The people of Carrara have a reputa-
tion, even amongst themselves, as "hard and closed," but my
experience refutes that. I cannot begin to list all those who shared lav-
ishly of their time, knowledge, and encouragement in the course of
this effort. Many are not credited, or not credited sufficiently, in the
text: Maria Matthei, Stefanie Oberneder, Antonio Doretti, Monsignore
Raffaello Monsantini of the Duomo di Carrara, Aldo and Roberto
Canale of EuroMarmi, Enrico Dolci of the Accademia di Belle Arti,
Antonella Cucurnia and Franco Barattini of Cave Michelangelo,
Mauro Franchini, Carlo Musetti, Antonio Criscuolo of the *comune* of
Carrara, Barbara Giampedroni and colleagues at the Camera di Com-
mercio; Andrea Balestri of the Industrial Association; Giancarlo and
Giacomo Dell'Amico; Marcello and Carlo Orlandi; and Carlo,
Francesca, and Carlotta Nicoli. Special thanks to Ann Perrault, Amer-
ica's unofficial goodwill ambassador in Carrara, and to Umberto,
Oreste, and Giuliana Giromella Morescalchi for insight, hospitality,
fables, and splendid postcards.

Mario Venutelli, president of the Sezione Apuo-Lunense of Italia
Nostra and keeper of Carrara's historical memory, and his comrade in
preservation Gualtiero Magnani were especially generous with their
time and knowledge. In Florence, Agnese Parronchi, Francesco Pan-
nichi, Franca Falletti of the Accademia di Belle Arti, Cristina Acidini
and Carlo Billotti of the Opificio delle Pietre Dure, and Patrick Burke
and Mercedes Carrara of Gonzaga University shared their knowledge
and upheld that city's intellectual legacy. Lodovico Gierut, Costantino
Paolicchi, and Danilo Orlandi of Pietrasanta helped fill in the Ver-
siliese side of the picture.

Giuliano Cecchinelli, Vince Illuzzi Sr., Tess Taylor, Karen Lane, Di-
ane Isabelle, and Marjorie Strong explained Barre's quarry legacy, so
reminiscent of Carrara's. William Wallace, James Beck, John Paoletti,
and Jennifer Irwin shared their expertise and gave encouragement.

Among published sources, three volumes were particularly valuable: Wallace's *Michelangelo at San Lorenzo,* Caterina Rapetti's *Michelangelo, Carrara, e i maestri di cavar marmi,* and Christiane Klapisch-Zuber's *Les mâitres du marbre, Carrare, 1300–1600.*

A good librarian is a living treasure, and I met many. Those at the Biblioteca Civica C. V. Lodovici in Carrara assisted above and beyond duty's call; Olga Raffi and her staff at the Archivio di Stato di Massa even helped me through the shoals of cinquecento orthography and penmanship. The Camera di Commercio, Internazionale Marmi e Macchine, and the Circolo Culturale Anarchico Fiaschi in Carrara; the Henraux archive in Querceta; the Kunsthistorisches Institut, Harvard University's Bernard Berenson Library, and the Biblioteca Nazionale in Florence; the civic archives of Pietrasanta and Seravezza; and the Vermont Historical Society in Barre all opened their valuable collections.

Thanks also to Clarissa Szabados for linguistic insight, and to Ann Senechal, Giovanni Bissi, and Simonetta Maturani for traveler's aid on the road to Carrara.

Coffee, bread, and wine mean even more in Italy than elsewhere, so here's a toast to a few of the many who supplied these and enough good cheer to cut an Apuan winter chill: Giorgio and the other master bakers of Panificio Dazzi, Dario, Jean-Pierre, and their clan at the Bar dell'Amico, and the gangs at Trattoria Nerina, Fuori Porta, and Cantina Saine.

I owe a special debt to those who made this book possible: my steadfast agent, Elizabeth Wales, and editor, Leslie Meredith, who saw the figure hidden in the stone. And to Leslie's able teammates at Free Press, Kit Frick, Martin Beiser, Ted Landry, and Gypsy da Silva. Together, they made it much better than it would have been. Also to Dominique Stroobant, sculptor and scholar, for his illuminating suggestions and critique, and Robert Gove, perhaps the only Californian ever to make a successful transformation into *carrarino,* a Virgil on a Vespa and a wise and indefatigable guide. And to Luigi, Luca, and Marco Brotini and Cecilia Manno, without whom I could not have begun this book, and Lucia, without whom I could not have finished.

INDEX

ABOUT THE AUTHOR

ERIC SCIGLIANO is the author of *Love, War, and Circuses: The Age-Old Relationship Between Elephants and Humans* (Houghton-Mifflin, 2002) and of two illustrated regional books, *Seattle from the Air* (Graphic Arts, 2002) and *Puget Sound: Sea Between the Mountains* (Graphic Arts, 2000). He is also the co-translator, with Joseph Do Vinh, of "Love Songs of a Madman: Poems of Peace and War by Trịnh Công Sơn," published by Yale University's *Việt Nam Forum*. A longtime journalist and former commercial artist, Scigliano has written for *Harper's, Discover, Art News, The New York Times*, and many other publications. His work has received Livingston, American Association for the Advancement of Science, and Robert F. Kennedy writing honors, and was selected for *The Best American Science and Nature Writing 2004*. His ancestors were quarrymen and stone carvers at Carrara, the source of the marble for Michelangelo's masterpieces.